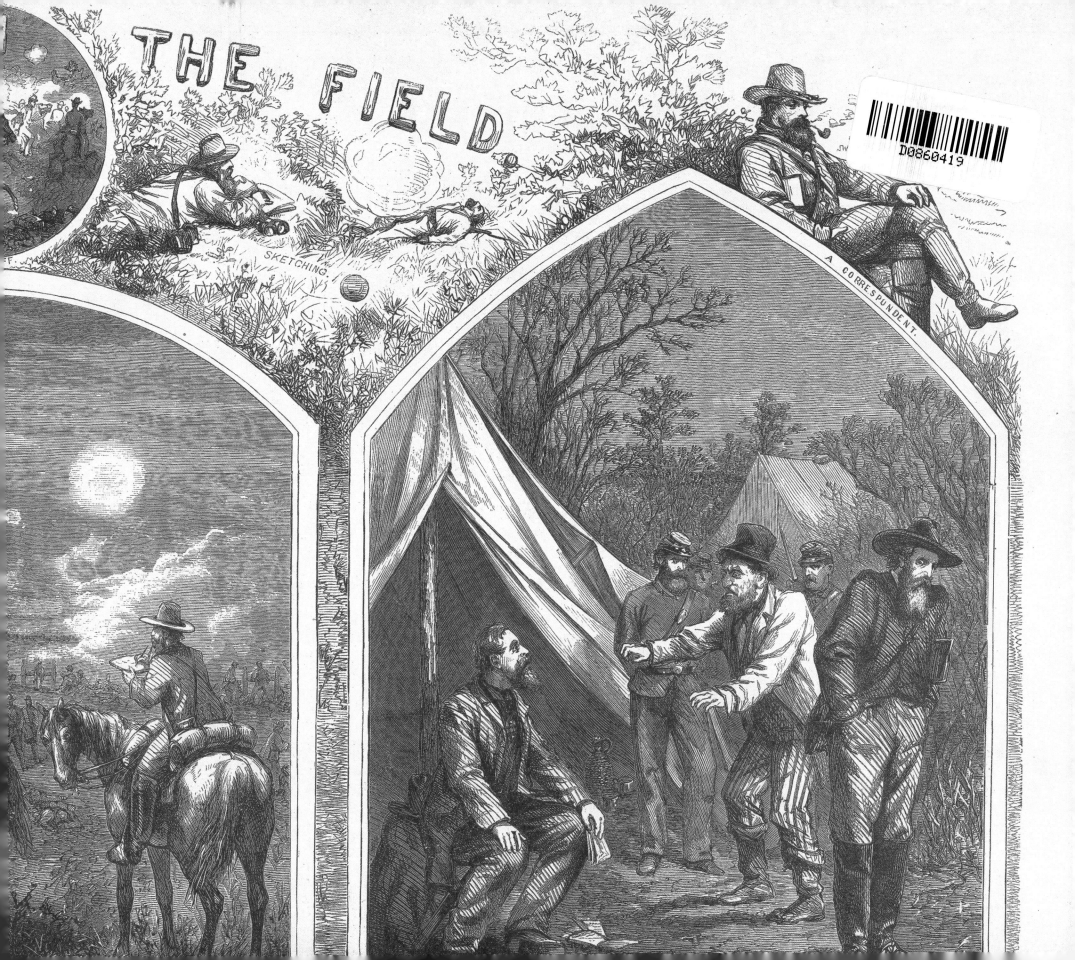

THE FIELD

SKETCHING.

A CORRESPONDENT.

Civil War Sketch Book

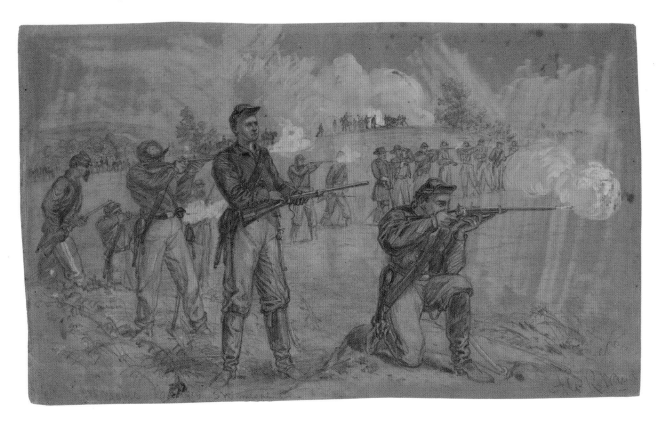

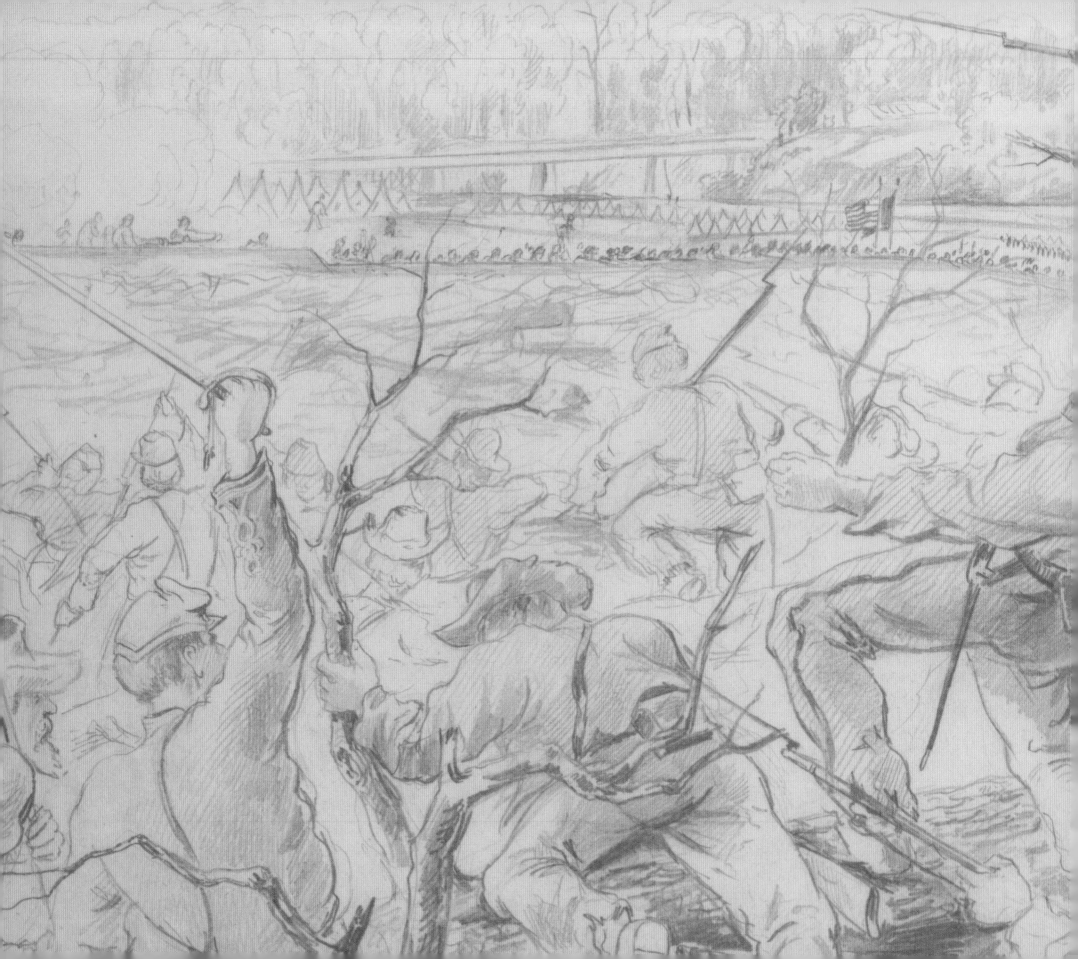

Civil War Sketch Book

DRAWINGS FROM THE BATTLEFRONT

Harry L. Katz and Vincent Virga

With a Preface by Alan Brinkley

W. W. Norton & Company

New York London

For my father, in memory of my mother.
—H.L.K.

For my sister, Julianne Virga, with thanks for all her loving care.
—V. V.

✤ ✤ ✤ ✤ ✤ ✤

Text copyright © 2012 by Harry L. Katz
Compilation copyright © 2012 by Vincent Virga
Preface copyright © 2012 by Alan Brinkley

For information about permission to reproduce selections from this book, write to
Permissions, W. W. Norton & Company, Inc., 500 Fifth Avenue, New York, NY 10110

For information about special discounts for bulk purchases, please contact
W. W. Norton Special Sales at specialsales@wwnorton.com or 800-233-4830

Manufacturing by RR Donnelley Shenzhen
Book design by Laura Lindgren
Production manager: Julia Druskin

Library of Congress Cataloging-in-Publication Data
Katz, Harry L.
 Civil War sketch book : drawings from the battlefront / Harry L. Katz and
Vincent Virga ; with a preface by Alan Brinkley. — 1st ed.
 p. cm.
 Includes bibliographical references and index.
 ISBN 978-0-393-07220-4 (hardcover)
 1. United States—History—Civil War, 1861–1865—Pictorial works.
2. United States—History—Civil War, 1861–1865—Art and the war.
3. Drawing, American—19th century. I. Virga, Vincent. II. Title. III. Title:
Drawings from the battlefront.
 E468.7.K38 2012
 973.7—dc23 2011044004

W. W. Norton & Company, Inc.
500 Fifth Avenue, New York, N.Y. 10110
www.wwnorton.com

W. W. Norton & Company Ltd.
Castle House, 75/76 Wells Street, London W1T 3QT

1 2 3 4 5 6 7 8 9 0

Contents

LINCOLN

AUTHOR'S NOTE AND ACKNOWLEDGMENTS

This book began with a desire to give the Civil War Specials their due, for their brilliant, courageous documentation of the era and as pioneers of photojournalism. Confronted by such a daunting task I took encouragement from Carl Sandburg, who conceded in the foreword to *Abraham Lincoln: The War Years* that the Civil War record is "so stupendous, so changing and tumultuous, that anyone dealing with the vast actual evidence cannot use the whole of it, nor tell all of the story." *Civil War Sketch Book* tells the story of the war as the Specials saw, sketched and lived it. The images were selected to show a wide range of artists, styles, techniques, issues, topics, regions and war theaters; they span the war and its major campaigns.

Producing this book required a company of professional colleagues to assist me and I am deeply grateful for their help. Any errors are my own. At W. W. Norton, Tom Mayer supported the project at every step, along with Denise Scarfi. My thanks to Virginia McRae for improving the manuscript. I am indebted to historians Stephen W. Sears and Richard S. West for their careful readings and constructive criticism. I also benefited from the camaraderie of my own Bohemian Brigade in the Publishing Office of the Library of Congress, including Ralph Eubanks, Peggy Wagner, Linda Osborne and Susan Reyburn. The Prints and Photographs Division at the Library of Congress recently scanned their entire collection of Civil War drawings and they are now all online; my thanks to Chief Helena Zinkham, "Chief" Jeremy Adamson, Phil Michel, Martha Kennedy and Sara Duke. Floramae McCarron Cates at the Cooper-Hewitt, National Design Museum, Smithsonian Institution, and Carlotta Owens at the National Gallery of Art aided my research into Winslow Homer. Clifford Ackley and his staff at the Museum of Fine Arts, Boston, welcomed me to the Karolik Collection, and Roberta Olson and Alex Mazzitelli from the New-York Historical Society gave the book an early boost. The New York Public Library Print Room helped during the early stages of my work, as did Anne Bahde, Special Collections Librarian at San Diego State University. At the Boston Athenaeum, my old friends Catherina Slautterback and Sally Pierce pointed me to Sheila Gallagher and Judith Bookbinder, who revealed to me the Joseph Becker Collection. That was a great trip to Boston! For their assistance with permissions and reproductions, I wish to thank Stefan Saks, Marta Fodor, Nicole Contaxis, and Duncan Burns of the Union League Club. I want to thank John Adler, creator of harpweek.com, the online version of *Harper's Weekly*, for supporting my research, Susan Severtson and my friend Eileen Lawrence of Alexander Street Press.

At the Dijkstra Agency, I am blessed with the extraordinary support of Sandra Dijkstra, Elise Capron, Elisabeth James and the rest of the office staff. Thanks to my father, Arthur Katz, for his editorial contributions. My family, Annie Hutchins and Devereux Katz, marched with me; I could not have managed without them. Finally, my thanks to Vincent Virga, who always helps me see things in a different, more illuminating light.

—Harry L. Katz
Del Mar, California
February 2011

Alfred Waud, *Lincoln Resting, Top Hat in Lap*, ca. 1862–1864, Library of Congress.

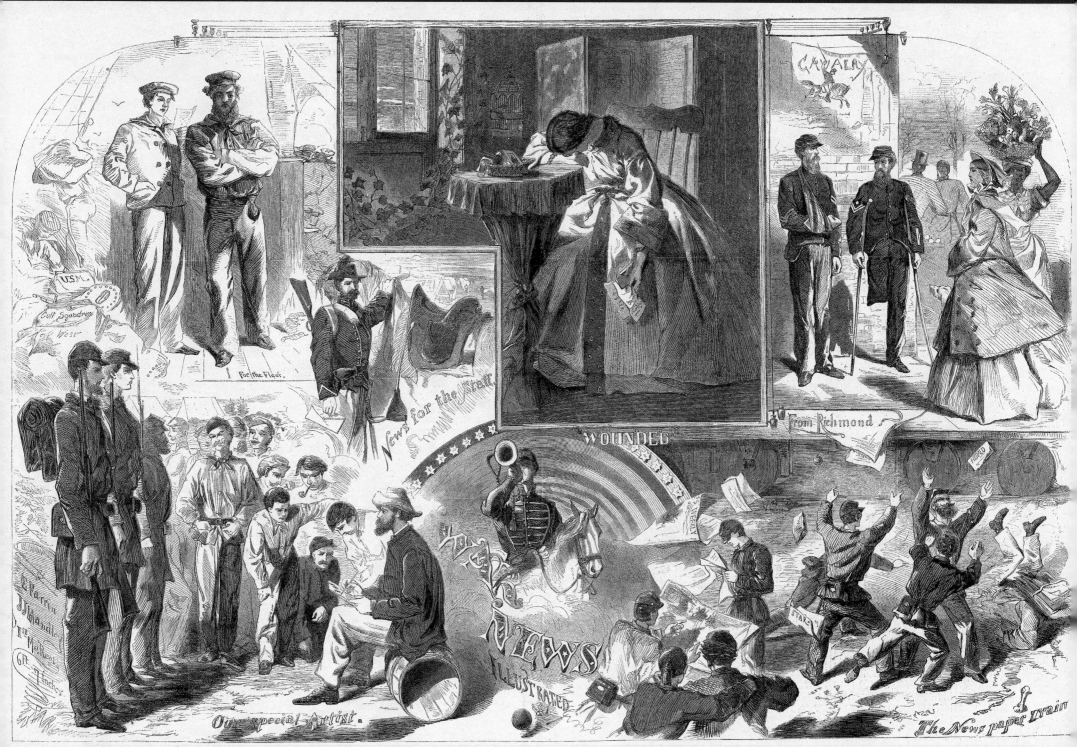

NEWS FROM THE WAR.—[DRAWN BY OUR SPECIAL ARTIST, MR. WINSLOW HOMER.]

PREFACE
BY ALAN BRINKLEY

In the early days of the Civil War, Alfred Bellard, the eighteen-year-old son of an engraver from Hudson City, New Jersey, enlisted in the 5th New Jersey Infantry. He was an ordinary private (later promoted to corporal). He followed orders, fought when necessary and avoided trouble when he could. At the same time, he quietly recorded his experiences, just as many other soldiers did. But while most soldiers chronicled their war experiences through letters or diaries, Bellard illustrated his writings with pencil drawings and watercolors—well over a hundred of them. Some of them were crude and almost amateurish, but many others were vivid images of some of the war's most important events.

Almost from the start, Bellard understood the magnitude of the war—a conflict that drew over 3 million soldiers and left over 620,000 of them dead, by far the bloodiest conflict ever fought by Americans. Bellard's drawings and paintings started out with pastoral images of campsites and marching soldiers. But before long, he was capturing pictures of the injuries and deaths that surrounded him everywhere, determined to record what he saw and what he believed. This obscure young man understood the enormity of the war, and his record exemplifies the need of many Americans to find a way to understand and recall their experiences in this extraordinary event.

Bellard's works survive only by remarkable chance. They were uncovered in 1962 and published in 1975 in a book edited by David Herbert Donald, a distinguished historian at Harvard. He titled it *Gone for a Soldier*. The public never saw the images at the time. The great body of images of the Civil War—the illustrations that depicted the war for the majority of the country during the fighting—are the product of the professional war correspondents who worked as artists for newspapers and magazines. They were known as "Specials" because their drawings were sent to magazines and newspapers by special delivery. Without them, our knowledge of the war would be much less vivid.

Many of the Specials traveled with the armies—sketching, painting and etching their experiences. They published their work broadly and allowed Americans far from the front to see powerful images of the war. Among the most prominent Specials in the North were Theodore R. Davis, Winslow Homer, Thomas Nast and Alfred Waud, all of whom were strongly supportive of the Union. The most significant war artist in the South was a British newspaper artist, Frank Vizetelly, who worked for the *Illustrated London News* and who crossed the lines from the North to the South to chronicle the Southern military as he became enamored of the Confederate cause. Together these talented and courageous men created an important body of art as well as a remarkable documentation of this most romantic, passionate and destructive of American wars.

War correspondents, and especially war artists, exposed themselves to danger constantly. They were, to be sure, less endangered than the soldiers themselves, but the war, in its magnitude, killed and injured thousands of civilians. The closer that they were to the front, the more risk they faced—and the civilian artists themselves were often among those in harm's way. But they continued to accept the risks—not only because the war could prepare them for fame and successful careers, but also because they became entwined with the fates of the two dueling armies and because they were witnesses to a new kind of war. Their body of work has now been collected in a beautifully published book that will add to our understanding not just of the battles and campaigns but also of how soldiers lived during the Civil War.

Of all American wars, the Civil War remains the most fascinating to millions of people. It has become an American *Iliad*, a tale of glory and horror constantly told. No other American conflict has attracted so much attention as the Civil War, even 150 years later. There are thousands of books about the Civil War era, and the numbers continue to grow. Hordes of people reenact Civil War battles. Enormous numbers of tourists visit Civil War battlefields and museums every year.

But the war itself—for all the interest it has created—was more than a series of battles. It reshaped American life more significantly than any other event in the nation's history. It accelerated the growth of industry and technology, espe-

Winslow Homer, *News from the War, Harper's Weekly,* June 14, 1862, image provided courtesy of HarpWeek.

cially in the North. It ended three hundred years of slavery (although it did not end African American poverty and oppression). For better or worse, the war was the doorway to the modern world.

"The world never saw such a war," a Southern observer said in 1863. Northerners made similar claims. Both the North and the South created technologies of destruction and death that had never been seen before—the iron-clad ships, the new and more deadly rifles, the more powerful cannons and the great industrial growth that made it possible for the war to continue. Its extraordinary carnage was an early model of the catastrophic wars of the twentieth century. A conflict that began with a search for glory and triumph turned instead into a level of desolation never seen before.

The images of the Specials allowed Americans of the nineteenth century to see the arc of the conflict. George Hayward's *Departure of the 7th Regiment* (page 10) portrayed the excitement and romance of soldiers and officers parading through town on their way to war in April 1861. But only a few weeks later, Frank Vizetelly replaced the glory with death in *The Stampede from Bull Run* (page 22), when the Northern army faced its first battle, confident of victory, only to have been forced back to Washington in a chaotic retreat. The almost pastoral image of a Christmas Day in 1861—Alfred Waud's *Holiday in the Camp of the 23 Penn. Vol. near Bladensburg* (page 38)—was countered a few months later with his rough pencil drawing *Fair Oaks after the Battle, Burying the Dead—and Burning the Horses* (page 66).

The images were often polemical. The war artist Edwin Forbes celebrated Emancipation in 1863 by drawing an open carriage filled with hopeful slaves searching for Union camps (page 134). Thomas Nast published a cynical comment in *Historic Examples of Southern Chivalry*—a group of pictures showing barbaric Confederates with images of Northern soldiers beheaded, captured soldiers executed and other forms of cruelty (page 100). Another of his etchings was a triumphant image, *The Emancipation of the Negroes* (page 101). At its center was an illustration of the domestic bliss that the end of slavery seemed to promise; surrounding it were the images of oppression and violence that Emancipation seemingly had ended. And a third, *The War in the West* (page 102), portrayed the dangers facing civilians caught in the maw of the war.

The most challenging tasks facing the artists came during 1864. When General Ulysses S. Grant took command of the Northern army, the campaign ceased to be a traditional war relying on the tactics and strategies that officers had learned for centuries. Instead, it became a war of attrition. Grant—aware that the Union's greatest advantage was the size of his army—promised that "there will be no turning back." The casualties were enormous, but the battles continued. The artists responded in kind. In *Gen. U. S. Grant at Wilderness* (page 156), Edwin Forbes captured Grant exhorting his troops as they began their bloody campaign, which produced over thirty thousand casualties in three days. Alfred Waud's *The Toughest Fight Yet. The Fight for the Salient [Spotsylvania]* (page 161) suggested how terrible the slaughter had become. At about the same time, Theodore R. Davis drew General William T. Sherman mobilizing his own western army in *General Sherman's Campaign* (page 169). Shortly after, J.F.E. Hillman's *A Battle Two Miles West of Atlanta* (page 170) captured the savage destruction as the Union army marched toward the sea, destroying huge swaths of the South along the way. Alfred Waud captured both the glory and the revenge that characterized the end of the war. In *Raising the Stars & Stripes Over the State House Columbia* (page 211), he drew the excitement of Union victory. A day later, in *Columbia the Morning after the Fire* (page 212), he depicted vengeance as the long and terrible war approached its end.

Waud, the most prolific of all war artists, was at the end of the war just as he had been at the beginning. On April 9, 1865, he drew *Genl. Lee Leaving the McLean House after the Surrender* (page 222), followed later by *Rebel Soldiers Taking the Oath of Allegiance in the Senate Chamber at Richmond, Virginia* (page 221), on June 17, 1865.

The extraordinary and often courageous artists who chronicled the Civil War continued their work in peacetime. Alfred Waud enjoyed decades of great prominence at *Harper's Weekly*. Winslow Homer became one of the most revered artists of the nineteenth and early twentieth centuries. Theodore R. Davis also continued to draw for *Harper's Weekly*. And Thomas Nast pilloried corrupt politicians as one of the country's most celebrated political cartoonists.

The Specials helped shape our understanding of the war. And they, in turn, were shaped by the experience themselves. They forged a new visual language for America in the nineteenth century and beyond. Talented, ambitious, courageous and determined, the Specials left us an extraordinary body of images from America's most important war—the best of which are on brilliant display in this book.

INTRODUCTION

I have travelled in all directions—from Western Maryland to the Indian Territories; made the acquaintance of a great many different divisions of the army, and so informed myself of their movements, so as to be at the right place at the right time. All this has kept me moving incessantly, and, I repeat, it would take me months to work up the rough notes I have taken. I have made but one sketch from a distance (the battle of Lexington); all the rest were made on the spot, and are historically reliable.

Henri Lovie, Special Artist for *Frank Leslie's Illustrated Newspaper*[1]

Pictorial journalism came of age in America during the Civil War. To satisfy a growing demand for pictures of the conflict, newspaper publishers relied upon salaried, freelance, amateur and professional illustrators sent into the field to sketch the action. Called Special Artists or just "Specials," they became the first generation of pictorial war correspondents. Embedded with troops on both sides of the conflict, they documented with pencil, pen and brush scenes of human or visual interest. These men—no female sketch artists have come to light—followed the armies, drew the unfolding war and defined its progress for readers in America and abroad. They included the celebrated artist Winslow Homer as well as noted combat illustrators Frank Vizetelly, Alfred (also known as Alf) Waud (pronounced *Wode*) and his younger brother William (also known as Will), Edwin Forbes, Arthur Lumley, Henri Lovie and many others. The significant contributions of other wartime artists—John R. Key, Conrad Wise Chapman, Adalbert Volck, John Sneden, Adolph G. Metzner, A. E. Matthews and William McIlvaine, for example—are not considered here, as their work appeared outside the world of the illustrated weeklies.

Thousands of Specials' extant sketches of Civil War scenes are preserved in public and private collections nationwide. Among the least known and understood, yet most compelling and informative of Civil War images, these drawings are a ghostly reminder of the country's violent past. As artifacts created on or near the field of battle they illuminate a rarely seen personal and informal, yet often professional and informed, side of the war. They are pictorial "snapshots," capturing moments in time as vividly as any photograph, with the added emotional force of the artist's expressive use of composition, content and even color. Like Civil War veterans themselves these drawings survived the war; unlike those now long-dead warriors they remain with us to this day.

Photographers of the age couldn't keep up. Camera shutters were too slow to capture movement; bulky equipment, demanding a dark-room wagon for transport and processing, could be neither maintained nor maneuvered on a battlefield. And the technology required to reproduce photographs in newspapers was not yet invented. In actuality, relatively few nineteenth-century Americans viewed the static, posed images of war produced by such pioneering field photographers as Mathew Brady and Alexander Gardner. Their work, and prints by their professional rivals, could only be seen by visiting one of the photographic studios thinly scattered throughout the nation or by attending an exhibition at regional sanitation commissions and soldiers' relief fairs. Although photographs could be transformed into reproducible wood engravings, such images accounted for just 15 percent of published newspaper illustrations.

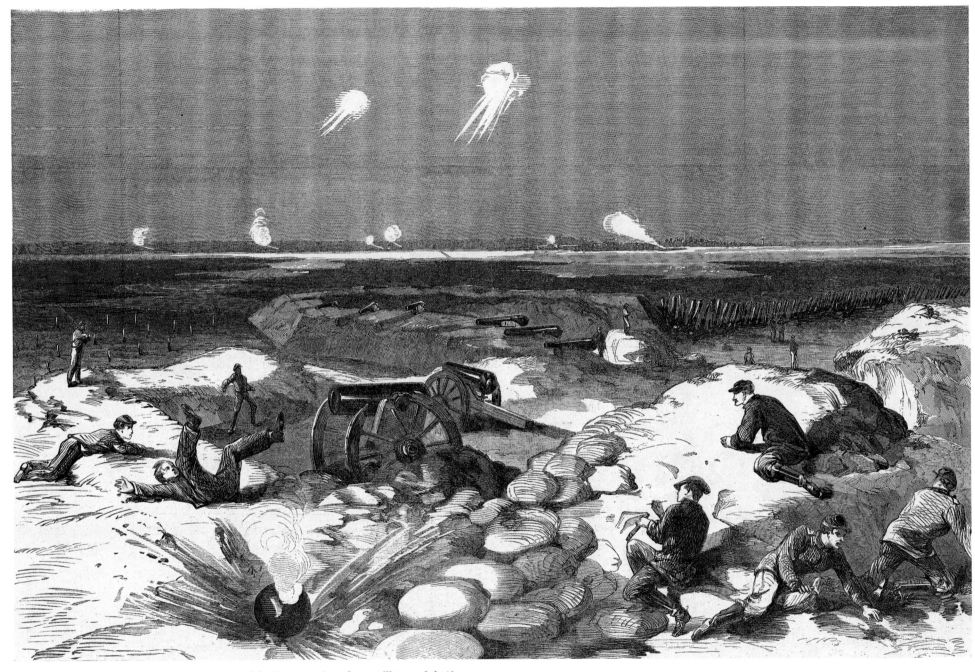

Theodore R. Davis, *The Siege of Charleston—Scene of the Desperate Assault upon Wagner, July 18, 1863—a Shell from Fort Johnson, Harper's Weekly,* September 26, 1863, image provided courtesy of HarpWeek.

The Specials pioneered the field of photojournalism. Generations before photographer Frank Capra hit the beaches of Normandy on D-Day or news photographer Bolivar Arellano suffered injury capturing the fall of the World Trade Center, sketch artists put themselves in harm's way to get the pictures and inform the public. Their coverage spans the Civil War and its devastating impact.

Prior to the fighting, publisher Frank Leslie sent his Special William Waud south to Charleston, South Carolina, in search of scenes related to growing Secessionist sentiment. Will Waud's sketches from Charleston predate the attack on Fort Sumter and offer a glimpse into the final days of the prewar South. They include his eyewitness view of the first shots fired on Fort Sumter, which set off declared hostilities.

In stark contrast, *Harper's Weekly* artist Theodore R. Davis's expedition to the Confederacy alongside acclaimed British correspondent W. H. Russell ended prematurely with the Special's rapid return north amid threats of legal and physical mayhem. Davis, looking back on a lifetime filled with Civil War campaigns, battles with Native Americans in the West and chance encounters with unsavory characters in lawless territories, recalled his brief sojourn with the British journalist as the most terrifying episode of his career. That adventure is described here fully for the first time. Henri Lovie's coverage of the carnage at the Battle of Shiloh in April 1862 set a new standard for accuracy, detail and realism in the midst of combat. During the Peninsula Campaign in Virginia later that spring, his colleagues Alf Waud and Arthur Lumley were busy, their drawings growing grimmer by the week. By comparison, Winslow Homer's sketches from Yorktown in spring 1862 are full of confidence and military verve. The war took its toll, though, and his subsequent studies are more somber. How could it be otherwise, after he and his colleagues had suffered so much and witnessed so much bloodshed for so little success?

At the Battle of Antietam, in early fall 1862, Frank Schell, Alf Waud and Edwin Forbes all produced significant portfolios. Just previous to the battle, in fact, Alf Waud found himself behind enemy lines and sketched the 1st Virginia Cavalry in a stunning group portrait. While Waud and his colleagues sketched the action at Dunker's Church or watched Mumma's farm burn, their English colleague Frank Vizetelly made his way south, stung by the refusal of the Union military command to allow him access to the front lines. Vizetelly's story, told here through his sketches and letters, is one of the great obscure adventures of the Civil War. The most celebrated combat artist of the era fell in with rebel General Jeb Stuart, illustrated Confederate military exploits through the fall of Richmond, and sketched President Jefferson Davis's final days of freedom before his capture by Union forces.

Vizetelly was on his way to Vicksburg when the rebel stronghold on the Mississippi fell in summer 1863. Fred Schell, sketching for *Frank Leslie's*, witnessed the Siege of Vicksburg and its surrender. His documentary sketches of the living conditions experienced by soldiers and citizens add poignancy to their plight. While Schell and Davis covered Vicksburg, Alf Waud and Edwin Forbes chronicled the Union's decisive victory at Gettysburg on July 4, 1863.

After Gettysburg, through the Specials we witness Grant's Overland Campaign from the Battle of the Wilderness to the Siege of Petersburg; Sherman's campaign through Georgia; Sheridan and Custer in the Shenandoah Valley; Richmond in ruins; the Confederate surrender, and the assassination and funeral of President Lincoln. *Harper's Weekly* paid tribute to the enduring skill and perseverance of the Specials in a notice printed in early June 1865:

> They have made the weary marches and dangerous voyages. They have shared the soldier's fare; they have ridden and waded, and climbed and floundered, always trusting in lead pencils and keeping their paper dry. When the battle began they were there. They drew the enemy's fire as well as our own. The fierce shock, the heaving tumult, the smoky sway of battle from side to side, the line, the assault, the victory—they were a part of all, and their faithful fingers, depicting the scene, have made us a part also.[2]

In the field and at the front the Specials themselves often provided the most accurate reporting of what had transpired. At a time when verbal and written reports were often confused, or inaccurate, the sketches revealed what had really happened and who was actually involved. Sketch artists put themselves in the heat of the action, in order to capture accurate, informed, realistic pictures of battle. Edwin Forbes put it this way, reporting to *Frank Leslie's Illustrated Newspaper* from the Northern Virginia front lines, in spring 1862:

> I send you a batch of sketches which I am sure will interest your readers. They have been taken at considerable risk for the country is overrun with small gangs of sneaking Secessionists, who are as bloodthirsty as [infamous Confederate general] Albert Pike. For one day I got an escort of ten men and made some sketches in comparative safety, which I herewith forward. All who have seen them say they are very accurate. I need hardly assure you that I do my best to make them so, as fidelity to fact is, in my opinion, the first thing to be aimed at.[3]

If not for the sketch artists' work, countless otherwise undocumented incidents and events from the Civil War era would have been lost to history. As pictorial reporters, the artists could quickly identify the scene's focal point, block out the composition with telling details in minutes and flesh it out later. Few of the sketch artists' works bear the signs of prideful, finished artistry; they were created for newspaper reproduction, not for exhibition or connoisseurship. They differ in size, color, finish, quality and purpose, and in their tales of creation, inspiration, conception, production, publication. And yet as original works of art they often convey emotion, energy, drama and picturesque beauty well beyond their documentary purpose.

In 1861, when war broke out, two rival pictorial weeklies, both founded and published in lower Manhattan, dominated the national scene. *Frank Leslie's Illustrated Newspaper*, first issued in 1855, led the way, followed shortly by *Harper's Weekly*, founded in 1857. The brainchild of veteran English pressman Henry Carter (also known as Frank Leslie, 1821–80), *Frank Leslie's* routinely boasted print runs in excess of one hundred thousand even before the war began; special editions could top three times that number. Leslie founded his namesake journal on the pursuit of investigative pictorial journalism and his experience managing the engraving department at the *Illustrated London News*, the world's first and most prestigious illustrated weekly. The journal remained nonpartisan throughout the runup to the election of Lincoln and the war. Editorially, *Leslie's* claimed "to be *strictly and entirely neutral* in our course of Journalism, chronicleing [sic] events as they transpire in every section of the country, without bias and without feeling; adhering closely to facts, but advocating neither one side nor the other of the disturbing element of partisan politics."[4] *Leslie's* gave the South the benefit of the doubt, and they returned the favor, providing his newspaper, correspondents and advertisers access to Southern homes and businesses.

By contrast, Fletcher Harper, editor of *Harper's Weekly* and a scion of the renowned Harper Brothers literary publishing house, stood firmly with the Republican Party, President Lincoln, the Abolitionists and the Union. His views, his reporters and his pictorial weekly were decidedly not welcome in Secessia. Initially, *Harper's* proved more literary than journalistic, as befit the journal's erudite heritage. The war changed all that. By the beginning of the war's second year, in the midst of a fierce circulation battle with *Frank Leslie's*, Fletcher Harper hired top talent and gave them more resources to fill *Harper's* pages with war sketches equal to those of its foremost rival.

A third paper, the *New York Illustrated News*, first appeared in 1859 and for several years challenged the two national weeklies. The *News* started fast at the outset of the war, employing in its short-lived heyday both Thomas Nast and Alfred Waud, two of the era's most celebrated war artists. The *News* focused its attention on the city of New York, representing a large, urban Democratic population opposed to Lincoln's Republican policies. Had the weekly prospered it no doubt would have been a boon to the Copperhead movement, which supported negotiated peace with the Confederacy. Northern success at the time, however, meant Republican success; support for Democrats in the Union waned, along with their press organs, and with limited circulation and funds the *News* never acquired either the means or the influence to make a national impression. The journal ceased publication

Southern Illustrated News, September 20, 1862, image provided courtesy of HarpWeek.

in spring 1864. While all three New York–based pictorial weeklies appeared patriotic toward the war effort, there were nuances: neutral *Frank Leslie's* boosted the Union yet lamented the loss of the antebellum South; *Harper's Weekly* openly advocated for Union military victory, emancipation and political domination by Republicans; the *New York Illustrated News*, less literate and journalistic than its rivals, appealed to a more Democratic and metropolitan readership.

Unfortunately, the Specials produced relatively few sketches of life from the Confederate perspective. The South's sole pictorial journal, the *Southern Illustrated News*, which printed its first number in fall 1862, contained hardly any sketches of documentary merit, and lacking artists, paper, printing presses, transportation and subscribers. While the South could boast some soldier-artists, the only significant professional artist to follow the Southern war effort was veteran British combat illustrator Frank Vizetelly, whose drawings appeared irregularly in the *Illustrated London News*. Vizetelly began his American engagement reporting from Union encampments in the North in summer 1861, but in summer 1862 cast his lot with the Confederate army after Union military leaders banned him from the Richmond front. His original drawings and the engravings made after them are uniquely informed views of life within

Mathew Brady, attributed, *Frank Vizetelly,* ca. July 1861, Library of Congress.

the rebel lines. Importantly, his pro-Southern sketches and reports appeared before senior British diplomats in London then arguing over whether England should extend political recognition or material support to the Confederacy.

For each of these publishers and all of the artists the process of publication was identical. From the battlefield, the artists' drawings were dispatched by horse courier, train or ship to the publisher's office, where a talented "Home Artist," perhaps Thomas Nast or Sol Eytinge at *Harper's,* copied the image by hand onto a series of small blocks of wood bolted together to form a larger unified block. The large block would then be disassembled and the smaller components distributed to a team of engravers who carved their own section of the drawing onto their small block. Experienced engravers often worked on more detailed figures while apprentices completed the simpler background tasks. The small carved blocks were then bolted together again, creating the final completed wood engraving. After a wood engraving was cut, the block was "electrotyped," or copied onto metal plates in preparation for printing on the journal's huge rotary presses. Electrotyping protected the soft blocks and allowed large print runs. The engravings could also be copied and sent overseas to foreign publishers for added revenue. Usually it took three to four weeks for the drawn image to appear in print, although images of particularly important events or battles were rushed into print.

Specials worked under wildly varying conditions, routinely adding notations to their sketches for the copy artist and engravers. As one *Leslie's* artist suggested on his April 1861 view of soldiers at ease around campfires, "There can

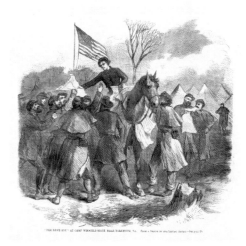

Arthur Lumley, *The News Boy, New York Illustrated News,* May 17, 1862, image provided courtesy of HarpWeek.

be plenty of figures put in."[5] On the back of his sketch of Union Army engineers constructing a log barricade in Fairfax, Virginia, in July 1861, Alf Waud wrote:

> Put in any quantity of men with axes in their shirt sleeves skirmishers with a blanket over shoulder have sack canteen and ammunition—rifles. If you please put in the extreme foreground—a cannon—and on the left continue the woods at the side of the road and make horse and foot winding through.[6]

They were not always as specific. Henri Lovie, incapacitated, wrote this desperate note on his sketch from Fort Henry, Tennessee, in early February 1862 after the Union victory there:

> Make scene as wild as possible, I am entirely disabled by diptheria, Quincy or heaven knows what. // Contrast the black smoke well with the powder smoke. // Finish gunboats from former sketches, no changes except pilot houses who have this shape. // Flagship Cincinnati 450 yards from Fort. // Wooden gunboats high chimney finish from former sketches add top bulwark.[7]

The Specials' images were subject to manipulation or censorship. Politicians, senior officers and other VIPs enjoyed seeing themselves pictured in the field. That could work to the Specials' advantage, as Henri Lovie noted in an inscription found on a sketch depicting Camp Lily (western headquarters for Union general John Charles Frémont):

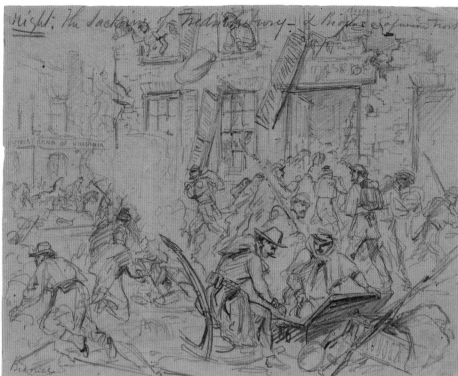

Camp Lilie Fremont's Headquarters Jefferson City. // You will see that this sketch is a little finer in touch than most. Reason, Mrs. Fremont and Lily took special interest in it, and, I hope that you will make a careful and pretty engraving of it, as it will be looked for with interest at the Headquarters. The figures are all portraits.[8]

Sketch artists could try to gain access and influence through flattery, but they could do little about more serious manipulations and censorship carried out by their own publishers as both Fletcher Harper and Frank Leslie did their part to shape public opinion. Neither man shied from censoring images considered too negative or graphic, or manipulating drawings in order to make them more stirring or upbeat. After all, the drawings could be altered in any man-

ner once they arrived in New York at the engraver's desk. Once the sketches left their hands Specials had little control over the images or their use. For example, Alf Waud's drawing of a leg amputation performed at an Antietam field hospital was re-composed to accommodate squeamish readers. Later, engravers "freshened" another Alf Waud sketch of tired horses dragging artillery carts slowly through the mud by showing them with lifted heads, spirited tails, swiftly spinning wheels and flying clods, producing a more animated portrayal of dedicated teamsters racing ammunition to the front. The publishers, rarely the artists, made these decisions. Sometimes they censored by omission. Frank Leslie chose not to publish a particularly dramatic depiction from December 1862 by Arthur Lumley of Union troops sacking the city of Fredericksburg, Virginia. Perhaps Leslie reasoned that publishing a picture of undisciplined Union troops running

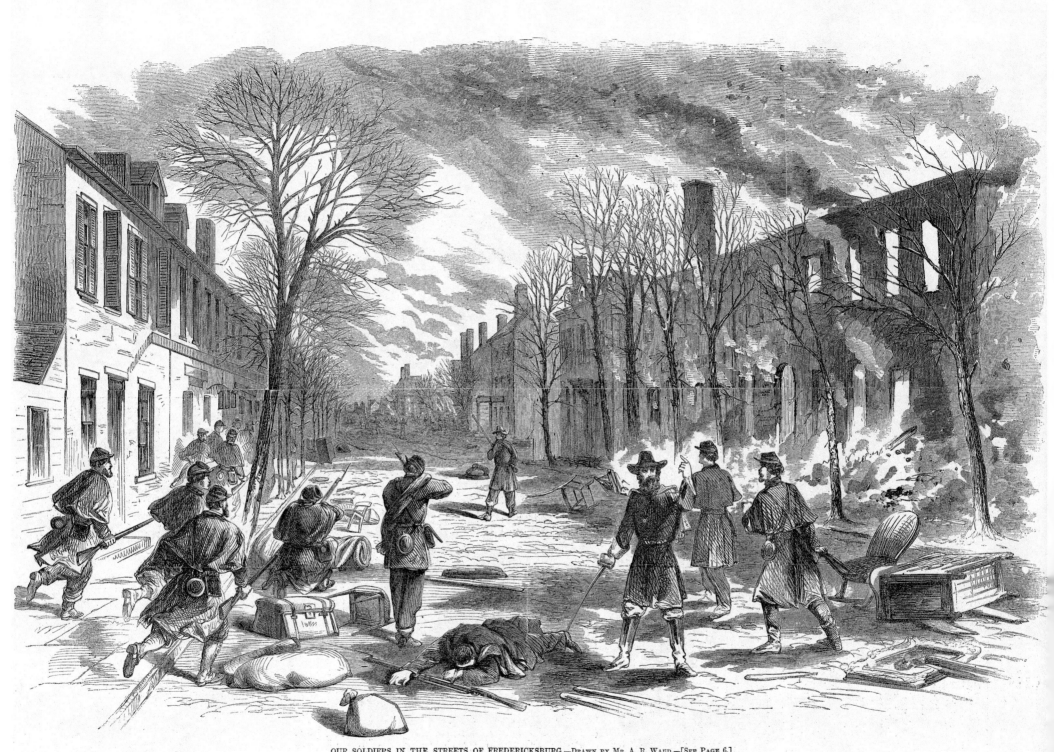

OUR SOLDIERS IN THE STREETS OF FREDERICKSBURG.—Drawn by Mr. A. R. Waud.—[See Page 6.]

riot in the streets previous to their worst defeat of the war might seem unpatriotic and not sit well with Northern readers. *Harper's* reproduced Alf Waud's sketch of Union soldiers clearing rebels from Fredericksburg streets.

The sketch artists themselves were a diverse lot. Many were young men starting out in careers of commercial illustration or journalism seeking income, experience and adventure. In 1861, at the war's outset, Arthur Lumley and Alex Simplot were both aged twenty-four, Edwin Forbes was twenty-two, Theodore Davis twenty-one, *Harper's* artist Alf Waud immigrated to America from London at age twenty-two in 1850, and his countryman Frank Vizetelly, a veteran combat artist, arrived in summer 1861, just in time to sketch the war for the *Illustrated London News. Frank Leslie's* employed a large, representative stable, including young Joseph Becker, who came late to the war. Born in Pottsville, Pennsylvania, he worked as an errand boy at the journal before his promotion to sketch artist in 1863 on the strength of natural talent. William T. Crane, born in Portsmouth, New Hampshire, in 1832, was already an experienced illustrator by 1860 and became one of *Frank Leslie's* finest and most prolific artists. Edwin Forbes built a successful postwar career from his Civil War work. Born in New York City, he studied art before the war with famed genre painter Arthur Tait. Belgian-born John F. E. Hillen (probably related to C.E.F. Hillen, another Special) lived in Philadelphia in the early 1850s and trained as a lithographer before enlisting in the Union Army in 1861. Wounded and discharged in 1862, he was hired as a Special for *Frank Leslie's* after *Harper's Weekly* published some of his freelance sketches. Henri Lovie was also foreign born—in Berlin, Prussia, in 1829. By the 1850s he, too, had immigrated to America. Once settled in Cincinnati, he worked as painter, designer, illustrator and instructor. Arthur Lumley, a Dublin-born Irishman, became a United States citizen in 1858 and lived in Brooklyn, New York. Before the war Lumley studied art, exhibited at the National Academy of Design and worked as a book illustrator. Frank (or Francis) Schell, a graphic artist and lithographer in Philadelphia during the 1850s, was apparently unrelated to fellow Special Fred Schell, who was born in Philadelphia and studied art at the Pennsylvania Academy of Art.

Even in situations of darkness, embedded with armies on the brink of destruction, these men found moments of light and beauty. Henri Lovie described the evening previous to General Ambrose Burnside's advance across the Rappahannock River on Fredericksburg, Virginia, December 12, 1862: "Although a slight

Alfred Waud, *Our Soldiers in the Streets of Fredericksburg, Harper's Weekly,* January 3, 1863, image provided courtesy of HarpWeek.

mist shrouded the lower part of the scene, floating a few feet above the river, the moonlight was resplendent. The shore was crowded with troops, while the glimmer of the bayonets and the camp-fires made a picture never to be forgotten."[9] Alf Waud produced numerous stunning views of Fredericksburg in the days before Burnside's attack. His tranquil wartime city views remind us that life went on for citizens from both sides despite the conflict raging around them.

In general, Specials traveled light and unarmed, as noted by Fletcher Thompson in his 1959 book, *The Image of War:*

> To acquire mobility, the sketch artists burdened themselves with a minimum of baggage. Their clothing was entirely utilitarian: tough shoes or jack boots for protection, coats and trousers of a strong fabric that they could wear for weeks and even months without a change, and a wide-brimmed hat to shade their eyes and sketchpads from the sun. Alf Waud wore a holstered pistol, but most of the artists did not carry weapons. A large portfolio suspended from a strap over the shoulder contained paper, pencils, crayons, charcoal, ink, pens, brushes, and a few water colors. For battle sketching they ordinarily made pencil drawings, but for camp scenes they often preferred crayon and charcoal. They used ink and water colors for the more detailed illustrations they submitted to their publishers. A pair of powerful field glasses, a sure-footed horse, a rolled blanket, saddlebags with a change of clothing, a few rations, and extra drawings supplies completed their essential equipment.[10]

Understandably, there was a lot of turnover among the artists, for they lived among the soldiers and suffered the same privations. Specials received about five to twenty-five dollars per published drawing—very little considering the hardships they had to endure. Theodore Davis and Alf Waud were the only Civil War sketch artists with the will, courage and constitution to follow the armies from Fort Sumter through the end of the war. Like most Specials, Alf Waud's younger brother, William, appeared intermittently at the front. Sometimes, like William T. Crane and other artists, they covered a specific region, in Crane's case, the Carolinas. Specials were often attached to particular army corps or theaters of operation, and they were expected to illustrate engagements involving those troops. They lived in the army camp, ate with the officers, spent time with the soldiers, became familiar with them, shared their hardships and discomforts, injuries and diseases. Arthur Lumley and the Waud brothers were all severely debilitated by exhaustion and illness during the Peninsula campaign

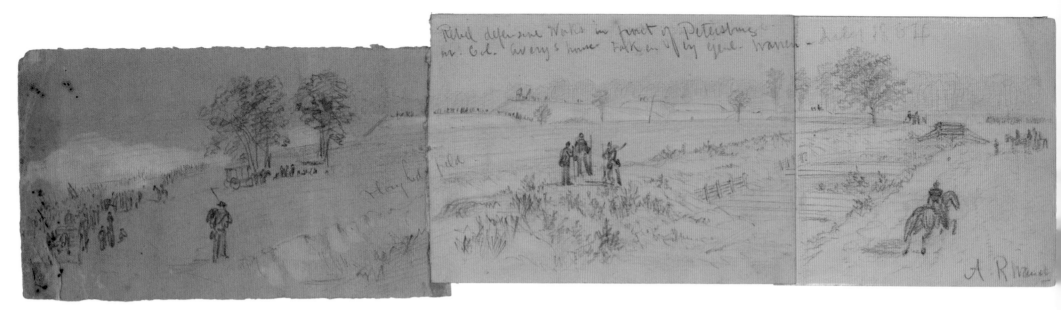

Alfred Waud, *Rebel Defensive Works in front of Petersburg nr. Col. Avery's House taken by Genl. Warren—July 1864*, July 1864, Library of Congress.

in spring 1862. In summer 1864, Alf Waud fell ill again and reported to his boss Fletcher Harper from the Petersburg trenches:

> There is a lot of picturesque material now, in the trenches, but I cannot get around to attend to it. I am down, sick and helpless with an acute attack of dysentery. It will be weeks before I get out—if I ever do—Firing is constant—I cannot sleep for it. I send what sketches I have on hand. Will write a letter by next mail. Yrs resfly A. R. Waud[11]

A part-time artist, James E. O'Neill, was killed while being held as a prisoner, and C.E.F. Hillen and Theodore Davis were both wounded. According to Davis, Waud's colleague on the *Harper's* staff, these were the qualities demanded of a professional sketch artist:

> Total disregard for personal safety and comfort; an owl-like propensity to sit up all night and a hawky style of vigilance during the day; capacity for going on short food; willingness to ride any number of miles on horseback for just one sketch, which might have to be finished at night by no better light than that of a fire … this may give an inkling of some of it, and will, I trust, be sufficient to convince my

readers that the frequently supposed mythical special was occasionally "on the spot."[12]

Sketch artists' letters recall numerous chance encounters and narrow escapes on ships, at the front and in scouting parties throughout the various theaters of war. In March 1863 Frank Vizetelly found himself threatened by Federal gunboats shelling Fort McAllister, on the Ogeechee River south of Savannah. His London letter noted, "My sketch is very rough, as it was made amidst flying sand and earth, besides which I had to keep dodging pretty briskly."[13] The *Harper's* artist with Farragut's fleet at New Orleans in spring 1862 registered a similar situation, less coolly than the veteran Vizetelly: "I started to go forward to see how things were working there, and the wind of a huge rifle-shell knocked the cap off my head. It was a time of terror."[14] J.F.E. Hillen, a *Leslie's* artist and former soldier, expressed his do-or-die attitude in a report inscribed on the back of a sketch sent from the front to his publisher during Sherman's Atlanta Campaign in 1864:

> It has been raining for these two days—I am going to the right where heavy firing is going on & will send you the results of what I have seen—The report is that we have surrounded the Rebs—how true this

is I do not know—this is the 3rd day that the battle is going on on the line of the front and I will fear no pain to get your sketches . . .[15]

In 1864 *Frank Leslie's* hailed the bravery of its Specials:

Those who fought at Roanoke island recollect the Artist sketching in the forefront of the battle; the soldiers who fought at Chicamauga and Chattanooga remember the Artist who, with a party, was captured, and escaped by sending their captors down the rocky heights; the papers of a week back tell how another, at Pleasant hill, lost all his sketches of the line of march and incidents of campaign.[16]

Despite their skills and the lengths to which the Specials extended themselves to secure accuracy, some scholars doubt the veracity of the sketches. Skeptics cite prominent Rhode Island politician William Hoppin, who testified before the New-York Historical Society in 1864:

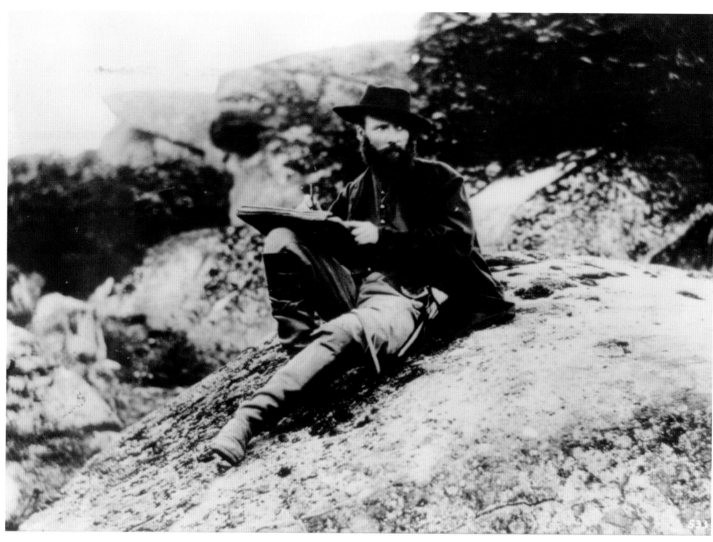

Timothy O'Sullivan, *Gettysburg, Pa. Alfred R. Waud, Artist of Harper's Weekly, Sketching on Battlefield,* July 1863, Library of Congress.

It is true that the illustrated newspapers are full of sketches, purporting to be pictures of important scenes; but the testimony of parties engaged shows that these representatives are, when not taken from photographs, not always reliable. The desire of producing striking effects sometimes overcomes all other considerations, and the truth is now and then sacrificed to the demand for dramatic action or pleasing play of light and shadow. Many of these designs are of little value . . . Some of them are positively lying and fabulous.[17]

Photo-historian Michael Carlebach has suggested that "[t]he utterly graphic and realistic portrayal of war [by photographers] was something entirely new, and contrasted significantly to the more imaginative and romantic work produced by sketch artists like Winslow Homer and Alfred R. Waud."[18] This in spite of conclusive reports that such celebrated documentary photojournalists as Walker Evans and Frank Capra manipulated their most memorable compositions.

Most critics, in fact, mistake the Specials' artistry for artifice in judging the

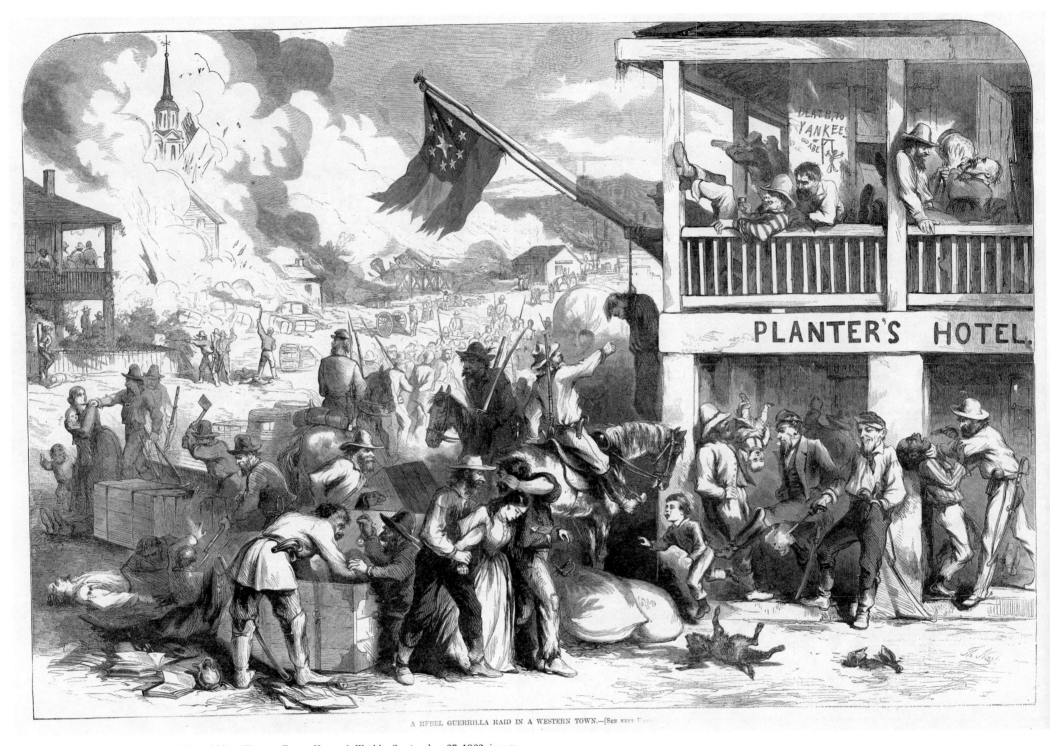

A REBEL GUERRILLA RAID IN A WESTERN TOWN.—[SEE NEXT PAGE.]

Thomas Nast, *A Rebel Guerrilla Raid in a Western Town, Harper's Weekly,* September 27, 1862, image provided courtesy of HarpWeek.

value and historical accuracy of their Civil War sketches. They believe the Specials offered a subjective, emotional, inaccurate view and feel the truest picture of the war is found in the thousands of photographs made by Mathew Brady, Alex Gardner and their fellow photographers—even though these photographs could not capture battlefield action. After all, through more than one hundred and fifty years of photographic history, we have accepted the belief that the camera doesn't lie, that it records whatever falls within its field of view. We now know, from historian William A. Frassanito's research into such iconic Civil War images as Timothy O'Sullivan's and Gardner's view of a dead rebel sharpshooter at the Devil's Den on the Gettysburg battlefield, that enterprising photographers were not above staging scenes to improve reality. The truth is, even in the age before computer technology made manipulation relatively easy, photographers could fudge the truth. And more often than not, the sketch artists got it right. In fact, Alfred Waud's "obsessive concern for detail and accuracy" in his Gettysburg views led the fussy Frassanito to single him out for praise.[19]

Each artist brought his own style and character to bear on his work. Such Specials as Schell, Lumley, Lovie, Vizetelly, and Waud often remained in the trenches with the soldiers, sketching dramatic vignettes of individual courage and chaos. Forbes, in contrast, stayed above the fray, positioning himself on nearby hillsides and using binoculars so that he could sketch entire battle scenes: regiments arrayed, batteries aligned and strategies apparent in panoramic display. Although he apparently never reconciled himself to the sounds of combat or the sight of blood on the battlefield, his more distant views of Burnside's Bridge and other features of the Antietam battlefield and other great Civil War sites are powerful lasting representations of the battlefield. Henri Lovie, by comparison, rendered some of the earliest, most graphic depictions of war dead and wounded—which his publisher, Frank Leslie, did not shy away from using. Lovie's views of the Battle of Shiloh, including the engagement at Pittsburgh Landing, and many of the originals in the Joseph Becker Collection thought lost or destroyed, offer panoramic, epic and detailed eyewitness records of the momentous events that took place over the course of two days in April 1862 in southwestern Tennessee.

At the Battle of Shiloh (the first engagement producing casualty counts in the tens of thousands), Lovie scoured the battlefield for factual accounts to enhance his own impressions. The battle stretched his ability to compose drawings depicting masses of men and to capture their exertions and expressions of fear, anger, maddened fury and violence, which reached epic proportions during the fighting. It seemed to require all of Lovie's artistic and journalistic skills, instincts and experience to fully convey the bravery and carnage of those terrible days.

Winslow Homer and Thomas Nast, perhaps the two most celebrated artists from the Civil War era, were anomalies. Homer produced fewer than thirty war illustrations for *Harper's*, about one-tenth the output of his fellow sketch artist Alfred Waud, the most prolific Special. Homer visited the front periodically and completed his assignments with characteristic verve but never fully accepted the role of combat artist. Nast began the war as a Special, illustrating actual events as he observed them in the streets and public halls of Washington, D.C., but soon became far more famous for his editorial cartoons supporting the Union war effort. On the strength of Nast's propagandist images published each week in *Harper's* from 1862 through the 1864 election, President Lincoln reportedly labeled the cartoonist as "our best recruiting sergeant."[20] Each of these young men made key contributions during the war and afterward became important figures in the history of American art.

Alexander Simplot, a young Iowa native and self-taught illustrator, brought a somewhat romantic and naive outlook to the war during his two years with *Harper's Weekly*, while such seasoned sketchers as Frank Schell and Fred Schell combined technical facility with journalistic insight. Frank Schell's Antietam sketches, for example, seem hurried and impressionistic, yet faithfully manage to convey both the chaotic pace of the fighting as well as the gently swelling farmland and forests stitched by roads and fences. Without the sketches of artists such as Andrew McCallum, Edward F. Mullen, and J.F.E. Hillen, we would have only the most piecemeal, distant and incomplete view of the era. Even under the duress of combat and fatigue, their compositions are balanced, figures proportionate and modeled, faces fairly differentiated and expressive, landscapes recognizable and realistic. Realism and accuracy were the hallmarks of the sketch artists, harbingers of future photojournalism. The Specials' sketches—unique, timeless, topical—reveal the war as it happened before their eyes, recalling the skills, dedication and courage that defined the first generation of American pictorial journalists to go to war.

OUR ARTIST.

Civil War Sketch Book

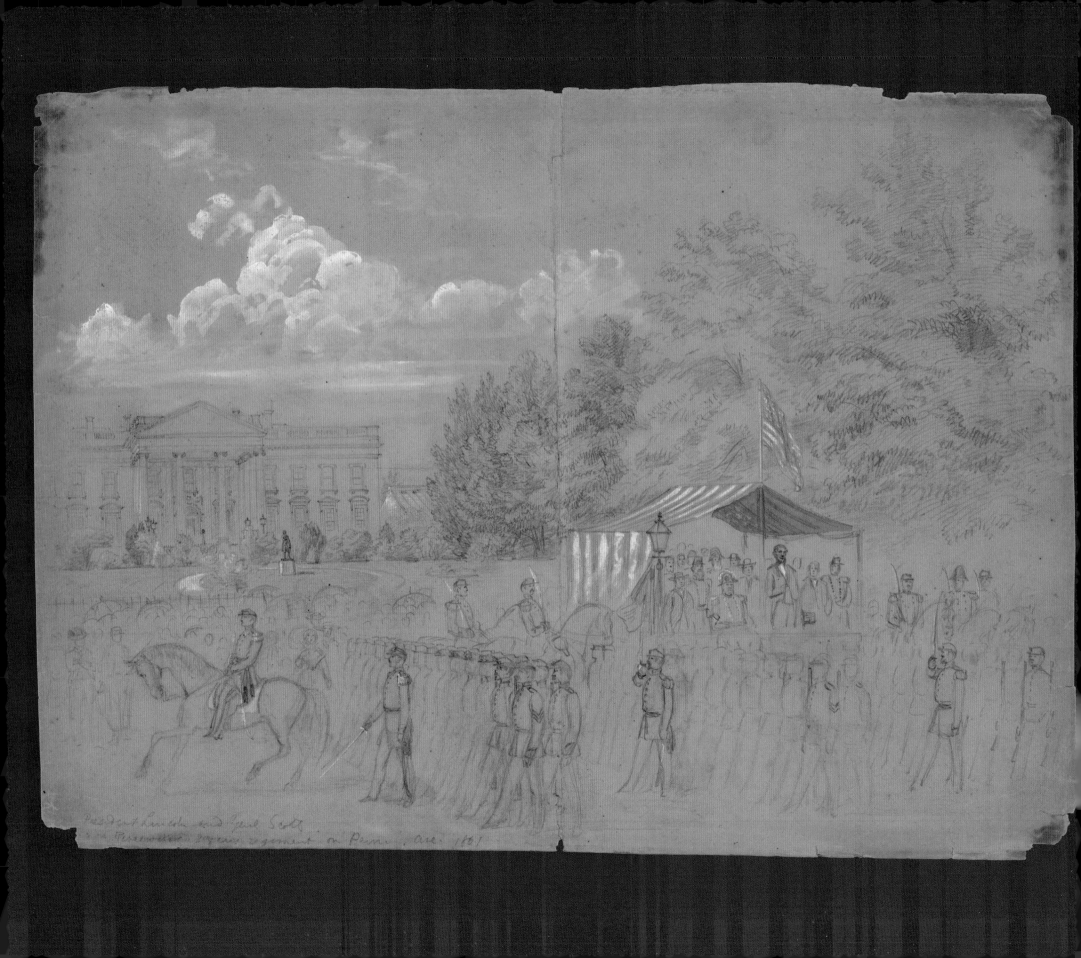

President Lincoln and Genl Scott
... Pennsylvania ... regiment on Penn. Ave. 1861

War Call

Charleston, South Carolina, became a cauldron of anti-Union fervor in the aftermath of Abraham Lincoln's election as president in early November 1860. Frank Leslie, anticipating Charleston's crucial role in the South's political future, sent Special Artist William Waud to document a city "boiling over with the spirit of secession."[1] By late November Will Waud was furnishing the journal with incendiary images of Charlestonians taking to the streets in support of separation from the Union. Leslie's choice of Waud was inspired. The English-born artist could claim neutral status and reasonably represent his publisher's desire "to produce a paper which shall be so entirely free from objectionable opinions or partizan views of national policy, that it can be circulated in every section of the Union and be received in every family as a truthful exponent of facts as they occur, and

Alfred Waud, *President Lincoln and Genl. Scott Reviewing 3 Years Regiment on Penn Ave. 1861,* ca. summer 1861, *New York Illustrated News,* June 16, 1861, Library of Congress.

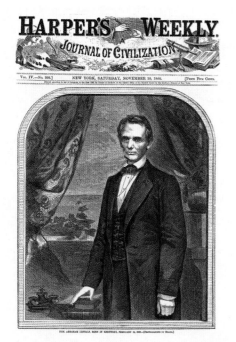

After Mathew Brady, *Hon. Abraham Lincoln, Born in Kentucky, February 12, 1809, Harper's Weekly*, November, 10, 1860, image provided courtesy of HarpWeek.

a reliable Illustrated History of the time in which we live."[2] *Frank Leslie's* for December 24, 1860, included a Will Waud illustration of politicians exhorting a crowd outside Charleston's City Hall with Henri Lovie's portrait of President-Elect Abraham Lincoln receiving well-wishers in the Court Room of the State House at Springfield, Illinois. Appealing to readers from every region by alienating none, *Leslie's* had made few enemies in the South and his artist moved safely through the region. In the January 26 issue, typically, the journal printed Will Waud's sketches of Fort Sumter manned by federal forces alongside those of Fort Pinckney, another Charleston garrison served by South Carolina troops, along with this announcement:

NOTICE TO OUR READERS

Our Special Artist in Charleston.

We are receiving every day from our Special Artist in Charleston, S. C., important and striking sketches of all the exciting events which occur in that city, its harbor and surroundings. No other representative artist from the North is or has been in Charleston during the stirring time . . .[3]

By mid-February Waud was in the new rebel capital at Montgomery, Alabama, reporting on the Confederate Congress and the Jefferson Davis inaugural; his cover drawing of Davis addressing a crowd opened the edition for March 16 while a double-page spread made from his view of the inauguration ceremony dominated the March 23 issue. At this stage, *Leslie's* was far ahead of the domestic competition.

William Waud, *Secession Orators Addressing the People Outside of the City Hall, Charleston, S.C., Frank Leslie's Illustrated Newspaper*, November 24, 1860, image provided courtesy of HarpWeek.

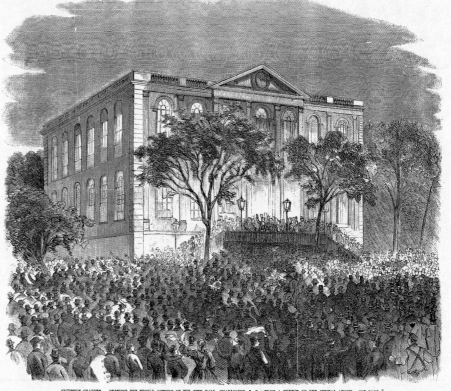

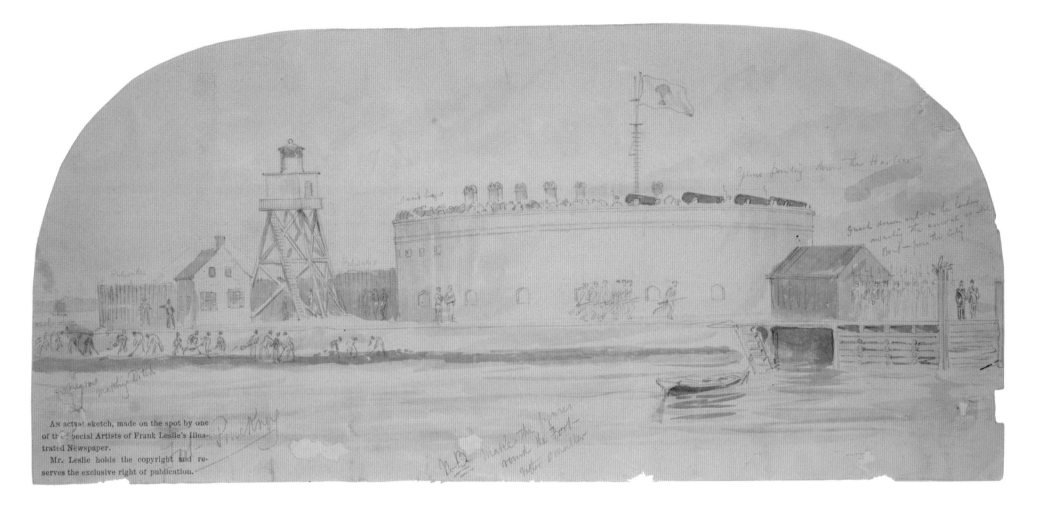

An actual sketch, made on the spot by one of the Special Artists of Frank Leslie's Illustrated Newspaper.

Mr. Leslie holds the copyright and reserves the exclusive right of publication.

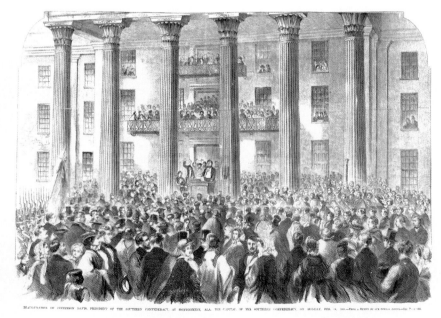

By late spring 1861, *Harper's* managed to deploy a covey of Specials to cover the war, including D. H. Strother, Theodore Davis, Alex Simplot and Henry Mosler, along with a number of capable illustrators among the military and a host of obscure, more and less talented freelance contributors. The journal got off to a slow start, however, in the wake of Lincoln's election. For months, through the winter, *Harper's* offered only sparse postelection coverage and general views of growing Southern Secessionist sentiment. A series of portraits of Southern congressional delegations after photographs by Mathew Brady stand out in the archived issues amidst more pedestrian portrayals of Northern politicians and patriotic illustrations from the revolutionary past and contemporary Washington,

ABOVE: **William Waud**, *Castle Pinckney*, ca. December 1861, *Frank Leslie's Illustrated Newspaper*, January 26, 1861, Print Collection, Miriam and Ira D. Wallach Division of Art, Prints and Photographs, the New York Public Library, Astor, Lenox and Tilden Foundations.

LEFT: **William Waud**, *Inauguration of President Jefferson Davis*, *Frank Leslie's Illustrated Newspaper*, March 23, 1861, image provided courtesy of HarpWeek.

HARPER'S WEEKLY

A JOURNAL OF CIVILIZATION

VOL. V.—No. 214.] NEW YORK, SATURDAY, FEBRUARY 2, 1861. [PRICE FIVE CENTS.

Entered according to Act of Congress, in the Year 1861, by Harper & Brothers, in the Clerk's Office of the District Court for the Southern District of New York

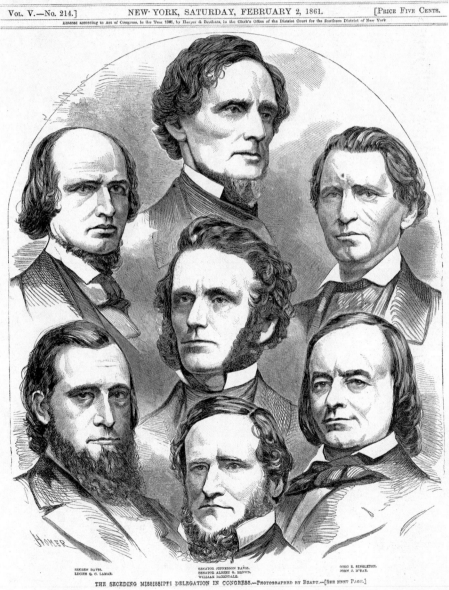

THE SECEDING MISSISSIPPI DELEGATION IN CONGRESS.—PHOTOGRAPHED BY BRADY.—[SEE NEXT PAGE.]

D.C. With no assembled company of Special Artists to sketch the impending conflict, *Harper's* relied heavily on officers at the scene who could draw or local artists of limited experience.

Fletcher Harper recognized the deficiency and began commissioning brilliant war art and political cartoons. Under his guidance, *Harper's* became a pro-Union paper. Increasingly, war news and related reports supplanted the serializations of Wilkie Collins's *Woman in White* and Charles Dickens's *Great Expectations*. Soon military scenes drawn by on-the-spot artists began to appear. In its April 27 edition, the journal proudly listed the war pictures it had published to date including dozens of topics and titles from Fort Sumter to Fort Pickens, from Virginia to Texas.

While it lasted, the *New York Illustrated News* published numerous noteworthy images of the war. Begun by publisher John King in 1859, it gave its readers early pictures of the Union's military preparations. In spring 1861 the *News* boasted two stars of the pictorial publishing world: Thomas Nast and Alfred Waud. Later in the year King sold out to T. B. Leggett, who tried to maintain the journal's initial quality but did not have the resources to keep up with his richer rivals. Within a year or two Nast and Waud had accepted better offers from a rival journal. Finally, after infusions of money and varied content could not lift the paper's fortunes, new owner William Jennings Demorest merged the weekly with another journal in August 1864.

Offered every Saturday for the price of six cents—three dollars per year by subscription (by one estimate about $93 per year in 2010 dollars), the *News* featured a panorama of life in America's most prosperous, diverse and cosmopolitan city. The masthead offered a fine waterfront view by Alf Waud of Castle Garden on the southernmost tip of Lower Manhattan, now known as Castle Clinton within Battery Park. Before the war this sixteen-page illustrated journal comprised news, literary serials, topical gossip, a Ladies' Department, columns on chess and billiards, police reports and criminal trials, picturesque views from around the globe, portraits of politicians and public figures, and sketches from disasters such as the 1860 Pemberton Factory fire in Lowell, Massachusetts, which appeared in print just four days after the terrible event. In February 1860, readers discovered a muckraking pictorial portfolio of life in the notorious neighborhood of Five Points in New York. One month later, in anticipation of extreme public interest, the paper sent correspondent Francis Darragh and artist Thomas Nast to London to cover the upcoming international championship boxing bout between the Englishman Thomas Sayers and the American John C. Heenan. In

The Seceding Mississippi Delegation in Congress—Photographed by Brady, Harper's Weekly, February 2, 1861, image provided courtesy of HarpWeek.

the same spirit of populist reform that inspired the Five Points feature, the paper ran sketches by C. A. Barry of the shoemakers' strike in Lynn, Massachusetts.

As 1861 dawned, scenes from the South—secession rallies, slave auctions, federal fortifications—dominated the paper's pages. Readers could scarcely believe the news. An editorial in the journal from January 12 notes:

> We, in common with all true citizens, have watched the progress of the movement hitherto with unfeigned sorrow and anxiety, although we can scarcely yet realize the fact that we have revolt and insurrection in our midst. It seems impossible that any member of this glorious confederacy of States should seek of its own accord to break asunder the ties which bind it to the rest—and most impossible of all, that it should take up arms against the Federal Government.[4]

And yet, when it came to slavery, one of the prime reasons for the war, the journal took the side of the South. It editorialized on February 9:

> The whole thing lies, as it seems to us, in a nut-shell. Slavery is legal in the United States, and is guaranteed, with all its accompaniments, by the Constitution and the laws of the Republic. What the law recognizes as goods and chattels, whether it be negroes, or sugar, or cotton, is so far sacred as property, and is invested with all the rights and safeguards of property. Good liberty-loving citizens may question the justice of the law, and do their best to create a public opinion to get the law amended or abolished—but while it is law they are bound to obey it, and to aid its officers in the execution of it.[5]

The *News* appealed to a more partisan Democratic Party readership, although outwardly it did appear to balance its pictorial content. For example, the March 2, 1861, issue featured portraits of Lincoln, along with scenes of his arrival at the Astor House and a reception by citizens at New York's City Hall, and portraits of Confederate President Jefferson Davis and Vice-President Alexander Stephens. Two weeks later the edition was dominated by a Nast double-page spread of Lincoln's inauguration in Washington, D.C. On May 4, the *News* voiced a patriotic, though qualified opinion supporting the Union but not Abolition:

> This journal is conducted on conservative principles. Opposed equally to restless change and to obstinate quiescence, the New York Illustrated News avoids interference with partisan tactics or sectarian quarrels . . .

> Equally insane, the Abolitionist and the Slaver have recklessly opposed each other, with a resolute determination that the opposite end of the see-saw should go into the air, until the load became too great; the plank snapped, the Union is dissolved, and we are all in the mire together.[6]

"The Abolitionist and the Slaver," the North and the South, were now at war, a truth the *News* appeared reluctant to admit and support. The paper described Lincoln Republicans as reckless and extreme. In fact, the *News* and the city of New York itself leaned heavily Democratic throughout the war and even elected a mayor, Fernando Wood, who spoke in conciliatory terms of the Confederacy. Southern cotton and commerce brought profits and jobs to New York City wharves. Immigrants, particularly Irish Americans, were wary of abolition and the draft; their wariness turned to anger and violence in July 1863 when rioting and looting broke out in anticipation of a draft lottery.

At the war's outset the *News* possessed two of pictorial journalism's most talented Special Artists. Both made their way to Washington, D.C., that spring. Thomas Nast drew scenes he witnessed in the city's streets, halls and parlors, while Alf Waud rode to soldiers' encampments, the front lines and beyond on military reconnaissance and raids, and often sent back colorful written accounts with his sketches. In the March 9 issue the *News* announced:

> We have much pleasure in acquainting our friends and patrons, and the public generally, that we have made arrangements with our well-known and popular artist, Mr. Nast, for his attendance on the Presidential journey to the Capital; and we feel assured that he will receive such facilitations in his duties as will enable us to gratify the public curiosity with faithful pictorial representations of every noteworthy event in this most remarkable epoch in our country's history. Mr. Nast has just returned to this country after having attended Garibaldi in his memorable campaign; and his beautiful sketches of Italian scenes and incidents, as they appeared in the New York Illustrated News, will be fresh in the memory of our patrons.[7]

The journal published Nast's sketches of Lincoln's first appearance at the Capitol with former President Buchanan, and scenes from inauguration night. The *News*, particularly proud of these latter sketches, crowed:

> Our artist, Mr. Nast, who, on all occasions of this sort, goes about like a roaring lion seeking what and whom he may devour, for the special

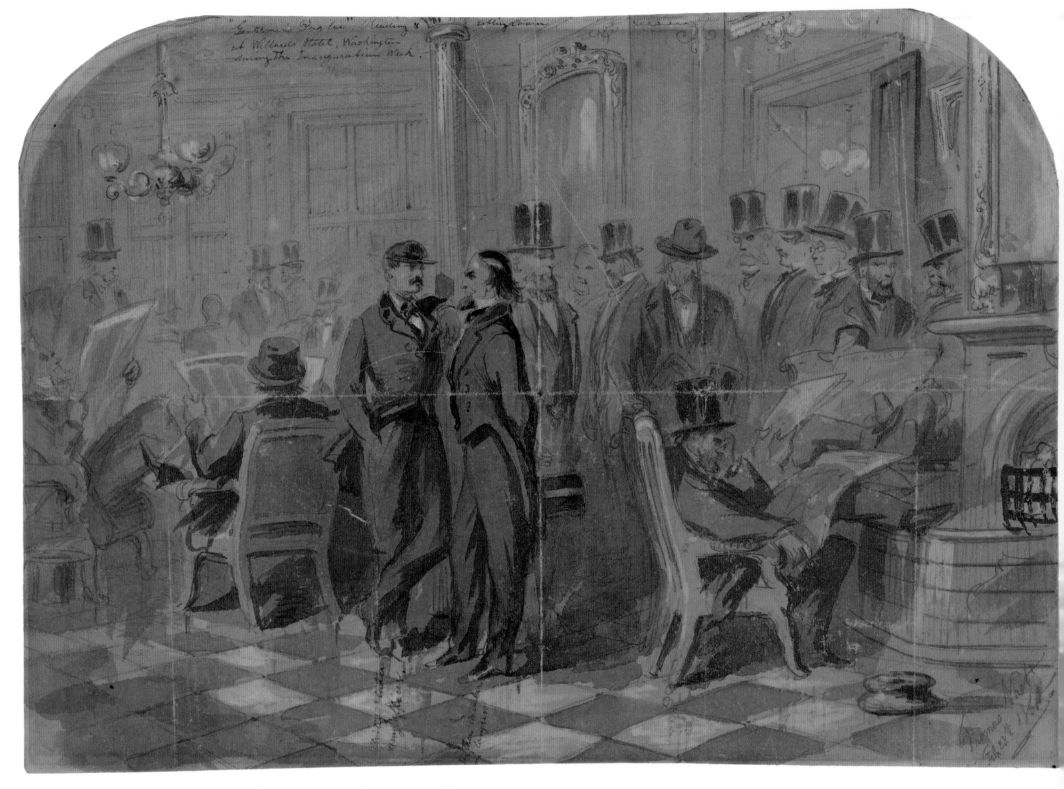

Thomas Nast, *Gentelmen's [i.e., Gentlemen's] Parlor, Reading and Sitting Room at Willard's,*
February 28, 1861, Library of Congress.

benefit of this paper, has made some extraordinary sketches of these extraordinary scenes at Washington aforesaid, which suggest a good deal more than they picture (if we may coin a word in such connection), and give a lively idea of the discomfort to which even visitors at Willard's Hotel were subjected on the night of the memorable 4th of March.[8]

More Nast sketches followed, including Lincoln's arrival at the Camden Station in Baltimore on February 23, a scene that refuted current rumors that the new president shamefacedly hid from rebel assassins when the train rolled in. With Lincoln safely installed in the White House, Nast began the business of sketching daily activities and events occurring around the city as the capital and the nation prepared for war.

The war came on April 12 with the Confederate assault on the federal garrison at Fort Sumter in Charleston Harbor. *Harper's* reported on April 27 that "at 4.27 A. M. on [the] 12th fire was opened from Fort Moultrie on Fort Sumter. To this Major Anderson replied with three of his barbette guns after which the batteries on Mount Pleasant, Cummings's Point, and the Floating Battery opened a brisk fire of shot and shell."[9] *Harper's* offered a few views by officers on the scene, but it was *Leslie's* Special William Waud who managed to be the only professional sketch artist on hand during the shelling of Fort Sumter. Like *Harper's*, the *New York Illustrated News* first reported the attack in its April 27 edition with numerous descriptive accounts and illustrations by B. S. Osborn, a sketch artist on assignment for the *New York World*, and by other unnamed Specials. In response to the battle of Fort Sumter, on April 15, President Lincoln issued a call for troops and soon regiments from all over the Union descended on Washington. With military preparations under way the *News*, on May 25, printed this note:

TO OUR READERS.

We have made arrangements to obtain authentic sketches and information of the interesting and important events of the war. Alfred Waud, Esq., one of our most talented artists, and a special correspondent, will accompany the army through the campaign.[10]

By the time of this announcement, Waud's sketches had already begun to appear in the journal. A week later the *News* published his illustration depicting two soldiers drummed out of camp for refusing to take the oath of allegiance to the Union. His sketch is included with several drawings of troop encampments, including that of the New York Twelfth Regiment, of great local interest to readers of the *News*, which provided the following description:

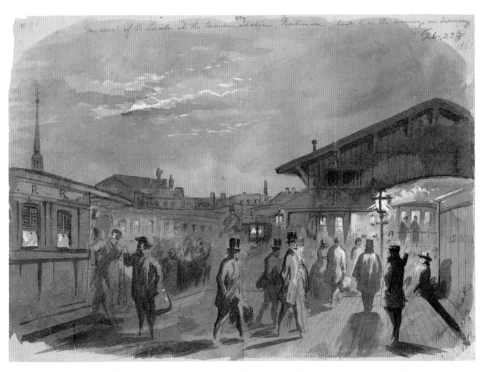

Thomas Nast, *Arrival of Mr. Lincoln at the Camden Station, Baltimore, February 23, 1861*, February 23, 1861, *New York Illustrated News*, March 9, 1861, Museum of Fine Arts, Boston.

A life in camp is not merely a pleasant episode, it is an actual instruction, which serves as a prelude or foundation for the bivouac without canvas. The gallant New York 12th is profiting by the opportunity, a few weeks halt in camp has given them, to study the art of campaigning. Our special artist, Mr. A. Waud, has taken the sketch from the engineers headquarters, and has represented the soldiers' temporary barracks, and the parade, with a party of the 12th at drill. Of course woman, omnipresent woman, is there too. And should some bould [sic] son of Mars sing gaily,

"O say, bonny lass, will you lie in a barrack,
And follow a soldier, and carry his wallet?"

Bright eyes and musical voices will reply,
"None but the brave deserve the fair."[11]

Alf Waud was one of numerous Specials then in and around Washington sketching the fresh troops drilling and preparing for battle. He was well suited

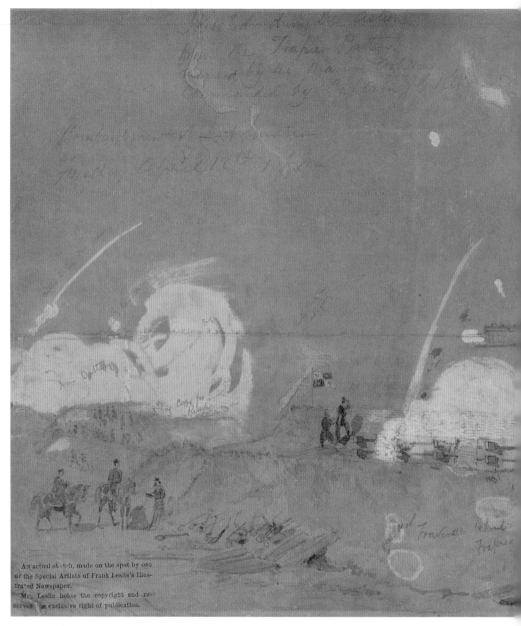

LEFT, TOP: **William Waud**, *Rebels Preparing to Bombard Fort Sumter—Scene on Cummings Point / Sketched by Leslie's Artist When in the Rebel Service*, ca. March 1861, *Frank Leslie's Illustrated Newspaper*, March 30, 1861, Print Collection, Miriam and Ira D. Wallach Division of Art, Prints, and Photographs, the New York Public Library, Astor, Lenox and Tilden Foundations.

LEFT, BOTTOM: **William Waud**, *Negroes Mounting Cannon in the Works for the Attack on Ft. Sumter 1861—Morris Island*, ca. April 1861, Library of Congress.

ABOVE: **William Waud**, *The First Gun Fired against Fort Sumter*, April 12, 1861, courtesy of the Union League Club.

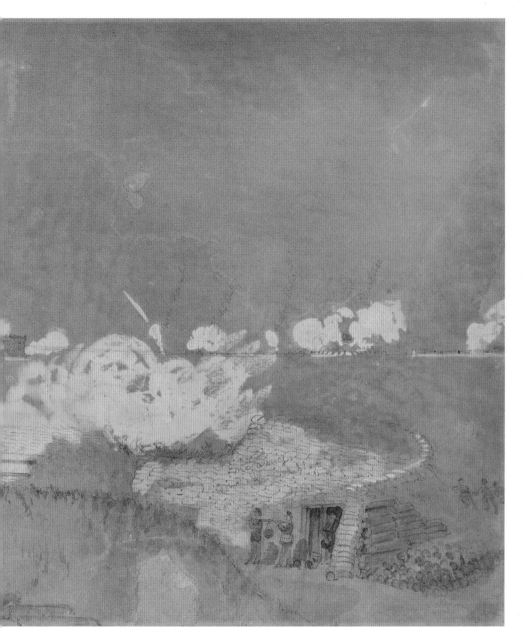

Alfred Waud, *Schenks Ohio Regiments*, June 17, 1861, *New York Illustrated News*, July 13, 1861, Library of Congress.

Competing gamely, *Leslie's* published numerous sketches that spring depicting regimental encampments and activities in and around Washington, D.C. Of particular interest, of course, were the troops originating from New York City. *Frank Leslie's* artist, probably Arthur Lumley, offered a view of Camp Cameron on Georgetown Heights, home to the New York Militia Seventh Regiment, with a long description in the May 25 edition:

> One of the regiment thus describes their mode of life: "We are under strict military discipline. Rise at five, roll call; breakfast at seven; at nine drill one hour; dinner served at twelve; five, dress parade; and lights out at nine. Guards are set, with loaded pieces, and all know that to make any infringement on rules is to be shot. Our room is twelve by ten feet, and when all are stretched out at night it is close packing; but we are so much better fixed than the rest that we are satisfied."[12]

to the role of war artist and very different from his colleague Thomas Nast. Nast was born in Germany, Waud in England. Nast later found lasting fame as an editorial cartoonist hounding "Boss" William Tweed and his ring of crooked cronies into jail, disgrace and infamy. Waud, though recognized by his peers as the era's leading illustrator of the American scene, is virtually unknown today. Differences aside, this pair created outstanding images during the first year of the war, often exceeding work published in the pages of their richer, more successful crosstown rivals.

Camp life could be boring for the Specials but the tedium was intermittently broken by such displays of discipline as the "drumming out of thieves," or the punishment of gamblers and cheats. On occasion artists were required to attend the execution of soldiers tried and sentenced for desertion, the ultimate dishonor. Throughout the spring, Union troops gathered, drilled and were disciplined in the capital as *Leslie's* artists' corps also increased its numbers. In the June 1 issue *Frank Leslie's* printed a list of artists under contract. It includes several, namely Arthur Lumley, Frank Schell and Henri Lovie, who became cele-

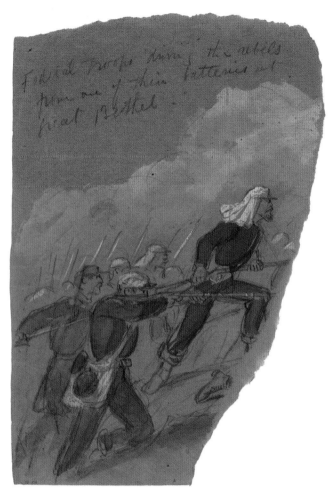

Alfred Waud, *Federal Troops Driving the Rebels from One of Their Batteries at Great Bethel*, June 10, 1861, Library of Congress.

brated for their war work, and one, James E. O'Neill, who is remembered as the only Special to die by enemy hands. The journal trumpeted on July 6:

OUR WAR ILLUSTRATIONS.
We have one Special Artist
With Maj.-Gen. McClellan's command;
We have one Special Artist
With Maj.-Gen. Butler's command;
We have one Special Artist
With Gen. McDowell's command.
We have made special arrangements with

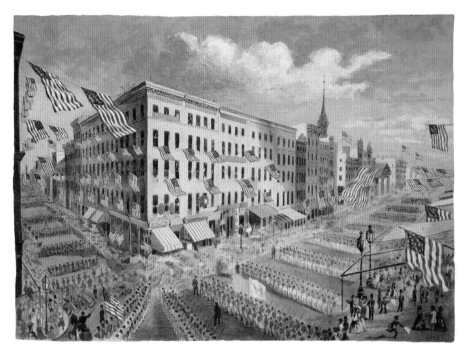

George Hayward, *Departure of the 7th Regiment, N.Y.S.M., April 19, 1861*, Museum of Fine Arts, Boston.

Over Fifty Corresponding Artists,
in the various regiments now at or proceeding to the seat of war,
and on the United States ships of war now engaged on the blockade,
besides numerous first-class Photographers in the cities through
which our troops pass.[13]

Fletcher Harper tried to keep pace. In the May 4 edition, the paper announced its plans to upgrade its artists' corps, which initially mostly comprised contributors from the military. It "dispatched an artist to the *South*, in company with Mr. *Russell*, the correspondent of the London *Times*. Another of their special artists is traveling with the *Seventh Regiment*; a third is now in *Baltimore*; and a fourth is with the *Southern Army* in *Virginia*."[14] It also utilized better paper and the price per copy rose from five to six cents to fund this improvement and expansion.

The Special "with the Southern Army in Virginia" was D. H. Strother, better known by his pen name, Porte Crayon. A contributor to *Harper's* as an illustrator before the war, Strother was a good choice for the Southern beat. A native Virginian, he looked and sounded like a solid son of the South. His sentiments were with the North, however, and he went on to serve the federals as a civilian topographer and then an officer in the Union Army.

For the first time, Northern readers vicariously experienced real combat

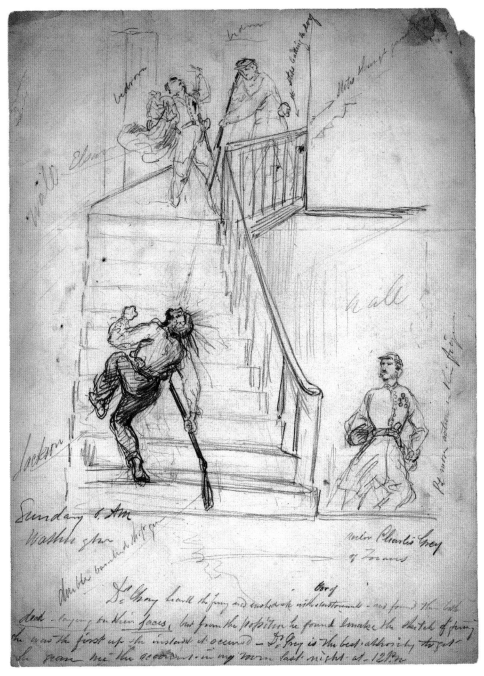

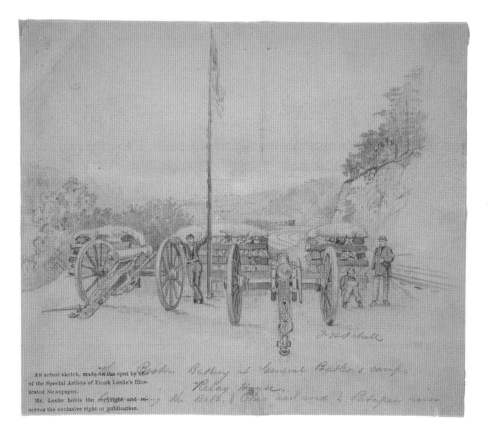

ABOVE: **Arthur Lumley,** *Assassination of Col. Elmer Ellsworth*, May 24, 1861, courtesy of the Becker Collection, Boston, MA.

RIGHT, TOP: **Arthur Lumley,** *Georgetown, Washington, Alexandria, B&O RR Boston Battery*, ca. May 1861, Print Collection, Miriam and Ira D. Wallach Division of Art, Prints and Photographs, the New York Public Library, Astor, Lenox and Tilden Foundations.

from the Southern side. Strother's fellow Virginians were unaware of his pro-Union sentiments in spring 1861 when, in the May 11 edition, *Harper's* published his astonishing account of the Confederate raid on Harper's Ferry. On April 18, four days after the surrender of Fort Sumter, just one day following Virginia's secession from the Union, he had accompanied several hundred Southern troops marching to capture the federal arsenal. Warned of their imminent arrival, the outmanned, overwhelmed Union forces burned the arsenal and fled the town. With his sketches, Strother sent a letter that described the rebel's rendezvous at Halltown, Virginia, their night march and desperate effort to keep the fire from spreading and to salvage arms and ammunition from the flames. Strother's torn loyalties are evident in his eloquent account:

The movement was regarded as a military necessity, and as such executed. To many of us who looked on, the scenes of that night were inexpressibly sad and solemn. The clouds of fire rolled up magnificently from the depths of the romantic gorge, illuminating the confluent rivers and the encircling cliffs for miles around, each rock and pinnacle associated with the name of some one of our great historic founders. In the

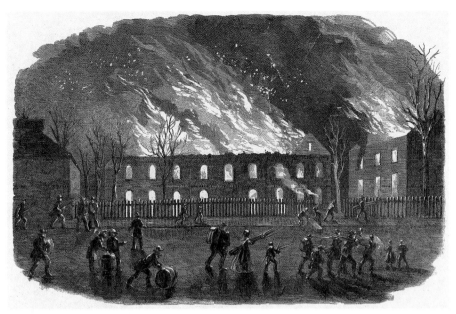

D. H. Strother, *The Burning of the United States Arsenal at Harper's Ferry, 10 P.M., April 18, 1861,* *Harper's Weekly,* May 11, 1861, image provided courtesy of HarpWeek.

martial column revealed by the blaze there stood arrayed, with deadly ball and bayonet, the firstborn pride of a hundred hitherto peaceful and happy families. In the town below, between them and their enemy, were neighbors, friends, and fellow-citizens—the enemies themselves our late patented defenders and countrymen.

Brethren, what has forced this fatal necessity upon us?

"As the smoke and vapor of a furnace goeth before the fire, so reviling before blood." D.H.S.[15]

The first images of the war in the West appeared in late May, although in June the journal published what may have been the earliest image of Confederate troops in action. It just took a while to arrive. Former federal soldier Carl Iwonski sent in a sketch of his fellow rebel recruits bivouacking in Las Moras, Texas, on their way to take up posts at Confederate forts. Depicting a scene from March, the image bears the inscription: "This was the first war sketch recd by Harpers . . . Following the surrender of Genl. Twiggs." (Brigadier General David Twiggs of the Union Army, in charge of the Department of Texas, surrendered his command to Confederate commissioners on February 19, 1861.) Soon, *Harper's* Special Alex Simplot sent drawings from Dubuque, Iowa, where two volunteer companies were departing by steamer for Cairo, Illinois.[16] As the war spread, the journal expanded its reach to emerging theaters.

Harper's May 4 announcement that it had "dispatched an artist to the *South,* in company with Mr. *Russell,* the correspondent of the London *Times,*" launched one of the most intriguing and potentially dangerous adventures experienced by any Special during the war. English journalist William Howard Russell of the London *Times* enjoyed a worldwide reputation as a war reporter. Fletcher Harper gambled that his sterling standing and neutral status would protect the artist who was to accompany him, young Theodore Davis, from Secessionist threats. Unfortunately, the journal's self-serving public announcement that Russell would be accompanied by a Northern sketch artist forewarned the South and set off a remarkable series of events.

Theodore Davis's first graphic dispatches appeared in early June, sketches from Montgomery, Alabama, and Fort Pulaski, Georgia, on the Savannah River.[17] His written description of Montgomery, still the Confederate capital at that early stage of the war, includes details of life in the city, crops and provisions, and President Jefferson Davis's schedule, not the sort of thing fighting rebels would want to share with Northern readers. Southerners quickly objected and the same issue of *Harper's* in which Davis's report appears includes a reprinted note from Russell to the editor of the Mobile, Alabama, *Register* artfully distancing himself from *Harper's Weekly*:

Sir,—My attention has been called to a statement in *Harper's Weekly,* couched in the following words: "The proprietors have dispatched an artist to the South in company with Mr. *Russell,* correspondent of the London *Times.*" In reference to that statement, I have to observe that my companions are two, viz.: Mr. *Ward,* a personal friend, who is kind enough to act as my secretary and traveling comrade, and who has no connection whatever with any journal in the United or Confederate States, and Mr. *Davis,* a young artist, who is taking sketches for the *Illustrated London News,* and who assures me that he is not engaged by or connected with *Harper's Weekly,* although he formerly sent sketches to that periodical.

My position is that of a neutral, and I am employed on a mission that requires that utmost impartiality on my part, although I shall claim for myself the utmost freedom in the expression of my convictions and of my observations to the journal which I have the honor to serve. The expression of these convictions and observations, however, is meant only for England, and I shall not permit the position I occupy to be abused under any circumstances whatever by those who accompany me, although I have every reason to believe that their good faith would

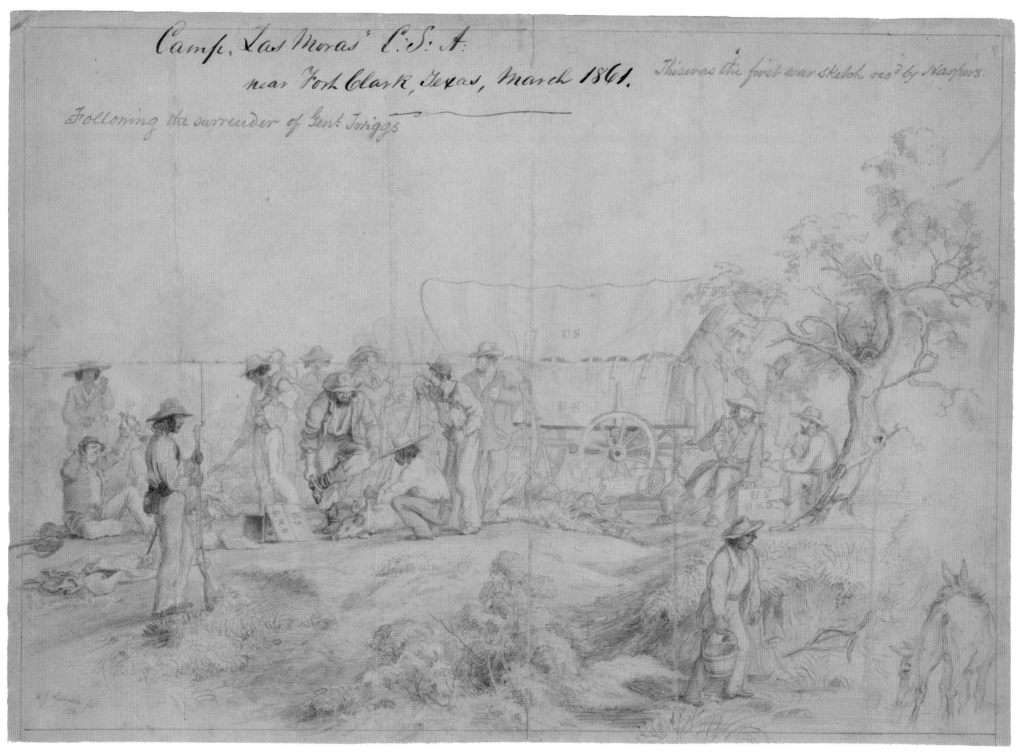

Camp, Las Moras' C.S.A.

near Fort Clark, Texas, March 1861. This was the first war sketch rec'd by Harpers.

Following the surrender of Gen'l Twiggs

Carl G. Iwonski, *Bivouac of Confederate Troops on the Las Moras, Texas, March 1861, Harper's Weekly,*
June 15, 1861, Library of Congress.

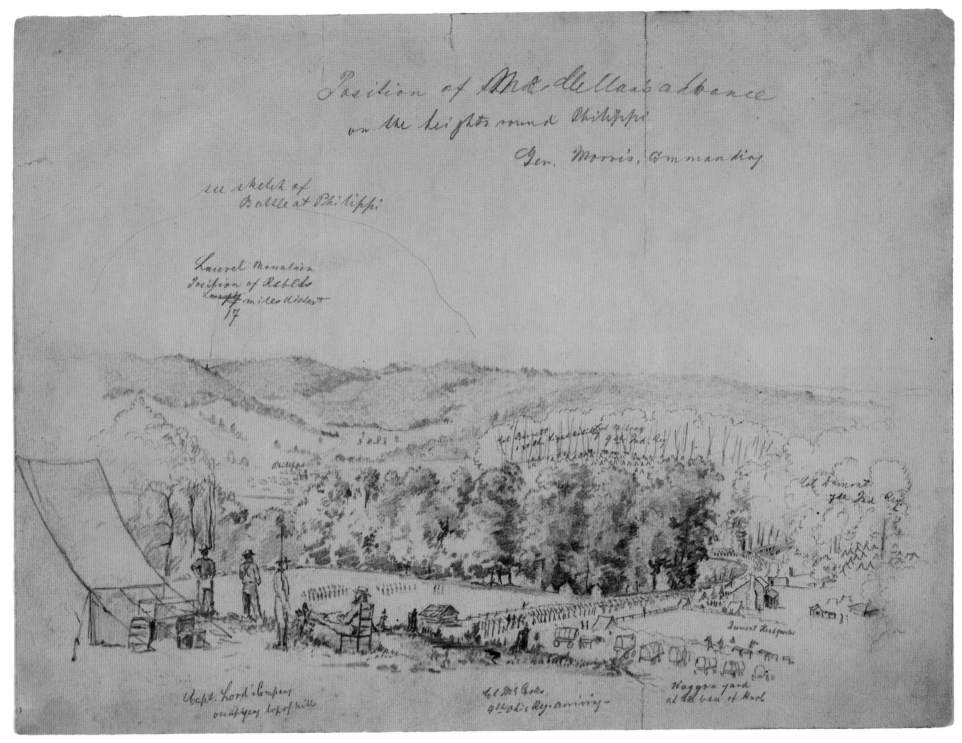

Henri Lovie, *Position of McClellan's Advance on the Heights round Philippi. Gen. Morris Commanding,*
June 3, 1861, *Frank Leslie's Illustrated Newspaper,* June 22, 1861, Collection of the New-York
Historical Society.

render such a guarantee or assurance on my part unnecessary. I have only to say in addition that by this post I have forwarded to the paper in question a request that they insert my formal denial of the statement which has occasioned this communication. I have the honor to be, Sir,

Your faithful servant, W. H. Russell, LL.D., Barrister at Law.

Harper's responded by positively identifying Davis as their paid artist, endangering the Special's life:

We have not received the "formal denial" to which Mr. Russell alludes. But we owe it to ourselves to say that the Mr. Davis he mentions is the special artist of Harper's Weekly, is traveling at our cost, and is not to our knowledge drawing for the Illustrated London News. We are sorry to add that we are informed Mr. Russell was aware of these facts before he wrote the above letter.[18]

In following editions the paper promised its readers to furnish additional Southern scenes: "Notwithstanding the abuse of Southern journals, we seem to have friends left at the South, who promise to keep us supplied with sketches by smuggling them across the lines."[19] With the magazine again having claimed him, Davis was soon detained by Secessionists in Memphis, Tennessee. His sketch of the incident appeared in the June 22 edition along with this description by *Harper's*:

OUR ARTIST OVERHAULED AT MEMPHIS.

Our artist, Mr. Davis, whose name has been brought prominently before the public by Wm. H. Russell, LL. D., of the London Times, met with an unpleasant adventure on his return from New Orleans. On his arrival at Memphis, Tennessee, he was waited upon by the Vigilance Committee, who inquired, after the fashion of those bodies, who he was, where he came from, what he was doing, where he was going, and whether he didn't need any hanging. Having obtained answers to these various queries, the Committee then proceeded to inspect Mr. Davis's trunk, which they overhauled with commendable thoroughness. Finding at the bottom of the trunk a number of sketches made for us, they examined them minutely, and each member, by way of remembering Mr. Davis, pocketed two or three of the most striking. As the only revenge Mr. Davis could take on these polite highway robbers, he sketched them in the act of despoiling him, and we reproduce the picture on page 394.[20]

THE VIGILANCE COMMITTEE AT MEMPHIS, TENNESSEE, ROBBING OUR SPECIAL ARTIST OF HIS SKETCHES.—[See Page 397.]

Theodore R. Davis, *The Vigilance Committee at Memphis, Tennessee, Robbing Our Special Artist of His Sketches, Harper's Weekly,* June 22, 1861, image provided courtesy of HarpWeek.

Harper's disingenuously placed the blame for Davis's notoriety squarely and unfairly on Russell's shoulders. The young sketch artist was fortunate to escape the South physically unharmed.

One of Davis's most compelling sketches, described in his own words, portrayed a slave auction he witnessed in Montgomery. It appeared in the paper published on July 13. The scene deeply disturbed the young artist:

I am neither sentimentalist nor Black Republican, nor negro-worshiper, but I confess the sight caused a strange thrill through my heart. I tried in vain to make myself familiar with the fact that I could, for the sum of $975, become as absolutely the owner of that mass of blood, bones, sinew, flesh, and brains as of the horse which stood by my side. There was no sophistry which could persuade me the man was not a man—he was, indeed, by no means my brother, but assuredly he was a fellow-creature.[21]

A SLAVE AUCTION AT THE SOUTH.—From an Original Sketch by Theodore R. Davis.—[See Page 447.]

Theodore R. Davis, *A Slave Auction at the South, Harper's Weekly,* July 13, 1861, image provided courtesy of HarpWeek.

The slave auction sketch provided a coda to the Russell-Davis affair in *Harper's Weekly*. One week later the journal ran a series of letters and editorial replies offering testimony as to how Davis came to accompany Russell and who was to blame for the fiasco. Ultimately, the episode was a boon to history, as Davis's sketches provide insight into Confederate life early in the war. Had *Harper's* not blown his cover by publicizing the trip, his Southern sojourn might have been extended and more sketches might have found their way north. As it was, Davis was soon back in the Union.

D. H. Strother, *Harper's* Special with the Confederate States Army in Virginia, also felt increasingly uncomfortable with his assignment. As spring turned into summer and Southern troops massed for coming battles his disquiet grew. On July 13, his drawings of Virginia troops crossing the Blue Ridge Mountains and General P.G.T. Beauregard's camp foreshadowed the coming battle at Manassas Junction, or Bull Run. His written description accompanying the sketches is alarming in its portrayal of the Confederate troops, their military demeanor and disciplined approach. Union officers should have taken note:

> I never saw so many tents, soldiers, and horses before in my life. I would freely give you all the information in my power in regard to matters here, but it is one of the conditions upon which my friend has consented to take charge of my letters, that I send no intelligence abroad, as it might place us both in an ugly fix if any thing of the sort were found upon him. The people here are very suspicious, and no man who values his life should come here for the sake of curiosity. As for me, I shall get away as soon as I can ... I never was in such a warlike place before, and shall be glad to get back to Maryland, where at least there is some show of peace. When I leave here I think I shall try the Federal Army, where, no doubt, I will find more facility in sketching.[22]

By July, Strother had made good on his promise—he left the Confederacy and joined the Union Army to serve as an officer and topographical draftsman.

At this early stage of war, no other American weekly could compete with *Frank Leslie's* pictorial coverage. There was, however, another terrific source for images of the coming crisis, the *Illustrated London News*. This paper, created in 1840, was the model for all illustrated weeklies worldwide. With Lincoln's election the British took an especially keen interest in American affairs; the debate over whether or not to recognize the Confederacy consumed politicians and the public, particularly after the war started and secession became real. England had abolished slavery in 1833 but looked to the American South for cotton. The

journal's publishers knew that the United States and its citizens were of perennial interest. The *Illustrated London News* periodically published pictures from America, such as Lincoln's home in Springfield, Illinois, and sketches of Charleston by Eyre Crowe, Jr. Soon after the New Year in 1861 the *News* sent its own Special, G. H. Andrews, to Charleston, to form and draw his impressions. He, too, like Theodore Davis in Montgomery, was transfixed and transformed by the sight of a slave auction. He wrote of his sketch published in the London *News* for February 16, 1861:

> This was the first human being I had ever seen sold, and during the time of the biddings I felt the greatest difficulty in preventing myself from fainting. A dreadful, indescribable sickness came over me, which defied all my efforts to conquer. I felt giddy, and believe I must have fainted outright had I not fortunately had a bundle of tobacco strip in my hand. By smelling these, and being able to get at some iced water, I got over this my first visit to a slave auction. I saw about fifty persons of both sexes and different ages sold afterwards in this and other sale-rooms.[23]

Most editions of the *Illustrated London News* that spring covered events in America. In March, the journal reproduced Nast's drawing entitled *The Crowd at Baltimore Waiting For Mr Lincoln, President of the United States*.[24] In early May, several sketches by fellow New Yorker Frank Bellew appeared depicting "the manner in which cotton is taken on board the steam-boats that ply on the Alabama" River.[25] Scenes from the previous month's attack on Fort Sumter followed. By then Andrews had made his way north to Washington, D.C., and sent sketches from the vicinity of the capital. He was joined by veteran British war artist Frank Vizetelly, fresh from covering Giuseppe Garibaldi's campaign to liberate the Italian peninsula from Austrian rule. This campaign excited great interest in Britain, as it was supported by the British navy. At the time, Vizetelly was already a seasoned pictorial journalist renowned for his combat sketches and lively reports from the front lines during the Crimean War.

Although an uncertain Atlantic Ocean voyage separated his sketches from the engravers in London, Vizetelly's illustrations and written accounts appeared regularly during the first few months of the war. On June 15 he wrote of his arrival in New York:

> ... From morning to night nothing is heard but the sound of the drum or the martial strains from trumpet and bugle, as regiment after regiment passes on its way to the seat of war through streets crowded with

a maddened population. All trade is at a standstill. Store after store down Broadway has been turned into the head-quarters of Anderson's Zouaves, Wilson's Boys, the Empire City Guard, and hosts of corps too numerous or too eccentric in their names for me to recollect. Verily, a cosmopolitan army is assembled here. As one walks he is jostled by soldiers dressed in the uniforms of the Zouaves de la Garde, the Chasseurs à Pied, Infanterie de la Ligne, and other French regiments—so great, apparently, is the admiration of our cousins for everything Gallic. I must confess I should prefer to see more nationality. In justice, however, to the men, I cannot do otherwise than express my unqualified approval of the material out of which the North is to make her patriot army. Many of those I have seen marching through the streets appear already to have served in the field, so admirably do they bear themselves in their new rôles. The very children have become tainted with the military epidemic, and little toddling Zouaves, three and four years old, strut, armed to the teeth, at their nurses' apron strings. As I write I have a corps of chasseurs composed of all the small boys in the hotel exercising and skirmishing in the corridor outside my room; the shrill words of command from the juvenile Colonel pierce through and through my ears, and distract my attention terribly. There is not a house that does not display Union colours of some kind; there is not a steeple ever so lofty that is not surmounted by a star-spangled banner; there is not a man nor woman in the city that does not wear a patriotic badge of some kind. It is a mighty uprising of a united people determined to protect their flag to the last.

F. V.[26]

Vizetelly shortly moved south to Washington, D.C., and his letter and sketches from the capital, published a few weeks later on July 6, described daily forays from his quarters within the camp of the 2nd New York Regiment. Aside from the mosquitoes, he could not complain:

[H]ere, south of Mason and Dixon's line, on the borders of Virginia, every living thing that crawls the earth or has wings commences its revels at the approach of darkness and continues its riotous proceedings till dawn of day. The bull-frog and tree-toad hoarsely croak their dirges from swamp and wood, the whip-poor-will sighs forth his melancholy plaint, the screech-owl makes night hideous with his unearthly notes, while myriads of fireflies snap about in every direction like the sparks from a blacksmith's anvil, illumining the darkness with their tiny bright lamps.[27]

Vizetelly settled in nicely, seemingly comfortable with the aims and attitudes he found in the North.

I found that the Illustrated London News had its place in the American Cabinet, and my late connection with it had made my name familiar to many whom I met in the Minister's rooms. In the course of a short conversation I had with the Secretary of State I was asked if I thought of following in Mr. Russell's [disgraced *London Times* correspondent W. H. Russell] footsteps—that is, going South, and I fancied I could perceive a shade of irritation at the course our great "word-painter" had thought fit to pursue. I disclaimed any idea of so doing, and replied that my fortunes, at least for the present, would be cast with the army of the Union, and that I should study to delineate truthfully, with pen and pencil, without prejudice one way or the other, all that came under my observation.

Vizetelly did, however, go on to defend his colleague Russell while also admonishing the South for choosing secession and armed rebellion over political opposition or separation, and for seeking to increase slavery in the States. He suggested that the Union would win in the end, that "her ultimate success cannot for a moment be doubted."[28]

Vizetelly's letters continued through July accompanied by sketches of Secessionist raids and Unionist scouting forays across the Potomac. Bolder than most of his colleagues, Vizetelly joined one of those parties on a reconnaissance into Northern Virginia. His editor reported:

One night our Special Artist accompanied the scouting party, of which the annexed is an Illustration, twelve miles into the enemy's country. The men were dressed in round slouched hats, rough flannel blouses, and carried revolvers and bowie-knives in their belts. Two in advance carried guns ready cocked, keeping a sharp look out for ambuscades on each side among the trees. The Lieutenant in command and our artist were in the centre.[29]

In what might be considered an homage to a respected colleague, Alf Waud portrayed his fellow Englishman during a reconnaissance mission along the

Potomac with General Daniel Sickles and his staff.[30] Vizetelly's experiences as a war illustrator in Europe had given him a wealth of knowledge and expertise in military matters. In his letter published in the August 3 issue he includes prescient remarks regarding the rapidly expanding Union Army:

For a country like the United States—recollect I am speaking of only the northern division—to place 150,000 men in the field armed and equipped in the short space of little better than two months is indeed surprising. When I say 150,000 men I mean those actually in line of battle; not including the untold legions on their way to the seat of war and others drilling in the various States to which they belong. Your readers, to realise the energy that has been displayed, must take into consideration the fact that the standing army has scarcely ever exceeded 15,000; and that almost every man now called upon to serve has been enrolled, clothed, armed, and drilled in the period above mentioned. I do not mean to assert that this army goes to the field in as serviceable a condition as a European one of similar proportions; for in the essential of cavalry they are lamentably deficient. But perfection is not to be expected from a country that has never laid claim to be considered a military Power, though I very much doubt if America won't proudly assert her right to such distinction before the close of the lamentable strife she is now engaged in. To one fact I can bear positive testimony, which is, that no other nation could bring into array a more goodly show of sinew and muscle. There are regiments taken from among the hardy sons of Maine, Michigan, Vermont, Wisconsin, New Hampshire, and Iowa, men who gain their bread by following avocations in which physical strength and endurance go for more than mental capacity. It is not by any means uncommon to see in the ranks huge, brawny fellows, six feet three and four in height, "boys" who can hand a tree or start a raft over a fall, throttle a bear, or pole a barge down the rapids, and in whose hands a musket and bayonet is no more than a toasting-fork. Of course, every Northern state gives its quota to the national forces, and I have simply particularised the above for the sake of introducing some of the athletes about to enter the arena. The greatest failing probably in this army is the want of competent officers. The men themselves begin to feel this, and are murmuring openly at the corruptive practices which take wealthy tradesmen from behind their counters and dub them Colonels and Majors-General.[31]

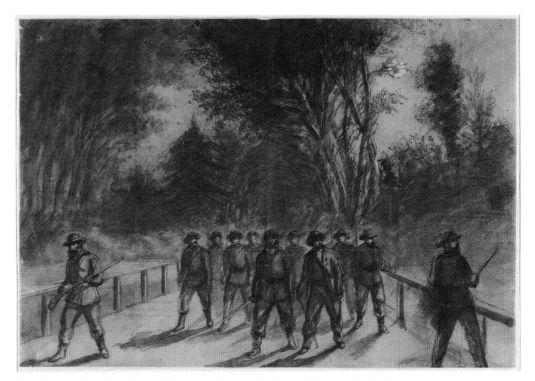

Frank Vizetelly, *Scouting Party of Unionists through the Woods of Virginia, in the Neighborhood of Alexandria, Illustrated London News,* July 13, 1861, MS Am 1585, Houghton Library, Harvard University.

In this letter he also sets out the respective locations of the two opposing armies, foretelling a great battle in the vicinity of Fairfax in Northern Virginia. Again, he was spot on. On July 21, soldiers under Union general Irvin McDowell advanced against Confederate troops led by General Beauregard across Bull Run at Manassas Junction, just west of Fairfax Court House. Initial reports promised a Union victory; they were mistaken. Rebel brigadier general Joseph Johnston brought reinforcements, including a brigade under charismatic leader Brigadier General Thomas Jackson, who won the nickname "Stonewall" for his actions that day in helping to turn a strong Union advance into a Confederate victory. All of the artists for the illustrated weeklies, numerous reporters, even Congressmen and their wives along with citizens from the capital enjoying a day out watching the battle were caught up in the chaos of the retreat.

Frank Leslie's was the first of the weeklies to report on the battle, with sketches and a reporter's account in its July 27 issue, an amazing six days after the event. These sketches, and those published a week later, were likely the work of Arthur Lumley. *Harper's* coverage, featuring sketches by Special Theodore Davis and an account by Henry Raymond of the *New York Times,* began on August 3. Davis's

Battle at Bull's Run, on Sunday, July 21, 1861—Gallant and Successful Assault of the N.Y. Fire Zouaves on a Rebel Battery, Which They Take at the Point of the Bayonet.—From a Sketch by Our Special Artist Accompanying Major-General M'Dowell's Command, Frank Leslie's Illustrated Newspaper, August 3, 1861, image provided courtesy of HarpWeek.

sketch of the moonlit withdrawal, guarded by Colonel Blenker's brigade, appeared in the August 10 issue with an account from the *New York Tribune*:

> I need not speak much in praise of the action of Blenker and the officers who served him so well. The events speak for them. Steady and watchful, he held his line throughout the evening, advancing his skirmishers at every token of attack, and spreading a sure protection over the multitudes who fled disordered through his columns. With three regiments he stood to fight against an outnumbering enemy already flushed with victory, and eager to complete its triumph. As the darkness increased his post became more perilous and more honorable. At 11 o'clock the attack came upon the advance company of Colonel Stahel's Rifles, not in force, but from a body of cavalry whose successful passage would have been followed by a full force, and the consequent destruction of our broken host. The rebel cavalry was driven back, and never returned, and at two in the morning, the great body of our troops having passed and found their road to safety, the command was given to retreat in order, and the brigade fell slowly and regularly back, with the same precision as if on parade, and as thoroughly at the will of their leader as if no danger had ever come near them. Over and over again Blenker begged permission to maintain his post, or even to advance. "Retreat!" said he to M'Dowell's messenger; "bring me the word to go on, Sir!" but the command was peremptory, and he was left no alternative.[32]

The recently arrived Englishmen recording the event for the *Illustrated London News* tell a different tale, of apparent victory turned to utter rout and total defeat. The journal for August 10 included sketches by Vizetelly with a vivid, lively, and all-too-unflattering description of Northern cowardice in the face of Southern courage by William H. Russell from the London *Times*:

> At the bridge the currents met in wild disorder. "Turn back! Retreat!" shouted the men from the front, "We're whipped, we're whipped!" They cursed and tugged at the horses' heads, and struggled with frenzy to get past. Running by me on foot was a man with the shoulder-straps of an officer. "Pray what is the matter, Sir?" "It means we're pretty badly whipped, and that's a fact," he blurted, out in puffs, and continued his career. I observed that he carried no sword. The teamsters of the advancing wagons now caught up the cry. "Turn back—turn your

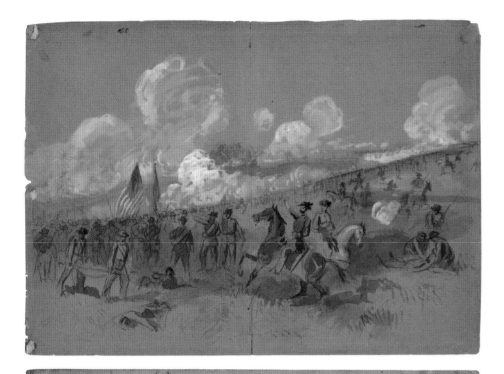

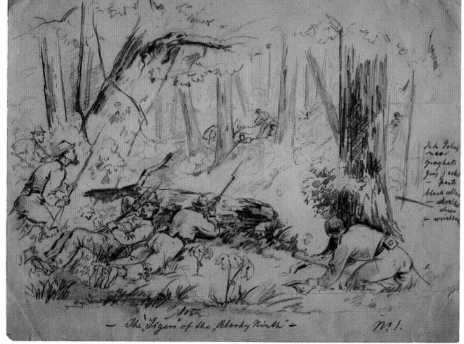

TOP: **Alfred Waud,** *Colonel Burnside's Brigade at Bull Run,* July 21, 1861, *New York Illustrated News,* August 5, 1861, Library of Congress.

BOTTOM: **Henri Lovie,** *The "Tigers" of the Bloody Ninth,* July 1861, courtesy of the Becker Collection, Boston, MA..

horses!" was the shout up the whole line, and, backing, plunging, rearing, and kicking, the horses which had been proceeding down the road reversed front and went off towards Centreville. Those behind them went madly rushing on, the drivers being quite indifferent whether glory or disgrace led the way, provided they could find it. . . . Drivers flogged, lashed, spurred, and beat their horses, or leaped down and abandoned their teams, and ran by the side of the road; mounted men, servants, and men in uniform, vehicles of all sorts, commissariat wagons thronged the narrow ways.[33]

Frank Vizetelly offered an equally damning addendum a week later with his sketch, *The Stampede from Bull Run,* and the attached description:

At half-past five the Federal troops were in full retreat, pursued at different points by the black horse cavalry of Virginia. Retreat is a weak term to use when speaking of this disgraceful rout, for which there was no excuse. The terror-stricken soldiers threw away their arms and accoutrements, herding along like a panic-stricken flock of sheep, with no order whatever in their flight. Those who had been fortunate enough to get places in the baggage-wagons thrust back others with their bayonets and musket-stocks. Wounded men were crushed under the wheels of the heavy, lumbering chariots that dashed down the road at full speed. Light buggies, containing members of Congress, were overturned or dashed to pieces in the horrible confusion of the panic."[34]

On the day after the Battle of Bull Run, *New York Illustrated News* published Alf Waud's vivid account of his threatening encounter with a Union soldier in Alexandria:

On Friday morning I had a skirmish on my own account. A soldier wanted to get my horse from me, seized the snaffle rein, and stated that he had dispatches and was ordered to take the first horse he saw to get into town speedily, and invited me to give up quietly. I whipped the animal violently, dragged the man a short distance, when the rein gave out; he drew his revolver and threatened to fire if I did not stop; wheeling around I drew mine, under cover of my portfolio, cocked it, and then pointed it at him, with the remark that I should kill him if he presented his—he was holding it pointing at the ground, and was very unsteady from the excitement, (it was very hot,)—as I had the advan-

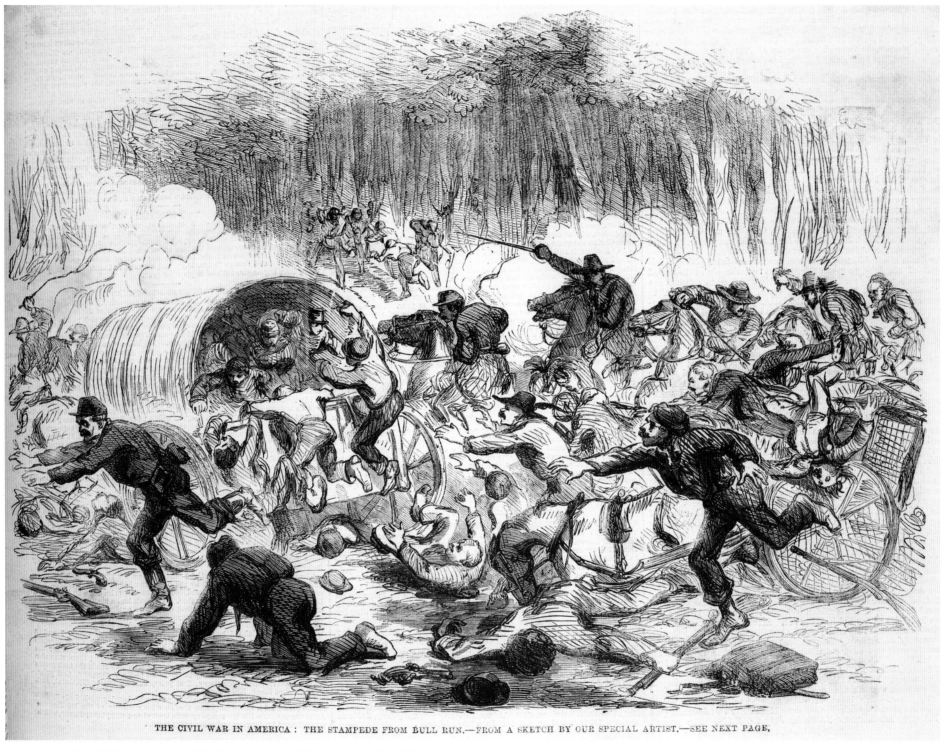

THE CIVIL WAR IN AMERICA : THE STAMPEDE FROM BULL RUN.—FROM A SKETCH BY OUR SPECIAL ARTIST.—SEE NEXT PAGE,

Frank Vizetelly, *The Civil War in America: The Stampede from Bull Run.—From a Sketch by Our Special Artist, Illustrated London News,* August 17, 1861, Library of Congress.

Arthur Lumley, *Flag Boat Yankee of the Potomac Flotilla—Scouting off Evansport,* August 1861,
Print Collection, Miriam and Ira D. Wallach Division of Art, Prints and Photographs, the
New York Public Library, Astor, Lenox and Tilden Foundations.

tage, he returned it slowly to his belt, and I rode off devilish quick. I asked afterwards if it was likely he had such orders, and was told he doubtless took me for a citizen of Alexandria who could be bluffed off his horse, so that he (the soldier) might ride in instead of walking it.[35]

Waud traveled to the Bull Run battlefield in the photographic wagon owned and driven by his friend, the now legendary photographer Mathew Brady. Already known for his prowess as an illustrator and good cheer in camp, at Bull Run, according to the *Boston Courier,* Waud soon became one of the few correspondents to take up arms against the enemy during the Civil War. On August 5, the *Courier* reported:

A Sketcher at the Battle—During the charge of the rebel cavalry upon the hospital used for Gen. Tyler's Division, a number of civilians assisted in the successful repulse. The foremost among them was Mr. Waud, an artist of the New York Illustrated News who picked first one, then a second rifle from the ground, where they had been thrown by a pair of fugitives, and used them against the assailants until the ammunition which accompanied them was exhausted.[36]

While the Union Army shored up the capital's defenses, the navy took center stage with a sea-going expedition of combined forces led by General Ambrose Burnside moving down the coast to North Carolina's Cape Hatteras. Several

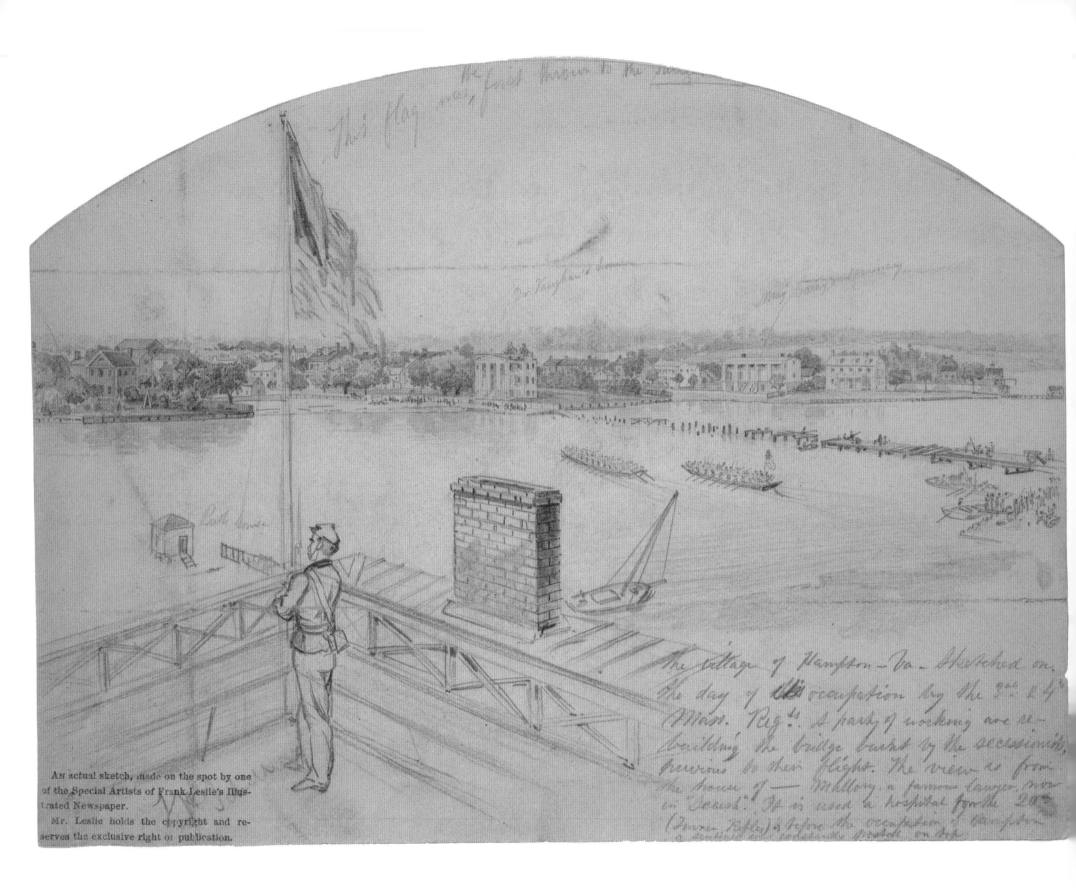

This flag was first thrown to the ...

This flag was first thrown to the ...

Dr Vaughan's house

Maj Gouvey... summary

Cook house

The village of Hampton — Va — Sketched on
the day of its occupation by the 3rd & 4
Mass. Reg.ts. A party of working are re-
building the bridge burnt by the secessionists,
previous to their flight. The view is from
the house of — Mallory, a famous lawyer, now
in "Secesh". It is used a hospital for the 2d
(Duryea Rifles) & before the occupation of Hampton
a sentinel was constantly posted on her

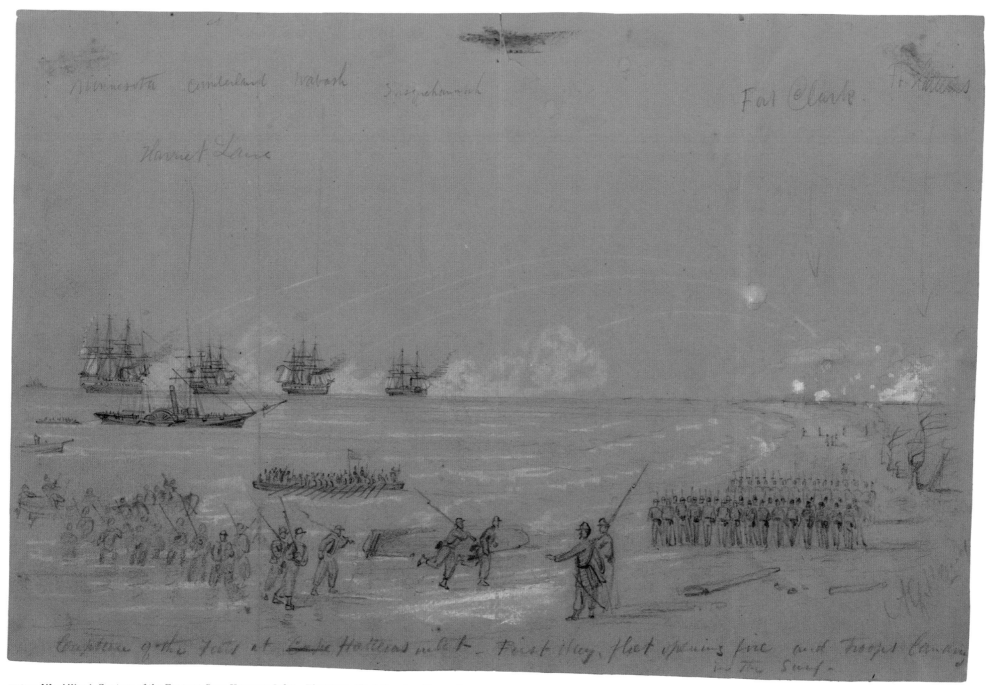

ABOVE: **Alfred Waud,** *Capture of the Forts at Cape Hatteras Inlet—First Day, Fleet Opening Fire and Troops Landing in the Surf,* August 28, 1861, *New York Illustrated News,* September 16, 1861, Library of Congress.

OPPOSITE: **Frank Schell,** *Village of Hampton, Va. Sketched on the Day of the Occupation by the 3rd and 4th Mass. Regiments,* August 10, 1861, Print Collection, Miriam and Ira D. Wallach Division of Art, Prints and Photographs, the New York Public Library, Astor, Lenox and Tilden Foundations.

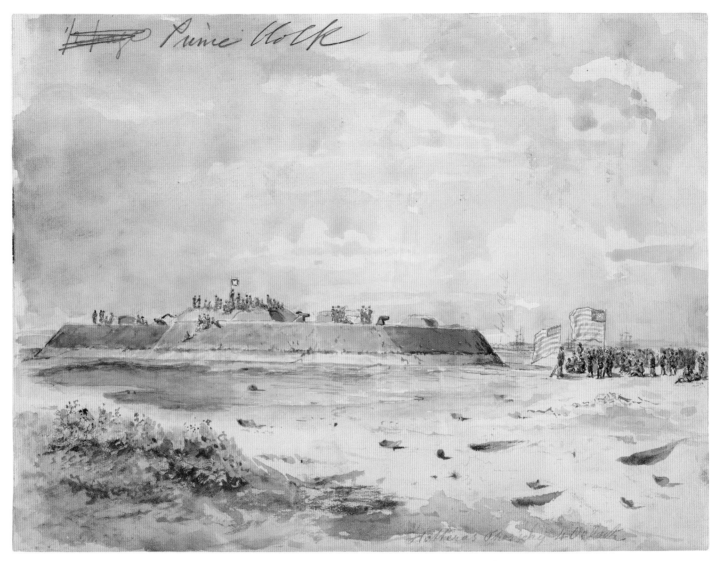

Theodor Kaufmann, *Fort Hatteras Just before the Surrender*, ca. September 1861, *Harper's Weekly*, September 21, 1861, Museum of Fine Arts, Boston.

Specials joined the Burnside expedition and sent back scenes of ships and fighting men forcing their way onto shore.

Public attention in the North soon turned west. In August, *Harper's* sent Alex Simplot, who also used the pen name A. S. LeClerc, upriver from Cairo, Illinois, to document the preparations of Frémont—known as "the Pathfinder" for his explorations beyond the Mississippi—to lead his troops into Missouri, a border state with strong secessionist sentiment. Simplot was impressed by Frémont, his popular wife Jessie, and the eight thousand strong gathered for the campaign.

He drew the general, his headquarters, and the army's departure from St. Louis "enthusiastically cheered by the people."[37]

Henri Lovie, sketch artist for *Frank Leslie's*, was already in Missouri, marching with a brigade of troops under Union general Benjamin Prentiss. By Lovie's own account, published with his sketches on September 28, the troops moved "slowly over a stony country road, through a mountainous region, covered with oak shrubs and small trees, nearly uninhabited, and exceedingly poor." The troops were provisioned for three days only and soon resorted to foraging. Lovie

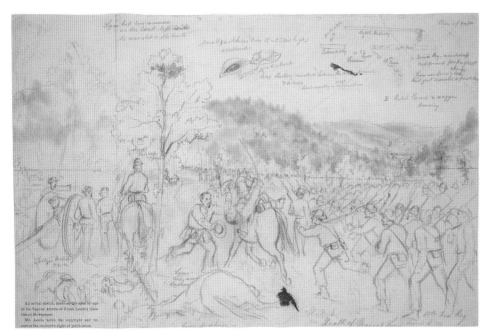

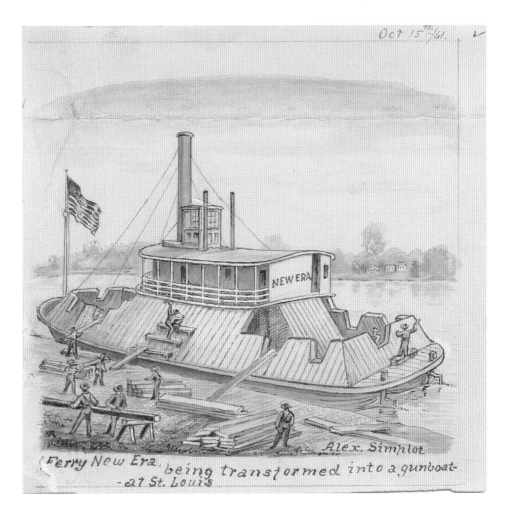

seized the comic possibilities of the situation, illustrating the lighter side of warfare, for the soldiers if not for the victimized civilians:

> [S]oon, the want of provisions being pressing, permission had to be given to forage, and then the real work commenced, affording a great deal of sport to the soldiers, and a good deal of unhappiness to the "widows" along the road—it being a remarkable fact that this whole section of country is inhabited by "lone widows" while the United States troops pass through it. One of these interesting females, whose husband was crippled, and away thrashing, etc., became the unwilling hostess for our army on the fourth night. She was the "hardest specimen" of female delicacy possible to conceive, being able to out-swear the roughest trooper and shed tears at will. She had a fine collection of geese and chickens around her loghouse, which was at a little distance from the roadside, surrounded by oak shrubs. The chase around and under the house, and through the bushes, was of the most exciting character, and our boys showed an agility which could have hardly been expected after the long and tiring march of the day. The woman stood in the doorway cursing and weeping alternately, rendering it impossible to pity her, and I could not help laughing when she asked me, "Are the devils, there, going to kill all my goslings?" Sure enough, all the goslings went, and all the chickens, too, while straggling shots sealed the doom of distant sheep and bullocks.[38]

Presaging Bertholt Brecht's famous comment "Grub first, then ethics," Lovie mused in a letter, "Morality is feeble before hunger." He gave his sketches such titles as *Slaughter of the Innocents* and *Secesh Oats.*

Lovie and Alex Simplot gathered with like-minded colleagues at Jefferson City, Missouri, forming an informal club called the "Bohemian Brigade." Their fellow Bohemian, *New York Tribune* scribe Junius Browne, described their anarchistic, adventuresome, romantic *esprit de corps:*

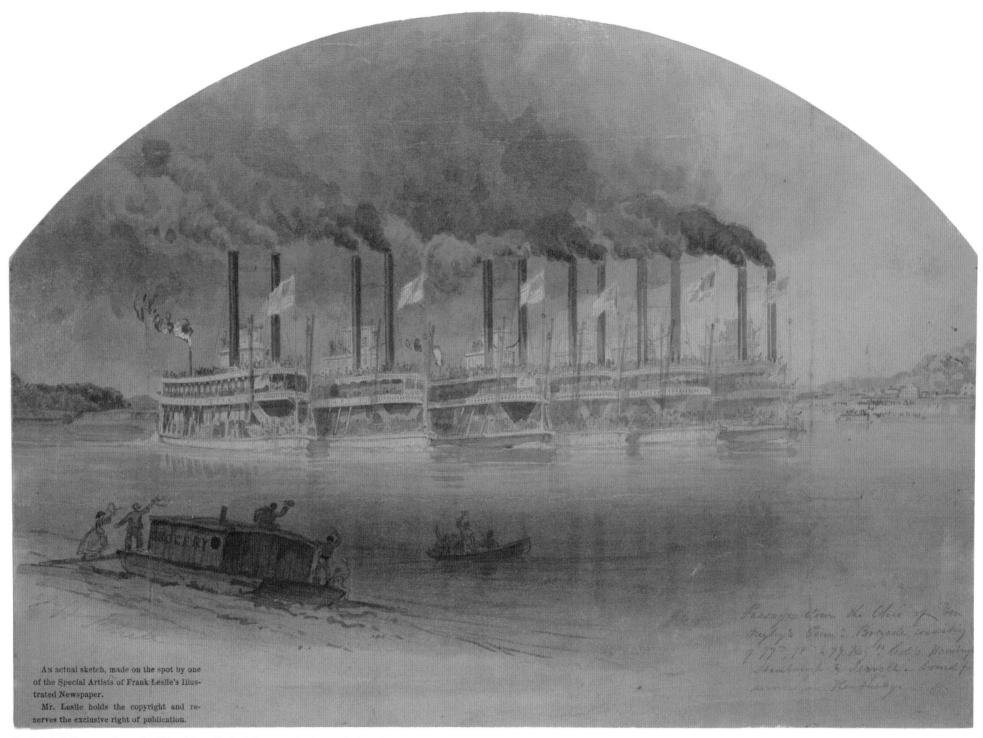

An actual sketch, made on the spot by one of the Special Artists of Frank Leslie's Illustrated Newspaper.

Mr. Leslie holds the copyright and reserves the exclusive right of publication.

Frank Schell, *Passage down the Ohio of Gen. Negley's Penn. Brigade Consisting of 77th, 78th, and 79th Regiments*, ca. October 1861, *Frank Leslie's Illustrated Newspaper*, November 16, 1861, Print Collection, Miriam and Ira D. Wallach Division of Art, Prints and Photographs, the New York Public Library, Astor, Lenox and Tilden Foundations.

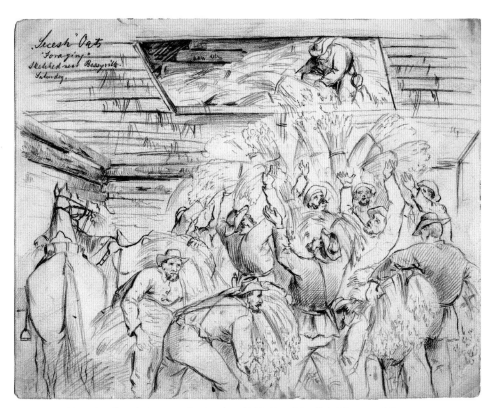

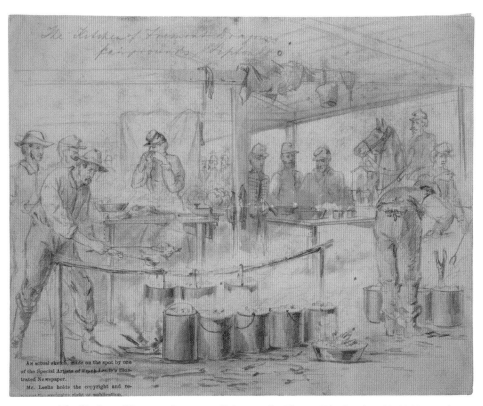

Henri Lovie, *Foraging Secesh Oats,* ca. September 1861, *Frank Leslie's Illustrated Newspaper,* October 12, 1861, courtesy of the Becker Collection, Boston, MA.

Henri Lovie, *The Kitchen of Fremont Dragoons, Fairgrounds, Tipton, Md.,* October 13, 1861, *Frank Leslie's Illustrated Newspaper,* November 2, 1861, Print Collection, Miriam and Ira D. Wallach Division of Art, Prints and Photographs, the New York Public Library, Astor, Lenox and Tilden Foundations.

With all its monotony, all its painful suggestions, there is a kind of charm in camp-life—in its freedom from ordinary restraint, its out-door existence, its easy, reckless tone, its devil-may-care indifference, and utter disregard of the formal barbarians the enlightened world calls "Society" . . . Of course, we had considerable leisure, and amused ourselves as best we could, in the absence of books, which were very scarce. We smoked pipes, played whist, discussed Poetry, Metaphysics, Art, the Opera, Women, the World, the War and its future, and various themes on which we then could merely speculate.[39]

Back east, the soldiers were settled in camp. In September, *Harper's* published a sketch drawn by a soldier, G. W. Andrews of the Cameron Cavalry. His sketch depicts the interior of his own tent and, as the journal's editors safely back home in Manhattan point out, "It looks comfortable enough."[40]

As the Union Army in Northern Virginia was generally idle that fall, Waud

crafted an extraordinary letter from camp, detailing a day in his life and the daily routine of the soldiers. The richness of his imagery and language makes this letter worth quoting at length.

A DAY IN CAMP WITH THE ARMY OF THE POTOMAC.

Enjoying the hospitality of the Colonel's tent. I had been sleeping luxuriously upon a hospital stretcher, my head supported on a valise by way of pillow, when the trumpeters, devoting themselves with might and main to the reveille, utterly routed Morpheus. Looking from the open entrance, the soldiers are seen rushing from their tents and finishing dressing, as they receive the hot coffee, which in well regulated commands is given them to keep off the ill effects of the chill morning air, at this season never wholly free from malaria. Roll call follows, and the band assembles on the parade. Details from each company form upon the ground for guard mounting, and after going through sundry evolu-

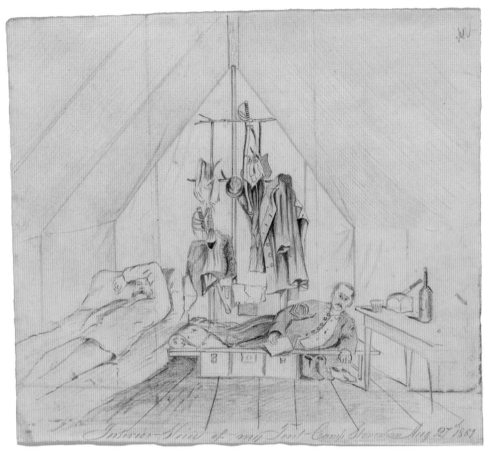

G. W. Andrews, *Interior View of My Tent*, August 27, 1861, *Harper's Weekly*, September 21, 1861, Museum of Fine Arts, Boston.

face with an awfully rough towel. Some boxes, a trunk, and a stand for saddles, cloaks, &c., complete the furniture, which is raised some six inches from the earth on a neat floor of boards.

The rush of orderlies into the adjutant's tent—which is "next door"—to deliver the company reports, the rapid movements of the men, now engaged in battalion drill, and, above all, the sudden appearance of the sun—imparting a dreadfully dissipated glow to the faces of the musicians, and the nose of the sentry outside the tent—overcomes me with a sense of the enormity of bed laziness. So having dressed and performed a pleasant toilet under the pine trees at the back of the tent, I am ready for breakfast, which is forthwith served in advance of the usual time, on one of the tables in the tent; beefsteak and potatoes, bread, poached eggs, pancakes and coffee, forming the bill of fare. Cigars follow, the colonel dives into business, reads reports, signs passes, gives orders, and dictates to his secretary.

More interesting are the proceedings outside. Two large armed working parties are on the march, fifteen hundred to one fort, and five hundred to another, to work on entrenchments, which, all things considered they do with commendable cheerfulness. Another body of twenty men from each regiment, under command of an engineer officer, is departing in still another direction to work upon the neighboring roads. Besides these heavy details, between sixty and seventy men are sent to the quarters of the general of the division to be placed on guard for the protection of those houses not deserted by their inhabitants. Deserted dwellings, unless known to belong to Unionists (although that is not always a protection), are soon dismantled to aid in adorning and making more comfortable the tents in adjacent camps.

The prisoners, namely, those soldiers under punishment for offences against discipline and order, are cleaning the camp, sweeping, shoveling, and removing in barrows the surface refuse, digging drains, &c., and at this sort of work they are employed from seven o'clock till noon, and from half-past one till six o'clock.

The men having had breakfast, clean arms and accoutrements, and drill again for two or three hours. I stroll about the camp, which is pleasantly situated, and in good order. The mud streets are on a level plateau alongside a railroad, up and down which a locomotive is constantly puffing with cars in tow, for conveyance of stores and men. It is the same train that carried the Ohio men into the ambuscade at Vienna . . . [At the battle of Vienna, Virginia, on June 17, 1861, Col. Rob-

tions, are told off to relieve those who have been on guard the preceding twenty-four hours. The music is pleasantly prolonged, (I tremble when I think of an idiotic proposal to discharge the bands on the score of economy), and feeling no obligation to rise, I continue to enjoy my stretcher, and look at things recumbently. And first this tent commands my admiration, it is spacious; and in the centre is a trophy formed of three gorgeous regimental flags sundry sarees, sashes, caps, operaglasses, pistols, and red bunting, over all two rifles crossed, two others being also dependant at each end of the ridge pole. There are two tables furnished with books on military tactics, account books, reports, passes, &c.; any quantity of camp stools, with and without books, washstand of primitive construction, the colonel's sleeping arrangement, from which he is already absent, though visible outside the tent often giving instructions to an orderly while he rasps the water from his

ert Schenck's train-bound regiment of Ohio troops were repulsed by a Confederate ambush.]

At twelve o'clock the dinner call is blown con amore, by a lanky bugler, who cracks frightfully on the three last notes, in his anxiety to finish and be off to his ration. Shortly after, dinner is announced in the mess tent, a spacious structure of the rustic order, with sides of cedar branches and roof of canvass. A gratifying smell of soup floats about, and the dinner, which reminds one of a picnic, is well served and most decidedly appreciated.

More drilling is done in the afternoon, and a dress parade is also accomplished. The working parties return, and if there is a necessity for great haste, other parties go out to continue the work through the night. And here I will express a regret at this necessary employment of so much of the time that is required to give the men greater proficiency in drill. Long strings of horses are taken, raising clouds of dust, to the creek, where they are watered; one or two break loose, and a grand scamper ensues after the runaways, giving an opportunity for harder riding than under ordinary circumstances is allowed. Standing near division headquarters, I watch the gradual approach of the wagon trains, rumbling noisily along into camp with loads of commissary and quartermaster's stores and ammunition.

The gradual arrival of groups of officers and the presence of the band in front of the General's quarters, proclaim the approach of the hour when the evening parade of officers is held. With an easy military air, free from the stiffness of a line parade, they form in front of his tent, occupying three sides of a square; the infantry in front and to the right, the artillery and cavalry on the left, before their horses.

The band plays a selection from "Robert le Diable," the officers chat and introduce one another; the rays of the setting sun slant glowingly upon the scene, and redly tinge the distant woods and hills, dotted with tented towns, over which crowning the heights, the red fortifications bear the cannon-crested bastions, and the smoke of a recent salute curls lazily about the flag-staff and floating off in orange and purple clouds. The echoes die away; and now the General, attended by his staff, comes forth from the rustic Gothic arches of cedar that enclose the space in front of his tent—a sort of open ante-room, giving an air of retirement to the inner quarters. Joining a group of field officers in the centre of the parade ground, greetings are exchanged, and conversation, very often of an animated character, follows. The exact topics

I cannot disclose for several reasons, the principle being, that even in the character of a newspaper correspondent, it is not possible to pluck up assurance enough to approach so distinguished a party with the base intent of eavesdropping . . .

The not unwelcome supper-call invites to the mess tent, now lighted by Chinese lanterns of colored paper, and wax candles in candlesticks or bottles, around which various specimens of the entomology of the country, perform voluntary auto-da-fe. Eating over, those officers not on duty remain some time to smoke, maybe to dispose of a bottle of light wine, always provided the Provost Marshal has not so strictly exercised the right of search on the Long Bridge, as to have frustrated all attempts to smuggle over that fluid.

Out into the calm moonlight of this delicious Indian summer, among lines of tents, through whose canvass walls to which the lights inside give a dull glow, comes the sound of laughter and singing. Ah, this is the time to realize the poetry of the scene, common places hidden in the broad deep shadows, or lost in still broader fields of pure effulgence, no longer intrude themselves upon the attention. One scene in the romance of the army is before us, none the less enchanting, because a peaceful one. From the band, Schubert's serenade floats dreamily, adding the only charm wanting to the time, linking it with other moonlit nights of past summers, on whose placid hours no thought of war intruded. The spell is of brief continuance, for from hill side and valley along the whole extent of our lines, bursts forth the music of innumerable military bands, playing marches, waltzes, overtures, and opera airs, according to the sweet fancy of the band masters, or by particular request of the commandants. Trumpets, bugles, drums and fifes, anon strike in, with a noisy selection of calls it being time for tattoo. The bands still struggle on with an universal predilection for the 'Star Spangled Banner,' till the signal is sounded for the extinguishing of lights. The tents lose their semi-transparency, and with the exception of the lamp in the guard tent, and another in that of the Colonel there is no opposition to the cold light of the moon, unless when the breeze wafts a shower of sparks from a decaying fire, by which a sentry leaning on his musket is waiting statue-like for the approaching relief.

As I am outside the lines, I receive a peremptory command to halt, to which the German sentinel bringing his piece to the charge, adds the usual: "Who goes there?" "A friend with the countersign" I answer. "Approach friend and give the countersign." Walking up to within six or

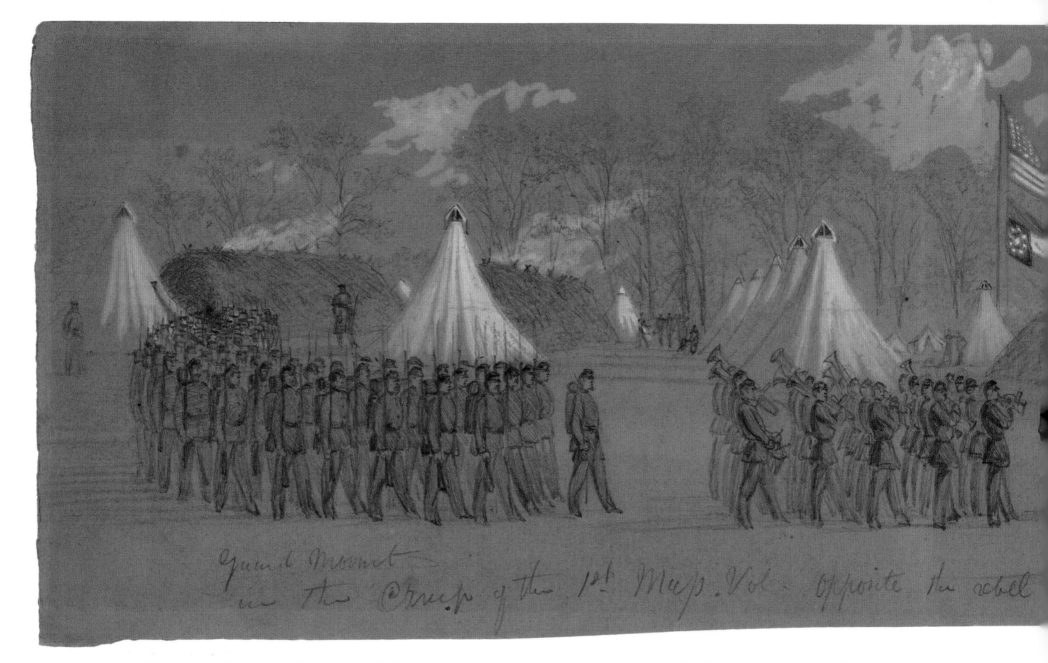

Guard Mount in the Camp of the 1st Mass. Vol — opposite the rebel

seven feet of the man, who then repeats the order to halt, I lean towards the bayonet, and—overcoming a strong desire to say Pumpernickel—whisper "Anderson."

"Countersign is right," says the sentry, "pass on."

About fifteen minutes later the Lieut. Colonel makes his appearance before the Colonel's tent, with some nine or ten others, not apparently in the same good spirits as their leader. It appears that the quartermaster of the regiment with some friends and other quartermasters, mostly Hebrews, had grown pot valiant and expressed anxiety to meet the enemy at any odds; the Lieut. Colonel, as officer of the day, readily acceded to their desire to accompany him on the grand rounds. Taking them on the outposts and giving them a wrong countersign, they were instructed to proceed, while he visited a point near by. Naturally the first guard they met, pronounced them impostors, and at once confined the poor quartermasters in the guard tent, not to be released till daylight. The Colonel having made his arrangements came and let his quondam associates out however, and they continued the inspection till the heart of a thick wood was reached. In the middle of a dreadful

anecdote of the ferocity of the rebels, and while contemplating the propriety of an immediate return to camp, bayonet and sabres gleamed around, and a savage voice ordered immediate surrender; at once the Colonel dashed away, calling all to charge and follow; this in view of the leveled pieces hardly seemed safe; so more dead than alive they dismounted, and were immediately disarmed and tied, their eyes at the same time being bandaged, and in this plight were hurried through close undergrowth, swamps, water courses, and fields of Indian corn, till worn out, they suddenly, and to their great relief, once more confronted the Colonel in company with their horses, on which one and all declared that they had seen through the joke from the very first, and in fact had been engaged in deceiving the Colonel the whole time.

After this, an occasional distant challenge from the guard, the drowsy hum and twitter of the innumerable insects, and the footsteps of the sentinel in front of the tent, are the only sounds that reach me; these gradually seem subdued, the panorama in front of the open tent fades, and a day in camp is closed by the perfect repose that accompanies sleep in the open air.

Alf. Waud[41]

Waud's extended letter offered readers a comforting glimpse of daily life in the Union Army, a sense that their soldiers were well cared for and stability reigned

Alfred Waud, *Reconnoisance* [sic] *of the Enemies Position in front of Fairfax Ct. House,* October 18, 1861, *New York Illustrated News,* April 12, 1862, Library of Congress.

Alfred Waud, *Discovering the Bodies of the Slain in the Potomac River,* ca. October 21, 1861, Library of Congress.

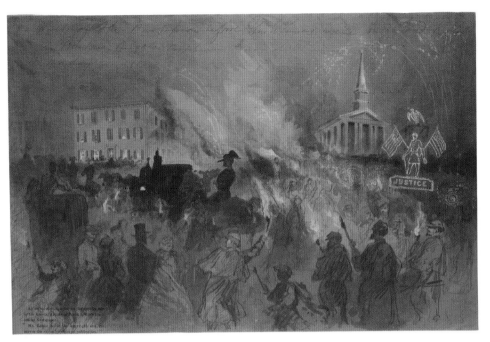

Arthur Lumley, *Halt of the Procession before Gen. McLenon's house on 15th and K Streets.*
Gen. Blenker's Brigade, ca. 1861, Print Collection, Miriam and Ira D. Wallach Division of Art,
Prints and Photographs, the New York Public Library, Astor, Lenox and Tilden Foundations.

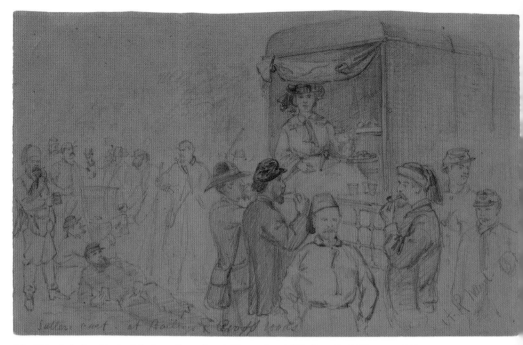

Alfred Waud, *Sutler Cart, at Baileys Cross Road*, November 1861, *New York Illustrated News*,
December 21, 1861, Library of Congress.

along the front lines. The romance of war and the camaraderie found among soldiers permeates his writing. Bull Run seems a distant memory; there is no hint of the vicious fighting to come.

After the Indian summer, other than a politically disastrous defeat at Ball's Bluff, Virginia, outside Washington, D.C., involving the death of a U. S. senator, and a minor Union victory at Port Royal, South Carolina, the armies from both sides largely hibernated for the rest of the year. Henry Mosler, assigned to cover the war in Kentucky for *Harper's*, was at Camp Nevin with General McCook in November keeping an eye on the rebels at Bowling Green. Alex Simplot remained in St. Louis sketching the construction of "Mortar-Boats" to be used as troop-carriers and shell-launchers in an expedition down the Mississippi.

On December 9, the *New York Illustrated News* published a double-page spread illustrating a grand review of the Army of the Potomac by its commanding officer, General George B. McClellan. The review had taken place in Virginia on November 20th. The *News* took great pride in exclaiming, "This fine picture is the largest wood engraving ever produced in the United States." (Historian Richard S. West notes at least two mammoth plate engravings produced by Frank Leslie in the 1850s.) Drawn by Alfred Waud, this image was carved in the block by "principal engraver, Mr. *Anthony*, who is universally recognized as the first in

his line of Art, on this side of the Atlantic."[42] Looking carefully at the image, one cannot fail to note that the only artist named within the image itself is Thomas Nast, who copied Waud's sketch onto the block to be engraved! Nast is remembered as one of America's greatest graphic artists, but his penchant for taking credit where it might not be due did not always endear him to his fellow Specials. In an unguarded moment Alf Waud wrote, in July 1862 during the Peninsula Campaign, possibly to his friend Edward A. Paul, a correspondent for the *New York Times*, "I envy you your quiet jog plenty to eat and drink and no risk from dammed shells and bullets. I heard Nast was with you. Between you and I, I detest him."[43] Nast signed a number of Waud images and never looked back. Waud apparently never forgave him.

Winslow Homer, a future American "Old Master" painter, made his debut as a Special in *Harper's* in November with a visual medley representing popular war songs. His original drawing for the wood engraving, preserved in the Library of Congress, balances war themes with patriotic and sentimental touches. He depicts scenes representing such familiar wartime ditties as "We'll Be Free and Easy Still," "Rogue's March," Hail to the Chief," "The Girl I Left Behind Me," and "Glory Hallelujah." Parenthetically, he drew the composition on the back of a contemporary French lithograph entitled *Cours de Dessin*, or Drawing Course,

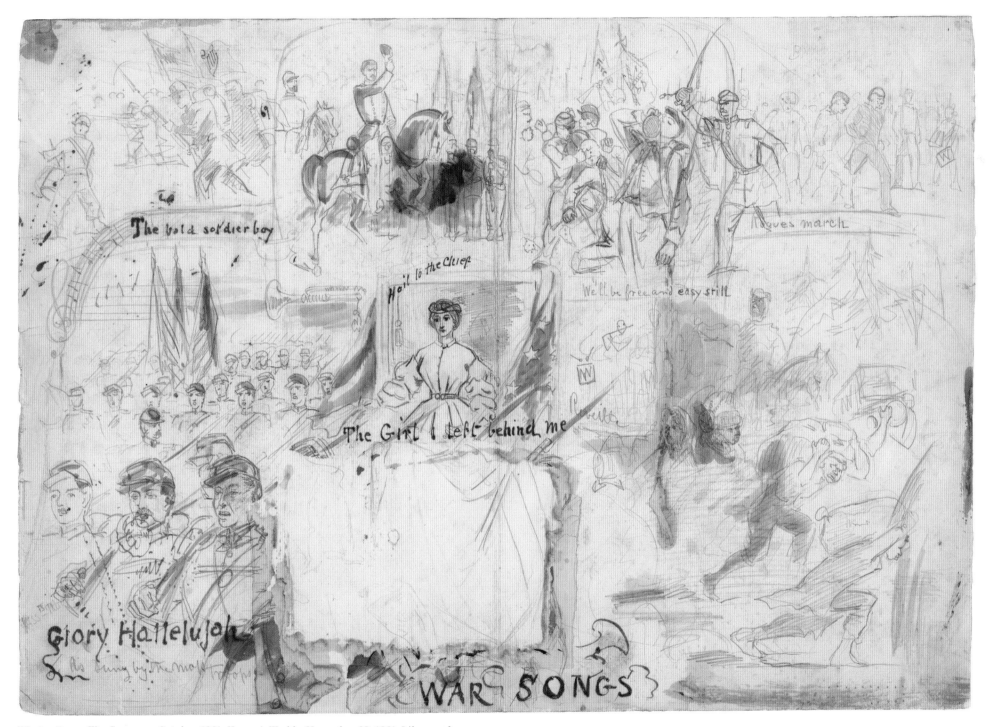

Winslow Homer, *War Songs*, ca. October 1861, *Harper's Weekly*, November 23, 1861, Library of
Congress.

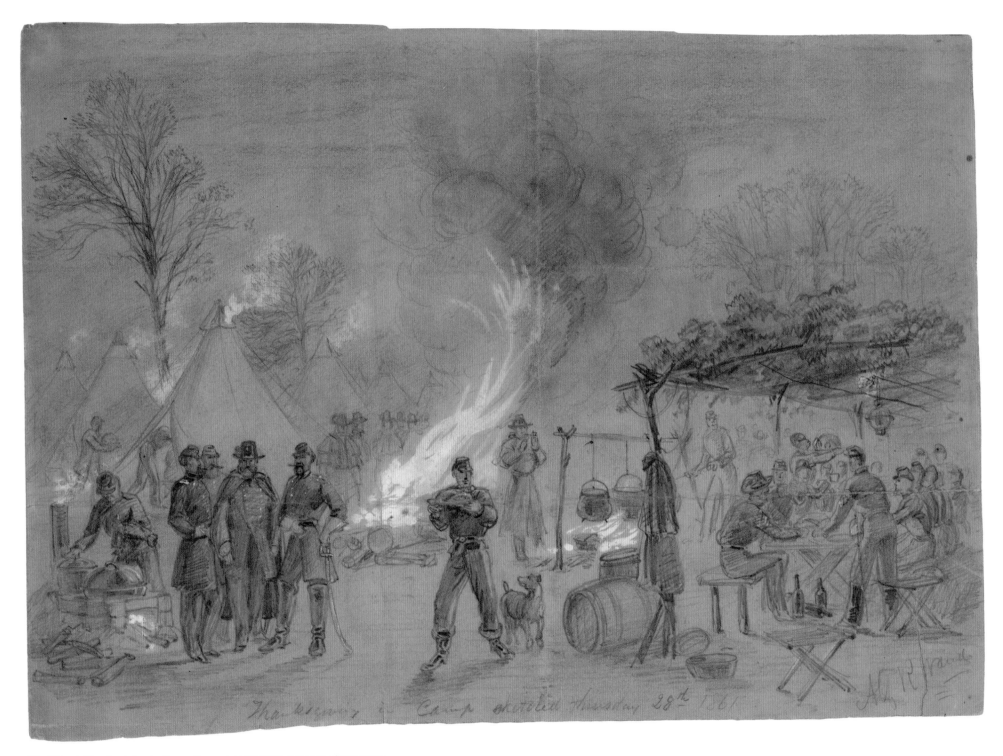

Alfred Waud, *Thanksgiving in Camp,* November 28, 1861, Library of Congress.

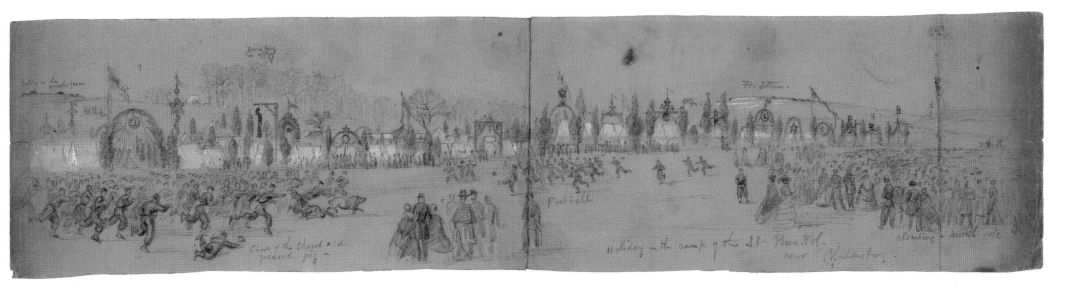

Alfred Waud, *Holiday in the Camp of the 23 Penn. Vol. near Bladensburg,* ca. December 25, 1861, Library of Congress.

by Leon Coignet. Five years later, Homer made a postwar pilgrimage to Paris to study art.

Alf Waud finished out the year sketching varied subjects as the armies in Virginia lay dormant. On December 9, the *News* published his sketch of the Potomac blockade established by the rebels. Waud noted, "Schooners and oyster boats run the blockade with cool effrontery, the rebels never having hit one yet."[44] In late December he made sketches (published early in the New Year) of the Lincoln Cavalry Regiment in winter camp, and wrote:

> The Lincolnites are no exception to the general rule, and have raised any quantity of bough huts to stable their horses, and for occasional shelter for themselves, when not in the tents. Very interesting it is to watch the smiths and barriers in their military dress covered by an ample apron in the chequered light cast by the trees, working merrily at the army forges making the sparks fly and the woods ring by the stout blows of their hammers. A Landseer could find subjects enough in this camp to fill an album. The men are somewhat in want of new uniforms, but that makes them only the more picturesque.[45]

The coming campaigns would bring new scenes for Waud and his fellow artists in the field, scenes less fit for Landseer than for Goya.

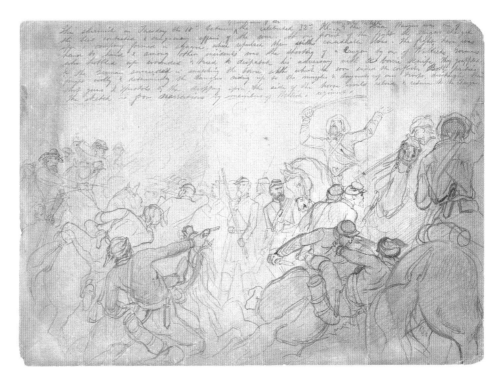

Frank Schell, *Skirmish with the Texas Rangers on Tuesday the Eighteenth,* December 18, 1861, courtesy of the Becker Collection, Boston, MA.

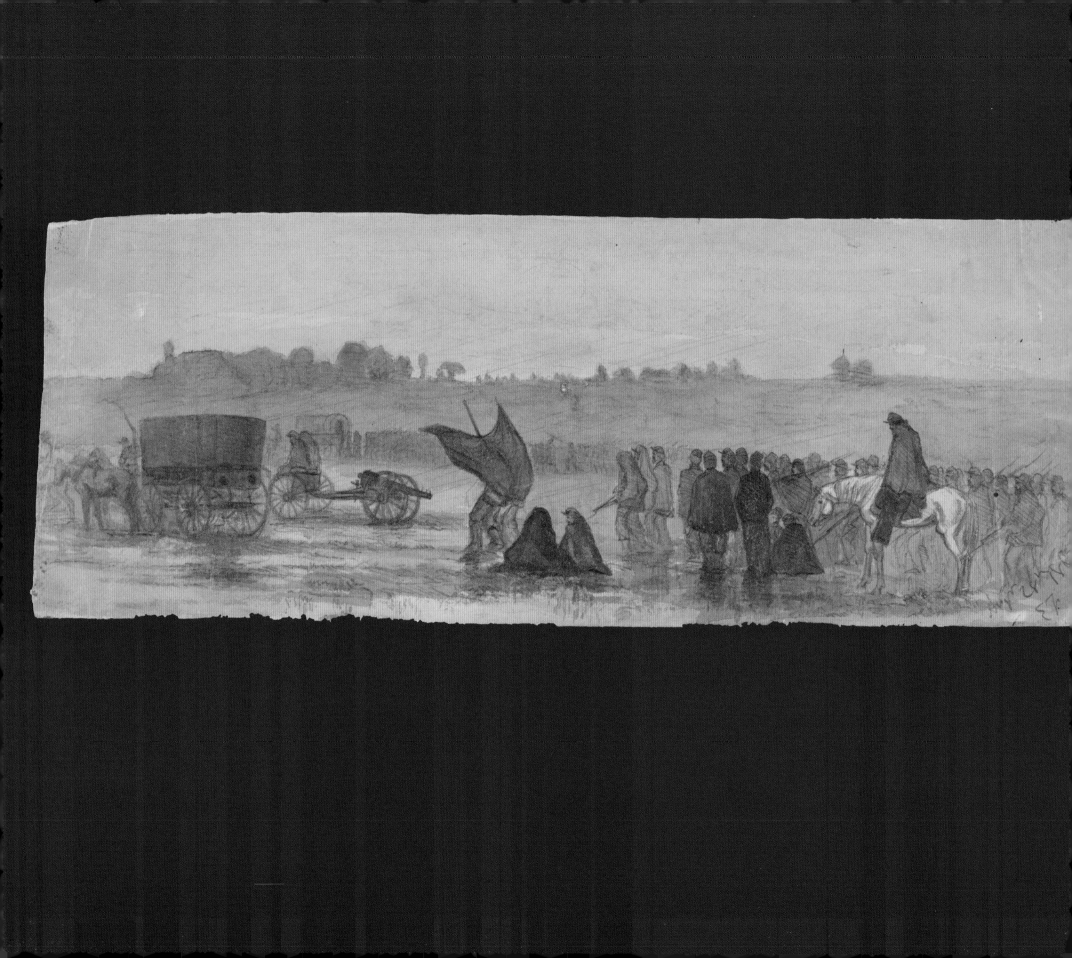

Glory No More

The war's second year opened slowly as the armies emerged from winter camp in anticipation of spring campaigns. The illustrated newspapers had bolstered their corps of Specials for the coming campaigns. *Harper's* made the most gains over the winter. In February, the journal debuted its newest acquisition, Alf Waud, hired away from the *New York Illustrated News*. Waud's first published sketch for the paper, an illustration of an attack on a party of Texas Rangers in Occoquan, Virginia, appeared on February 15. The following week's edition reproduced his satiric ode to *King Mud in Camp, or WHY THE ARMY OF THE POTOMAC DOESN'T MOVE.* The editors noted:

> The Army of the Potomac is literally stuck in the mud, and no one attempts loco-
>
> motion unless obliged. Those who think it as much as life is worth to get the feet

Edwin Forbes, *Retreat of the Army of the Rappahannock (Gen. Pope) to Groveton, Manassas Junction,*
August 28, 1862, Library of Congress.

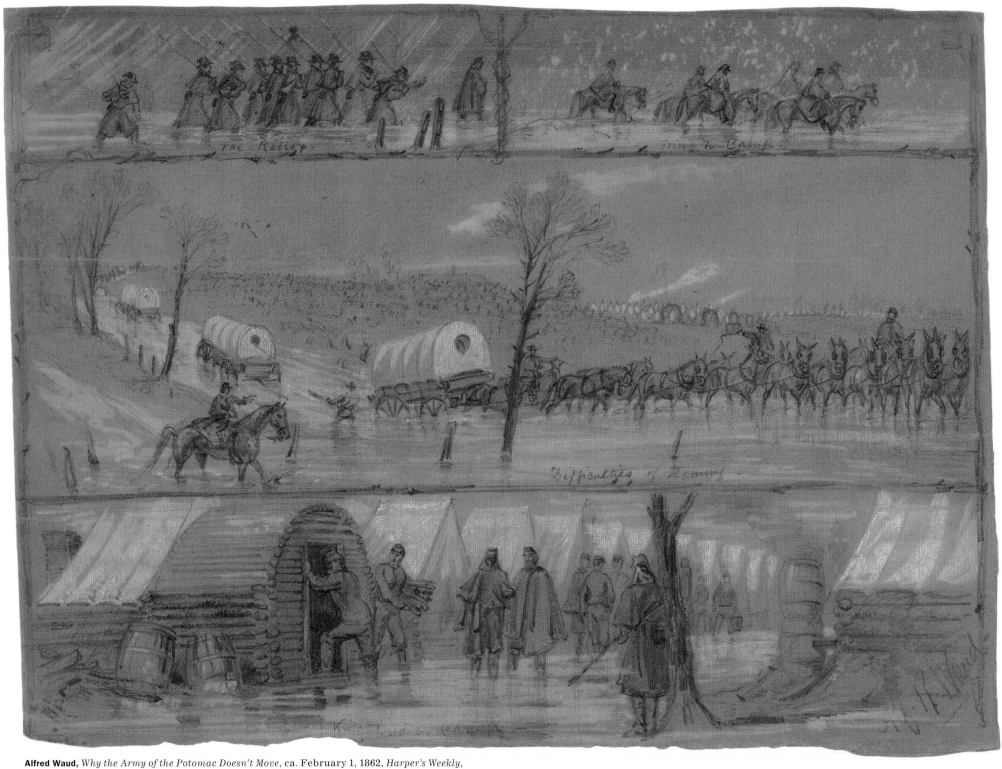

Alfred Waud, *Why the Army of the Potomac Doesn't Move,* ca. February 1, 1862, *Harper's Weekly,* February 22, 1862, Library of Congress.

wetted should see how little difference it makes to the soldier. When he steps out of his tent at reveille, it is to sink at each step half-way to his knees in liquid mud; and from that time till tattoo is sounded he has to get along as well as he can with wet boots.[1]

Waud traveled with the Army of the Potomac in Virginia. Alex Simplot followed Grant while Henry Mosler chronicled General Don Carlos Buell's activities in Kentucky. Theodore Davis stuck with Brigadier General Thomas W. Sherman on the Savannah River and Angelo Wiser accompanied General Burnside's naval expedition moving on Roanoke Island. Homer's sojourns to the front were irregular and periodic. Along with employing all of these Specials in the field, *Harper's* also hired Thomas Nast, primarily employing his skills as a "Home Artist" and editorial cartoonist. The journal further supplemented its Specials with numerous "occasional and volunteer correspondents in the Army and Navy."[2] One contributor, Sergeant J.F.E. Hillen, color-bearer for the Thirty-fourth Ohio Volunteers, provided a sketch in January of a skirmish in Western Virginia and soon found employment as a sketch artist with the *New York Illustrated News*, which had found an able replacement for Alf Waud in new hire Arthur Lumley, lured away from *Frank Leslie's*.[3]

Leslie's remained a pictorial juggernaut with artists seemingly in every field and theater of war. The loss of Lumley was a blow, but the paper carried on. W. R. McComas covered the campaign in Kentucky, while Frank Schell witnessed Gen-

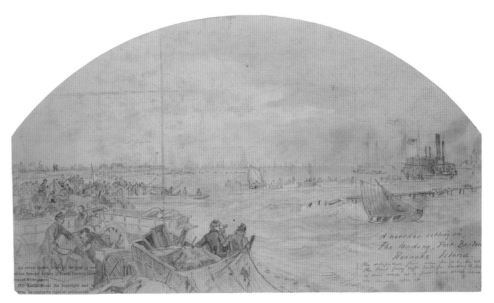

Frank Schell, *A Norther Settling In. The Landing. Fort Barton, Roanoke Island*, ca. March 1862, Print Collection, Miriam and Ira D. Wallach Division of Art, Prints and Photographs, the New York Public Library, Astor, Lenox and Tilden Foundations.

eral Burnside's and Flag Officer Louis M. Goldsborough's victorious combined naval and ground assault on Roanoke Island, Virginia, in February. In fact, Schell became an active participant. On March 1 the journal quoted correspondence from the *Philadelphia Inquirer*:

> **We have had occasion to remark that the life of a "Special Artist" is one not of adventure alone, but often of peril** . . . Pushing forward in advance of the troops, who were occupied with the 2,000 and odd prisoners in their hands, Mr. Bently, of the Philadelphia *Inquirer*, in company with Mr. Schell, the artist of *Frank Leslie's Illustrated Newspaper*, reached Fort Huger, the largest of the three earthworks on the Sound, in advance of the Union forces, and finding the fort deserted, hauled down the rebel flag with his own hands.[4]

The Englishman Frank Vizetelly was also at Fort Huger, having joined Burnside on his voyage down the coast to North Carolina. In two lengthy letters accompanied by sketches published by the *Illustrated London News*, Vizetelly recorded the hazards encountered by Burnside's expedition to Cape Hatteras

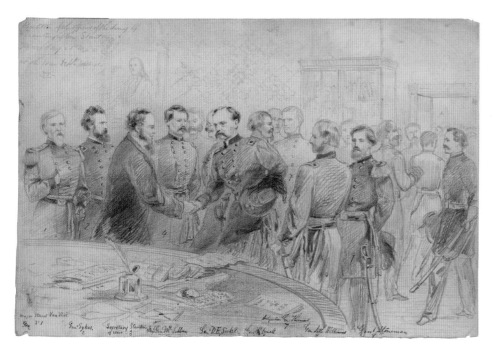

Arthur Lumley, *Reception of the Officers of the Army by Secretary of War Stanton. Monday, P.M. at the War Dept. Washington D.C.*, *New York Illustrated News*, February 8, 1862, Library of Congress.

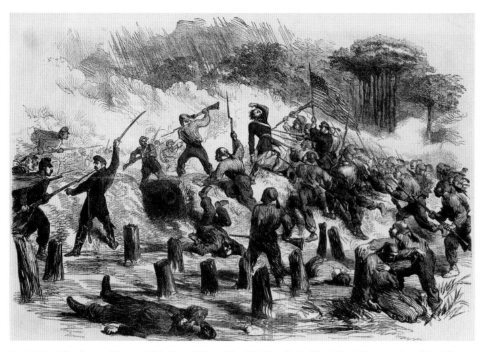

Frank Vizetelly, *General Burnside's Expedition: The 9th New York (Hawkins's Zouaves) and the 21st Massachusetts Taking the Confederate Fieldwork on Roanoke Island at the Point of the Bayonet, Illustrated London News,* March 22, 1862, Library of Congress.

and Roanoke Island. With gripping detail and romantic Victorian flourishes he described ships lost at sea, enemy artillery and measles among the men. The Special added, "I have been here long enough to ascertain one fact, and that is, with a few exceptions, General Burnside is the only competent man in the expedition ... Whenever a ship has been in distress the General has been the first man off to her assistance; and there is not a grade in his army that he has not filled during the last fortnight, so anxious is he for the wellbeing and comfort of his troops."[5] He recounts the Union strategy to take Roanoke Island, capture New Berne and ultimately Raleigh, North Carolina, with the intention of cutting off Confederate troops in Northern Virginia from sources of food, supplies and reinforcements. He speculates that news of Union advances in Kentucky and Georgia might augur "tidings of the last of the Confederate States' Government."[6] The Federal victory at Roanoke Island prompted Vizetelly to write, in a letter dated February 28 and published in the *Illustrated London News* of March 22:

> I am no 'Sir Oracle,' so I will not attempt to prophesy a triumph for the Federalists; but, seeing the improved condition in the morale of the Union forces, and feeling somewhat competent to give an opinion, I am

inclined to believe that these first successes are not to be their last. I have watched the Northern army almost from its first appearance in the field. I have seen it a stripling, and known it in its hobedeyhoyhood the prey of bullying politicians, who by their pernicious counsels are responsible for its earliest defeats. I now see it arrived at man's estate, and it should or ought to achieve for itself an honourable future.[7]

In the glow of victory, for the first time, Vizetelly suggests a growing respect for the Union Army, if not the Lincoln Administration, and a sense that the South is in for a fight.

On the Tennessee River in February combined Union forces led by Commodore Andrew Foote and General Ulysses S. Grant showed their mettle, first taking Fort Henry and subsequently storming Fort Donelson to capture the garrison and secure the state of Kentucky and precious transportation routes west for the Union. *Harper's* artist Alex Simplot and *Leslie's* Special Henri Lovie sketched in the midst of the action. They drew the battles from numerous vantage points—from the gunboat decks, on shore and inside the forts—giving readers a kaleidoscopic view of the fighting. On March 15, *Frank Leslie's* issued their self-proclaimed "first double number of an Illustrated Newspaper ever published in America," filled with views of the victories in the west. The edition boasted:

> *2,600 Square Inches, or 20 Square Feet!*
> All drawn and engraved within four days!
> The amount of paper used in the first edition of this number exceeds
> *Twenty-one Tons!*
> Printed on NINE Mammoth Cylinder Presses![8]

Harper's Weekly countered one week later, printing a notice listing their impressive Specials, and citing a weekly circulation in excess of one hundred twenty thousand copies. *Harper's* and *Leslie's*, each coveting the growing audience for battle pictures, engaged in a marketing and circulation war as vigorous as the conflict they covered.[9]

The battles for Roanoke Island and the Tennessee River forts proved tune-ups for main events to come in the eastern and western theaters of war. The Battle of Shiloh in southwestern Tennessee along the Tennessee River in early April proved the war's first major, multiday epic bloodletting, with casualties on both sides exceeding twenty thousand, beyond anything experienced in the war, or, in fact, American history, to date. *Leslie's* artist Henri Lovie with General Grant's army was the only Special on hand throughout the fight. *Harper's*

Alexander Simplot, *Sketch Map of Battle of Island #10*, February 1862, Wisconsin Historical Society, Image ID #32926.

sketcher Alex Simplot had moved to the Mississippi River with Commodore Foote, laying siege to Island No. 10. His *Harper's* colleague Henry Mosler and fellow *Leslie's* artist W. R. McComas arrived at Shiloh with General Buell the second day, April 7, to reinforce Grant. In his war career Lovie produced numerous memorable drawings of scenes, incidents, locations and locales, but his Shiloh sketches rise above them all.[10]

After Shiloh, Grant moved on to Corinth, Mississippi, in support of General Henry Halleck, who took the crucial railroad center, and Lovie moved with him. In the east, readers followed administrative shuffling in the Union military hierarchy as President Lincoln, frustrated by failure, inaction and infighting, stripped General George B. McClellan of overall command of the Northern armies, replaced him with Halleck and limited his command to the Army of the Potomac with orders to advance upon Richmond.

The southeast theater remained active in the papers as Frank Schell operated in North Carolina while William T. Crane continued his coverage from South Carolina. William Waud brilliantly illustrated the Union capture of New Orleans by combined forces under Admiral David Farragut. Waud's series of sketches followed Farragut's flotilla up the Delta and into the city. *Harper's* unnamed Special on the spot recorded the scene from a Union gunboat:

> After dark I went on deck to see New Orleans by gaslight. How changed the scene! A little over twelve months ago miles of shipping lined the levee; the buildings hid behind the forests of masts and rigging of vessels bearing the banners of all nations of the world. None were here now. The busy hum of workmen and the cheery song of the sons of Africa, who worked at night, was not to be heard. No hissing puff of steamers going and coming to and from the cities on the banks of this great river. No ships—no signs of life were present now. A few gaslights were burn-

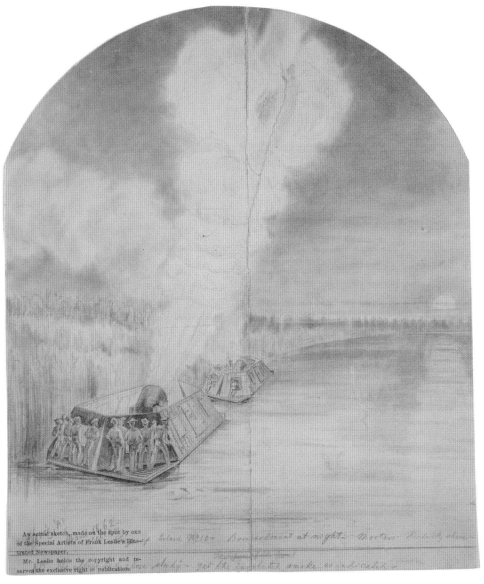

Henri Lovie, *Siege of Island No. 10. Bombardment at Night, Mortars, Kentucky*, March 18, 1862, *Frank Leslie's Illustrated Newspaper*, April 5, 1862, Print Collection, Miriam and Ira D. Wallach Division of Art, Prints and Photographs, the New York Public Library, Astor, Lenox and Tilden Foundations.

ing along the levee, and the dull embers and heavy smoke gave proof of a reign of anarchy and terror. The buildings were wrapped in a sombre light, and we felt that it was a city clothed in sackcloth and ashes.[11]

News of Farragut's capture of New Orleans had shouldered its way between accounts of Grant's victories along the Tennessee River. In turn, pictorial cover-

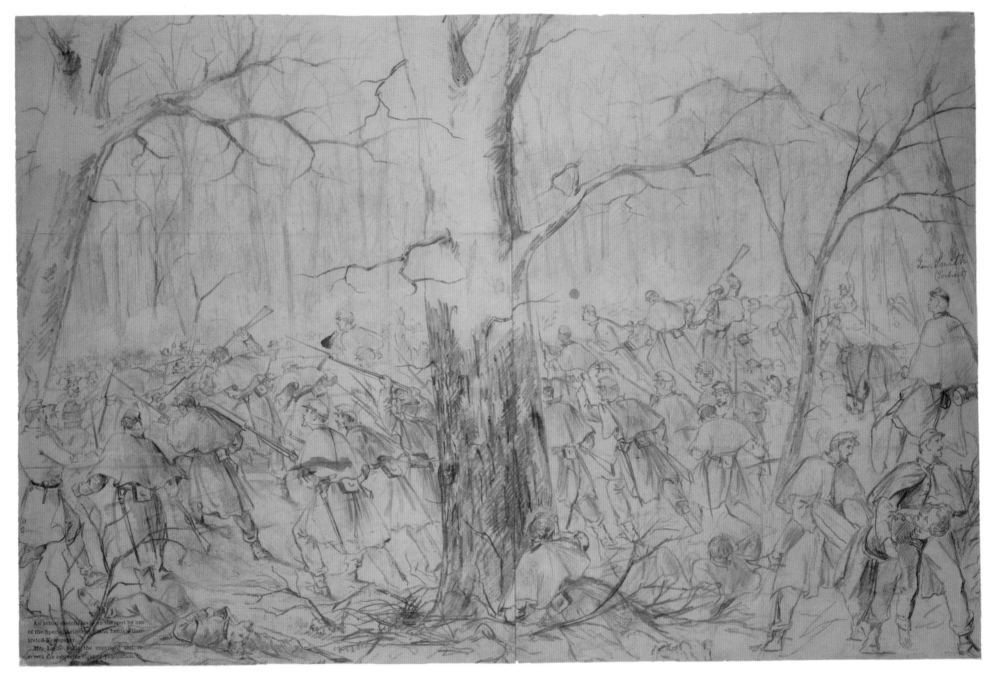

Henri Lovie, *The Iowa 2nd Regiment Storming the Rebel Entrenchment at Fort Donelson, Febr. 15th, 1862. Gen. Smith on Horseback,* Frank Leslie's Illustrated Newspaper, March 15, 1862, Print Collection, Miriam and Ira D. Wallach Division of Art, Prints and Photographs, the New York Public Library, Astor, Lenox and Tilden Foundations.

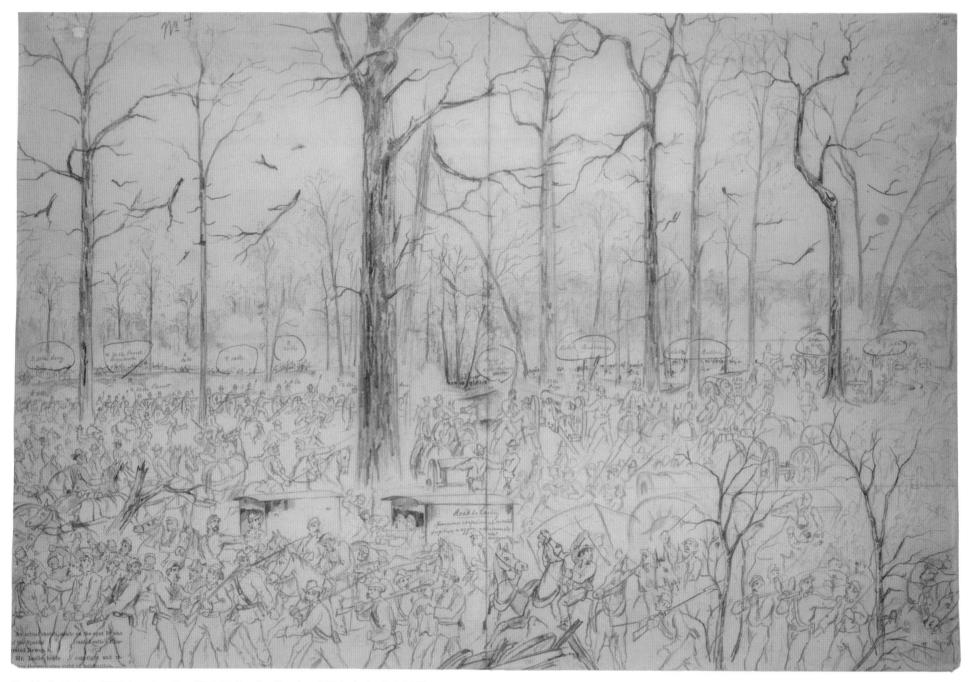

Henri Lovie, *Battle of Pittsburg Landing (Shiloh), Sunday Evening, 6 O'clock,* April 6, 1862,
Frank Leslie's Illustrated Newspaper, May 17, 1862, the New York Public Library, Astor, Lenox
and Tilden Foundations.

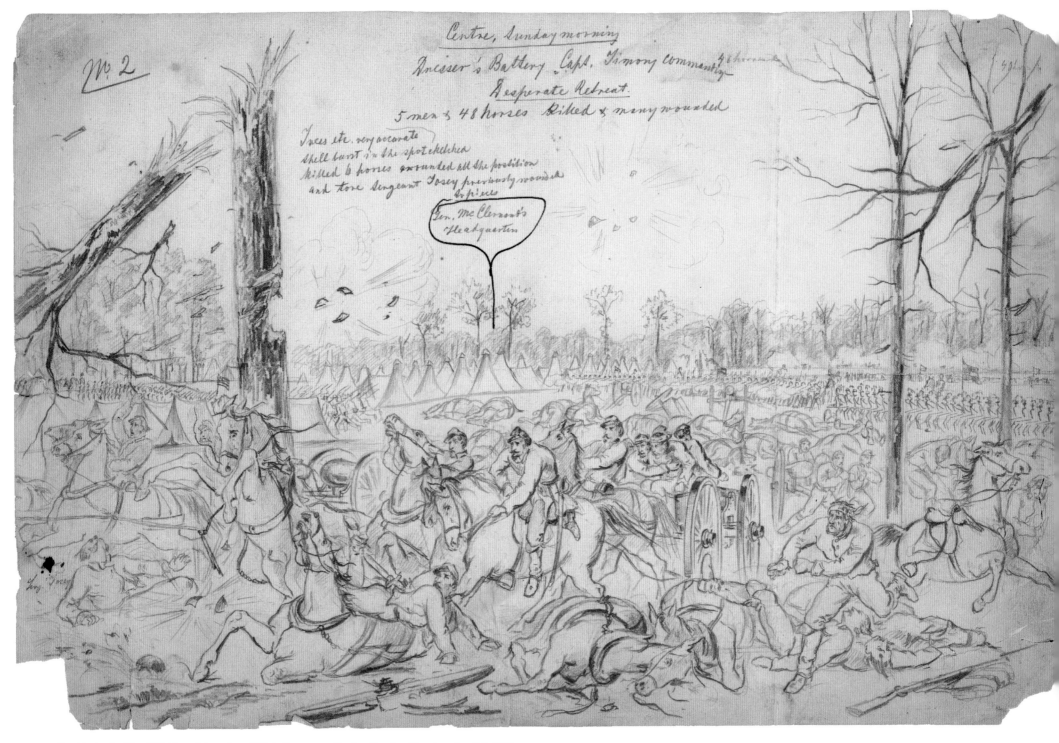

Henri Lovie, *Battle of Pittsburgh Landing, Shiloh, Tennessee: Centre, Sunday Morning,* April 6, 1862,
Frank Leslie's Illustrated Newspaper, May 17, 1862, courtesy of the Becker Collection, Boston, MA.

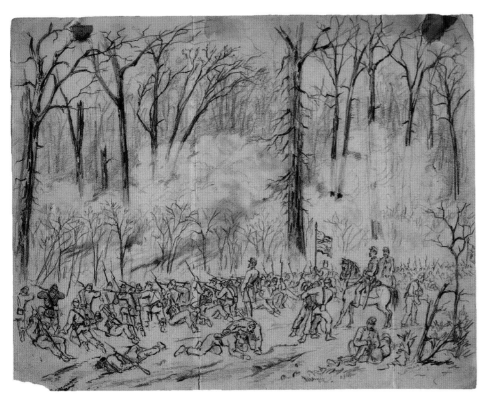

ABOVE: **Henri Lovie,** *Battle of Pittsburgh Landing, Shiloh, Tennessee: Left Wing near the Peach Orchard,* April 6, 1862, *Frank Leslie's Illustrated Newspaper,* May 17, 1862, courtesy of the Becker Collection, Boston, MA.

RIGHT: **William Waud,** *Our Artist Aloft Our Special Artists, Mr. W. Waud, Sketching the Naval Engagement between the Federal Fleet and the Rebel Forts, Rams and Gunboats, in the Mississippi River, from the Foretop of the U.S. War Steamer Mississippi, Commander Melancthon Smith,* Frank Leslie's Illustrated Newspaper, May 31, 1862, image provided courtesy of HarpWeek.

age of McClellan's much anticipated, and much demanded run toward Richmond soon subsumed pictorial coverage of the war in the west. In what was called the Peninsula Campaign, McClellan commenced his move by landing an amphibious force at Fortress Monroe on the James River southeast of the Confederate capital. Gathering, and worse crediting, faulty intelligence that he faced superior forces, he stayed put for weeks on end, allowing Confederate generals Johnston, Lee, Jackson and Stuart to literally run circles around his immobile troops. Following a series of humiliating stunts, raids, encounters and defeats at the hands of the rebel generals, McClellan's run slowed to a crawl and, finally, a tortuous withdrawal. Months into the campaign soldiers were dropping by the score on either side, felled by combat or disease, with no progress and no end in sight. By

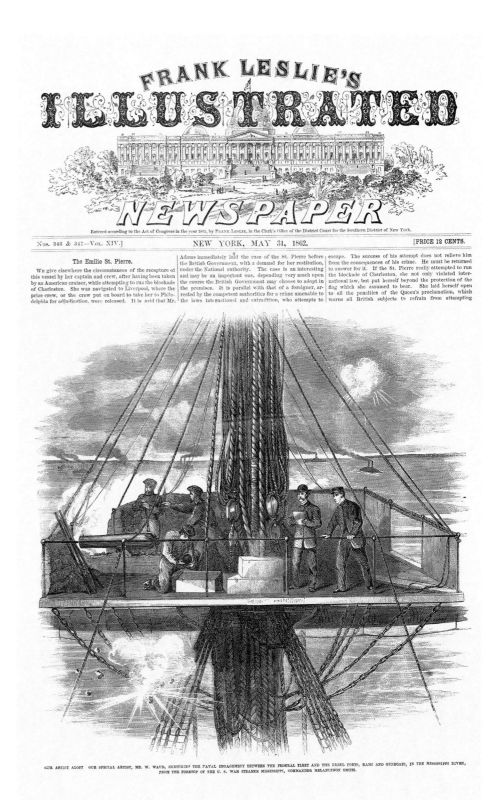

William Waud, *The United States Fleet Coming to Anchor in front of the City of New Orleans,* ca. April 1862, Print Collection, Miriam and Ira D. Wallach Division of Art, Prints and Photographs, the New York Public Library, Astor, Lenox and Tilden Foundations.

summer 1862 it was clear, to the artists at least, that the sporadic, tentative fighting of 1861 had given way to a new kind of warfare. On either side, the idea of a quick victory or end to conflict was soon laid to rest; the sketch artists witnessed this new level of death and destruction.

During the Peninsula Campaign, Arthur Lumley seemed ubiquitous for the *New York Illustrated News.* He joined scouting expeditions, sketched scenes in and around Fortress Monroe, illustrated such innovations as Union military signal stations, even ascended to one thousand feet in a hydrogen balloon with federal aeronaut Professor T.C.S. Lowe to perform aerial reconnaissance and sketch

a bird's-eye view of the battlefront. Edwin Forbes debuted as a Special for *Harper's Weekly* in April. Sketches by Alf Waud and Winslow Homer, now united on the *Harper's* staff, were combined to create a double-page spread of images, *Our Army Before Yorktown,* in the May 3 edition. Both artists presumably felt cheated; we know Homer did. He had submitted numerous sketches to be published as individual images and was dismayed to find that Fletcher Harper had used his drawings as vignettes on a page, forcing him to share credit and payment with Waud.[12]

In *Leslie's* May 17 issue, Lumley contributed an ode to the "news boy," celebrating the lowliest rung in journalism:

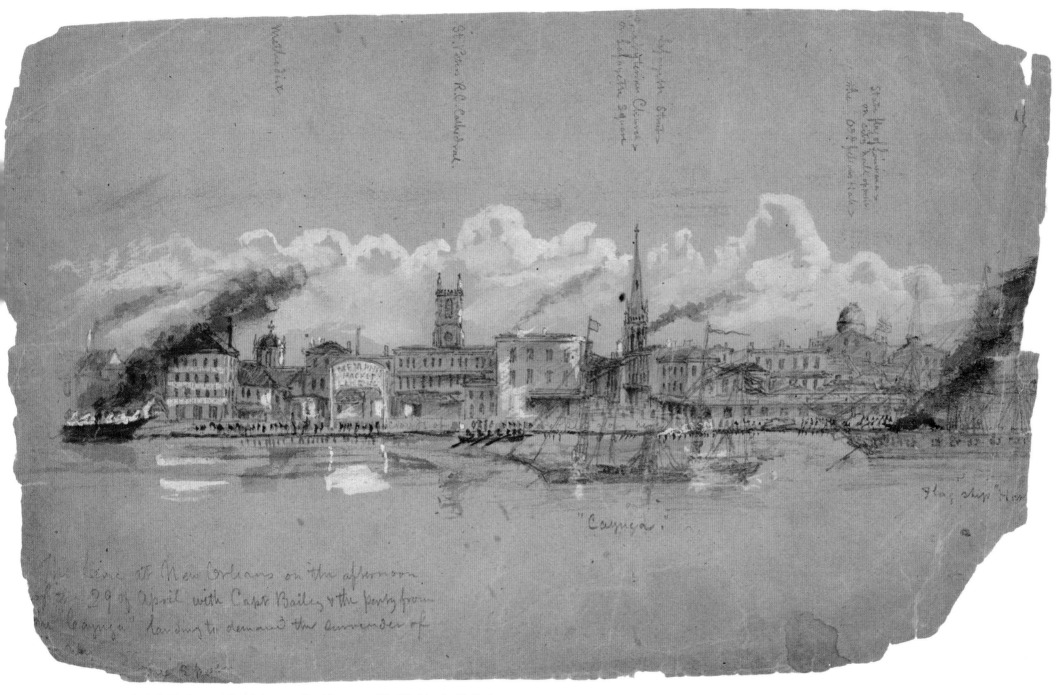

William Waud, attributed, *The Levee at New Orleans on the Afternoon of the 29 of April with Capt. Bailey and the Party from the "Cayuga" Landing to Demand the Surrender of the City,* April 29, 1862, Collection of the New-York Historical Society.

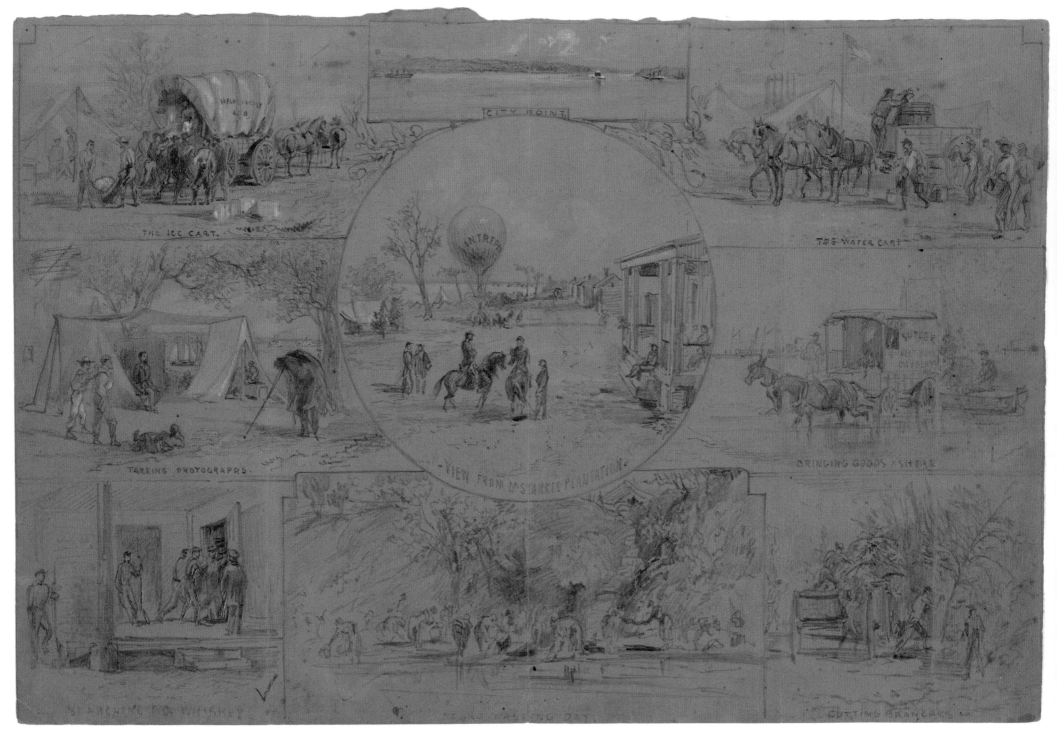

Arthur Lumley, *Life in Camp [Nine Camp Scenes],* ca. August 1862, Library of Congress.

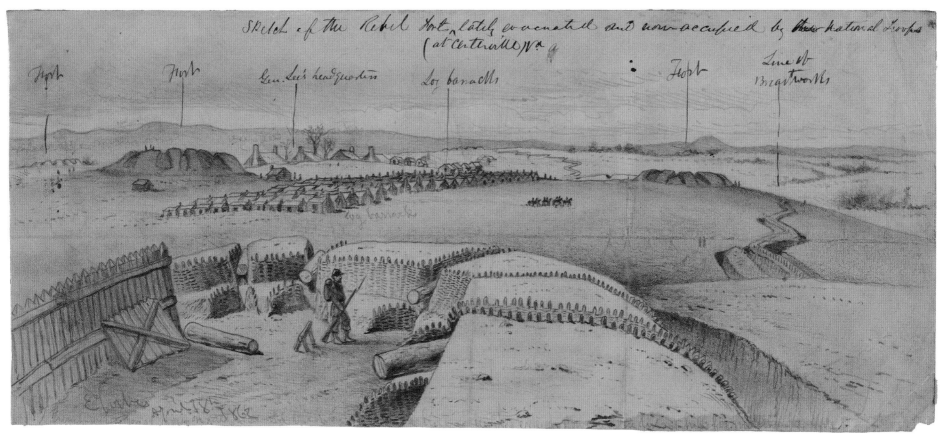

Edwin Forbes, *The Defenses of Centreville*, April 18, 1862, Library of Congress.

THE NEWS BOY AT
CAMP WINFIELD SCOTT. NEAR YORKTOWN.

Our special artist says:—The news boy has just arrived in camp, and there is no one more universally welcomed, and no one more cheerful than he is with the prospect ahead; there is a ready sale for all the papers his poor horse could carry from Cheaseman's landing, seven miles distant; through swamps and over flexible corduroy [log] roads the difficult task is accomplished; he knows well he is first on the ground, before any opposition arrives, and trusts always to his Yankee ingenuity.[13]

Besides submitting these side stories, Lumley focused on the action. His cover sketch for May 24, *Dashing Charge of the Hawkins' Zouaves on a Masked Battery*, depicts hand-to-hand combat with startling reality.

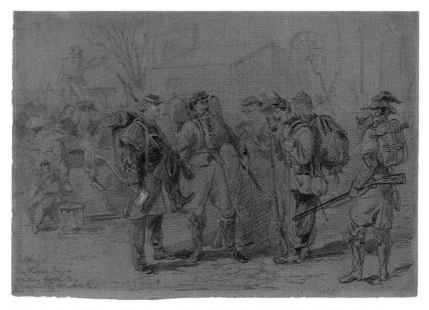

Arthur Lumley, *Soldiers of Gen Augurs Brigade Waiting for the Cars to Take Them to Uptons Hill, Va. Their Old Camp*, ca. 1862, Library of Congress.

Winslow Homer

Winslow Homer's appearance in Yorktown at this time adds a new dimension to the work of the Specials during the war. Homer was of them but apart. He brought a different sensibility to the front, his sketches being more allegorical and artistic in nature than those of his contemporaries; his eye was cast on a farther star. Homer began his career in Boston as a lithographer's apprentice, turning out comic sketches and commercial illustrations. Chafing under the restrictions imposed by his lowly status, copying other artists' work or producing generic images, Homer aspired to create original work. He soon found his opportunity as a sketch artist in the mid-1850s, first for *Ballou's Pictorial Companion*, the Boston-based successor to the nation's first successful illustrated weekly and, beginning in 1857, *Harper's Weekly*.

Although Homer's work appeared in *Harper's* only intermittently, he soon became one of the magazine's most recognizable illustrators, known for his signature bold style, engaging artistry, energized street scenes and light-hearted genre studies. He appeared at the front on assignment for *Harper's* initially in fall 1861 but the full weight of his talent and individuality emerged in spring 1862 when he traveled to Yorktown, Virginia, to sketch McClellan's Army of the Potomac during the Peninsula Campaign.

At Yorktown and elsewhere that spring, Homer created numerous images of interest. While Alf Waud and other war illustrators drew what they saw with an eye toward realism and accuracy, Homer created pictures with subtlety and depth. His celebrated image of a lone sharpshooter aiming at the enemy from a treetop, for example, has been interpreted as a menacing portrayal of a new type of military monster: an anonymous, cold-hearted, inhuman killer hiding among the branches, a product of man's modern mechanistic war-waging. Late in life Homer recorded his impression of Civil War snipers "as being as near murder as anything I ever could think of in connection with the army & I always had a horror of that branch of the service."[14] By contrast, his boldly drawn, beautifully rendered camp scenes and portraits are full of animated life, portraying the camaraderie and transcending the drudgery of daily military existence. His charcoal sketches of individual soldiers are immediate, intensely individual and universal. He drew children in and around war, with grace and sensitivity.

Homer remained at the front for several weeks in spring 1862, as a freelance illustrator now on contract rather than salary with *Harper's*, but he suffered from illness and the restrictions imposed by military life. He brought remarkable verve to such illustrations as *A Bayonet Charge* and *The Surgeon at Work*, but reacted angrily to the suppression in April of *Harper's Weekly* by the Union Army. Secretary of War Edward Stanton approved this censorship of the pictorial press in response to fears that the artists' sketches provided too much military information to the enemy. Homer presumably agreed with the sentiments of his employers as expressed in the May 17 issue of *Harper's*:

> We need hardly remark that seizures of this journal at particular points involve no pecuniary injury to us. Not a single copy of *Harper's Weekly* goes to Fortress Monroe, for instance, which has not been paid for in advance, with the exception of copies which we send gratuitously to regiments, officers, or soldiers in the army. To seize this journal, therefore, is merely to rob our gallant troops of property which belongs to them.[15]

In addition, according to his mother, Homer "suffered much," during the campaign, "was without food 3 days at a time & all in camp either died or were carried away with typhoid fever. . . . He came home so changed that his best friends did not know him."[16]

Along with his *Harper's* sketches, Homer created a few commercial portfolios of comic war illustrations. His later studies, however, are darker, more somber and serious, without the insouciant liveliness evident in his early Yorktown sketches and comic drawings. In *Three Days On the Battlefield*, and his Pieta-like sketch of a wounded soldier given water by a comrade, he achieves the gravitas that infused his later works. His use of colored paper and opaque highlights lends monumentality and depth to his work. The only other artists in the field employing those technical and stylistic tools included the three Englishmen Alf and Will Waud and Frank Vizetelly. Alf Waud shared studio space with Homer in Boston in the late 1850s. No doubt Homer benefited from techniques he learned from the older, veteran artists in the field. Unlike most of his colleagues, Homer had higher ambitions than a career in illustration. As Homer specialist David Tatham concludes, he found his role as a pictorial reporter in conflict with his emerging self-image as a fine artist.[17] His postwar paintings are marked by a ferocious humanity and masterful juxtaposition of allegory and actuality. His experiences at the front beginning with the Peninsula Campaign in spring 1862 helped shape his career, the power of his greatest works, and ultimately his reputation as one of America's most influential fine artists. Among the Specials, Homer was unique, and walked a different path.

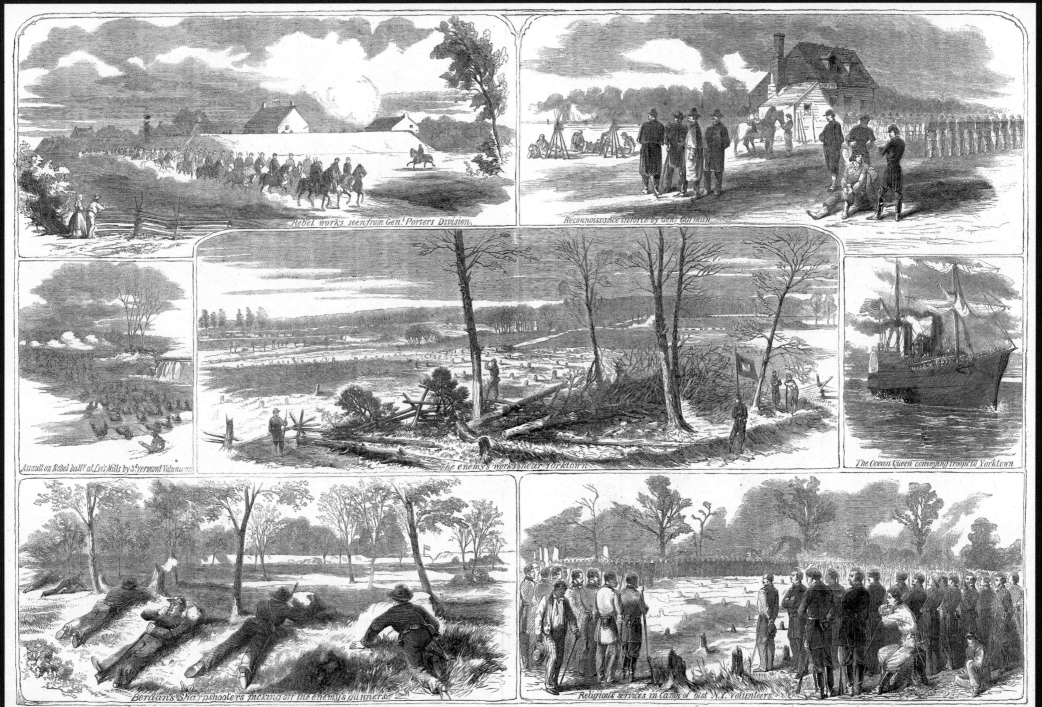

Rebel works seen from Genl Porters Division.

Reconnoissance in force by Genl Gorman

Assault on Rebel batty at Lee's Mills by 3d Vermont Volunteers

The enemy's works near Yorktown

The Ocean Queen conveying troops to Yorktown

Berdan's Sharpshooters picking off the enemy's gunners.

Religious services in Camp of 61st N.Y. Volunteers.

OUR ARMY BEFORE YORKTOWN, VIRGINIA.—From Sketches by Mr. A. R. Waud and Mr. W. Homer.—[See Page 283.]

Winslow Homer and Alfred Waud, *Our Army before Yorktown*, ca. April 1862, *Harper's Weekly*, May 3, 1862, image provided courtesy of HarpWeek.

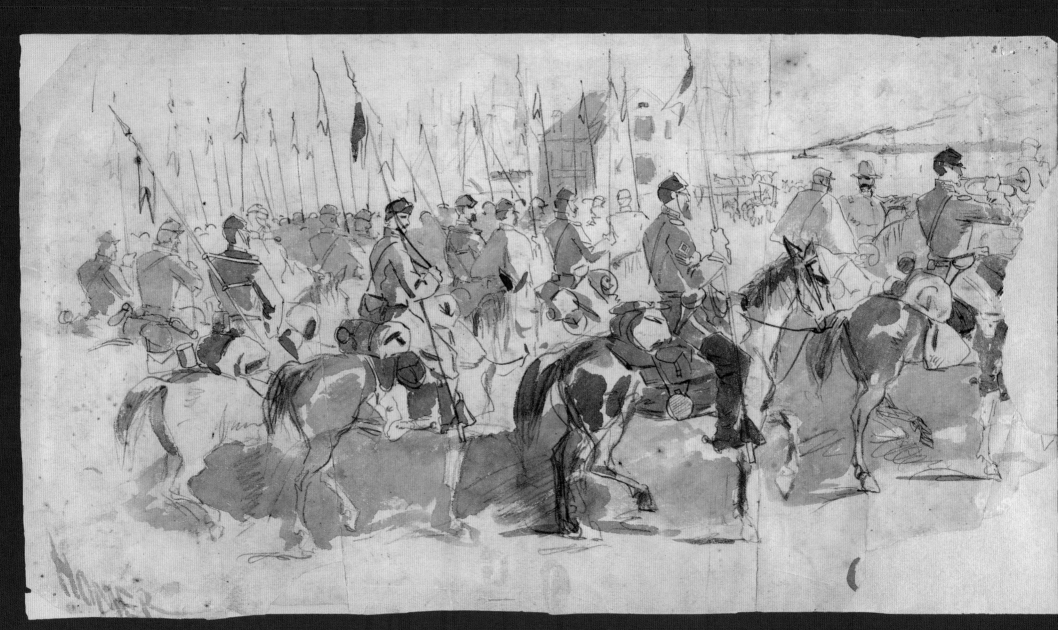

Winslow Homer, *General McClellan's Sixth Pennsylvania Cavalry Regiment Ready to Embark at Alexandria for Old Point Comfort*, ca. 1862, Cooper-Hewitt, National Design Museum, Smith-

ABOVE LEFT: **Winslow Homer,** *Soldier Taking Aim*, 1864, John Davis Hatch Collection, Avalon Fund, image courtesy of National Gallery of Art, Washington.

ABOVE RIGHT: **Winslow Homer,** *Zouave*, ca. 1864, John Davis Hatch Collection, Avalon Fund, image courtesy of National Gallery of Art, Washington.

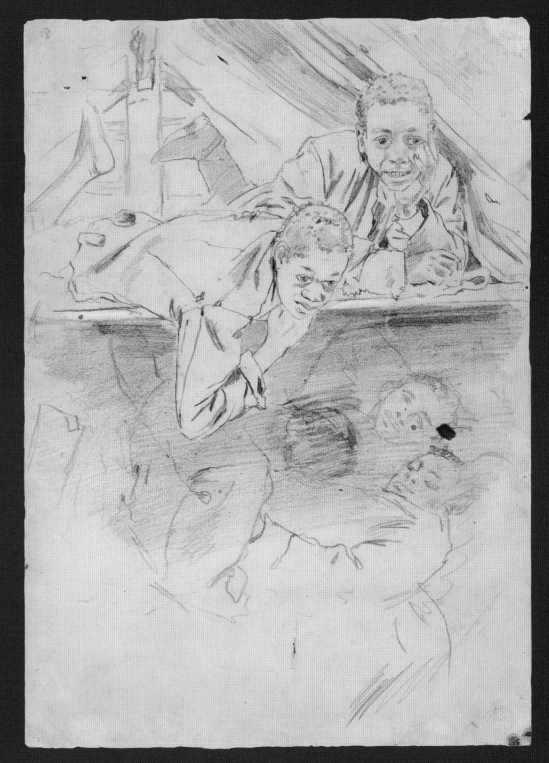

Winslow Homer, *Study for Army Boots* (verso), 1865, gift of Dr. Edmund Louis Gray Zalinski, II, image courtesy of National Gallery of Art, Washington.

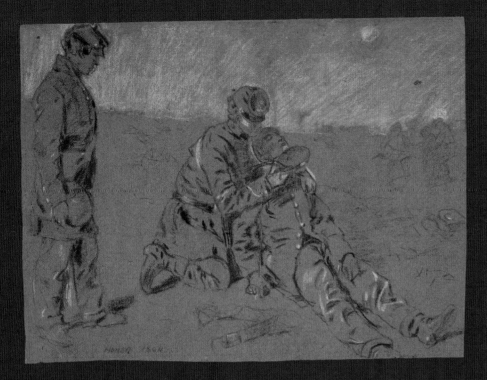

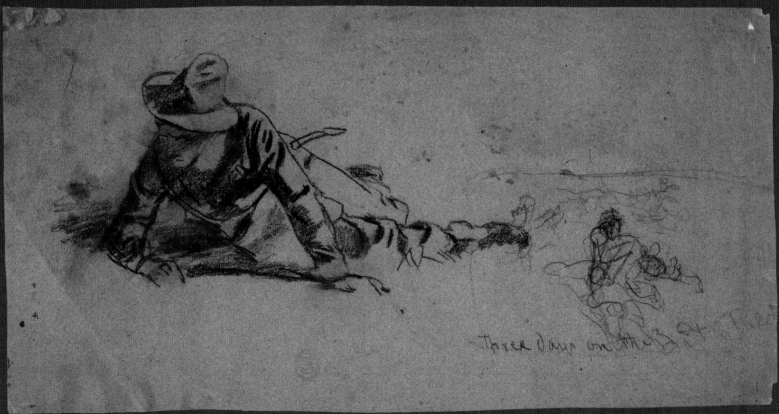

ABOVE LEFT: **Winslow Homer,** *Wounded Soldier Being Given a Drink from a Canteen,* ca. 1864, Cooper-Hewitt, National Design Museum, Smithsonian Institution / Art Resource, NY.

ABOVE RIGHT: **Winslow Homer,** *The Army of the Potomac—a Sharp Shooter On Duty,* Harper's Weekly, November 15, 1862, image provided courtesy of HarpWeek.

LEFT: **Winslow Homer,** *Three Days on The Battlefield,* ca. 1862, Cooper-Hewitt, National Design Museum, Smithsonian Institution / Art Resource, NY.

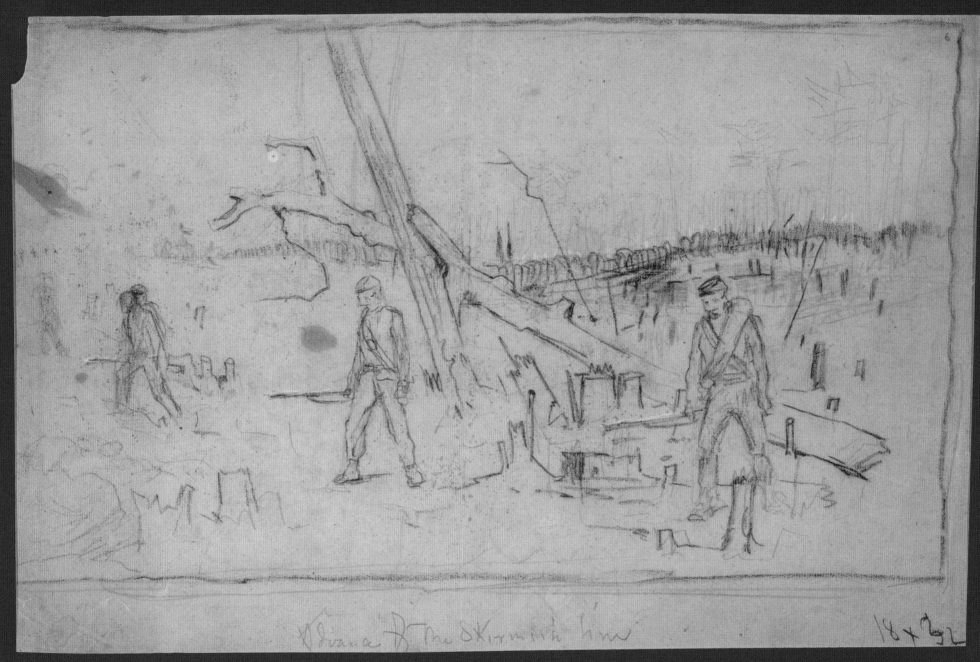

Winslow Homer, *Advance of the Skirmish Line*, ca. 1867, gift of Dr. Edmund Louis Gray
Zalinski, II, image courtesy of National Gallery of Art, Washington.

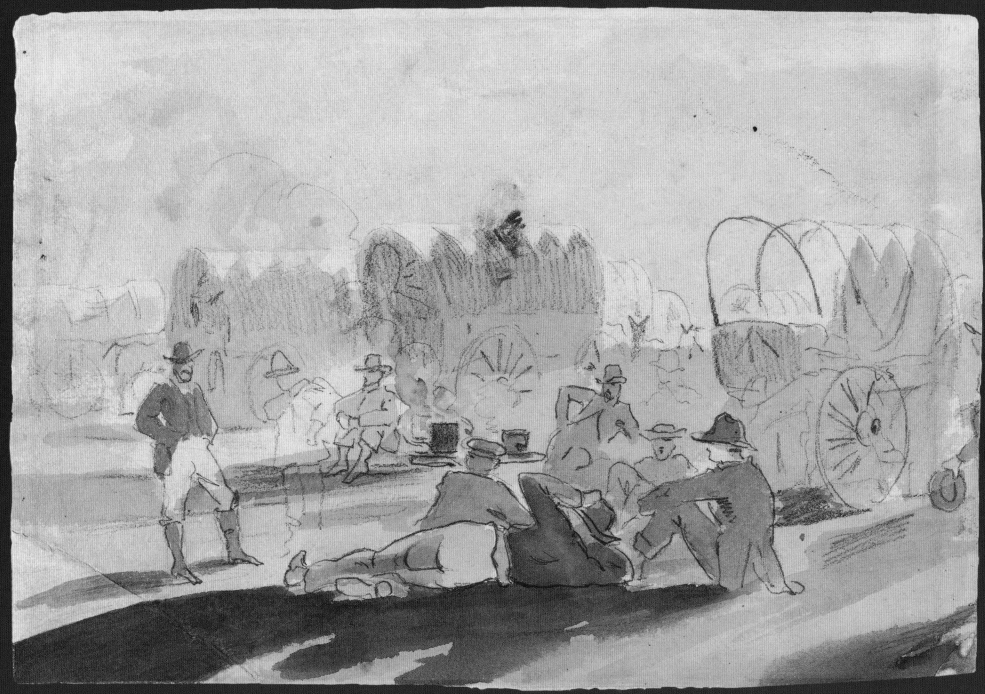

Winslow Homer, *Caravan with Covered Wagons* (recto), ca. 1862–1865, gift of Dr. Edmund Louis Gray Zalinski, II, image courtesy of National Gallery of Art, Washington.

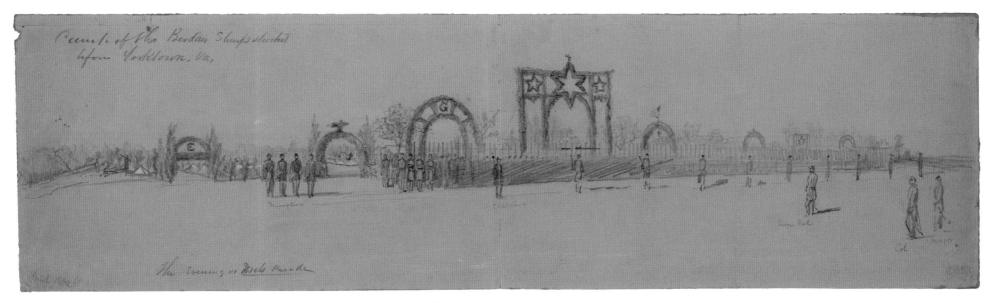

Alfred Waud, *Camp of the Berdan Sharpshooters before Yorktown, Va.,* April 1862, Library of Congress.

The Peninsula Campaign proved a drawn-out affair and the artists suffered with the soldiers. By late spring, the Specials were established in the field and inuring themselves to conditions although many suffered from privation and disease. Alf Waud corresponded with a friend regarding his brother Will, then on assignment with *Frank Leslie's,* who had recently joined him on the front lines:

> He [Will] made sketches and forwarded them of what subjects I do not know as about this time I was down with an attack of the bilious remittent fever brought on by exposure to the damned climate in cussed swamps &c. For a month I could scarcely crawl dosed with mercury quinine iron whiskey &c till I have learned to hate that fluid and cannot smoke without nausea. However I am well and almost as strong as before in which I am lucky, as numbers of the soldiers have died of the same fever. To return to Will—three weeks ago he had a sunstroke and fell insensible to the ground while visiting Sickles Brigade. Since that time he has been sick, a low fever having used him up—a bad thing to have—(I can tell you) a week ago to be sick, was to fall into the hands of the enemy. Will talks of coming home soon, to save his health although he is better than he has been.
>
> To tell the truth, no amount of money can pay a man for going through what we have had to suffer lately, and being to my great astonishment alive, I feel a good deal like leaving myself.[18]

In fact, Alf soon recovered and spent the bulk of the war in the field with the Army of the Potomac. Will also saw the conflict through, occasionally taking time out to rest and recuperate. Edwin Forbes suffered from exposure after the Battle of Cedar Mountain but soon recovered. More often than not, sketch artists came and went, drawn by the excitement of battle, publication and prestige, yet soon sent packing by fear, injury, deprivation or disease. Winslow Homer appeared intermittently at the front for a few weeks or months at a time between 1861 and 1864, while Alex Simplot contributed war pictures to *Frank Leslie's* regularly through 1862 until a chronic case of diarrhea forced his early retirement from the field. Henri Lovie's story is happier: in spring 1863 while covering the Vicksburg campaign he speculated successfully on cotton futures; instantly rich, he walked away from the war and returned home to Cincinnati and a quieter, safer life.

The Specials were not soldiers but they lived, slept and ate among the fighting men. Some had served as soldiers and others were valued in their respective armies for their military minds. Alf Waud, who had fired upon the enemy, never backed down in a confrontation. George Augustus Sala, a prominent British journalist of the period recalled:

> He had been offered, time after time, a staff appointment in the Federal service; and, indeed, as an aide-de-camp, or an assistant quartermaster, his minute knowledge of the theater of war would have been invaluable. Often he had ventured beyond the picket-lines, and been chased by the guerillas; but the speed and mettle of his big brown steed

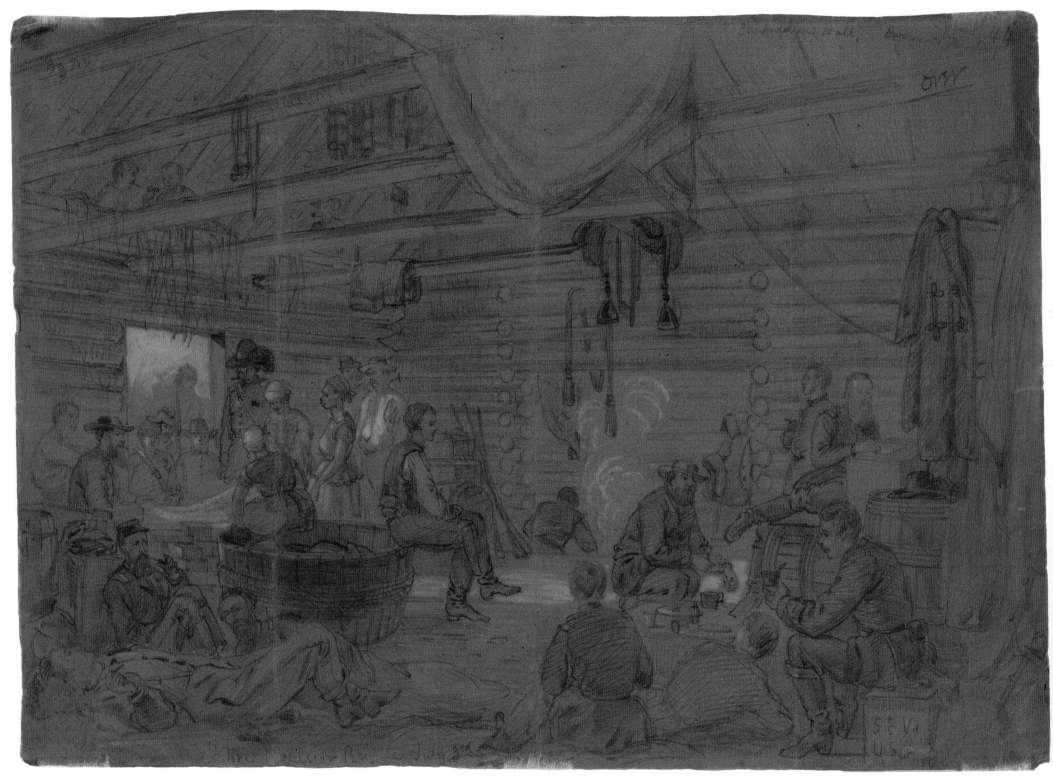

Alfred Waud, *Skedaddlers Hall, Harrisons Landing,* ca. July 1862, Library of Congress.

Alfred Waud, *Lt. Custer Wading in the Chickahominy River*, May 1862, Library of Congress.

had always enabled him to show these gentry a clean pair of heels. He was continually vaulting on this huge brown horse, and galloping off full split, like a Wild Horseman of the Prairie. The honours of the staff appointment he had civilly declined. The risk of being killed he did not seem to mind; but he had no relish for a possible captivity in the Libby or Castle Thunder.[19]

General Meade often favored Waud with requests to sketch rebel defenses and apparently offered special access in return, as Waud noted in a letter from the front published in fall 1863:

> Your artist [Waud] was the only person connected with newspapers permitted to go upon the recent advance to the Rapidan. An order of General Meade's sent all the reporters back. It was a very wet and

Arthur Lumley, *Balloon Reconnaissance on Banks of James River*, ca. July 1862, Print Collection, Miriam and Ira D. Wallach Division of Art, Prints and Photographs, the New York Public Library, Astor, Lenox and Tilden Foundations.

uncomfortable trip part of the time. I did not get dry for two days; and was shot at in the bargain, at Raccoon Ford, where I unconsciously left the cover, and became a target for about twenty sharp-shooters. Luckily I was not touched; but I did some tall riding to get out of the way.[20]

Theodore Davis had also been offered an officer's commission in the Union Army, while Frank Vizetelly apparently carried equal status among C.S.A. military leaders. After all, he had likely seen in Europe and Asia more actual warfare than many of them and his expertise could prove useful in the field.

In July, Lumley returned to Manhattan to recuperate and personally supervise the engraving of his sketches. William Waud filled in at *Leslie's* during his absence, joining his brother Alf for the first time at the front. Alf Waud's sketches from the campaign are as complete as those of any other artist, covering virtually every aspect of the ill-fated Union movement. He drew Union sharpshooters, corduroy roads, rebel rifle pits, and officers lost in the woods.

As the violence escalated, Waud, Lumley and the rest realized that the nature of warfare was changing and their art would have to change with it. The pomp and circumstance of regiments departing for war in 1861 had given way to veterans returning from the field legless and armless. The numbers of casualties,

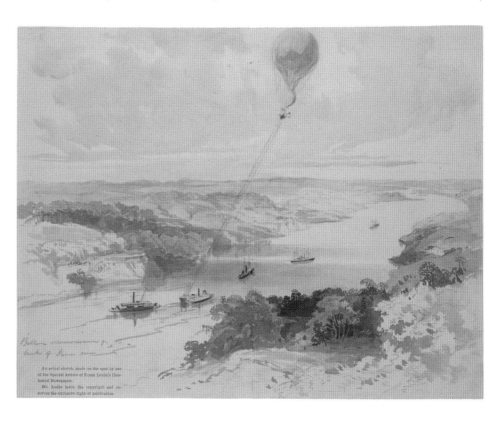

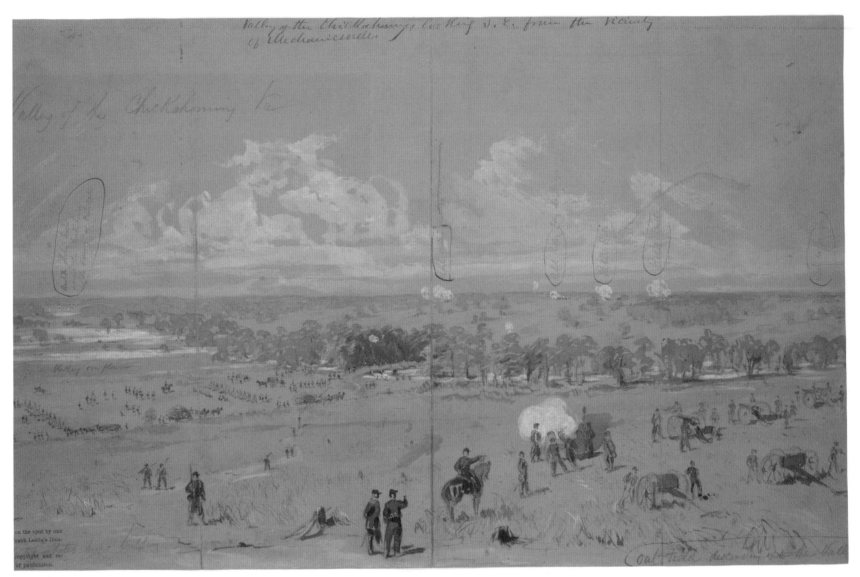

William Waud, *Valley of the Chickahominy, Va. Looking S.E. from the Vicinity of Mechanicsville,* ca. July 1862, *Frank Leslie's Illustrated Newspaper,* July 19, 1862, Print Collection, Miriam and Ira D. Wallach Division of Arts, Prints, and Photographs, the New York Public Library, Astor, Lenox and Tilden Foundations.

dead and wounded, rose rapidly from hundreds to thousands to tens of thousands. Pictures portraying plumed officers on horses bravely leading strong, healthy men arrayed in orderly rows into battle were neither accurate nor realistic. In the letter accompanying his sketch of Kearny's Division at the Battle of the Chickahominy, Waud wrote on June 30:

> In a fight, such as is represented in the picture, it is impossible to get a view of an extended line of battle from any one point. A major-

ity of the battles so far have been of this description, usually termed bushwhacking—very deadly, but hardly affording a chance for a display of tactics. For the rest, the picture describes itself, and gives a good idea of what our soldiers have to stand up to in the Virginia swamps and woods.[21]

Civil War battles were gruesome, clumsy, ugly and vicious affairs often fought for days on large battlefields with vast hosts of combatants. Plumed officers were easy targets and the first to fall, while truly healthy-looking men, given the poor

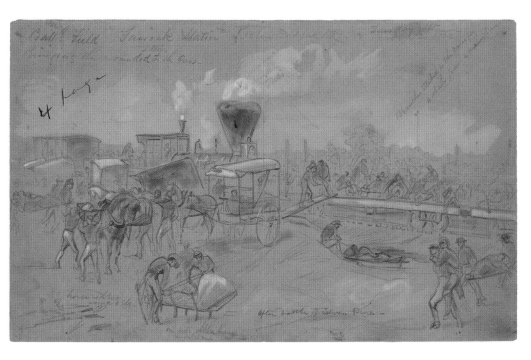

Arthur Lumley, *Bringing Wounded Soldiers to the Cars after the Battle of Seven Pines*, June 3, 1862, Library of Congress.

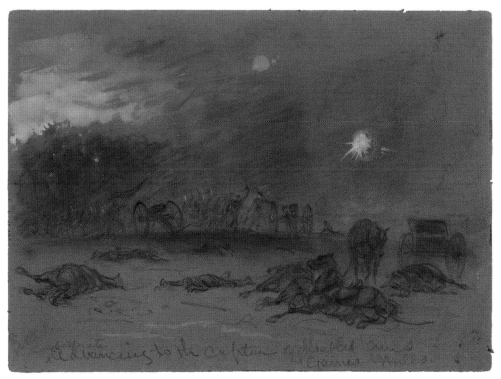

Alfred Waud, *Confederates Advancing to the Capture of Disabled Guns, Gaines Mills*, June 1862, Library of Congress.

diet, exhaustion and disease, were few and far between. Some of Alf Waud's early war pictures were scorned by soldiers for their generic, undifferentiated depiction of faceless rows of toy troops. By spring 1862 Waud's perception had changed. In a drawing entitled *Burying the Dead and Horses after the Battle of Fair Oaks*, he sketches a scene of great horror, as described in this memoir of the 25th Regiment, Massachusetts Volunteers:

> It was a horrible sight as we entered the enemy's works—dead and dying men, dead and dying horses, in every conceivable position, some alone, others in little heaps of two or three, all smeared with blood and begrimed with powder and dirt. Many, perhaps most, of the rebels, were shot in the head. We noticed a dead rebel soldier, seated on a log, his rifle beside him, and his back supported against a tree. He had been shot in the act of eating a piece of bread; the mouthful bitten off remained between his teeth . . .[22]

Nonetheless, there was beauty amidst the gore, as Specials sought out picturesque scenes of daily life in camp to color their grim, martial world:

Alfred Waud, *After Gaines Mill Sunday June 29th*, June 29, 1862, *Harper's Weekly*, August 16, 1862, Library of Congress.

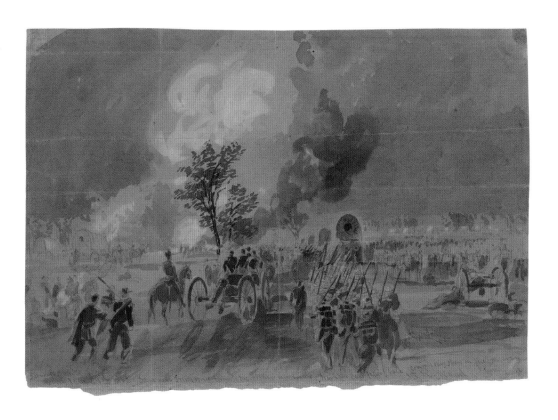

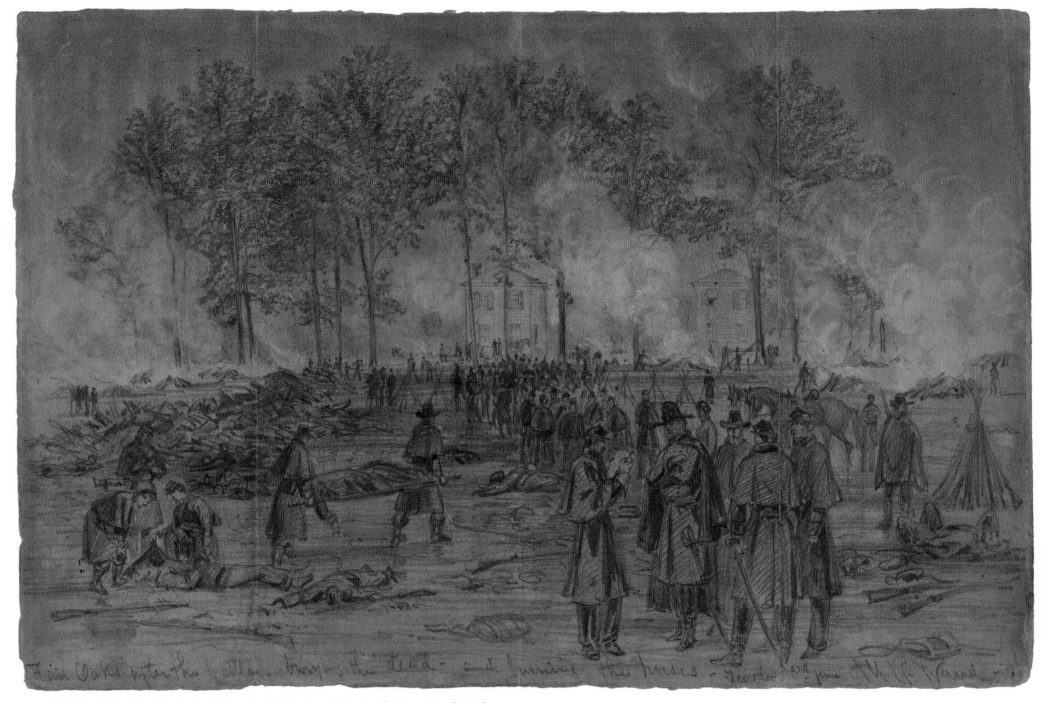

Alfred Waud, *Fair Oaks after the Battle, Burying the Dead—and Burning the Horses Tuesday 3rd June,* June 3, 1862, *Harper's Weekly,* July 19, 1862, Library of Congress.

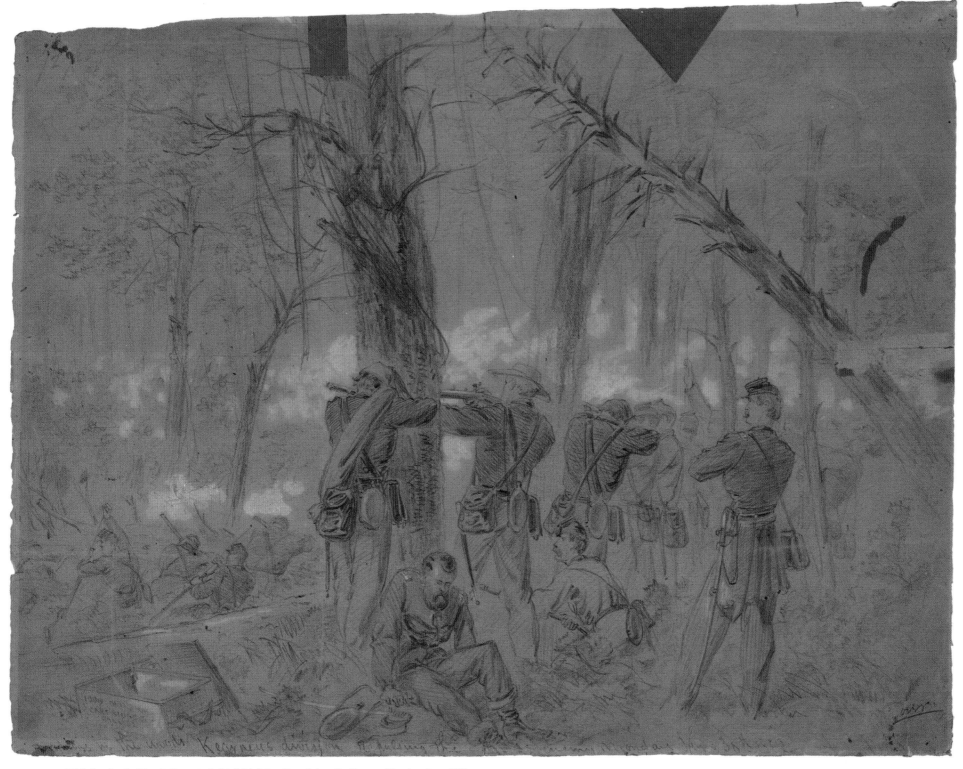

Alfred Waud, *Fighting in the Woods Kearney's [sic] Division Repulsing the Enemy Monday June 30th 1862,* June 30, 1862, *Harper's Weekly,* August 9, 1862, Library of Congress.

RELIGIOUS SERVICES AT HEAD-QUARTERS, HARRISON'S LANDING, VIRGINIA.

Every Sunday morning an open-air service is held in the camp of head-quarters, at which General M'Clellan is a punctual attendant. Seated around may be seen generals, with members of the staff, and other officers of the army; sometimes a naval officer, and a few outsiders of various denominations. The attention displayed must be gratifying to the chaplains who officiate, though the gentlemen who represent the Church here are not generally its most brilliant lights. The scene is not without its suggestions. The groups of officers and soldiers, so lately grimed with dust and battle sweat, and gaunt with fatigue and hunger, refreshed by rest, show few signs of their recent struggles. The sentries, leaning their heads upon their keen sabre-bayonets, join in the hymns—real Ironsides these. The military band takes the place of the organ, preluding and accompanying the hymns, in which few join, and playing for opening and closing voluntaries selections from Traviata. Down below rolls the placid yellow James, and from it arises other sounds: the hoarse roar of letting off steam; the rattling of a cable as a gun-boat or transport comes to an anchor; the shouts of drivers leading their horses splashing into the river to drink; and the spiteful, high-pressure puffing of a propeller looking after its tow. M'Clellan sits or stands calm and thoughtful through the service, the presence of a stranger drawing one quick, searching glance from him—a look which a sensitive individual would not care to encounter as a delinquent. In dress the General is, of all present, least ostentatious—a plain undress sack without shoulder-straps, pants without a stripe, gaiters, and a

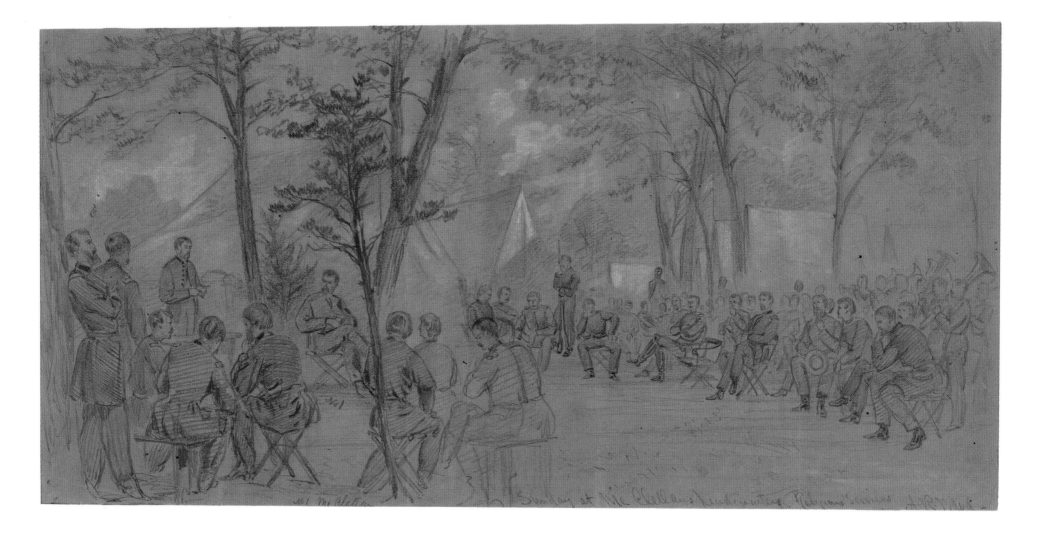

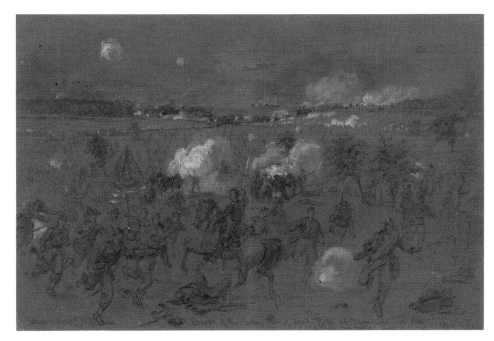

Alfred Waud, *Defeat of the Army of Genl. Pope at Manassas on the Old Bull Run Battle[gr]ound,* August 30, 1862, Library of Congress.

gray shirt comprising all. Yet none could fail to see at once in him the commander.[23]

By mid-August McClellan had given up his Richmond offensive and his army began evacuating the Virginia Peninsula. Confederate general Robert E. Lee, who replaced injured General Joseph Johnston during the campaign, took the initiative and attacked the Union Army of Virginia led by General John Pope in the vicinity of Centreville, Virginia, and the old Bull Run battleground. Edwin Forbes was on the spot for *Leslie's* while Alf Waud, assisted ably by a part-time artist named William H. Davenport, drew the hard-fought two-day battle for *Harper's Weekly.* Lumley, still with McClellan returning from the Peninsula, never made it to the field and the *New York Illustrated News* hardly covered the event. For the Union Army and Northern readers it was a terrible debacle and a grim reminder of the "Bull Run races" that had taken place on the same site one

OPPOSITE: **Alfred Waud,** *Sunday at McClellan's Headquarters, Religious Services,* July 1862, *Harper's Weekly,* August 16, 1862, Library of Congress.

RIGHT: **Edwin Forbes,** *Retreat of the Army of the Rappahannock, Commanded by Genl. Pope through the Town of Centreville. After the Battle of Second Bull Run,* August 31, 1862, Library of Congress.

summer past. Edwin Forbes captured the scene panoramically with his pencil and contributed a vivid written account:

> Our men were weary, tired and worn out by the long marches and excitement of the past 10 days, and required a stimulant until they got into the thickest of the fight; a hearty cheer and yell would be worth a thousand men at such a time, yet nobody seemed to feel the greatness of the occasion.
>
> The fight was opened by our batteries in front of the hill and woods on the centre and left. It was immediately replied to by the enemy's batteries in the orchard and along the crest of the hill about three-quarters of a mile distant. After the artillery fighting had lasted some time, our infantry attacked the enemy's left flank. The fighting here was very severe; huge columns of yellow smoke rolled up from the roads; the faint rattle and roll of distant musketry came across the open fields, interrupted occasionally by the boom of a heavy gun. Meanwhile, the enemy were making a very serious attempt to turn our left. Part of Gen. McDowell's corps was sent to drive them back. They moved in solid column across the field from the right, while the enemy, in overpowering force, was pushing our small number back.
>
> The fighting was terribly fierce at this point; the enemy throwing all their force on this flank. Our men retired across the field in the foreground and into the woods. On the right the enemy was driven from his position.

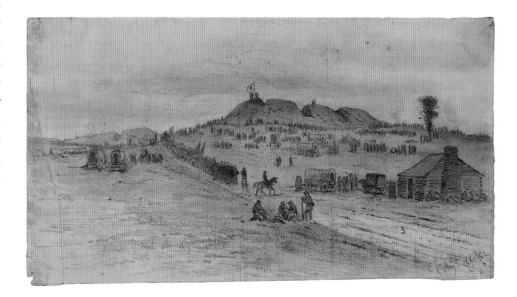

I have been at four battles where Jackson commanded the enemy's forces, and could not help remarking the similarity of the ground chosen by him in his several actions. His position is such that he invariably leaves a dense wood on one of our flanks and open ground on the other, and by moving his whole force under cover of the woods outflanks us.

I was in the hottest of the fire for quite awhile. When I attempted to get away I found myself cornered. I started with a party of skirmishers through a dense road, leading my horse, and after passing under a severe fire of shell, got a safe position.

Yours, EDWIN FORBES[24]

The Second Battle of Bull Run ended in much the same manner as the First, Union troops routed by the Confederates. Alf Waud produced a devastating drawing of Union lines in disarray and soldiers running from rebel guns; *Harper's* never published the sketch.

Through spring and summer artists with the Union armies in the west and south saw their work published between scenes of engagements on the Virginia Peninsula. Will Waud, Alex Simplot, Henri Lovie and Frank Vizetelly covered the Mississippi River. Vizetelly had hoped to follow the eastern armies toward Richmond but quickly ran afoul of the Union Army by criticizing its conduct at the First Battle of Bull Run. On the heels of extremely negative reports by his journalist countryman William H. Russell, the two—under the guise of a ban on all foreign correspondents from war theaters—were prohibited by Union Army officials, namely Secretary of War Edwin Stanton and General Henry Halleck, from covering the Northern armies at the Richmond front.

Alienated and disgusted, Russell sailed for London while Vizetelly headed west. On the Mississippi, Halleck allowed Vizetelly to pursue his profession but peevishly denied him military transport and open access to the battle lines. The Englishman expressed bitterness toward both Halleck and Secretary of War Stanton but managed to maintain a grudging respect for the Union Army's men and mission while he traveled with them. His letters to the *Illustrated London News* chronicling the fall of Memphis to the Union, however, detail his growing irritation with the Northern war effort and increasing desire to make his way to Richmond in defiance of Union authorities. Prior to his Memphis sojourn Vizetelly saw "no further hope for the Southern Confederacy . . . We find that each day the North is developing her gigantic resources; all her foundries are busily engaged in the manufacture of improved artillery; iron-clad gun-boats of models that revolutionise naval architecture, grow upon her ways, and regiment after regiment of well-equipped soldiers flow in legions from her States, and the cry is still "They come!"[25]

His tune changed quickly with exposure to the citizens of Memphis. In the aftermath of Union capture and occupation of the city in early June 1862, he wrote:

I may say positively that there is more bitterness of feeling evinced towards the North by the Memphians than I ever saw displayed by the Italians to the Austrians. If the entire South is actuated by the same sentiments breathed by the people of south-western Tennessee and Mississippi, why, then I declare the reconstruction of the Union impossible; and, though the North by superior power and resources may eventually conquer the South, she can never hold her in any other way than that which binds Venetia to the Tedeschi. Your readers must understand that I never saw anything of Southern people until I landed at Memphis. A "peculiar institution" of theirs had prejudiced me somewhat against them, and I believed from all I heard that the Secession movement was but skin deep after all, and that the people would willingly return to their allegiance to the Government of the United States if the old flag were carried to their midst and the leaders of the rebellion removed from among them. I have been astounded at the unanimity displayed by all on the one subject of separation . . . I say again, I believe the South to be unanimous, and with this belief my ideas have notably changed as to the future. In Memphis and its immediate neighbourhood I made it my business to mix with all classes and test their loyalty or disloyalty, and, though the stars and stripes floated from the public buildings, and the supremacy of the Federal Government had been asserted by the Federal arms, yet I found but one minute drop of Union oil to pour upon the troubled ocean of Secession: all were clamouring for separation. If, then, such are the sentiments of the entire South, and defeat does not bring them nearer to the Union, what is to be the result of all this bloodshed? A conquered people, writhing in the chains that bind them to their conquerors, seeking every fresh opportunity for outbreak. The civilised world will shortly demand that this wholesale massacre shall cease, and that the temperate counsels of European Governments shall take the place of unskilful Generals, who, while sacrificing the lives of thousands of brave men and deluging this vast continent with their blood, approach no nearer to a solution, but widen the gulf which separates the combatants and embitter the hatred which is daily growing fiercer.

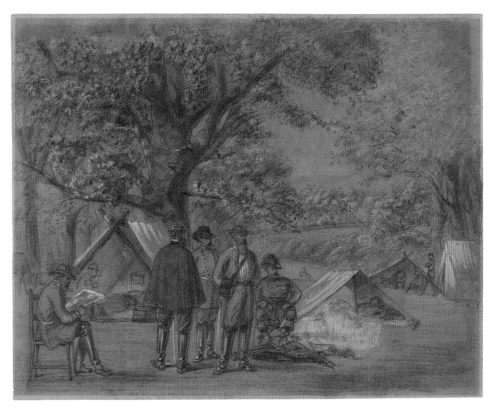

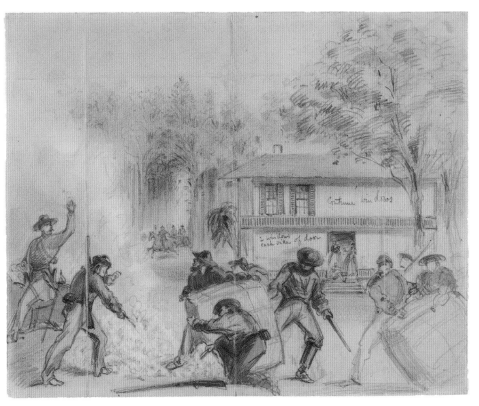

Frank Vizetelly, *Genl. Stuart's Head Quarters, Advanced Post. of the Confederate Army in Northern Virginia,* October–November 1862, MS Am 1585, Houghton Library, Harvard University.

Frank Vizetelly, *Cotton Burners on the Borders of SW Tennessee & Mississippi Surprised by Federal Scouts,* May–June 1862, *Illustrated London News,* August 9, 1862, MS Am 1585, Houghton Library, Harvard University.

As I have stated at the opening of this letter, my purpose in return-ing to Washington is, if possible, to reach the army on the James River. Very bad news for the Federalists will reach you by this mail, already, I suppose, anticipated by telegraph, and, though it is evidently the wish to make the best of it, I must caution you against believing in a victory where there was a defeat. At present I know but little about what has latterly transpired in front of Richmond, at least I am scarcely sufficiently posted to go into the matter, and must refer you to the general news. Of one thing there is no doubt, that M'Clellan has been forced to retreat seventeen miles with frightful loss, and yet hyp-ocritical journalists here chant a "Te Deum," and pronounce the move-ment to have been a masterly piece of strategy. I have still one or two more Mississippi Sketches to send you, and with them I will write more fully and from the best authority as to the actual condition of mat-ters with the army of the Potomac. I have hopes of getting on the spot

myself, and shall leave no effort untried to reach the James River, but how I am to achieve my purpose unless the Minister of War relents, I scarcely know.

F. V.[26]

Vizetelly soon achieved his purpose of reaching Richmond by simply relocat-ing and re-assigning himself as a Special with Confederate general Lee's Army of Northern Virginia. In late summer, according to an account by his brother, writer and publisher Henry Vizetelly, Frank journeyed to Baltimore, where he caught passage on a Chesapeake Bay steamboat to a small town opposite West-moreland County, Virginia. His initial attempt to cross the Potomac in a canoe with a black guide named Buck failed at the appearance of a federal patrol steamer. The pair, forced to hide in reeds for two nights and two days, sustained themselves with river oysters. After the patrol boat left, Buck paddled the artist across the Potomac in his "dug-out" to the Confederate side.[27] In early fall 1862,

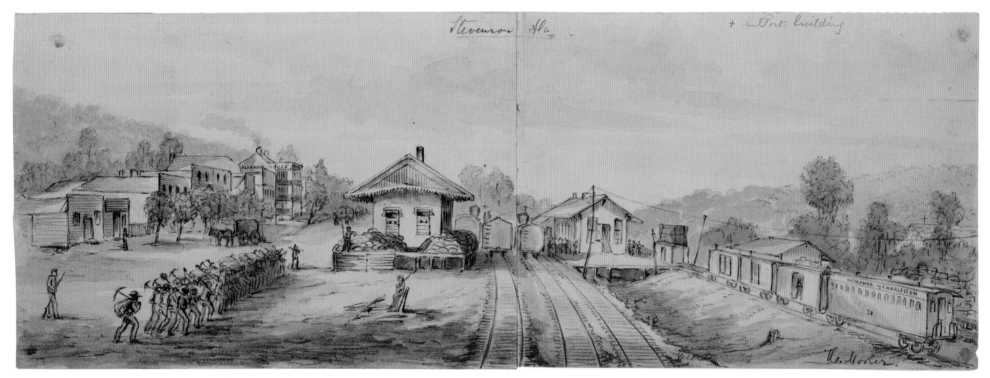

Henry Mosler, *Stevenson, Alabama,* ca. August 1862, *Harper's Weekly,* August 30, 1862, Museum of Fine Arts, Boston.

Vizetelly joined Lee's army along the Rapidan and took up the rebel cause, writing: "Surrounded as I am by the Southern people, I emphatically assert that the South can never be subjugated."[28] For the first time in the war the South had its own Special, although he worked for a newspaper published in London.

Vizetelly's drawings were shipped to London for reproduction in *The London Illustrated News*, the world's most widely read and influential illustrated journal. They cast the South and its fight in a righteous, positive light at a time when England and other countries were actively considering recognition of the Confederacy's political sovereignty. He was not alone in the South, although he was the only Special sketching from the rebel perspective for a major pictorial weekly. Theodore Davis contributed drawings from Baton Rouge, Louisiana, for *Harper's*, while William T. Crane continued his coverage of the war for *Leslie's* in Florida, Georgia and South Carolina. His colleague Henry Mosler operated in Kentucky and Alabama, where he sketched the town of Stevenson and a stockade built there by newly freed slaves working for the Union Army.

In the West that summer, sketch artists, like today's paparazzi, pursued opportunities to sketch such celebrities as rebel guerrilla leaders John Morgan and John Mosby, who were then wreaking havoc on pro-Union towns and villages in Kentucky, Ohio and Virginia. Henri Lovie caught up with Morgan in Court House Square at Paris, Kentucky, in early August, when he contributed to *Leslie's* a memorable portrait and report:

> Our Artist says that it was a most animated and interesting sight to see the blank dismay of the "Parisians" when the arch brigand and his men dismounted and bivouacked in their fine square. Beyond some robberies there were no outrages committed.[29]

"Brigands" like Morgan and Mosby were popular heroes in the South and feared adversaries in the North. Their portraits in the popular press must have sent a thrill of fear through every pro-Union reader. In fact, throughout summer 1862, the Confederacy seemed to gather strength. In late September *Frank Leslie's* reported on the creation of a new Southern pictorial newspaper, the *Southern Illustrated News*:

The South is going to have an art as well as a literature of its own.... We have before us *The Southern Illustrated News* bearing date of Richmond, Sept. 13, 1862. It is called illustrated, because it has one picture—an archaic portrait of "Stonewall Jackson." The editor, in his "Salutatory" confesses that the time for starting his paper is not altogether propitious, and that he "labors under some material disadvantages arising out of the blockade," but still he is hopeful if not confident."[30]

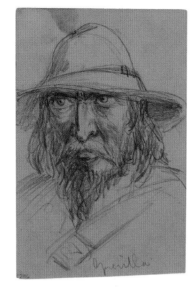

Alfred Waud, *Guerilla,* ca. 1862, Library of Congress.

McClellan's retreat from the Peninsula and Pope's rout at the Second Battle of Bull Run inspired hope and optimism in the South and unprecedented respect in the North for Southern soldiers. This Confederate high point occurred in mid-September as rebel troops occupied the Maryland cities of Frederick and Hagerstown and McClellan gathered his forces to oppose them. The Specials converged to sketch the impending clash, which occurred on September 17 along Antietam Creek outside Sharpsburg. Frank Schell, Edwin Forbes, Alf Waud and Arthur Lumley were on hand when the battle broke out. A remarkable illustration from Alfred Waud appeared in *Harper's* in late September, ten days after the bloody encounter. Depicting a regiment of Confederate cavalry, Waud described the scene in his accompanying letter:

Being detained within the enemy's lines, an opportunity occurred to make a sketch of one of the two crack regiments of the Confederate service. They seemed to be of considerable social standing, that is, most of them—F[irst]. F[amily]. [of] V[irginia].'s, so to speak, and not irreverently; for they were not only as a body handsome, athletic men, but generally polite and agreeable in manner. With the exception of the officers, there was little else but homespun among them, light drab-gray or butternut color, the drab predominating; although there were so many varieties of dress, half-citizen, half-military, that they could

scarcely be said to have a uniform. Light jackets and trousers with black facings, and slouched hats, appeared to be (in those cases where the wearer could obtain it) the court costume of the regiment. Their horses were good; in many cases, they told me, they provided their own. Their arms were the United States cavalry sabre, Sharp's carbine, and pistols. Some few of them had old swords of the Revolution, curved, and in broad, heavy scabbards. Their carbines, they said, were mostly captured from our own cavalry, for whom they expressed utter contempt—a feeling unfortunately shared by our own army. Finally, they bragged of having their own horses, and, in many cases, of having drawn no pay from the Government, not needing the paltry remuneration of a private. The flag represented in the picture is the battle-flag. White border, red ground, blue cross, and white stars.[31]

Frank Vizetelly contributed his own sketch of a rebel scouting party under General J.E.B. Stuart that appeared just days later in the *Illustrated London News.* According to London's editors, Stuart's troopers represented, in spite of their poor equipment, uniforms, supplies and provisions, "the finest irregular body of horse in the world."[32]

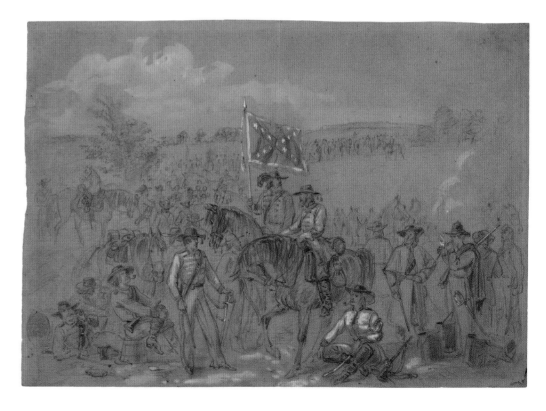

Alfred Waud, *1st Cavalry at a Halt September 1862,* ca. September 1862, *Harper's Weekly,* September 27, 1862, Library of Congress.

At Antietam, Lee's Army of Northern Virginia confidently crossed the Potomac, forcing a face-off with McClellan's Army of the Potomac for the first time on Northern soil. Before the fighting McClellan's troopers actually found a lost copy of Lee's orders of battle wrapped up with cigars in a pasture; McClellan had the rebel army in his sights, yet moved so slowly and tentatively that he lost the initiative (some historians argue that McClellan's affinity for the South, antipathy for the Lincoln Administration and personal ambition for political power led him to rein in the Army of the Potomac). Fought to a standstill, Lee slipped southward without pursuit while the Union Army claimed victory and recovered from its wounds. During the engagement Waud, Forbes, Arthur Lumley, Frank Schell, Theodore Davis and others produced a variety of battle sketches depicting hand-to-hand combat and bird's-eye views. The Dunker Church, Mumma's burning house, the Cornfield, the heroic Irish Brigade and Burnside's Bridge, all icons of the battle's lore come to life in their drawings.

The best of the Specials never ignored the artistic possibilities inherent in their task. Previous to the battle, Alf Waud produced a sketch of Confederate troops fording the Potomac River at night. His moonlit rendering casts an apparently romantic glow on what would become a dark event. His evocative drawing appeared in significantly altered form in a wood engraving signed by Thomas Nast and published in *Harper's* on September 27 along with the following account:

> The rebels are wretchedly clad, and generally destitute of shoes. The cavalry men are mostly barefooted, and the feet of the infantry are bound up in rags and pieces of rawhide. Their uniforms are in tatters, and many are without hats or caps. They are very sanguine of success, and say that when they get to Baltimore they will get every thing they need.[33]

Leslie's had two artists at Antietam, Frank Schell and Edwin Forbes. On October 11, their sketches appeared with the following notice:

THE REBEL RAID INTO MARYLAND.

Our paper of to-day contains some sketches of surpassing interest, chiefly from the pencils of Mr. Schell and Mr. Forbes, illustrating the recent battles in Maryland. The nature of the country is very different from that of Virginia, the hills rolling up gloriously, more especially around Frederick and towards the Potomac. The forests also are different from those in Virginia, there being less brushwood; consequently the rebels, like tigers who miss their jungles, lose half their facilities

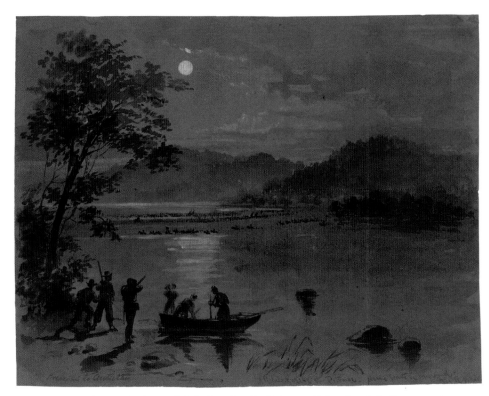

Alfred Waud, *Previous to Antietam. Rebels Crossing the Potomac. Union Scouts in Foreground,* September 1862, Library of Congress.

in fighting. Mr. Schell's sketch of Hooker's Division fording the Creek called the Great Antietam, speaks for itself, and has already been described by us in our account of the battle, which was commenced on the western bank of the creek and finished on the other.[34]

Such Specials as Schell, Davis, Lovie, Vizetelly, and Waud often inserted themselves into the fight, sketching vignettes of chaos and individual courage. Waud, in particular, produced numerous combat images during the battle. It is to his pictures we turn for the most dramatic coverage of the unprecedented violence and mayhem unleashed at Antietam. Edwin Forbes could never draw as well as Schell or Waud, nor overcome his fear of blood and combat, and yet his more distant views of Burnside's Bridge and other features of the Antietam battlefield and other great Civil War sites are memorable. Remaining beyond the fray he encompassed the whole scene: regiments arrayed, batteries aligned, and strategies apparent in panoramic display.

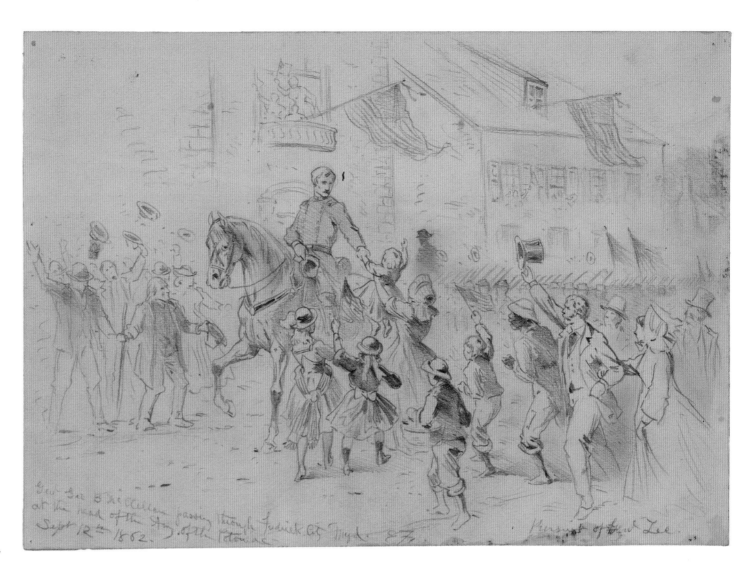

Edwin Forbes, *Genl. Geo. B. McClellan Passing through Frederick City Myd. at the Head of the Army of the Potomac. Pursuit of Genl. Lee,* September 12, 1862, *Frank Leslie's Illustrated Newspaper,* October 4, 1862, Library of Congress.

Alfred Waud, *Sharpsburg Citizens Leaving for Fear of the Rebels,* September 15, 1862, *Harper's Weekly,* October 11, 1862, Library of Congress.

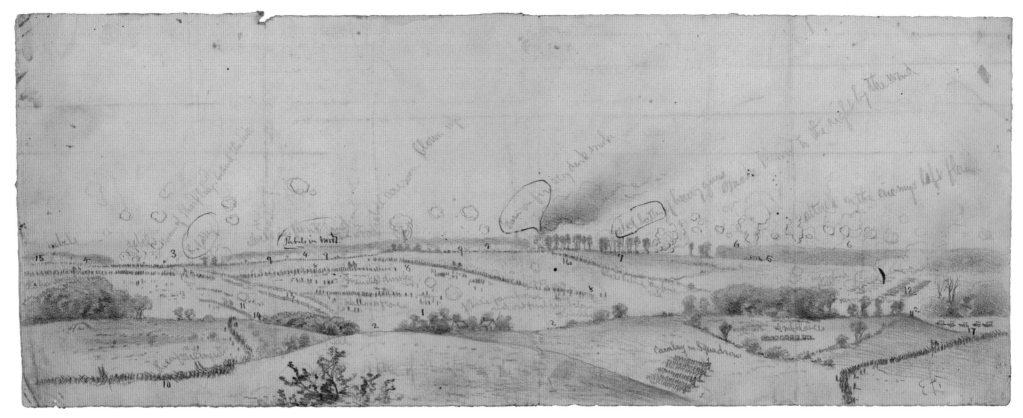

Edwin Forbes, *The Battle of Antietam or Sharpsburg, Sketched from a Point North of Antietam Creek and West of the Turnpike, Charge of Genl. Sumner's Corps on Centre of the Enemy's Position in the Lane in front of the Town,* September 17, 1862, Library of Congress.

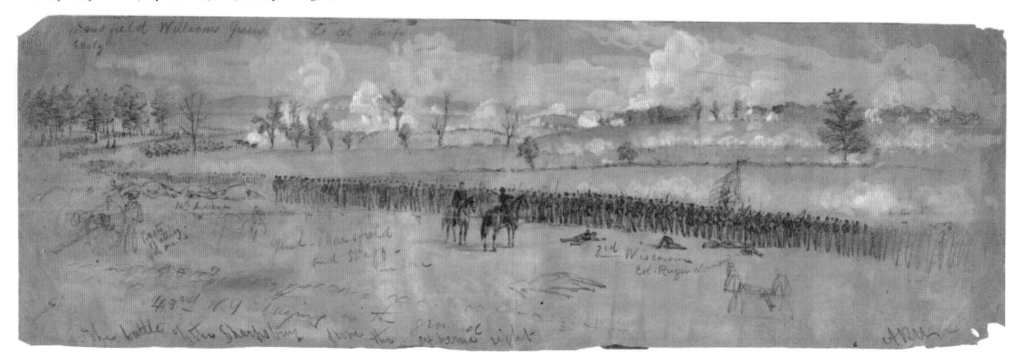

Alfred Waud, *The Battle of Sharpsburg from the Extreme Right,* September 17, 1862, Library of Congress.

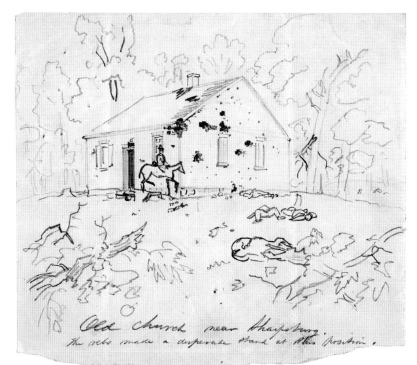

RIGHT: **Frank Schell,** *Old Church near Sharpsburg—the Rebels Make a Desperate Stand at This Position*, September 1862, courtesy of the Becker Collection, Boston, MA.

BELOW: **Edwin Forbes,** *The Battle of Antietam—Charge of Burnside 9th Corps on the Right Flank of the Confederate Army*, September 17, 1862, *Frank Leslie's Illustrated Newspaper*, October 11, 1862, Library of Congress.

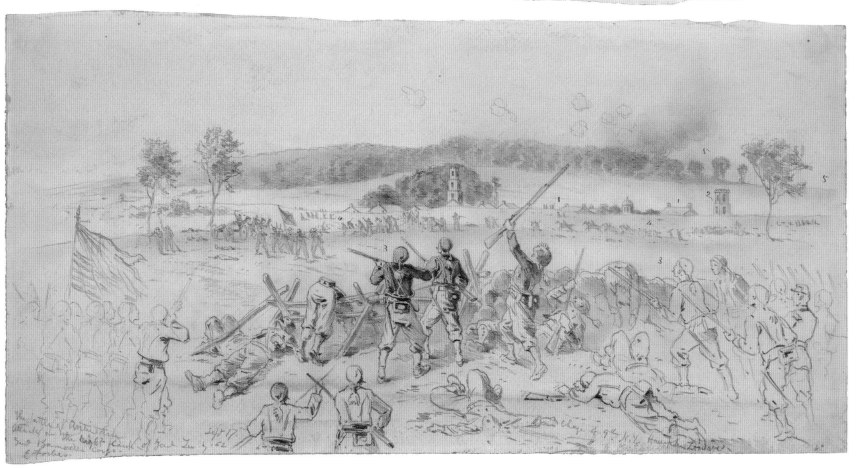

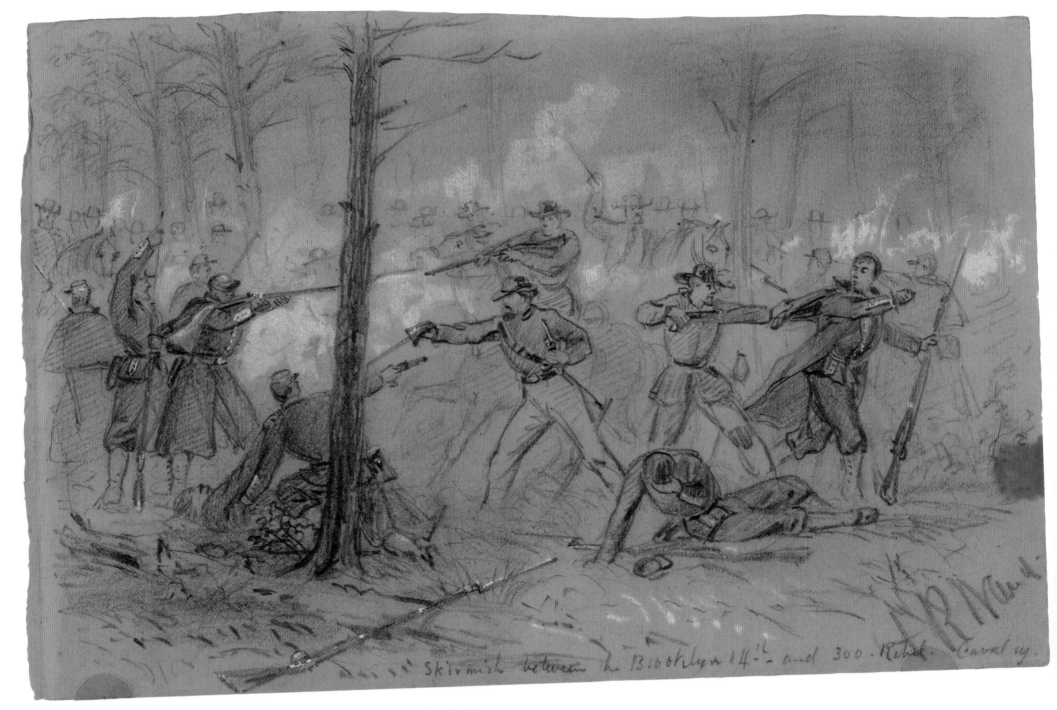

Alfred Waud, *Skirmish between the Brooklyn 14th and 300 Rebel Cavalry,* September 17, 1862,
Library of Congress.

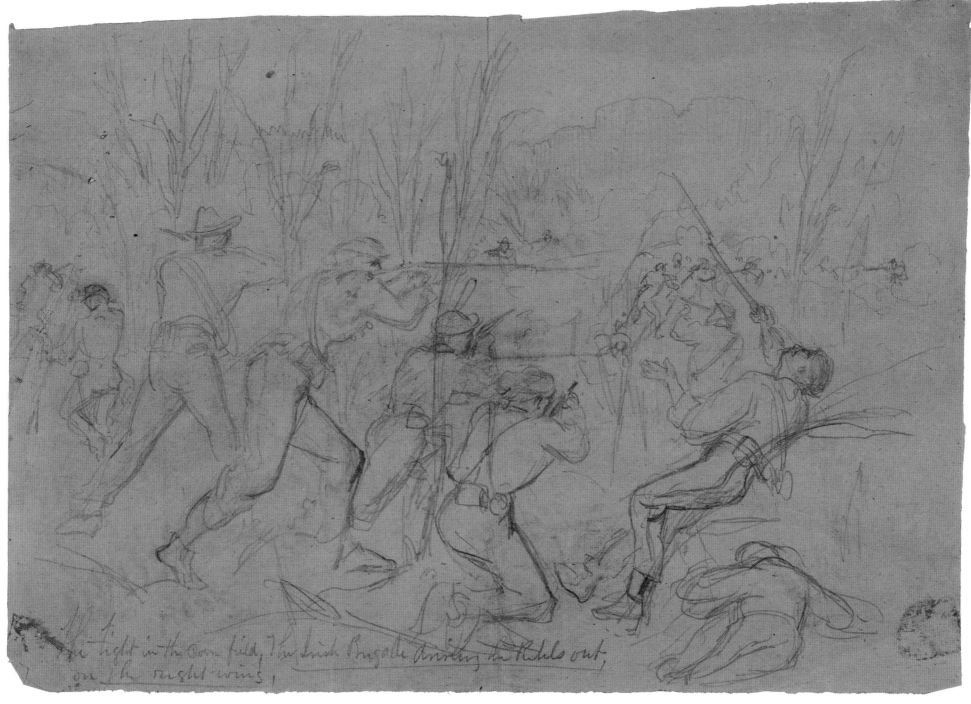

Arthur Lumley, *The Fight in the Cornfield; the Irish Brigade Driving the Rebels Out, on the Right Wing,*
September 17, 1862, Library of Congress.

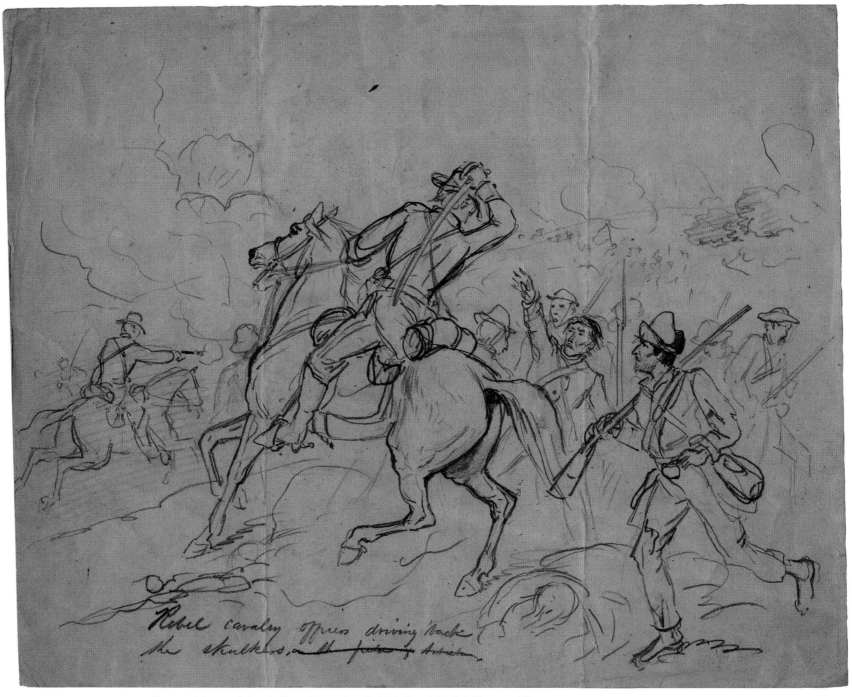

Frank Schell, *Rebel Cavalry Officers Driving Back the Skulkers*, September 17, 1862, *Frank Leslie's Illustrated Newspaper*, October 11, 1862, courtesy of the Becker Collection, Boston, MA.

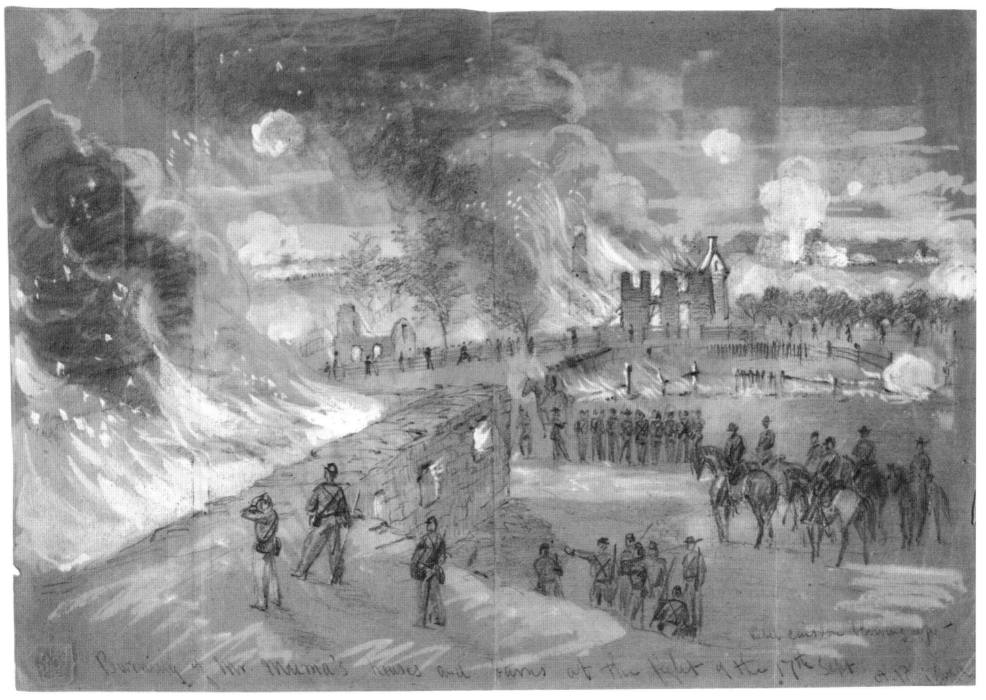

Alfred Waud, *Burning of Mr. Muma's [sic] Houses and Barns at the Fight of the 17th of Sept.,*
September 17, 1862, *Harper's Weekly,* October 11, 1862, Library of Congress.

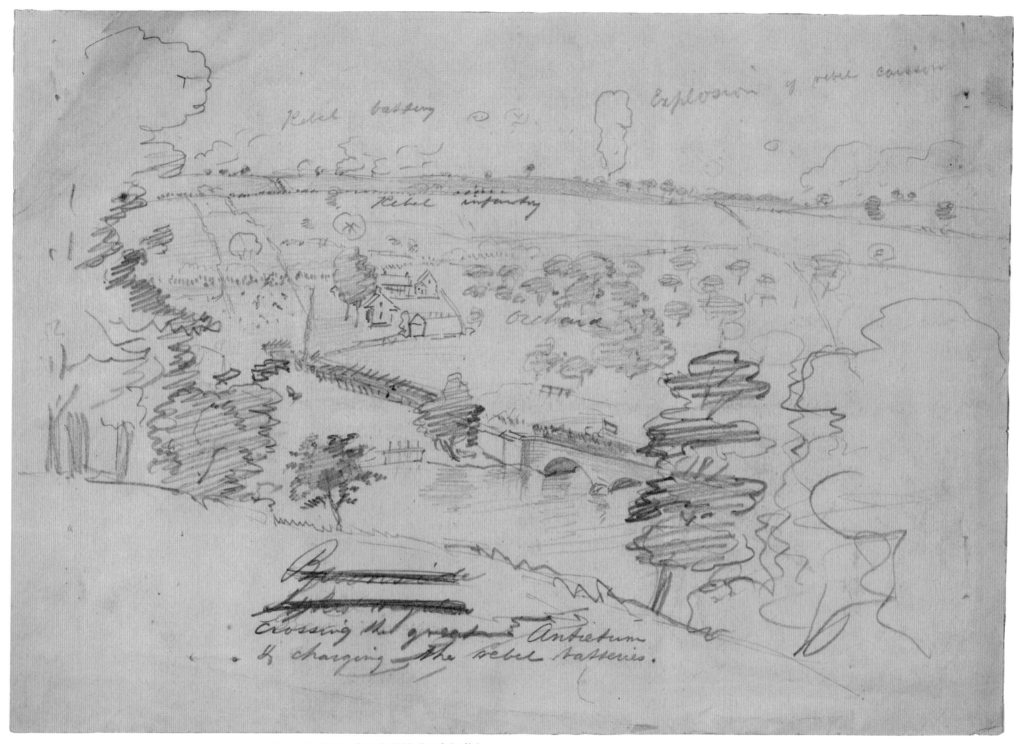

Frank Schell, *Crossing the Antietam & Charging Rebel Batteries*, September 17, 1862, *Frank Leslie's Illustrated Newspaper*, October 4, 1862, Collection of the New-York Historical Society.

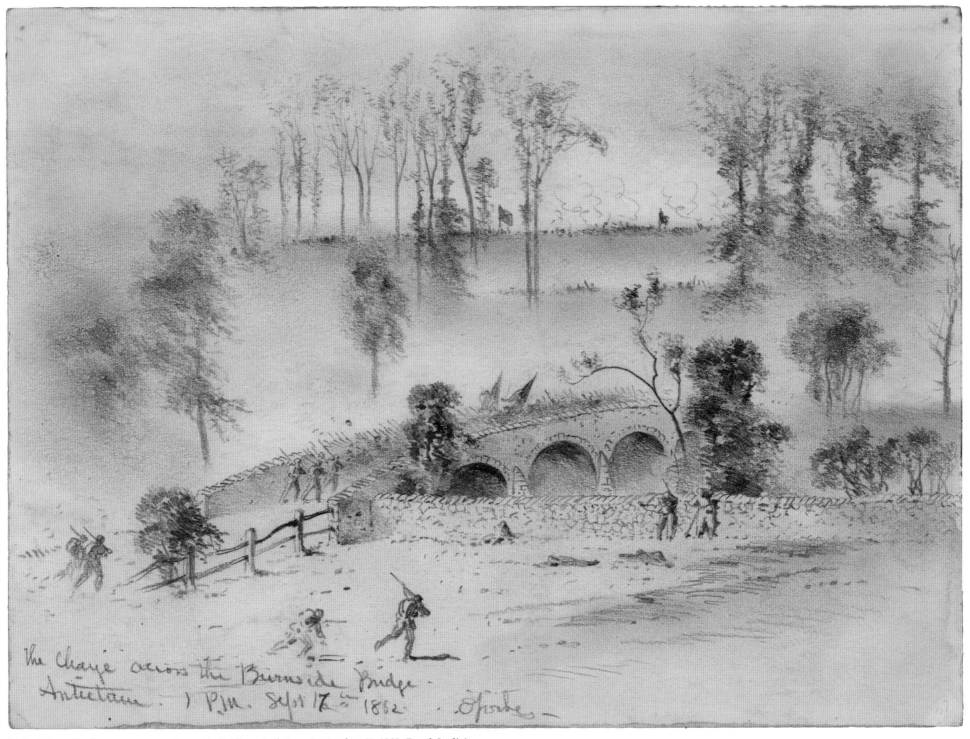

The Charge across the Burnside Bridge.
Antietam. 1 P.M. Sept 17th 1862. Forbes

Edwin Forbes, *The Charge across the Burnside Bridge—Antietam,* September 17, 1862, *Frank Leslie's Illustrated Newspaper,* October 11, 1862, Library of Congress.

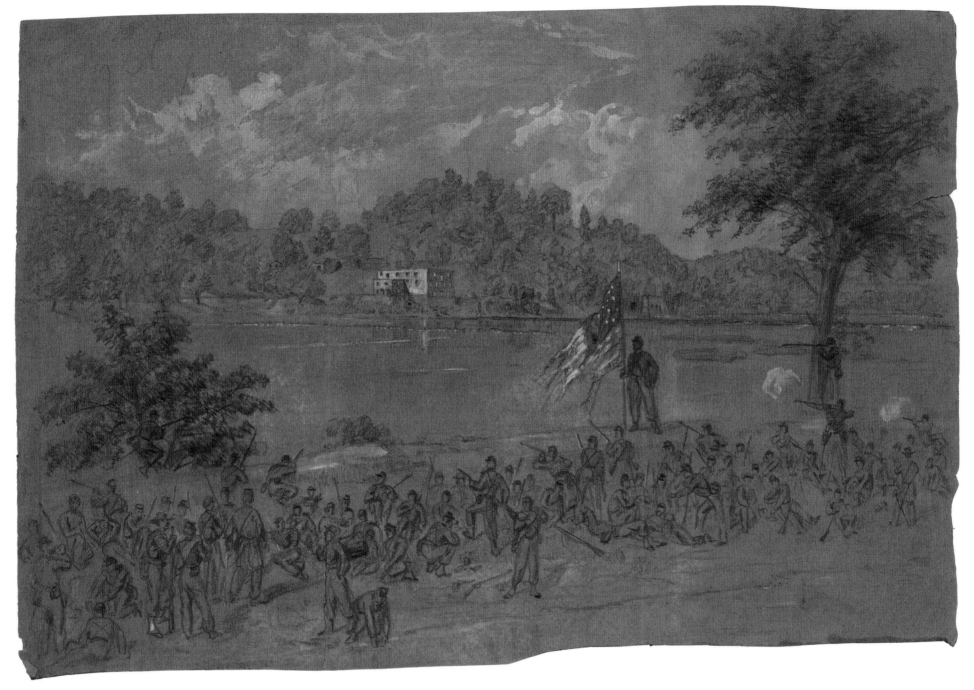

Alfred Waud, *Ford near Shepherdstown, on the Potomac. Pickets Firing across the River,* September 1862, Library of Congress.

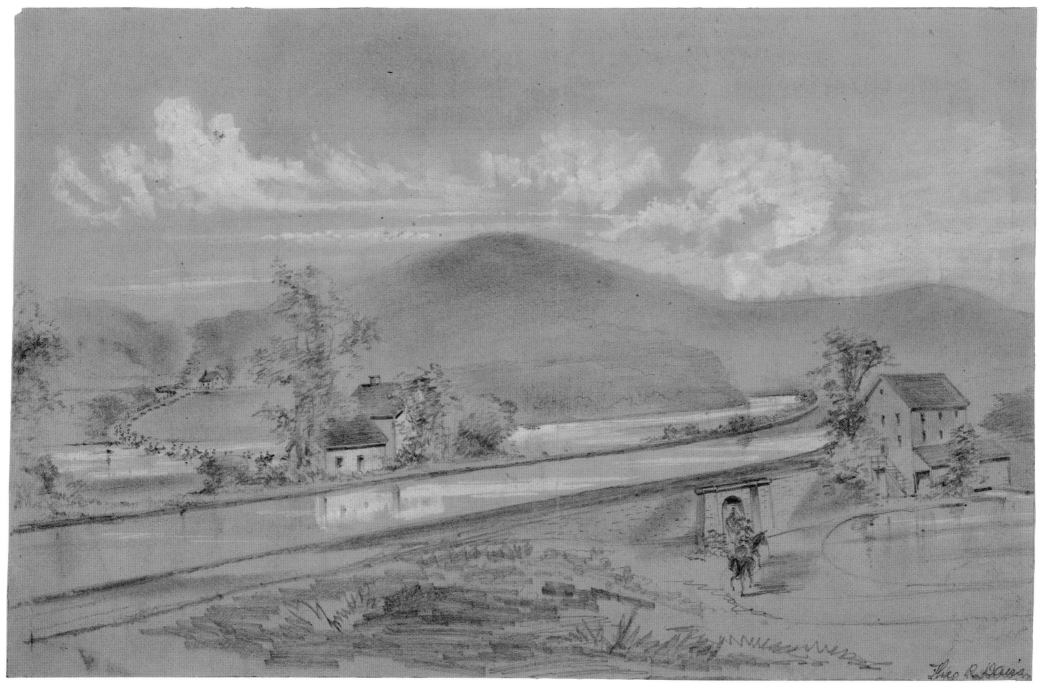

Theodore R. Davis, *Rebs under Stuart Crossing Potomac*, October 10, 1862, Library of Congress.

Though the South lost the battle of Antietam, it gained international respect in the aftermath in part due to the defection of Frank Vizetelly, who had finally achieved his goal and made his way to the Richmond front, on the Southern side of the James River. Just three days after Antietam, Vizetelly was in Richmond:

> The more I see of the Southern army the more I am lost in admiration at its splendid patriotism, at its wonderful endurance, at its utter disregard of hardships which, probably, no modern army has been called upon to bear up against. Wretchedly equipped, the soldiers of the Confederacy advance to meet their foes, the light of battle shining on their countenances, determined to be victorious or die. I have seen them marching over the hot and dusty roads of Virginia, uniformless, shoeless, many with nothing but a thin, well-worn shirt to shelter them from the scorching rays of the sun, and yet every man cheered his comrade, and all as they dragged their bleeding feet along made light of their sufferings, and with renewed elasticity strode forward on their way, many to their graves . . .[35]

Contributions continued to flow in from the western theater, where Henry Mosler, Henri Lovie, Alex Simplot and others were assigned. Lovie took the recently killed Union general William "Bull" Nelson to task for ordering the evacuation of women and children from Louisville, Kentucky, without providing adequately for their shelter and care. He produced sketches provoking concern for their welfare and anger at their treatment.[36] Freed slaves, called "Contrabands," were very much in the news. President Lincoln at the time was secretly drafting his Emancipation Proclamation, which was announced on September 22 and took effect in January 1863. Lovie and others sketched blacks in and around the Union Army contributing to the Northern war effort. In November, *Leslie's* published Lovie's illustrations of ex-slaves at Fort Pickering, Tennessee, with the following description:

> *Among* other disadvantages under which we labor is that of the negroes. The rebels, of course, have no scruples on this head, but, in accordance with their system of considering them as property, put them to their full use as animals. The National Government, on the other hand, treat them as human beings, and are, consequently, put to considerable expense, trouble, danger and inconvenience—for, as there are Benedict Arnolds and Jeff. Davises among the whites, so there are spies among the blacks, and the utmost vigilance is needful to prevent these ostensible refugees from giving intelligence to the enemy.

Indeed, so debased has the "divine institution" made many of the men thus rescued from slavery, that they are just as willing to betray their saviours as their oppressors.

> Close to Fort Pickering, Memphis, and on the banks of the Mississippi, the National Government has formed a Camp for the contrabands, which our Artist, Mr. Lovie, sketched lately. He says that they are employed in labor about the fort, which they perform willingly enough—but accustomed to work only under the lash, they do not seem to understand to labor freely, even though paid a *pro rata* for what they do. With firm overseers, they, however, contain material, which, with judicious culture, may be elevated and made more useful as free laborers than as slaves.[37]

Leslie's published additional sketches from Georgia by soldier-artist Colonel Douglas Brewerton of some of the first black troops to fight for the Union, along with glowing accounts of their courage in action:

EXPEDITION OF ARMED CONTRABANDS INTO GEORGIA.

Whatever may be the abstract opinion of the community as to the policy of forming contraband regiments, there can be no doubt as to the great interest with which the public must regard the first hostile collision between the slaves and their former masters. Through the kindness of an officer we present two sketches to our readers, illustrating two events in the recent expedition up the Doboy river, Georgia, under the gallant Col. Beard, whose report we give as a curiosity:

COL. BEARD'S OFFICIAL REPORT.
Beaufort, S. C., Nov. 22, 1862.

General—I have the honor to report that, as directed by you, I proceeded on the 13th inst., on the United States steamer Darlington, with 160 of the 1st South Carolina volunteers (colored regiment) in quest of lumber and other articles needed for the Department. The steamer Ben Deford, ordered by you to report to me at Doboy Sound, did not, owing to heavy fogs and adverse winds, reach that point until the 19th inst. On the 18th, accompanied by the United States gunboat Madgie, I proceeded to the mills located on Doboy river, Georgia. On reaching the mill found it necessary to reconnoitre the land adjacent thereto. To do this it was needful to cross a narrow causeway leading from the mill

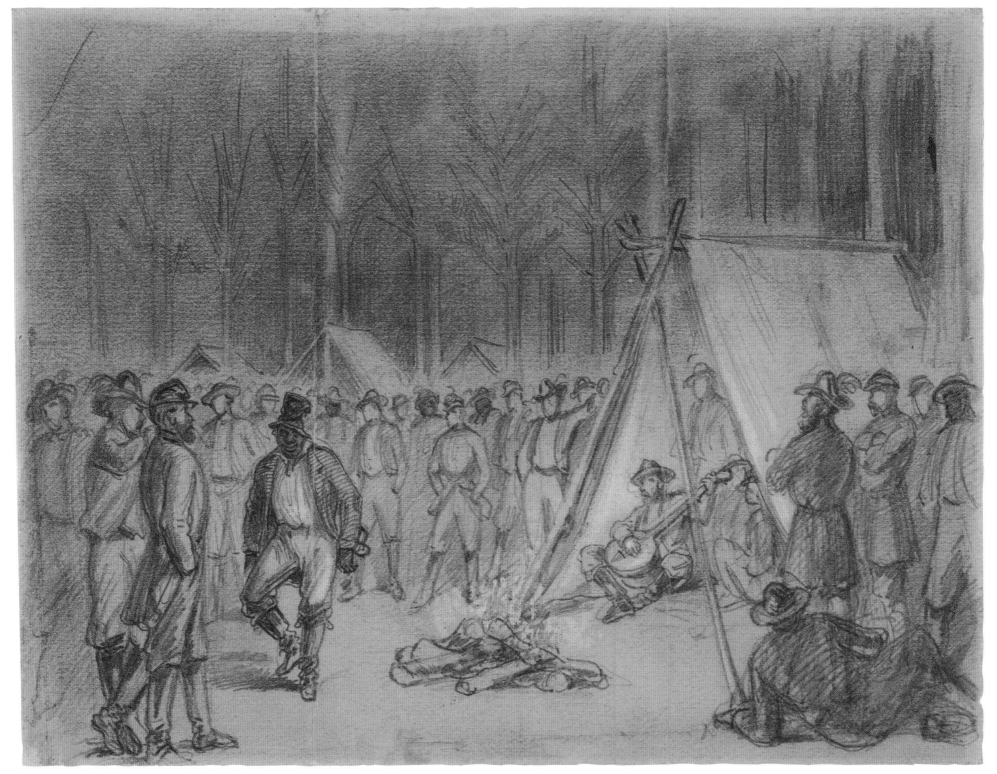

Frank Vizetelly, *"Barbarous" Treatment of the Negro in the Confederate Camp, Nights by the Pine Wood Fire,* October–November 1862, *Illustrated London News,* January 10, 1863, MS Am 1585, Houghton Library, Harvard University.

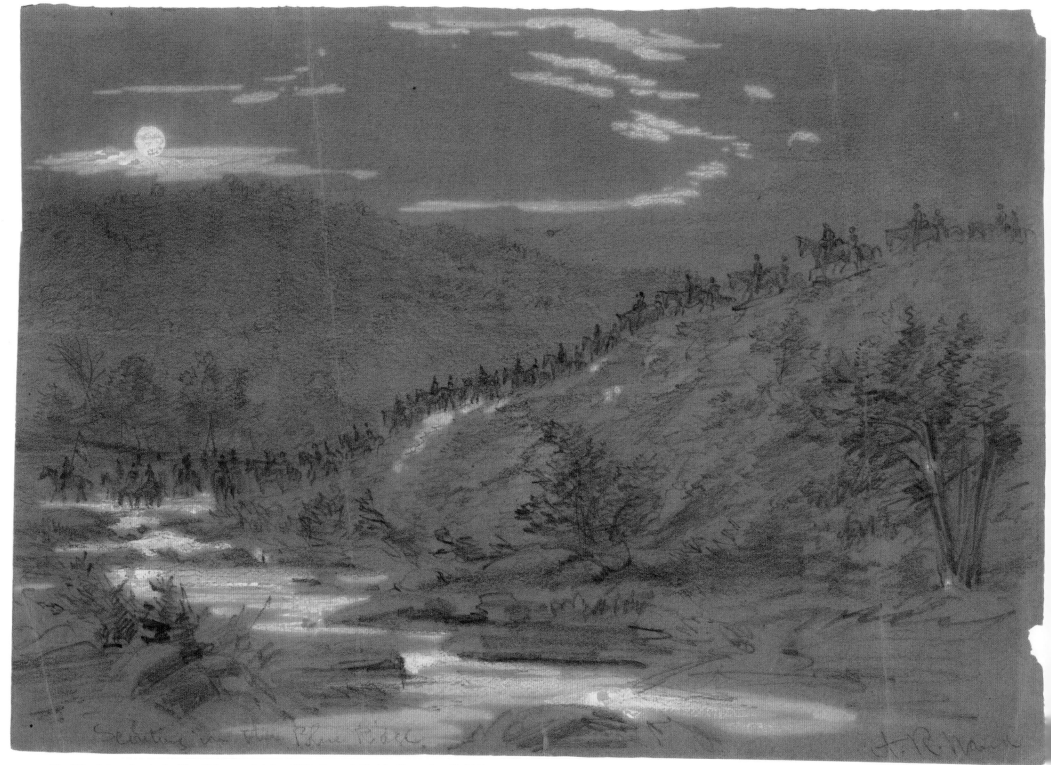

Alfred Waud, *Scouting in the Blue Ridge,* ca. October 1862, *Harper's Weekly,* November 22, 1862,
Library of Congress.

through a swamp to the main high land—a distance of about 450 yards. This high land was heavily wooded, except on the summit, which was cleared and occupied with houses. My men—34 in number—had no sooner passed across the causeway and through the woods to the clearing beyond, than they were fired on by the enemy, who were posted in the thicket in front and on both sides. On the first fire one man was dangerously wounded, and a momentary panic seized the men; but it was only momentary. They speedily rallied and opened a brisk fire on the places occupied by the concealed enemy. This fire they kept up with great regularity and coolness, until ordered by me to retire to the end of the causeway. They retired, firing as they went with a slowness and deliberateness that could not have been surpassed by veteran troops.[38]

By the end of the year, in spite of the results at Antietam, the Union was experiencing a downturn in the war effort. Southern general Robert E. Lee's tactics, carried out by such storied military leaders as Stonewall Jackson and Jeb Stuart, inspired rebel soldiers to great effort and effect. In the North, military infighting and incompetence took their toll. The leadership of the Army of the Potomac underwent a transformation. Lincoln fired McClellan for letting Lee escape and elevated Ambrose Burnside to command of the Army of the Potomac. The two opposing armies warily faced each other across the Rappahannock River at Fredericksburg.

Taking advantage of the picturesque landscape and the close proximity of Lee's encampments the Specials filled their notebooks and the weeklies with numerous scenes and incidents, including sentries fraternizing from opposite banks; skirmishes at river fords; and picturesque views of Fredericksburg and surrounding towns.

UNION AND REBEL SOLDIERS ON OPPOSITE SIDES OF THE BURNED RAILWAY BRIDGE.

This is a favorite spot for the soldiers of either army to meet within speaking distance and exchange remarks, frequently of an uncomplimentary character. Proposals for all sorts of exchanges (impossible of accomplishment) are made—such as offers to barter coffee or tea for whisky or tobacco, gray coats for blue ones—the rebels walking about in the clothes they have taken from Uncle Sam's men prompting

Alfred Waud, *Union Soldiers Exchanging Salutations with the Confederates at Fredericksburg, Va.,* November–December 1862, *Harper's Weekly,* December 13, 1862, Library of Congress.

the proposal. The seceshers show a laudable anxiety to get New York papers for Richmond publications; a number of them have asked after their Commissary and Quarter-master (meaning Pope and M'Dowell), and they generally express a belief that they "will whack the Union army now M'Clellan is gone." To their inquiry of our men, "How do you like Bull Run?" they receive for answer, "What do you think of South Mountain?" Some witty remarks are made on both sides, but it usually ends in a general black-guarding. One of them told a Zouave that they

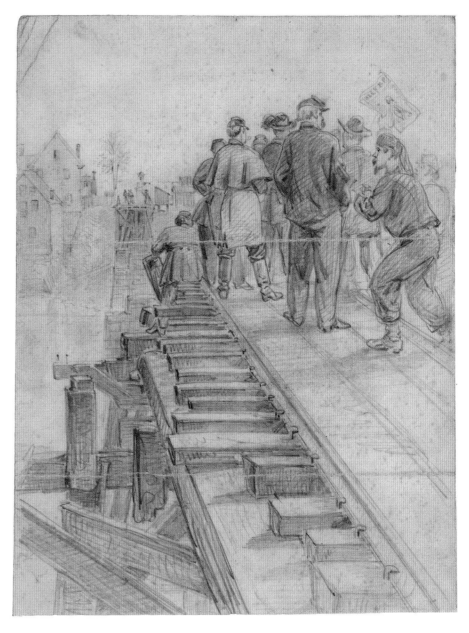

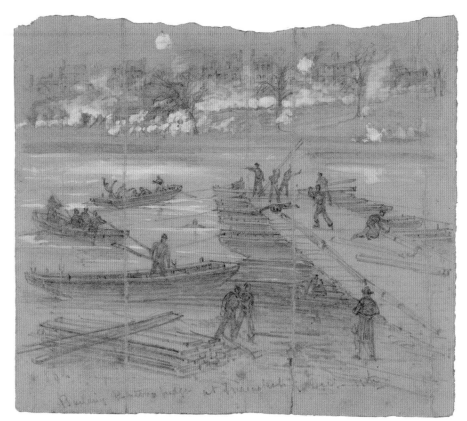

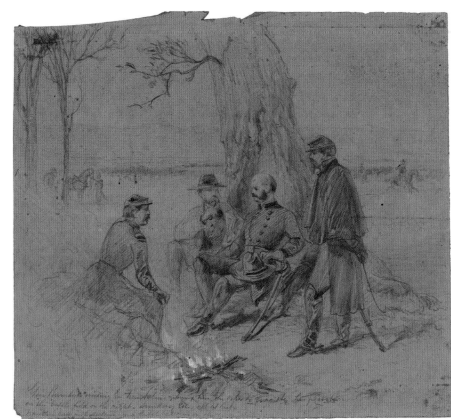

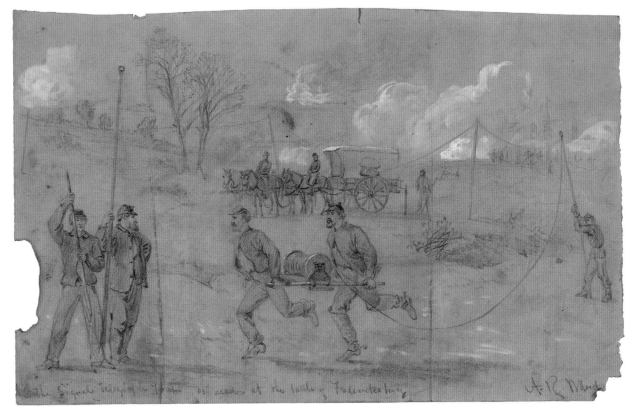

ABOVE, LEFT: **Alfred Waud,** *Building Pontoon Bridges at Fredericksburg Dec. 11 [1862],* December 11, 1862, Library of Congress.

ABOVE, RIGHT: **Arthur Lumley,** *Gen. Burndside [sic] Visiting Gn. Franklin Giving Him the Order to Evacuate His Position—on the Battlefield on the Right, Sunday Eve., All at Rest,* December 14, 1862, Library of Congress.

LEFT: **Alfred Waud,** *The Signal Telegraph Train as Used at the Battle of Fredericksburg,* December 13, 1862, *Harper's Weekly,* January 24, 1863, Library of Congress.

OPPOSITE: **Alfred Waud,** *Genl. Humphreys Charging at the Head of His Division after Sunset of the 13th Dec.,* December 13, 1862, *Harper's Weekly,* January 10, 1863, Library of Congress.

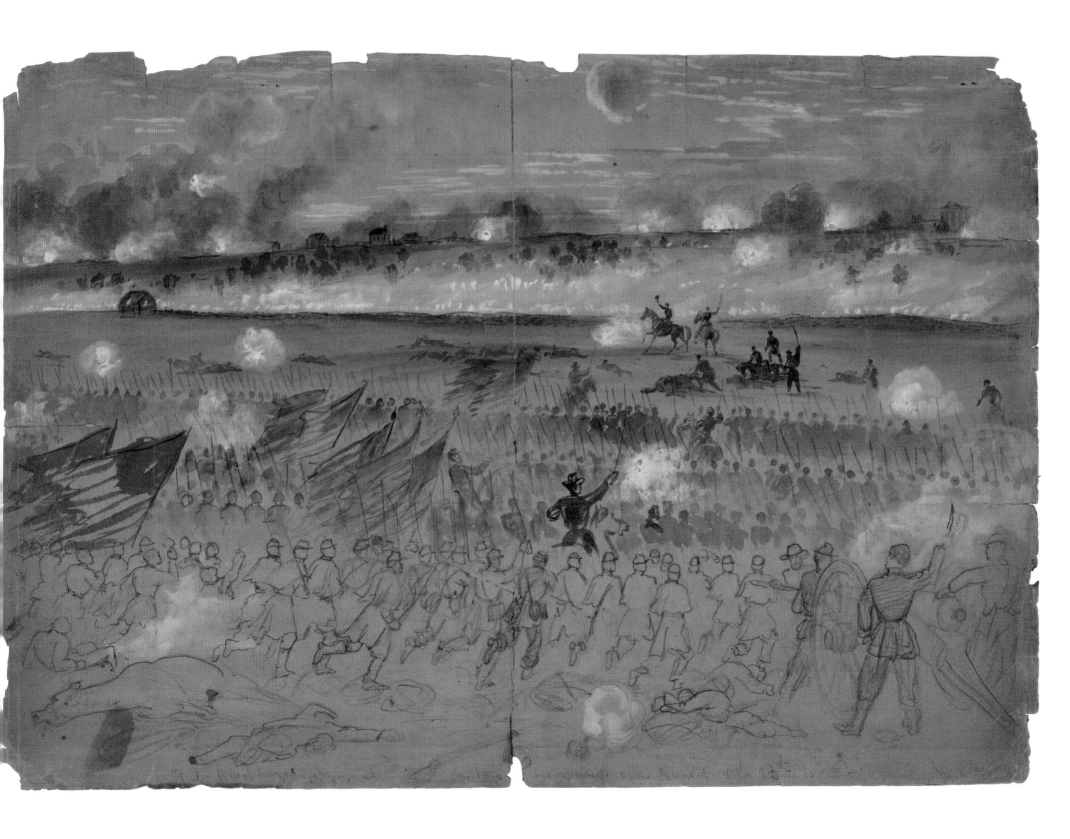

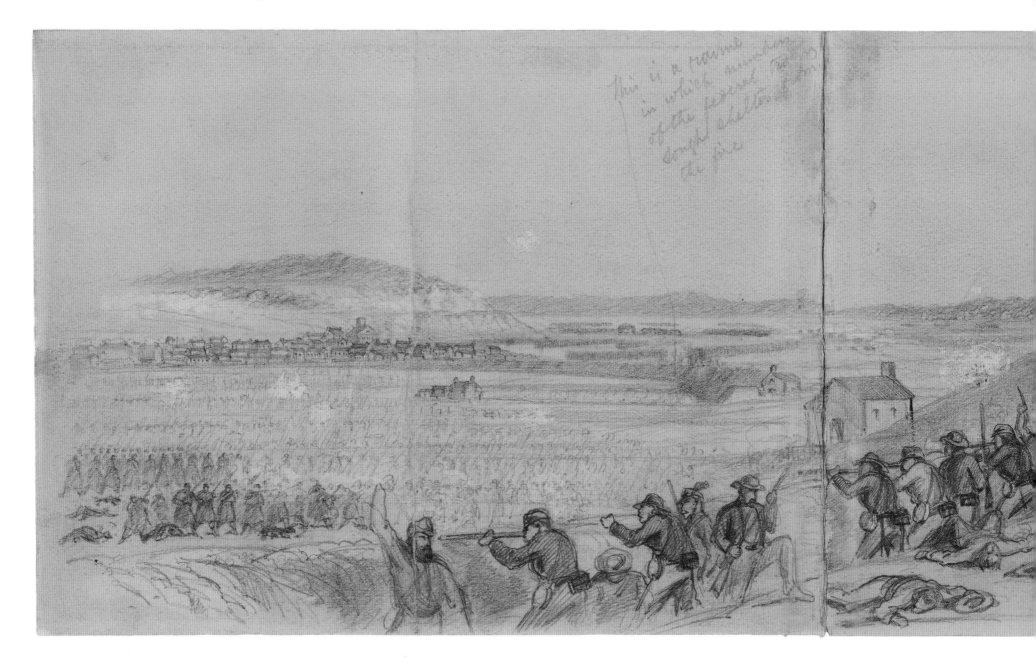

should shortly come over to look after us. "Yes," he answered; "so you will, under a guard.[39]

Soon, however, this peaceful late fall interlude shattered as Burnside, pressured by politicians and the press, ordered a general assault on Confederate positions dug in above the city. The Battle of Fredericksburg, fought between December 11 and 15, 1862, proved one of the war's great disasters as Burnside sent thousands of Union soldiers across the Rappahannock to die in the small hours of December 12. After initial troops cleared the city of lingering rebel snipers Union soldiers looted and ransacked buildings and residences. Lumley was on the spot to render a revealing sketch of Northern military misbehavior that *Leslie's* never published. The disgusted Special inscribed on the back of the sketch: "Friday Night in Fredericksburg. This night the city was in the wildest confusion sacked by the union troops = houses burned down furniture scattered in the streets = men pillaging in all directions—a fit scene for the French revolution and a discrace [*sic*] to the Union Arms—this is my view of what I saw."[40] (See page xix.)

Lumley then climbed atop the prominent local residence of Mayor Slaughter to draw the ensuing battle from an elevated vantage point and nearly came to

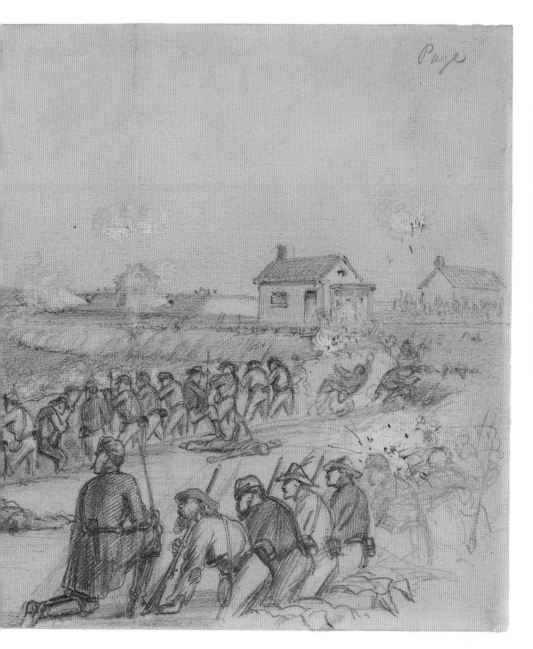

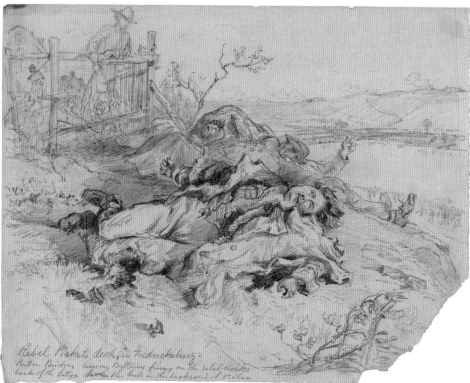

ABOVE: **Alfred Waud,** *Rebel Pickets Dead, in Fredericksburg. Pontoon Bridge, Union Batteries Firing on the Rebel Works Back of the City. From the Hill in the Background of Picture,* December 1862, Library of Congress.

LEFT: **Frank Vizetelly,** *The Battle of Fredericksburg. Assault of the Federals on Marye's Hill & the Battery of the Washington Artillery,* December 13, 1862, *Illustrated London News,* January 31, 1863, MS Am 1585, Houghton Library, Harvard University.

grief, according to his editors: "He writes us that when his drawing was about half finished, a large shell from the Rebels burst in front of the house, killing several officers who were standing about the door."[41] Alfred Waud drew a spectacular view of Union general Humphrey's troops massed below Marye's Heights awaiting their orders to charge the fortified rebel defenses above. In a chilling graphic counterpoint that might have given Burnside pause had he seen it, from the heights above Frank Vizetelly drew rows of Confederate soldiers in rifle pits, aiming down toward their Northern adversaries awaiting the order to fire. For three days thousands of Union dead and wounded lay untended on the field while Burnside's assault continued. Specials sketched the carnage and news of the crushing repulse stunned the Union.

With the Union defeat at Fredericksburg the year's military action came to an end in the east. The year 1862 was a turning point for the war and the Specials. They had witnessed a shocking escalation of violence and gore from Shiloh, through Antietam, Fredericksburg and numerous other battle sites. Any thoughts of a quick end to the conflict vanished. Like the soldiers they followed, the Specials knew they had been through hell. In the coming year the war would only get worse.

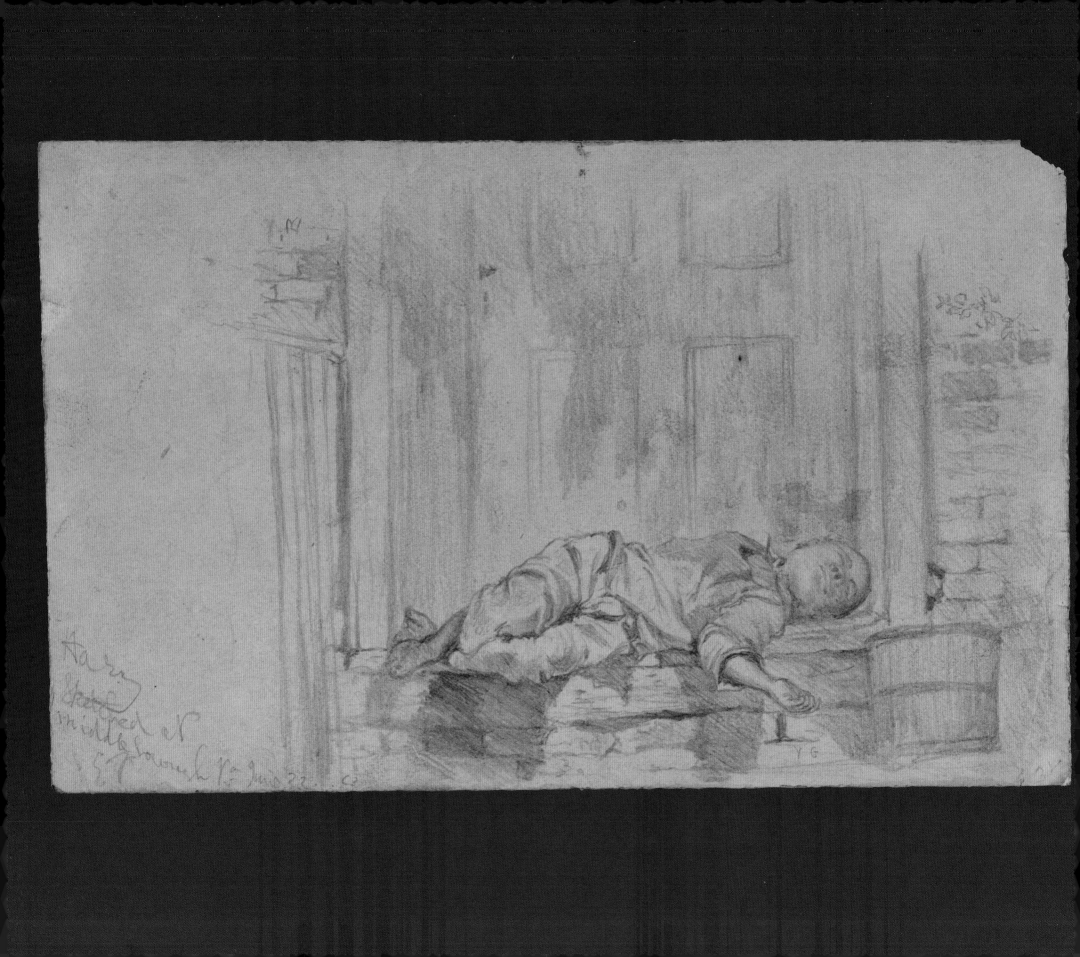

Emancipation Blues

The year 1863 opened in the North on a morally uplifting note with President Lincoln's Emancipation Proclamation but military reality lay with Burnside's bloodied army camped in the frozen mud on the Rappahannock opposite Fredericksburg. Meanwhile, in the west, Grant's army was bogged down in its attempts to take Vicksburg, the Confederate citadel on the Mississippi. Only the marginal victory by General William Rosecrans at the Battle of Stones River, fought between December 31 and January 2, raised Northern spirits. The Confederacy, having survived its second year and inflicted significant casualties and damage on the Union army, gave world leaders reason to consider it legitimate. The Northern New Year's newspapers overflowed with illustrations of Burnside's folly and its disastrous results. President Abraham Lincoln's watershed

Edwin Forbes, *Harry, the Innocent Contraband*, June 22, 1863, Library of Congress.

Edwin Forbes and Alf Woud documented Contrabands coming into Union camps or serving soldiers as cooks and valets. Frank Vizetelly recorded rebel soldiers entertained by black performers at night in camp, and wrote of his own affection for the Southern people and their ways. *Frank Leslie's* new Special Joseph Becker portrayed blacks with particular empathy and interest. Comic, stereotypical images of blacks did appear in the artists' work but, for the most part, African Americans were portrayed by the Specials with dignity and respect, as fellow citizens, soldiers, men, women and children. From the Union perspective, certainly, they were seen as human representations of one of the ultimate aims of the war, the abolition of slavery in the South.

Alfred Waud, *Black Soldier,* ca. 1863, Library of Congress.

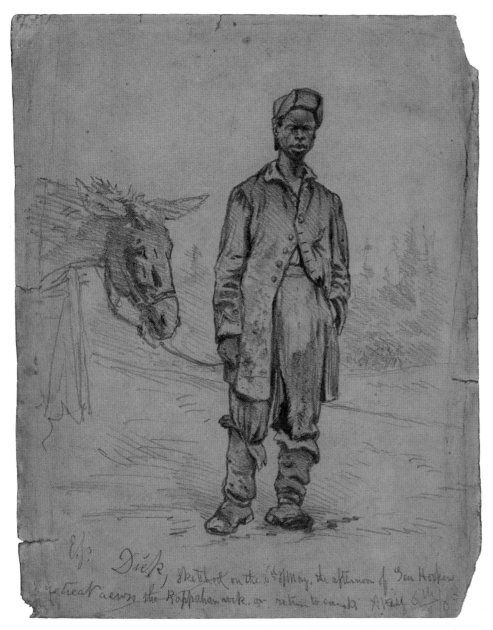

Edwin Forbes, Dick, *Sketched on the 6th of May, the Afternoon of Gen. Hooker's Retreat across the Rappahannock, on Return to Camp,* May 6, 1863, Library of Congress.

proclamation, which took effect on January 1, 1863 (and only in "Secessia"), gave moral purpose to the Union fight and a taste of freedom to Southern slaves. Increasingly, freed slaves became a part of the Union war effort and sketch artists drew images depicting the experiences of African Americans on both sides of the conflict.

Because of the standard delays in publishing images from the war, the American public relived Burnside's defeat at Fredericksburg in the pictorial press only after the New Year. The experience was like a terrible hangover. All the Specials weighed in. *Frank Leslie's* offered mighty praise for the Army of the Potomac's withdrawal across the Rappahannock, featuring a sketch by an unnamed soldier artist, *The Retreat to Falmouth, Va.*:

> We illustrate this week one of the darkest and yet the brightest pages in our history, for never did soldierly qualities shine through the gloom of a terrible disaster more brilliantly than on the night of Monday, the 15th December, when, disheartened and decimated by the frightful struggle of the previous Saturday, where division after division, and regiment after regiment were recklessly dashed against the iron impregnability of the heights of Fredericksburg, our glorious, and, though baffled, still indomitable army recrossed, in darkness and storm, that ill-omened Rappahannock, and regained their old position on the north side of the river.[1]

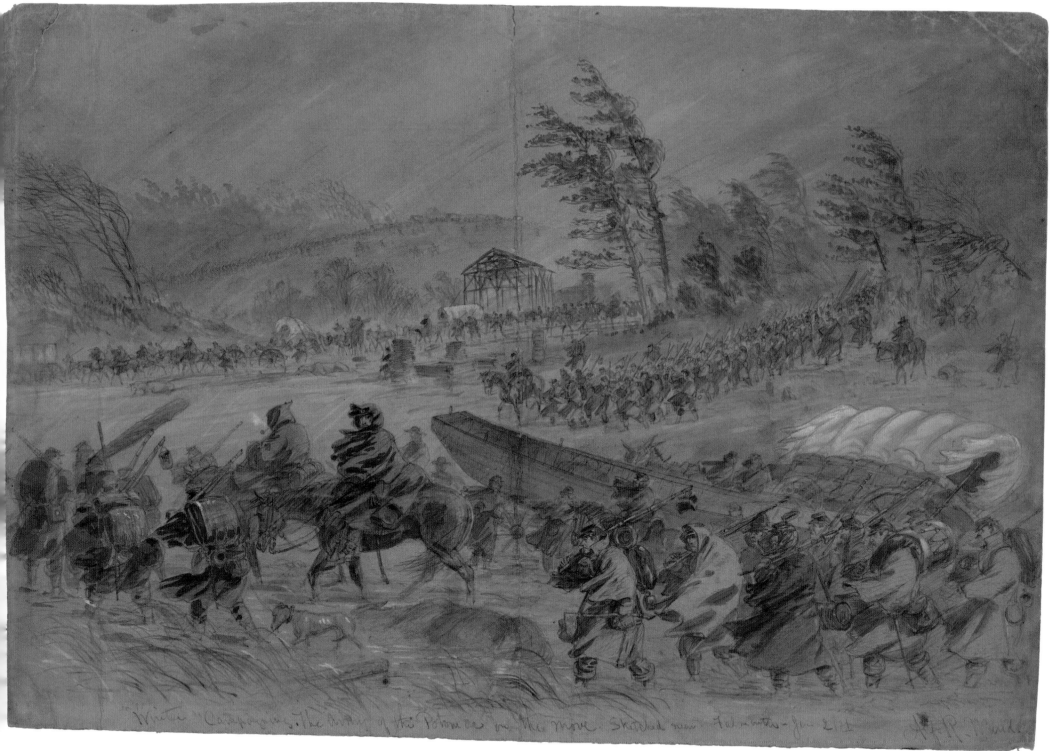

Alfred Waud, *Winter Campaigning. The Army of the Potomac on the Move. Sketched near Falmouth—Jan. 21st, [1863]*, January 21, 1863, *Harper's Weekly*, February 14, 1863, Library of Congress.

Harper's, featuring Alf Waud and Theodore Davis, provided comprehensive coverage. Waud's description of the battle includes the wounded left lying on the battlefield as evening fell and fighting ceased on December 13:

> Thus closed the battle, except for now and then the boom of a heavy gun from the heights and the constant sharp report of the rifles of the sharp-shooters. But the horrors of that night—the scenes of despair and gradual death upon that bloody ground in the bitter cold and darkness—can not be described. Imagination recoils from the cruelty of the scene. No help for the dying patriots on that awful night. To attempt to reach them was to share their fate. The murderous traitors, without remorse, shot down all who approached. Men with children dependent on them—men whose wives trembled for them—men who had been little children, and whose mothers would have feared to have a cold wind blow on them—there they lay. Of no avail affection; not for them the soothing touch, the warm chamber, and the thousand nameless attentions of kinsfolk. Drearily and with faint hope for the morrow, tired, bleeding, dying, they must stay, their noble efforts idly wasted in a fruitless struggle.[2]

Londoners did not get a chance to view Frank Vizetelly's sketches at Fredericksburg and read his account of the struggle until the end of January. From where he observed the battle in company with Confederate generals Lee and Longstreet, Vizetelly witnessed the barrage of artillery and ammunition raining down onto Union troops from Marye's Heights and other rebel defenses:

> I could see the grape, shell, and canister from the guns of the Washington artillery mow great avenues in the masses of Federal troops rushing to the assault, while the infantry, posted behind a breastwork just under the battery, decimated the nearest columns of the enemy. In the distance, Franklin's corps is seen deploying into line of battle on the Federal left. They have some field-batteries thrown forwards shelling the Confederate positions on the wooded range of hills. A portion of Fredericksburg is seen in the rear of the attacking forces, and beyond is the range of heights on the opposite side of the river from which the Northerners have heavy guns playing on Marye's Hill to cover the advance of their men. Numbers of their shell are bursting over the Confederate soldiers in the breastwork. It was here General Cobb was killed, and it is his brigade acting as sharpshooters. At the back of this

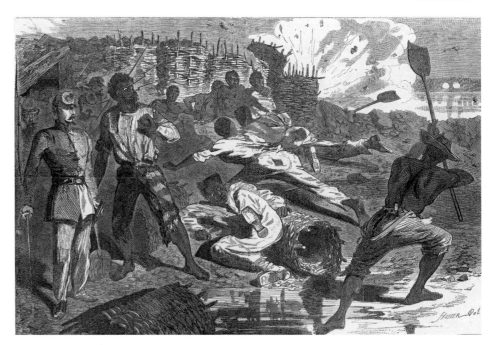

Winslow Homer, *A Shell in the Rebel Trenches, Harper's Weekly,* January 17, 1863, image provided courtesy of HarpWeek.

hill a South Carolinian had a portion of his head carried away within four yards of myself by a shell from the heights alluded to above.[3]

With the retreat to Falmouth, Burnside's army, and Lee's, moved into winter camp and the Specials' interest shifted once again to the daily incidents and drama of camp life. Theodore Davis depicted scenes entitled *The Army of the Potomac in Huts* for *Harper's* and Arthur Lumley contributed a medley entitled *Camp Scenes on the Rappahannock* for the *New York Illustrated News*.

Now flush with talent, *Harper's* published additional illustrations to pique their readers' interest. Alf Waud submitted the sketch *The Teamsters Duel*, "one of the humorous scenes in which our camps abound. When a quarrel arises between two colored teamsters a challenge passes, and the combatants lash each other with their long whips until one of them confesses that he can endure no more, and 'throws up the sponge.'" Winslow Homer contributed a drawing entitled *The Shell In The Rebel Trenches*, illustrating "an event of not uncommon occurrence. The secesh chivalry generally place their negroes in the post of danger; and when our gunners get the range of their works and drop a well-aimed shell into them, the skedaddle which ensues is such as Mr. Homer has depicted." The spirit of the times dictated that African Americans be treated comically in

Thomas Nast

At *Harper's*, Thomas Nast was on his way toward becoming America's most influential editorial cartoonist. Employing his considerable skills in the arts of caricature and propaganda to support the Lincoln Administration and Republican Party, he demonized the rebels and advocated Emancipation. He celebrated the president's proclamation in *The Emancipation of the Negroes, January, 1863*. He defended blacks and attacked the South in a visual compendium of Confederate atrocities entitled *Historic Examples of Southern Chivalry, Illustrated by Thomas Nast—Dedicated to Jeff Davis*. This double-page cartoon comprised vignettes of secessionist atrocities surrounding a central scene depicting a savage C.S.A. trooper holding aloft the severed head of a dead Union soldier. Nast's powerful graphic commentary, following press reports and rumors, inflamed public support for the Northern war effort.

Nast heaped derision on those in the North who opposed the war effort and sought negotiated peace with the Confederacy. Mostly Democrats, called "Copperheads" by political opponents who likened them to snakes in the grass, these citizens eventually created their own political movement supporting the former head of the Union Army of the Potomac General George B. McClellan against Lincoln in the 1864 presidential election. In perhaps the single most important cartoon of his entire career, entitled *Compromise With the South* (see page 193), drawn on the eve of the 1864 Democratic convention held in Chicago, Nast savaged McClellan and his followers for defaming the memory of dead Union soldiers and sullying their ultimate sacrifice. Well before the war's end, Nast already "waved the bloody shirt" of dead and wounded war veterans and their families on behalf of Lincoln, the Republican Party and the Union. On the strength of Nast's cartoons and several fortunate, well-timed Northern victories, Lincoln won election over the man who formerly commanded his forces in the field.

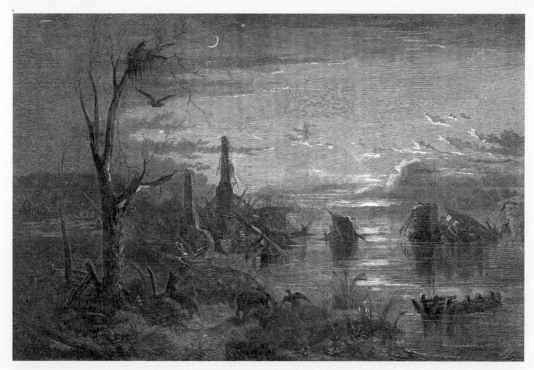

Thomas Nast, *The Result of War—Virginia in 1863, Harper's Weekly,* July 18, 1863, image provided courtesy of HarpWeek.

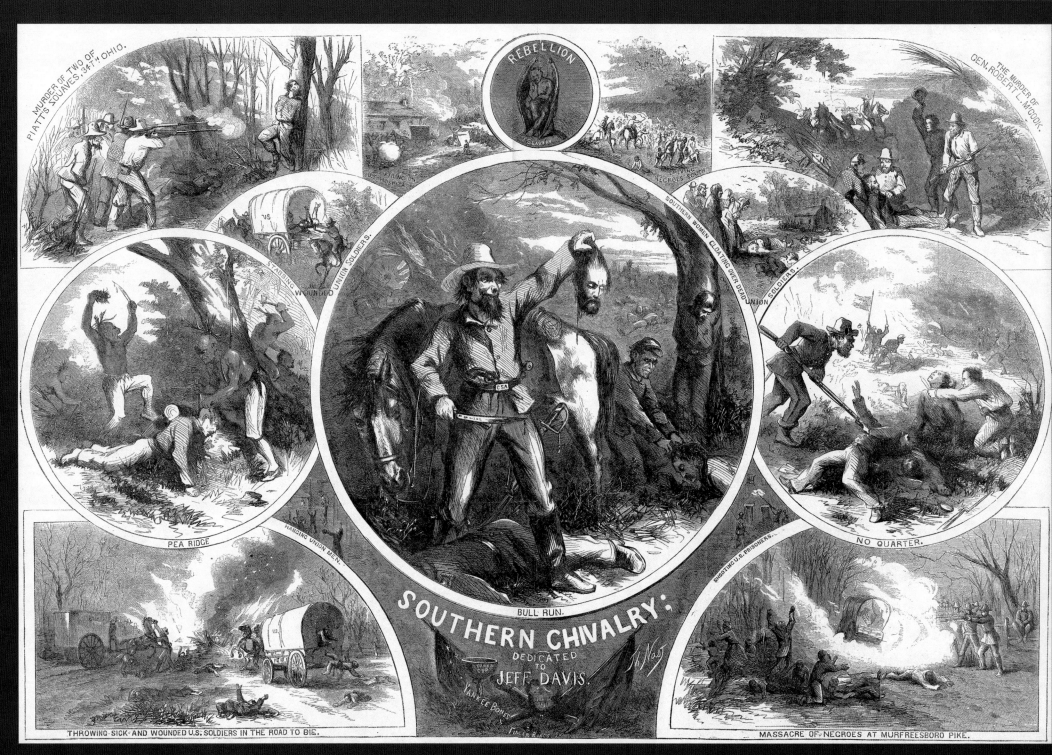

Thomas Nast, *Historic Examples of Southern Chivalry, Illustrated by Thomas Nast—Dedicated to Jeff Davis, Harper's Weekly,* February 7, 1863, image provided courtesy of HarpWeek.

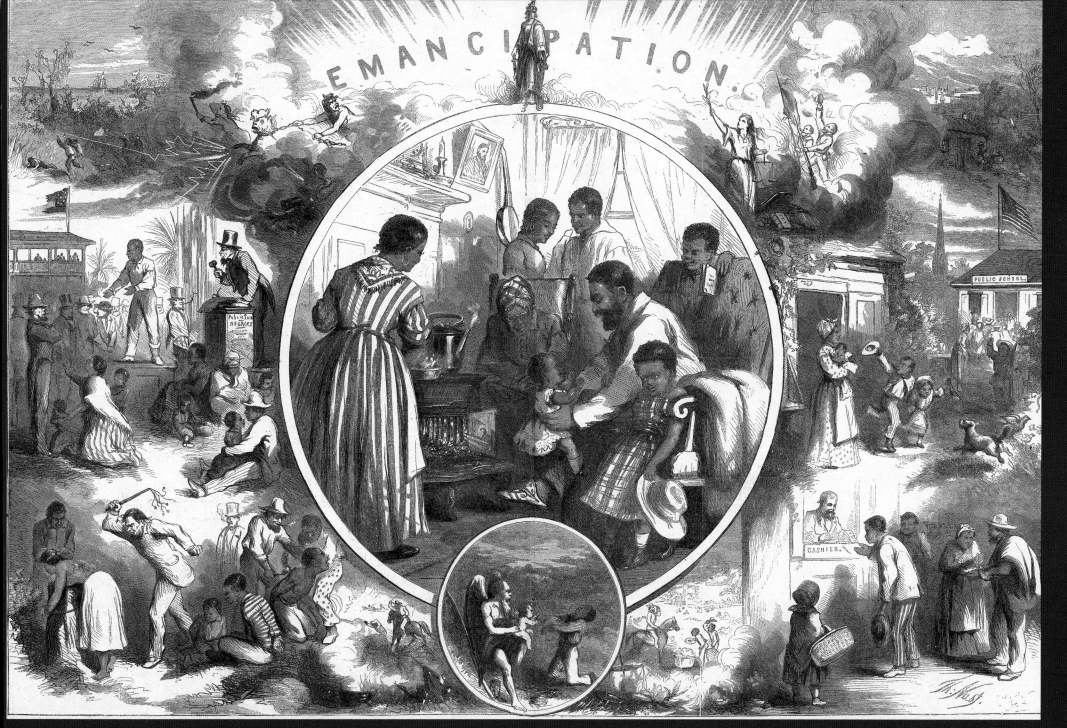

Thomas Nast, *The Emancipation of the Negroes, January, 1863—the Past and the Future, Harper's Weekly,* January 24, 1863, image provided courtesy of HarpWeek.

Thomas Nast, *The War in the West, Harper's Weekly,* January 17, 1863, image provided courtesy of HarpWeek.

the mainstream press; Homer authority David Tatham has noted the irony that *Harper's* published the comic sketches by Waud and Homer in the same edition as Lincoln's Emancipation Proclamation.[4]

Though opinion varied in the North, the Emancipation Proclamation inspired great interest among Northern readers in the fate of blacks in the secessionist South. The artists responded with varying levels of compassion and concern. J. R. Hamilton seems genuinely surprised by his positive first impression of black troops in Louisiana:

> Truth and honesty compel me to state that, as far as the privates were concerned, a more decent, orderly, obedient, and soldierly set of men I never saw; while, as regards the officers, had I come in contact with the same number of white men, taken at random, I could not have expected to find more general intelligence, education, and refinement.[5]

Theodore Davis openly advocated for black emancipation. Upriver from Hamilton, outside Vicksburg, Theodore Davis and Henri Lovie chronicled Grant's siege of the city. In early spring 1863 they drew Union engineers cutting canals to allow gunboats to bypass rebel batteries on the Mississippi. Davis offered a sketch illustrating

> an exploit of one of the negro soldiers, who went out in company with a small force of soldiers a few days since, shot one rebel soldier, captured two more, and taking their guns from them, brought the captured twain through the swamp to the party. The name of this bold African is *Jim*— 'Union Jim' the soldiers call him—and there are many more like him, brave and ready, who are to be armed and schooled as soldiers. Upon the other side of the map a sketch of the constantly recurring event, the coming in of what the soldiers call recruits of color; a stalwart negro with his little one riding 'pig-a-back,' and the family trudging along after.[6]

Davis's bold "Union Jim" and Hamilton's decent, intelligent soldier both contrast sharply with Frank Vizetelly's description of Southern blacks. The London Special, apparently assimilated to Southern views, wrote from Charleston in April, "As a rule, the negroes appear to be the most contented labourers at this and similar work imaginable, and, what with their singing and constant chattering, do as little for their living as any class of men I ever saw."[7]

Fighting began again in earnest while winter still held sway in early 1863. In the west and southwest the Union armies came at the rebels from all directions.

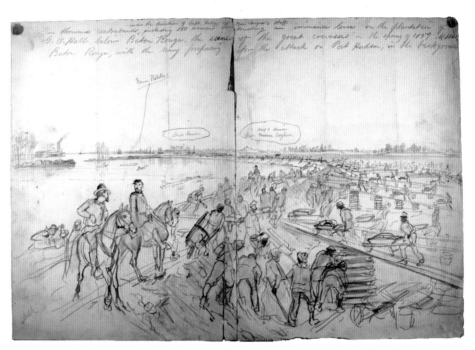

Frank Schell, *One Thousand Contrabands Building a Levee on the Mississippi River March 13, 1863,* March 13, 1863, *Frank Leslie's Illustrated Newspaper,* May 9, 1863, courtesy of the Becker Collection, Boston, MA.

Frank Schell, *The Steam Sloop Monongahela Experimenting upon the Batteries in Port Hudson, Louisiana,* March 14, 1863, courtesy of the Becker Collection, Boston, MA.

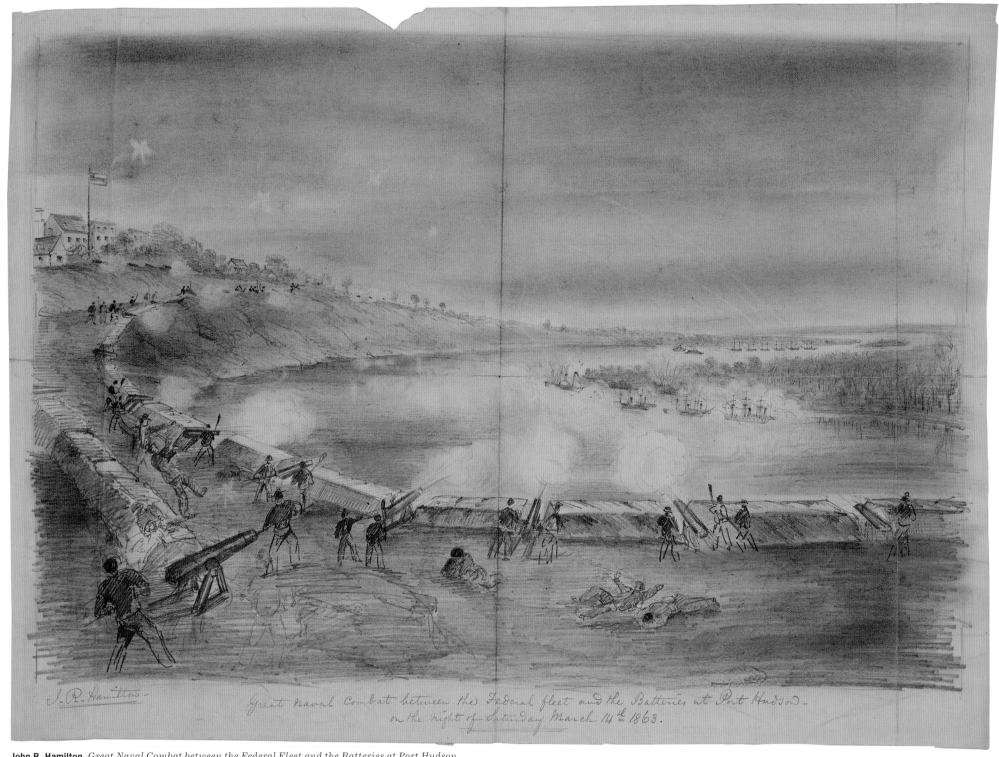

John R. Hamilton, *Great Naval Combat between the Federal Fleet and the Batteries at Port Hudson,*
La., ca. March 14, 1863, *Harper's Weekly,* April 18, 1863, Museum of Fine Arts, Boston.

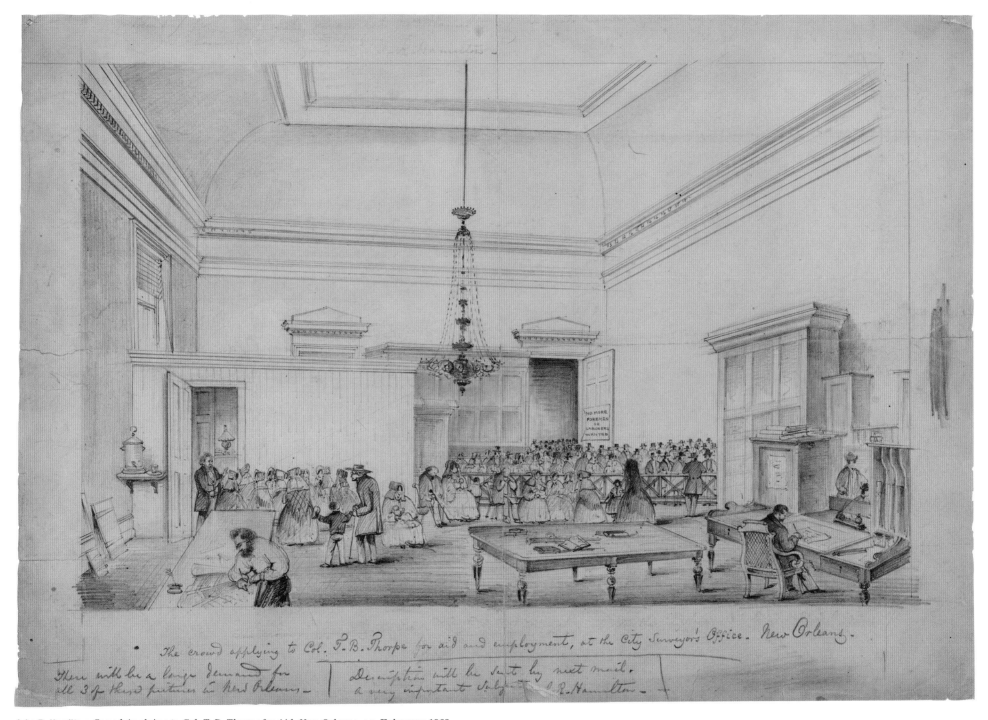

The crowd applying to Col. T. B. Thorpe for aid and employment, at the City Surveyor's Office. New Orleans.

There will be a large demand for all 3 of these pictures in New Orleans.

Description will be sent by next mail, a very important Subject. J. R. Hamilton.

John R. Hamilton, *Crowd Applying to Col. T. B. Thorpe for Aid, New Orleans,* ca. February 1863,
Harper's Weekly, March 7, 1863, Museum of Fine Arts, Boston.

Frank Schell, *Plantation Families Coming into the U.S. Commissary for Food, near Vicksburg, Miss.,* July 1863, *Frank Leslie's Illustrated Newspaper,* August 10, 1863, Print Collection, Miriam and Ira D. Wallach Division of Art, Prints and Photographs, the New York Public Library, Astor, Lenox and Tilden Foundations.

Grant moved from Corinth up the Mississippi toward Vicksburg, while General Nathaniel Banks led a combined army-navy force against Port Hudson, upriver from Baton Rouge. Frank Schell represented *Frank Leslie's* with the Banks Expedition while John R. Hamilton drew the assignment for *Harper's.* W. R. McComas, on staff for *Leslie's,* was also in the west, with Grant's troops in Arkansas at the Battle of Arkansas Post and the capture of Fort Hindman.

In late January 1863 as Banks and Grant moved on the Mississippi, Burnside re-emerged on the Rappahannock. Eager to get a jump on Lee's army camped across the river, he planned a surprise crossing designed to flank the rebel army. Two days of unrelenting rain turned roads into quagmires and Burnside's movement into a morass of men, horses, wagons and pontoons. Forced to turn back without crossing or fighting, the Army of the Potomac watched three days later as President Lincoln removed Burnside from command and replaced him

with General Joseph Hooker. Alfred Waud's double-page drawing, *Mud March,* recreates the suffering of the soldiers and the infamous conditions along the Rappahannock. Waud's empathy for the foot soldier—sent on a mad mission by a foolhardy general—infuses this large, finished sketch. The men and their ragged dog appear wretched but unbowed; they will persevere, overcoming the enemy and the mistakes of their misguided officers.

Across the Rappahannock River, Alfred Waud's counterpart and countryman Frank Vizetelly sat relatively warm and dry in the Confederate camp with generals Lee, Longstreet, Stuart and Jackson. Comfortable in his choice to side with secession, Vizetelly rendered portraits of its military leaders for his English audience. The *Illustrated London News* published his sketches of Lee and Jackson and copies of the same engravings appeared in *Harper's Weekly* one month later. Images from life of Confederate military leaders were rare and commercial gold

Edwin Forbes, *Winter Camp near Stoneman's Switch, Falmouth, Va.,* ca. January 1863, Library of Congress.

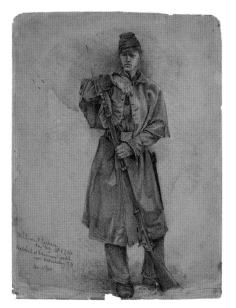

Edwin Forbes, *Study of Infantry Soldier On Guard—William J. Jackson, Sergt. Maj. 12th N.Y. Vols—Sketched at Stoneman's Switch, near Fredricksburg [sic], Va. Jan. 27th, 1863,* January 27, 1863, Library of Congress.

to publishers. *Harper's* scored a journalistic scoop and circulation windfall with the Vizetelly sketches, which they likely copied onto blocks for their own use before sending them on to London. The English journal quickly complained:

> The gentleman who has for some time past acted as our Special Artist and Correspondent in the Southern States of America finds the greatest difficulty in sending us the results of his labours. Our readers will no doubt remember that a short while back an English officer was arrested while running the blockade, and that the possession of correspondence addressed to us was held, amongst other causes, sufficient to warrant his detention and imprisonment. Upon that occasion the sketches found in his possession were forwarded not to us, but to the managers of *Harper's Weekly*, in New York, in the columns of which paper they in due time appeared, with a naïve acknowledgement that they were from the pencil of Mr. Vizetelly.
>
> But the large proportion of the Sketches intercepted on their way from the South are doomed never to see the light of day. "What," asks our Correspondent, in the last letter received from him, "has become of

Jackson's head-quarters, Lee's head-quarters, Stuart's head-quarters, encampment of the Confederates on the Shenandoah, view of Winchester, and many others? Where are all my letters from the Rappahannock and Richmond, one only of which is inserted, and which has been quoted in all the Southern papers?" Our readers may learn from the above that the long intervals which frequently elapse between our news and engravings of the progress of the war in the Southern States of America arise from no lack of spirit or industry on the part of our Special Artist, but from the impenetrability of the cordon which the North has succeeded in drawing around the seceded provinces. In reference to this subject—the difficulty, namely, of holding postal communication with England—Mr. Vizetelly mentions the fact that the *Times'* correspondent is said to pay 100 dols. in gold to every messenger who attempts to run the blockade with his letters from the Southern camp to Baltimore, and that they are frequently lost by his emissaries being captured on the Potomac.[8]

Vizetelly remained with the Confederate troops through the spring and arrived in Charleston in April in time to witness the siege and battle. He watched as the rebels repulsed the Union attack on Charleston Harbor's forts, then left for General Joseph Johnston's army in the southwest moving toward Vicksburg. There, Vizetelly insisted, would be decided "the duration of the war."[9]

At Vicksburg, Vizetelly worked opposite his Northern colleagues illustrating the campaign. Fred Schell had been there all along with Grant's army while Theodore Davis arrived just in time to chronicle the Union's successful surge to victory. Following Grant's army, Davis's reports describe scenes of devastation left by Union troops raiding rebel property in the South. They foreshadow the relentless total warfare Grant and Sherman pursued later in the east. In June, at Vicksburg, Davis looked on and kept his head down:

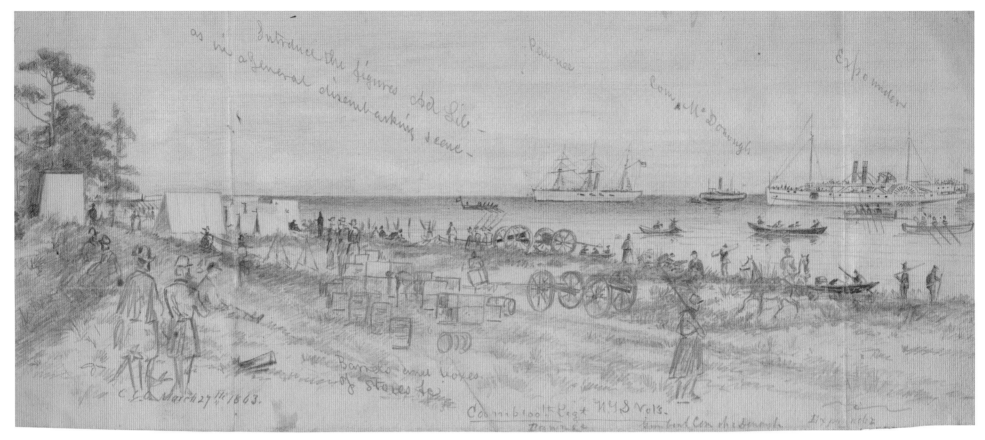

W. T. Crane, *The Advance upon Charleston—Landing of the 100th New York upon Coles Island,*
March 27, 1863, courtesy of the Becker Collection, Boston, MA.

A most gallant but unsuccessful attempt was made upon the 21st inst. to carry these works by assault. Since that time the sharp-shooters upon either side have been busy enough. The ping of a shot is sure to follow the exposure of any portion of one's person. My pony and sketch-book bear indubitable evidence that sketching in plain view of sharp-eyed rebels must be rapid enough.[10]

Fred Schell, *Leslie's* Special at Vicksburg, produced a stunning series of images during the final days of the siege. Schell shared the trenches with Union troops and witnessed the damage wrought within the city. He drew the fighting but also illustrated the mean conditions under which citizens and soldiers on both sides lived, the landscape "studded with the rude huts or quarters burrowed in the earth."[11] The fall of Vicksburg and opening of the Mississippi dominated coverage in the popular pictorial press during July. Schell and Davis both sent stirring images of Confederate general Pemberton's surrender and Grant's entrance into the city. Frank Vizetelly made his way with rebel volunteers as far as the outer federal pickets, twelve miles from Vicksburg. After staying to make a few drawings, he soon returned east.

Meanwhile, as Grant invested Vicksburg, events in Virginia in spring 1863 unfolded along the Rappahannock River. Edwin Forbes thought it was not a moment too soon:

[The most wearing thing in the world, the very essence of *ennui*, is winter quarters. And when to this are added insufficient accommodation, sixteen inches of mud which throws Spalding's glue into the shade, with the drowsy accompaniment of the wettest kind of rain varied with snow, you have a dreary purgatory in its highest state of cultivation.[12]

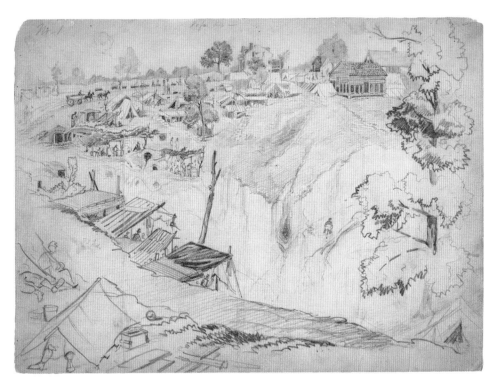

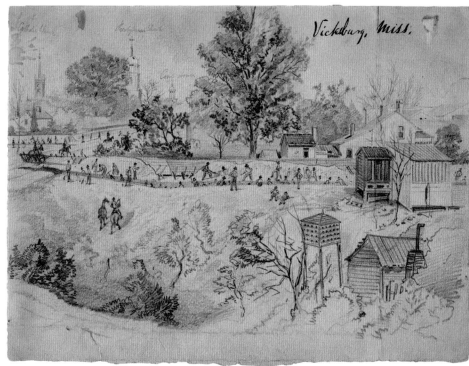

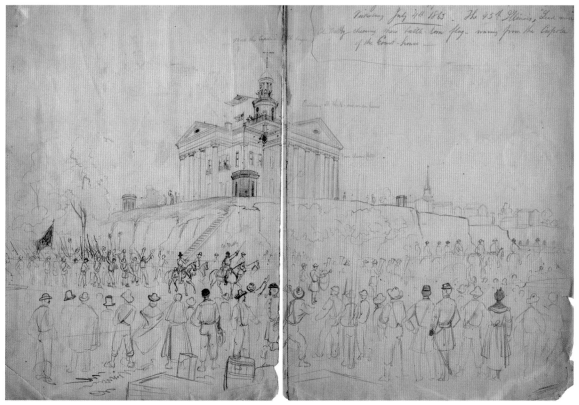

ABOVE, LEFT: **Fred Schell,** *Siege of Vicksburg—Life in the Trenches*, May–June 1863, *Frank Leslie's Illustrated Newspaper*, August 15, 1863, courtesy of the Becker Collection, Boston, MA.

ABOVE, RIGHT: **Fred Schell,** *Siege of Vicksburg—Soldiers at Work on the Fortifications*, May–June 1863, *Frank Leslie's Illustrated Newspaper*, August 15, 1863, courtesy of the Becker Collection, Boston, MA.

LEFT: **Fred Schell,** *Siege of Vicksburg—Entering Vicksburg, July 4th, 1863*, July 4, 1863, *Frank Leslie's Illustrated Newspaper*, August 15, 1863, courtesy of the Becker Collection, Boston, MA.

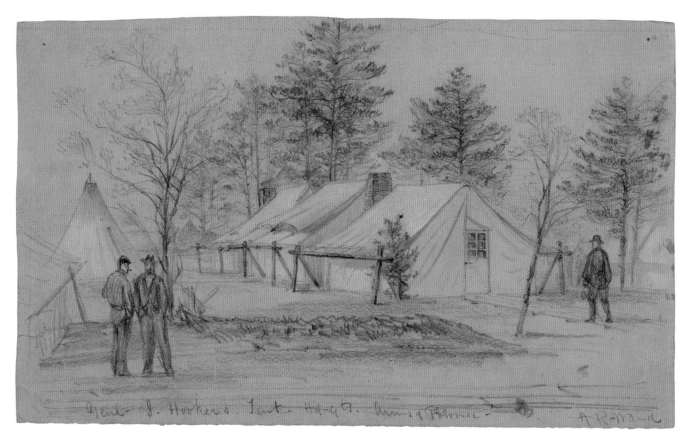

LEFT: **Alfred Waud,** *Genl. J. Hooker's Tent Hdqts. Army of Potomac,* ca. March 1863, *Harper's Weekly,* April 18, 1863, Library of Congress.

BELOW: **Alfred Waud,** *Commissary Dept. Hdqtrs. Army of the Potomac,* March–April 1863, *Harper's Weekly,* April 18, 1863, Library of Congress.

OPPOSITE: **Alfred Waud,** *Marriage at the Camp of the 7th N.J.V. Army of the Potomac, Va.,* March 18, 1863, *Harper's Weekly,* April 4, 1863, Library of Congress.

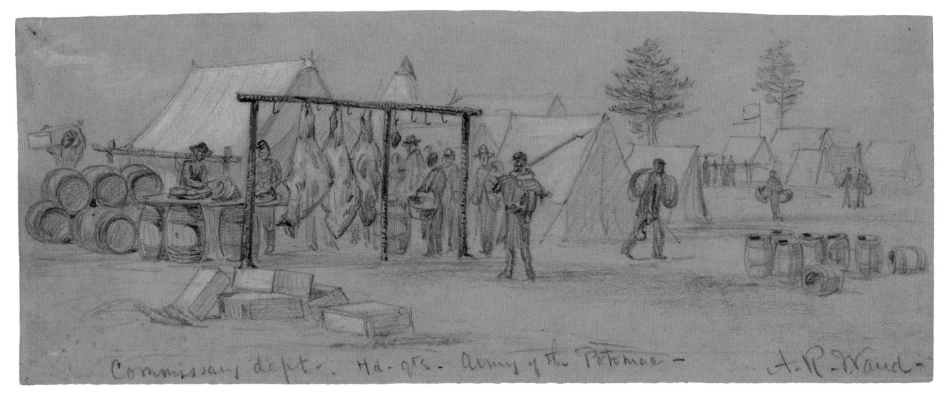

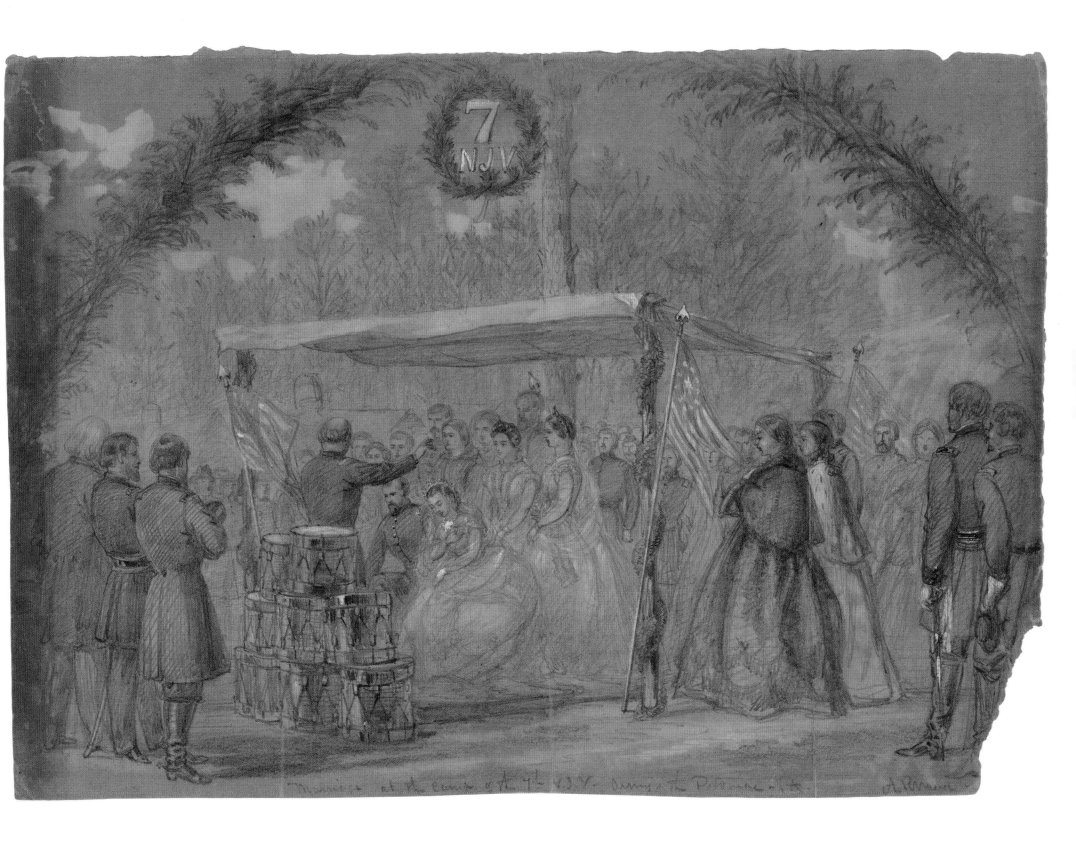

Marriage at the Camp of the 7th NJV. Army of the Potomac...

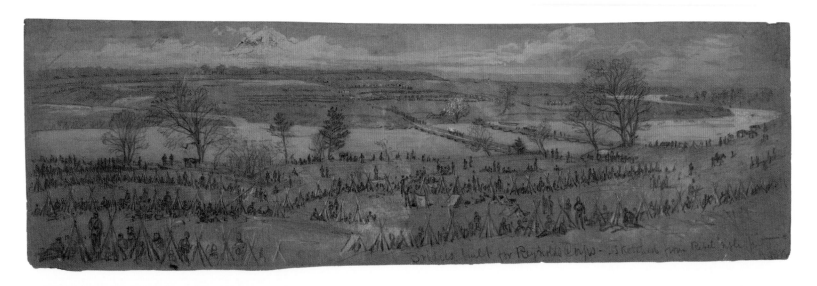

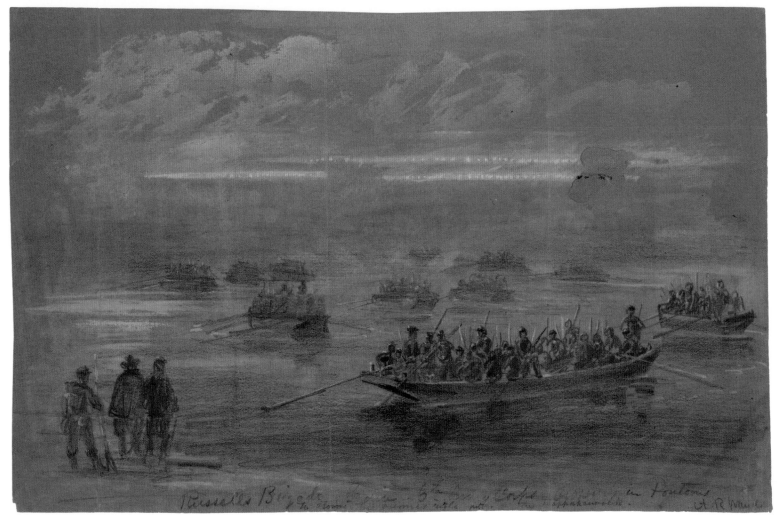

ABOVE: **Alfred Waud,** *Bridges Built for Reynolds Corps, Sketched from Rebel Rifle Pits,* ca. April 28–30, 1863, *Harper's Weekly,* May 16, 1863, Library of Congress.

LEFT: **Alfred Waud,** *Russells Brigade, 1st Div. 6th Army Corps, Crossing in Pontoons to Storm the Enemies Rifle Pits on the Rappahannock,* April 1863, *Harper's Weekly,* May 16, 1863, Library of Congress.

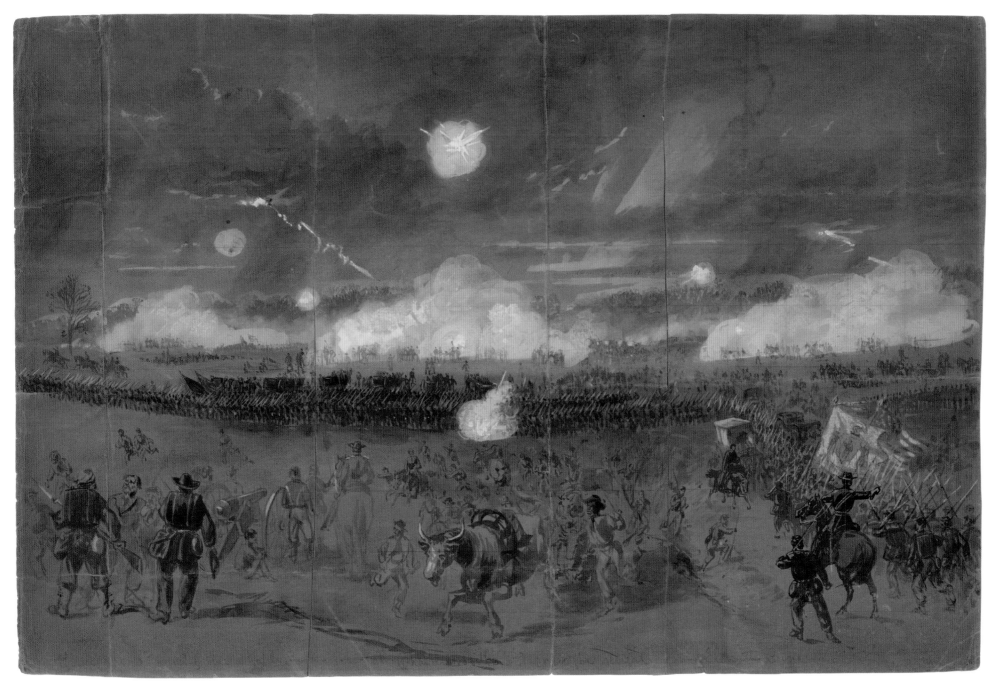

Alfred Waud, *Couch's Corps Forming Line of Battle in the Fields at Chancellorsville to Cover the Retreat of the Eleventh Corps Disgracefully Running Away*, ca. May 1–3, 1863, Library of Congress.

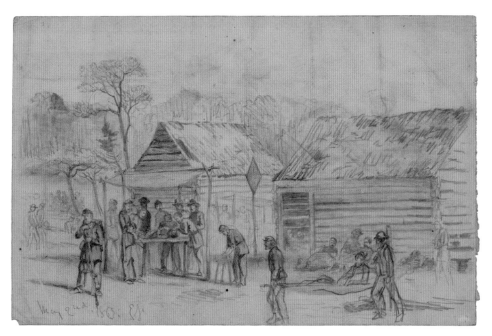

Edwin Forbes, *Field Hospital (Second Corps) on the Battlefield of Chancellorsville*, May 2, 1863, Library of Congress.

Forbes saw action soon enough beginning at Chancellorsville, where Arthur Lumley and Alfred Waud also produced complementary portfolios. During this key clash, Lumley sketched the compelling yet ultimately secondary action around Fredericksburg, where Union troops under General Sedgwick moved on Confederate forces led by General Jubal Early. Waud witnessed the main event taking place along the Rappahannock at Chancellorsville. There Union generals Hooker, Meade, Sickles, Couch, Howard and Slocum faced off against Southern leaders Lee, Anderson, McLaws, Stuart and the legendary Stonewall Jackson, mortally wounded there by friendly fire. The South lost their inspirational leader but the North was soundly thrashed, out-generaled again, with Hooker injured and replaced in the aftermath by Meade.

The Army of the Potomac reorganized yet again and recovered from its losses over the next several weeks while Lee and his generals planned another Northern invasion, this time through Pennsylvania. Rumors flashed through the state and citizens in Philadelphia and other municipalities in the commonwealth armed themselves, prepared for the worst. As the rebel army moved

Alfred Waud, *Entrance to Gettysburg—Sharpshooting from the Houses*, ca. July 1, 1863, Library of Congress.

north, Stuart's cavalry made forays and met resistance from the expanded Union horsemen led by General Alfred Pleasonton and General John Buford. Waud wrote:

CHARGE OF A PORTION OF BUFORD'S COMMAND.

This charge had to be made across a meadow intersected by four ditches, in jumping which some horses fell, their riders getting trampled under foot. At the other side of this field the ground rose to the woods, which also extended along the right flank. On the left of the road, upon the ridge, was a house used as Stuart's head-quarters, afterward captured—to its left a battery which shelled our men till they closed upon the rebs, the case and canister killing more of their men than ours.[13]

Buford is credited with recognizing the imminent danger posed by the large force of rebel troops he encountered at Gettysburg, Pennsylvania, on July 1 and immediately calling for support to establish a defensive position. Over three days the Union Army, its leaders and fighting men, were tested almost beyond endurance. The names of Meade, Hancock, Chamberlain and Custer number

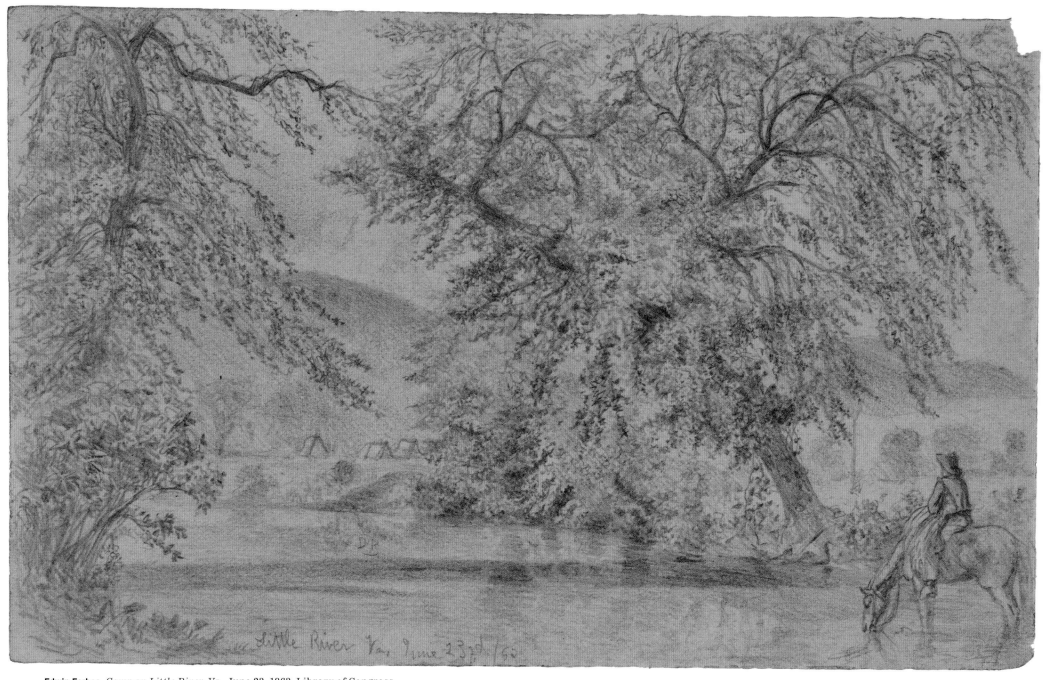

Edwin Forbes, *Camp on Little River, Va.*, June 23, 1863, Library of Congress.

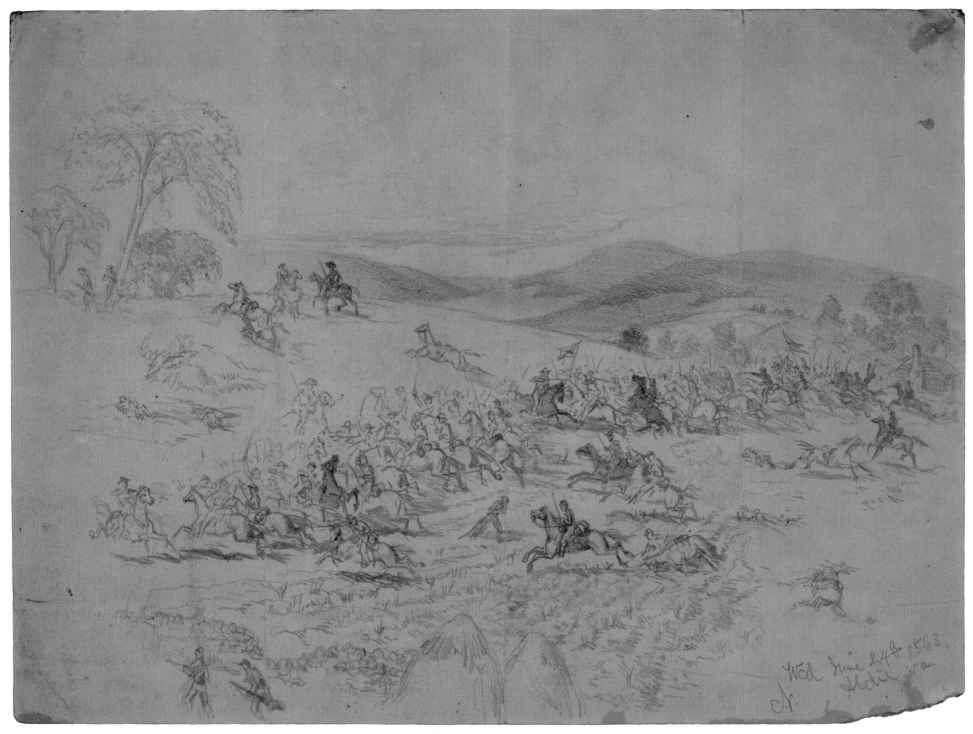

Edwin Forbes, *Cavalry Fight near Aldie, Va. During the March to Gettysburg; the Union Cavalry; Commanded by Gen. Pleasonton, the Confederate by J.E.B. Stuart June 24, 1863,* June 24, 1863, Library of Congress.

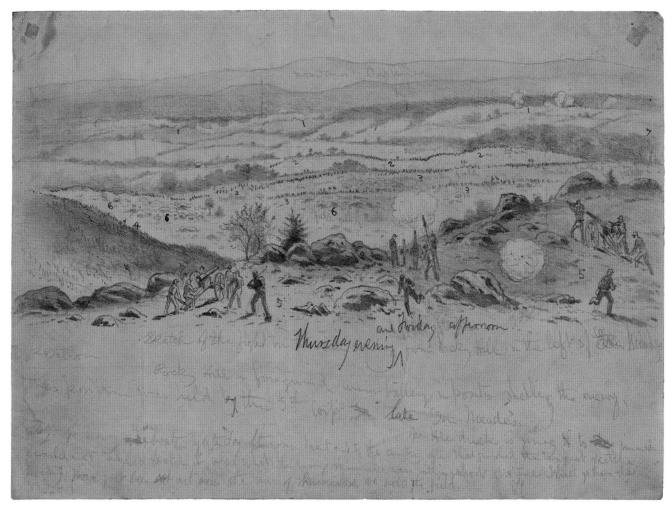

Edwin Forbes, *The Battle of Gettysburg. View from the Summit of Little Round Top. The Advance of Genl. Longstreet's Corps on the Union Position (5th Corps) on Little Round Top, Thursday Evening and Friday Afternoon,* July 2, 1863, Library of Congress.

among the Union heroes who overcame the weight of Southern military strategy, cunning and determination and led their troops to victory.

As the action at Gettysburg unfolded on the first day of the war's most epic battle only one Special made it into the field. Alf Waud arrived on July 1, and began creating sketches for what would become the most memorable portfolio of his career. Over the next several days he covered some of the battle's most sacred ground, iconic figures and scenes: the Devil's Den, Pickett's Charge at Cemetery Hill, the Louisiana Tigers, and General Winfield S. Hancock. Edwin Forbes showed up that evening and quickly made up for lost time. Again, as at Antietam,

while Waud's heated combat sketches convey the violent fervor of war, shot and shell and hand-to-hand combat, Forbes's cooler wide-angle views, by encompassing men, horses, artillery batteries and munitions wagons, landscape, tactics and strategy, seem to keep an emotional and physical distance.

The irony of the Specials' spectacular coverage of Gettysburg is that precious few of their images found their way into print. Most of the sketches reproduced here were never seen by the public. When pictures and accounts of the Union's epic July 4th victory at Gettysburg reached the presses at *Harper's, Leslie's,* and the *New York Ilustrated News* in Manhattan, there was little room left for the edi-

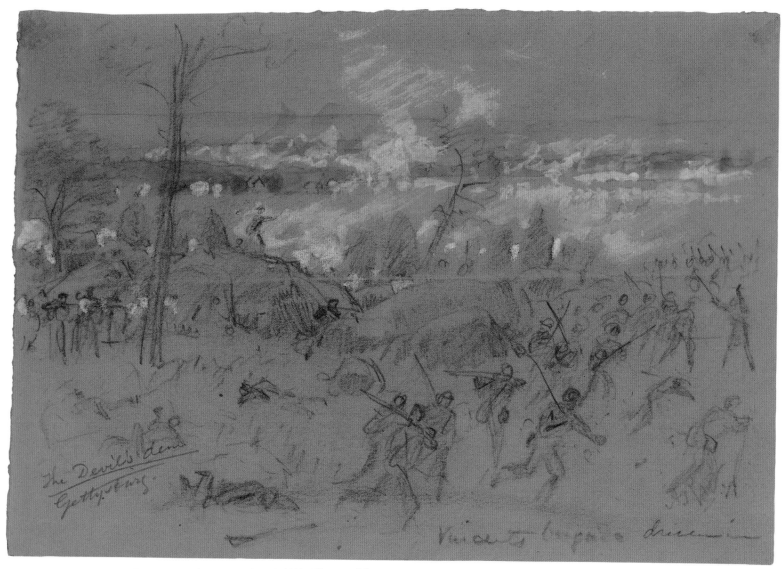

ABOVE: **Alfred Waud,** *The Devil's Den Gettysburg,* ca. July 1–2, 1863, Library of Congress.

RIGHT: **Alfred Waud,** *Appearance of Cemetery Hill Previous to Pick[ett's] Charge,* July 3, 1863, *Harper's Weekly,* August 8, 1863, Library of Congress.

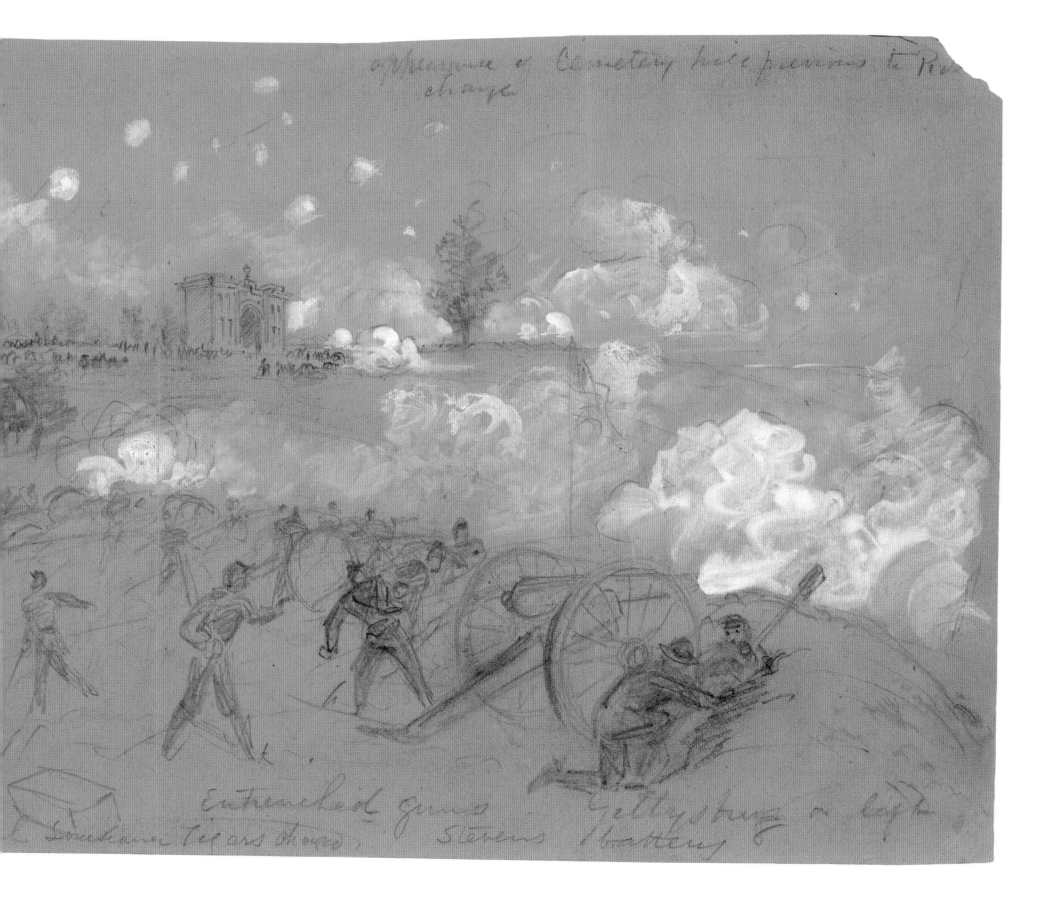

appearance of Cemetery hill previous to Pickett's charge

Entrenched guns ... Gettysburg on left
Louisiana Tigers charged ... Stevens Battery

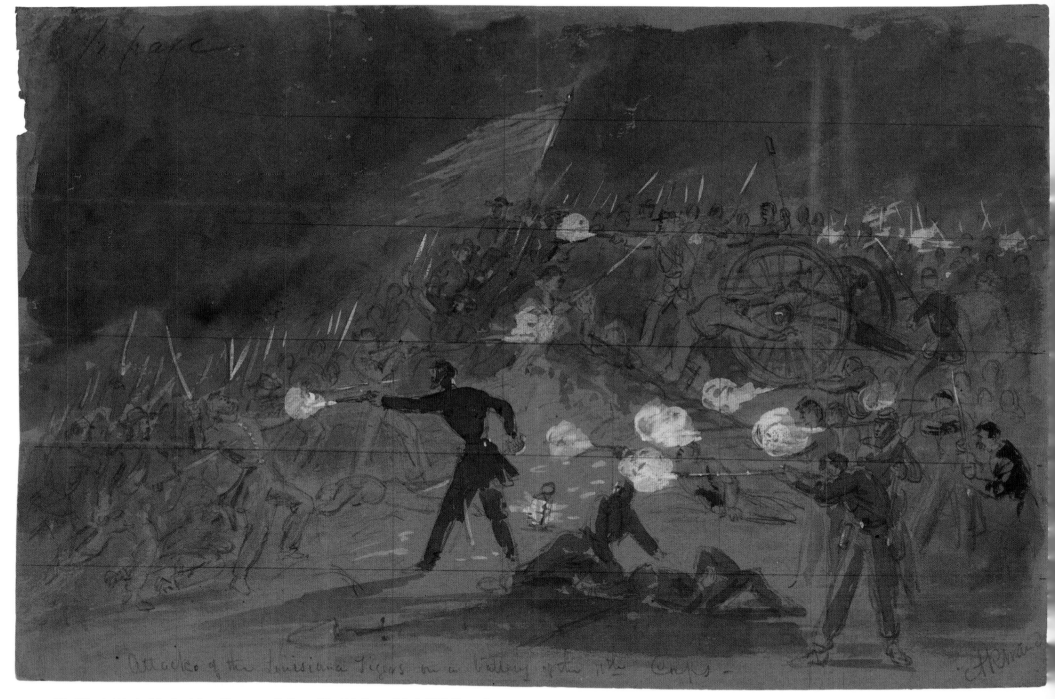

Alfred Waud, *Attack of the Louisiana Tigers on a Battery of the 11th Corps*, July 2, 1863, *Harper's Weekly*, August 8, 1863, Library of Congress.

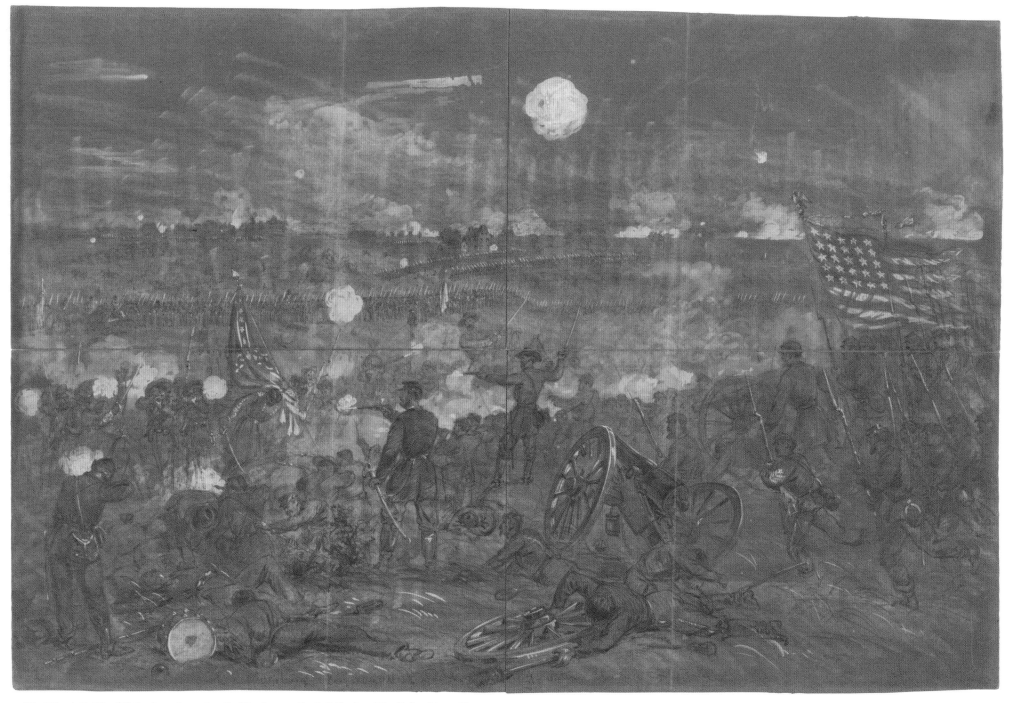

Alfred Waud, *Battle of Gettysburg. Longstreet's Attack upon the Left Center of the Union Lines. Blue Ridge in Distance*, July 2, 1863, *Harper's Weekly*, August 8, 1863, Library of Congress.

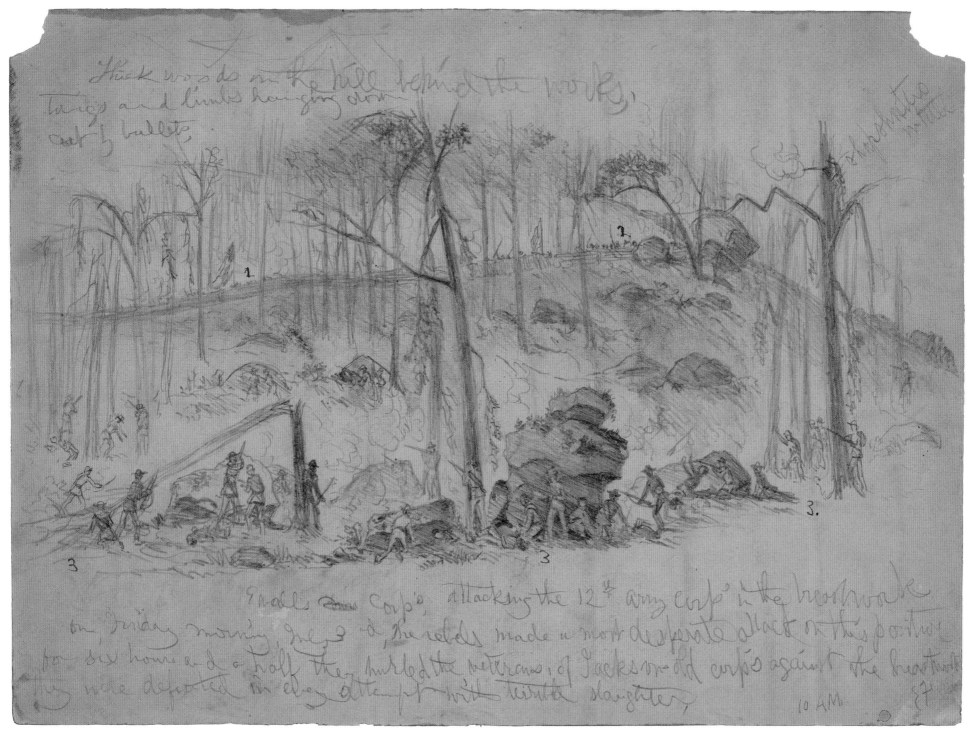

Edwin Forbes, *Attack of Genl. Ewell's Corps (Johnston's division), Formerly under Stonewall Jackson, on the Right Flank of the Union Army on Culp's Hill Held by the 12th Corps (Gen. Slocum) during the Battle of Gettysburg*, July 1863, Library of Congress.

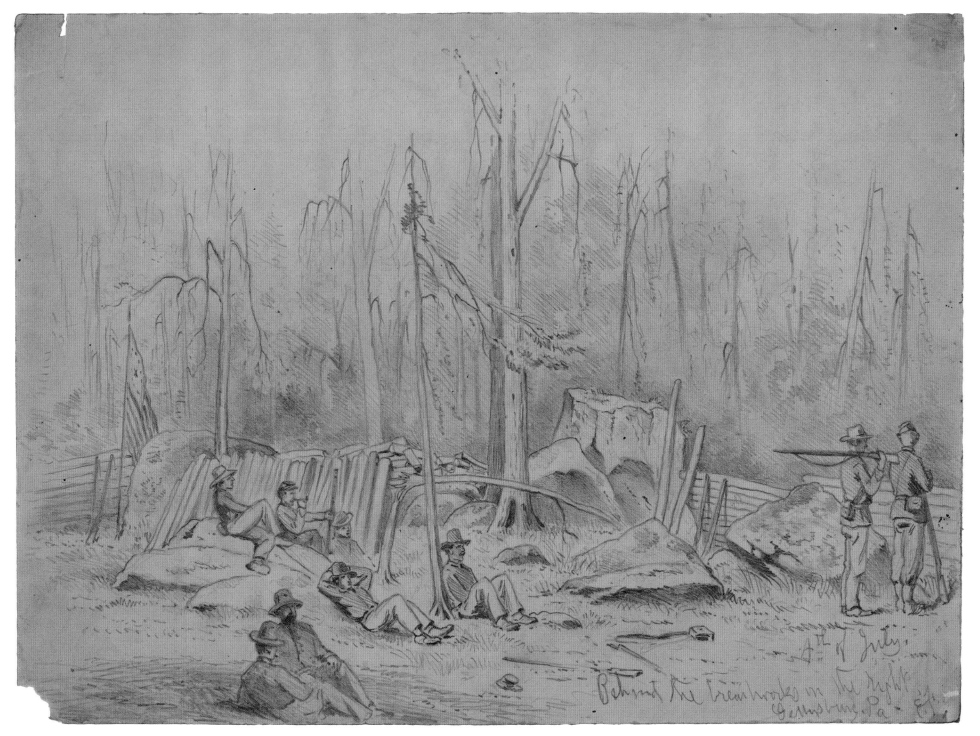

Edwin Forbes, *The Battle of Gettysburg,* July 4, 1863, Library of Congress.

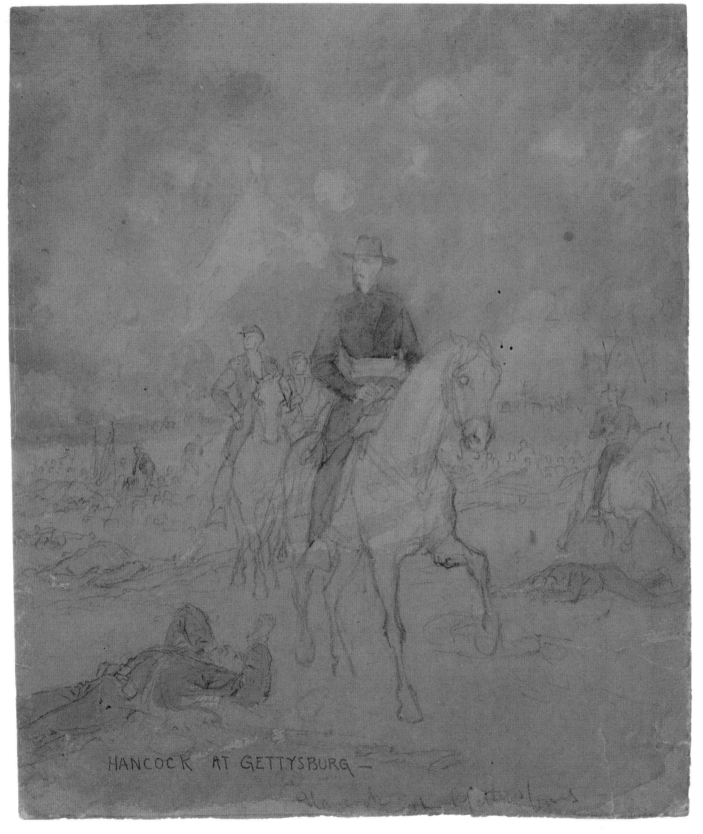

HANCOCK AT GETTYSBURG —

Alfred Waud, *Hancock at Gettysburg,* July 1–3, 1863, Library of Congress.

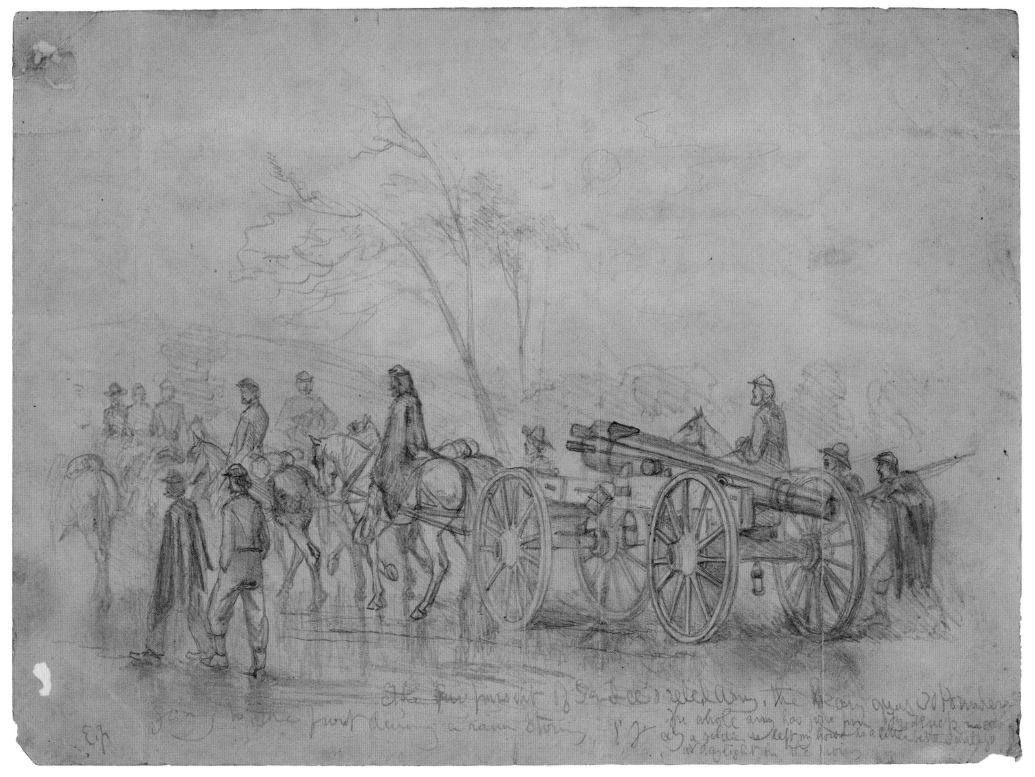

Edwin Forbes, *The Pursuit of Gen. Lee's Rebel Army. The Heavy Guns—30 Pounders—Going to the
Front during a Rain Storm,* July 10, 1863, Library of Congress.

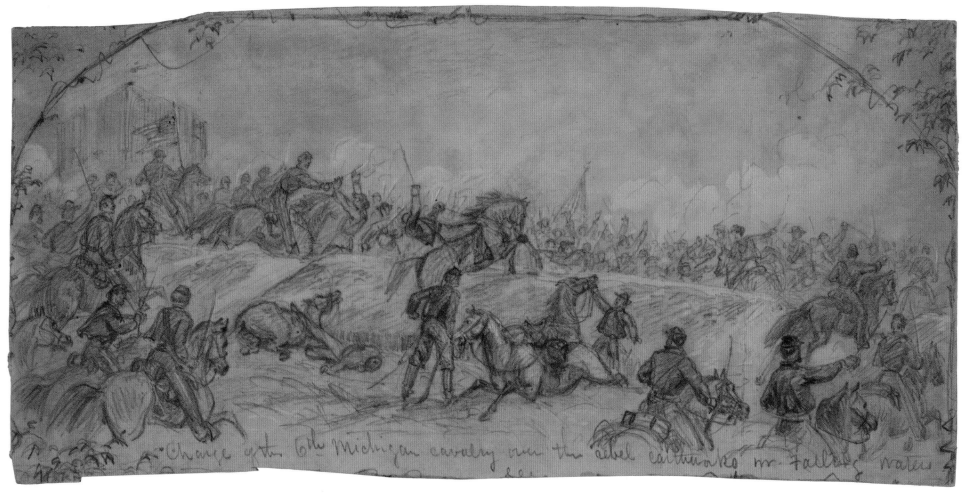

Alfred Waud, *Charge of the 6th Michigan Cavalry over the Rebel Earthworks nr. Falling Waters,*
July 14, 1863, Library of Congress.

tors to run them. The imminent surrender of Confederate forces at Vicksburg, and vivid descriptions of violent draft riots in the streets of New York City, a matter of intense concern to local readers of all the illustrated weeklies, competed for space with Gettysburg coverage.

Following Gettysburg and Meade's half-hearted pursuit of Lee's army south, the Specials descended on Charleston in August when combined Union forces made their final assault on the city's harbor defenses. *Leslie's* staff artist William T. Crane was already on hand to cover the attack along with Frank Vizetelly, who had returned from the southwest to sketch the coming action. Theodore Davis also soon arrived from Vicksburg. They watched as Union guns shelled the Confederate forts and ground forces assaulted from shore positions, without success.

The assault proved difficult, even for the Specials, as Theodore Davis mused in describing a Morris Island scene:

> The sketch shows, I think, the most comprehensive obtainable view of the 'situation' as we now see it. The extreme difficulty of 'approaching' an enemy's work on a sand beach will strike every one, as well as the admirable tact and skill used by the engineers in availing themselves of each swell and rift of sand for cover. The material and work are so vastly different from that at Vicksburg that I find myself wondering, when in the trenches, 'Where shall I dodge next?'[14]

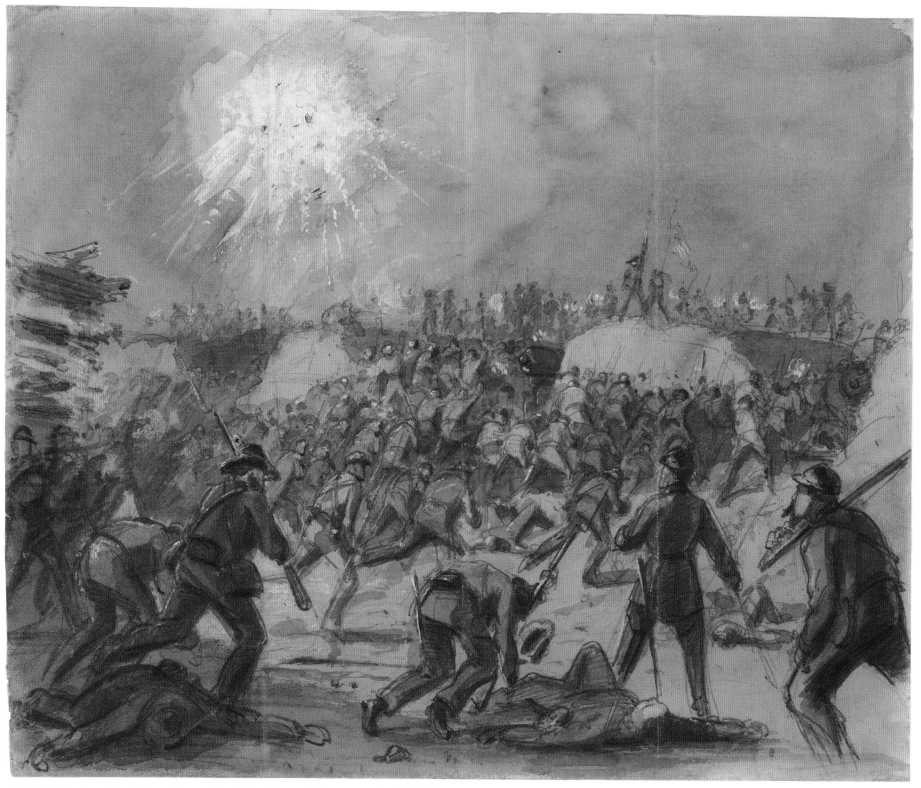

Frank Vizetelly, *Assault on Battery Wagner, Morris Island, near Charleston, on the Night of the 18th July—the Rush of the Garrison to the Parapet,* July 18, 1863, *Illustrated London News,* September 26, 1863, MS Am, 1585, Houghton Library, Harvard University.

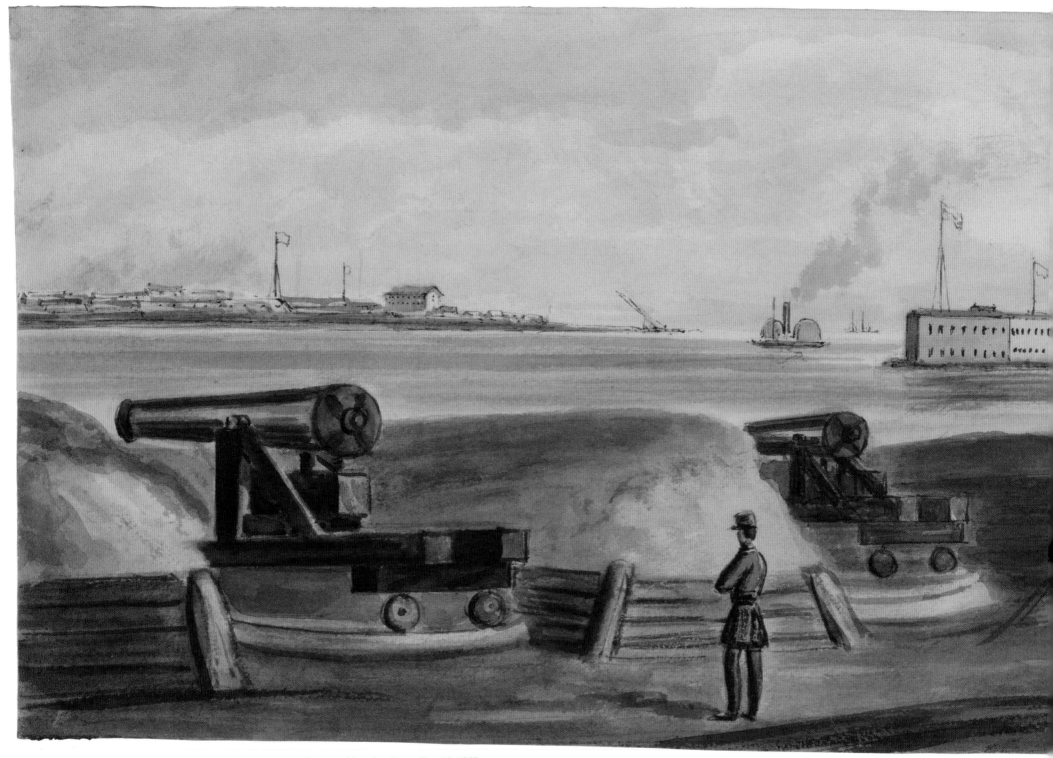

Frank Vizetelly, *Sketch of Charleston's Defense,* ca. 1863, *Illustrated London News,* May 16, 1863,
Library of Congress.

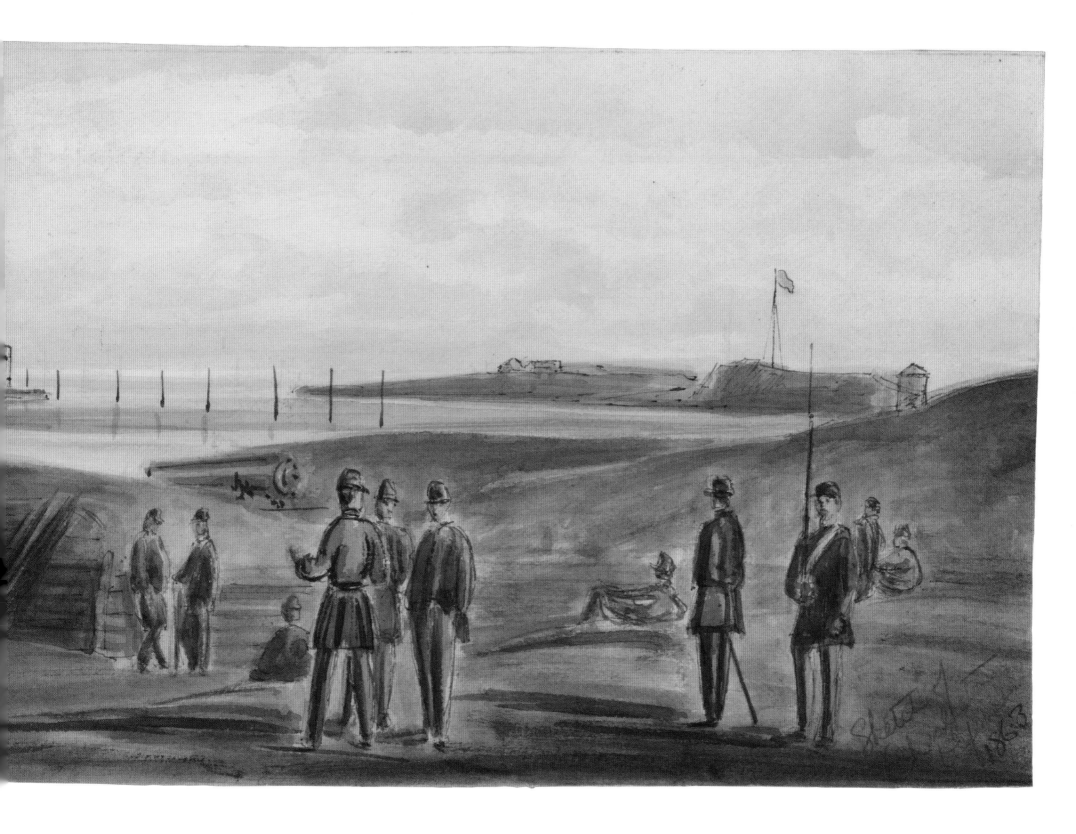

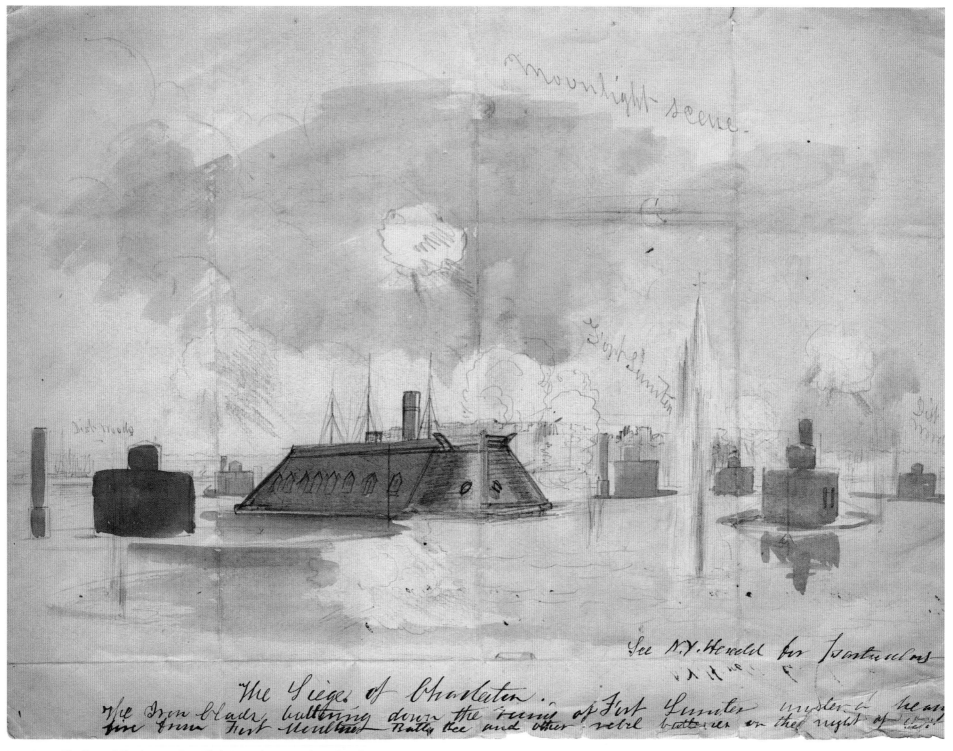

W. T. Crane, *The Siege of Charleston—Iron Clads Battering Down the Ruins of Fort Sumter under Heavy Rebel Fire,* September 1, 1863, courtesy of the Becker Collection, Boston, MA.

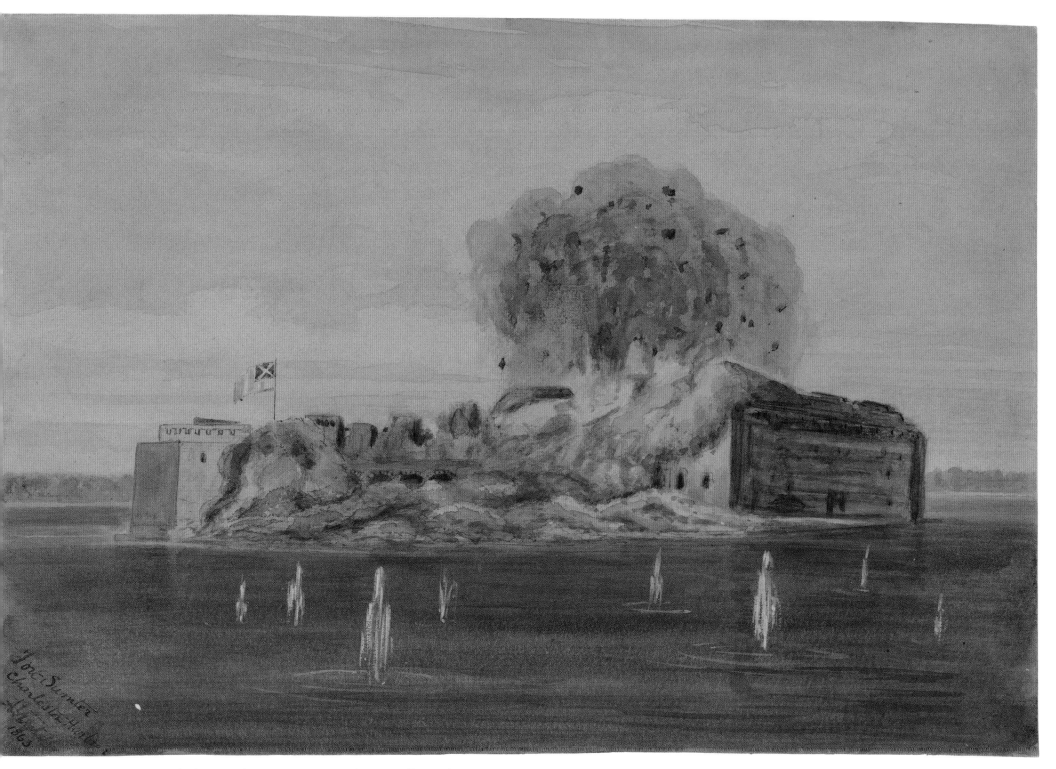

Frank Vizetelly, *Fort Sumter, Charleston Harbor,* ca. August–September 1863, Library of Congress.

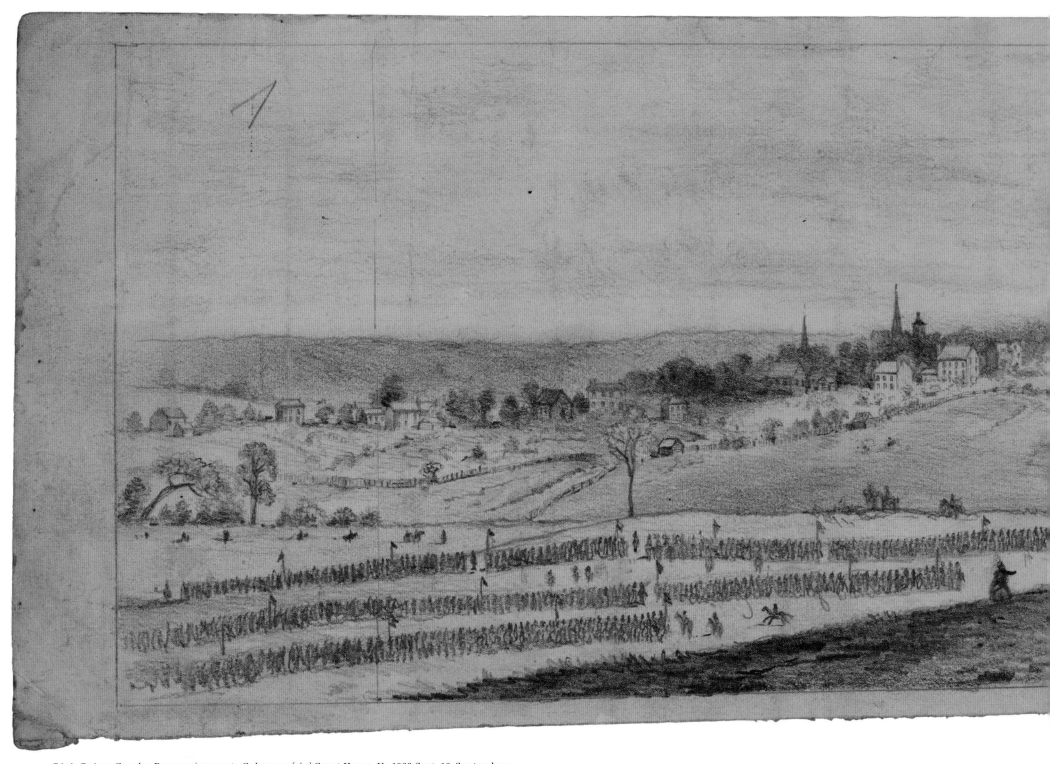

Edwin Forbes, *Cavalry Reconnaissance to Culpepper [sic] Court House, Va 1863 Sept. 16,* September 16, 1863, Library of Congress.

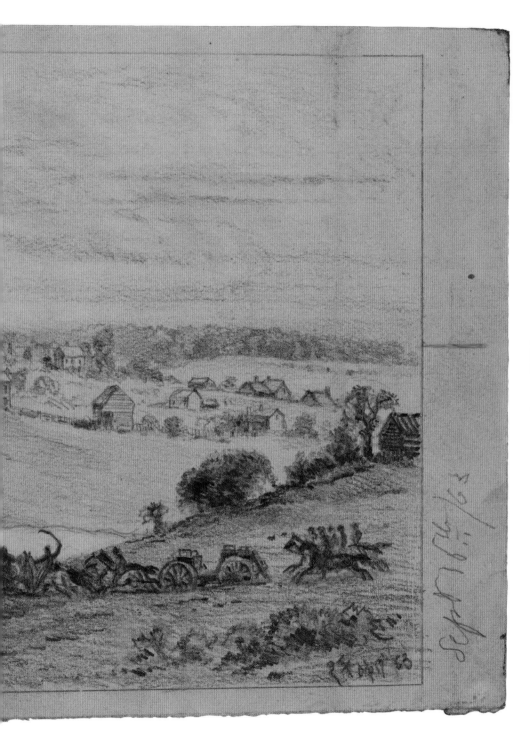

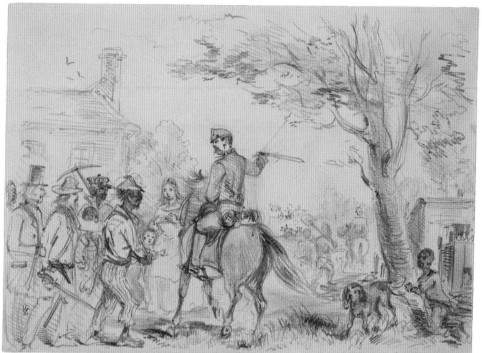

Frank Schell, *Rebel Cavalry Impressing Slaves to Work on Fortifications of Charleston Harbor (S.C.) from a Neighboring Plantation*, ca. summer 1863, Collection of the New-York Historical Society.

During the siege and fighting, Crane outdid himself, drawing every facet of the Charleston siege. *Leslie's* noted that "our Special Artist finds constantly new and important matter for faithful, interesting and historically valuable sketches."[15] Vizetelly sketched the historic July 18, 1863, assault on Fort Wagner by the legendary Massachusetts 54th Regiment of Colored Infantry led by Colonel Robert Gould Shaw. Taking the Southern side, Vizetelly's depiction of the event focuses on the heroism of the rebel defenders rather than the remarkable status of the attacking black Union troops.

The country's attention shifted west after the attack on Charleston to Chattanooga, where the Union Army of the Cumberland led by General Rosecrans faced rebel troops under C.S.A. generals Bragg, Hood and Longstreet. Rosecrans's troops were routed in attempting to force the rebels out of the city, their honor saved only by four divisions under General George Thomas, who became known as "The Rock of Chickamauga" for his exploits. In December, the *Illustrated London News* published Frank Vizetelly's sketches and descriptive letter which, "after considerable delay, reached us through one of the many gaps in the blockade," providing Europeans with a tantalizing taste of Confederate success:

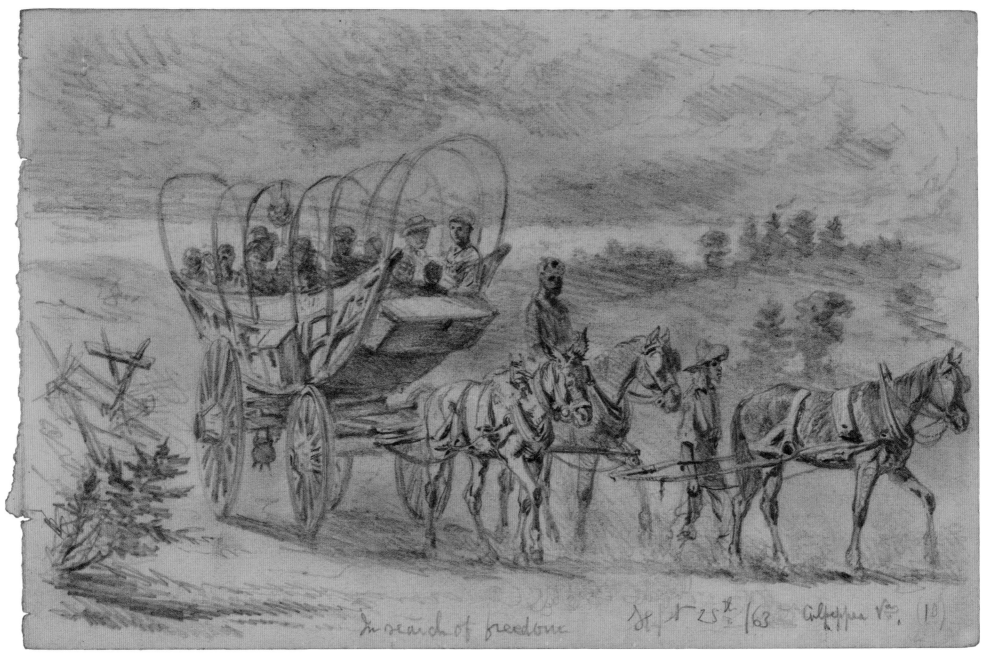

Edwin Forbes, *In Search of Freedom*, September 25, 1863, Library of Congress.

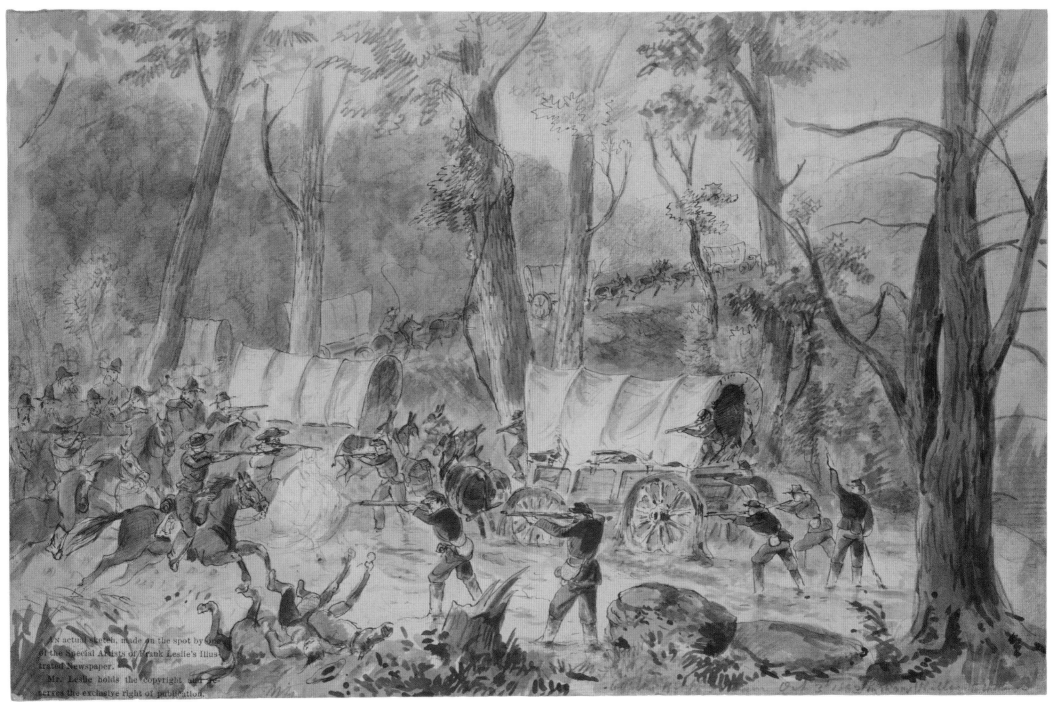

J.F.E. Hillen, *Attack of Federal Supply Train by Rebel Cavalry on Its Way to Chattanooga, Frank Leslie's Illustrated Newspaper*, October 3, 1863, New York Public Library.

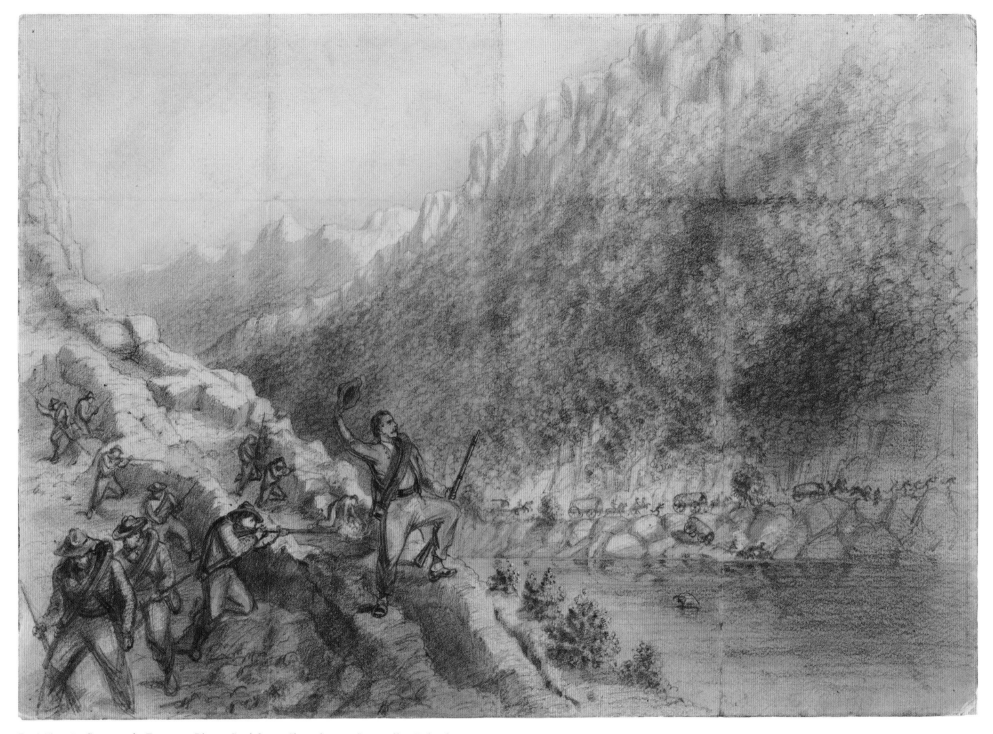

Frank Vizetelly, *Scene on the Tennessee River—Confederate Sharpshooters Stampeding Federal Wag-ons,* ca. September 18, 1863, *Illustrated London News,* December 5, 1863, MS Am 1585, Houghton Library, Harvard University.

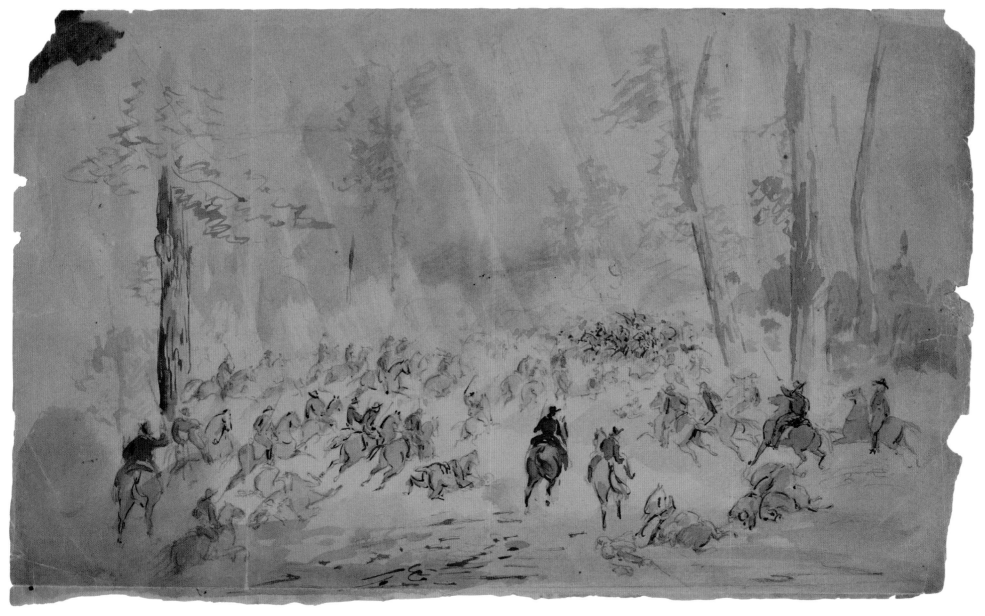

J.F.E. Hillen, *Charge of the Mounted Illinois Infantry*, ca. fall 1863, Collection of the New-York Historical Society.

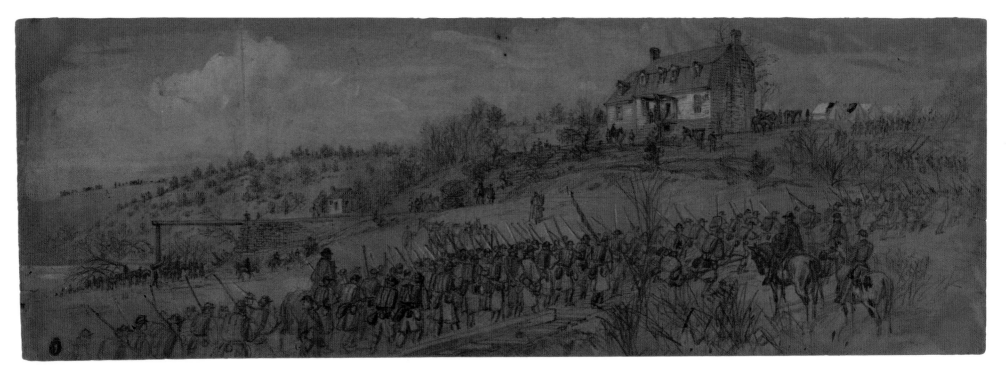

ABOVE: **Alfred Waud,** *Scene at Germanna Ford—6th Corps Returning from Mine Run*, ca. November–December 1863, *Harper's Weekly*, January 2, 1864, Library of Congress.

LEFT: **Unattributed,** *The 15th Army Corps of Maj. Gen. William T. Sherman Crossing the Tennessee River*, 1863, courtesy of the Becker Collection, Boston, MA.

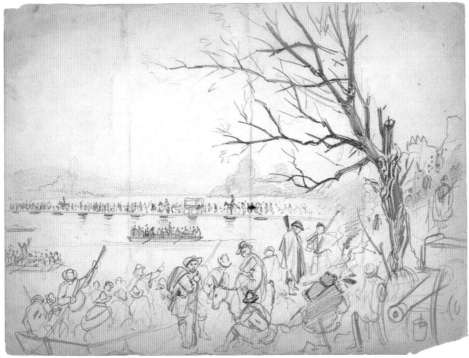

General Hood is, to my mind, the Bayard of the Confederate army, literally *sans peur et sans reproche,* and those who have seen him, as I have seen him at Fredericksburg and elsewhere, at the head of his gallant Texans, will admit I eulogise him no more than he deserves. About two o'clock on the 20th General Hood found his division in front of an opening in the woods, which ascended abruptly for some three or four hundred yards to a most formidable Yankee position on the skirt of a dense piece of forest. Fallen timber served to make its natural strength much stronger, and behind this fortification of logs were posted large bodies of Federal infantry and numerous pieces of artillery. General Hood determined at once to carry the position by assault, and, forming his men into two lines, gave the order to advance. The leading column moved forward half way across the opening, under a most withering fire, then paused for an instant and discharged their rifles, rushing on, with the bayonet, through the smoke. At this moment General Hood

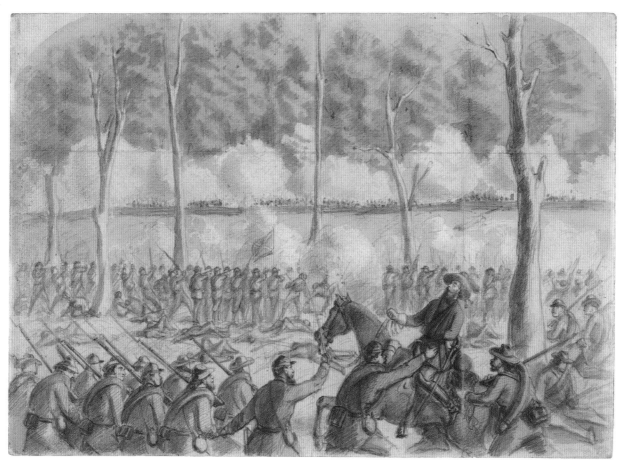

Frank Vizetelly, *Battle of Chickamauga—the Confederate General Hood Receiving His Wound,*
September 19, 1863, *Illustrated London News*, December 26, 1863, MS Am 1585, Houghton Library,
Harvard University.

was cheering forward the second column when an Enfield ball passed through his right thigh, smashing the bone to pieces, and as he was removed from the field he heard the shouts of his soldiers proclaiming their success and his revenge.[16]

In the meantime, shocking news came out of Kansas, where Leslie's Special James R. O'Neill died while a prisoner of Confederate captain William Clarke Quantrill's rebel raiders. These raiders had brutally attacked a regiment of black soldiers and a detachment of troops under Union major general James G. Blunt at Baxter Springs in early October. O'Neill appears to have been the only sketch artist killed in action during the Civil War.[17]

Ulysses S. Grant, elevated to command of the Union's western armies in mid-October, sent twenty thousand troops from the Army of the Potomac under General Joseph Hooker to reinforce Thomas, whom he had named to replace Rosecrans at the head of the Army of the Cumberland. In Tennessee, in late November, Thomas took the initiative, linking up with Hooker on the Tennessee River and assaulting the Confederate defenses in the Battle of Lookout Mountain. Theodore Davis, on hand to sketch the action for *Harper's*, made the following report:

There has not during the war been a more gallant fight than the assault by General Hooker's column upon the rebel works on Lookout Mountain. The men, climbing the steep mountain-side under a severe fire from the many rifle-pits, were never checked. Whitaker's brigade, sweeping over the ridge and taking in rear the works by the White House, is the sub-

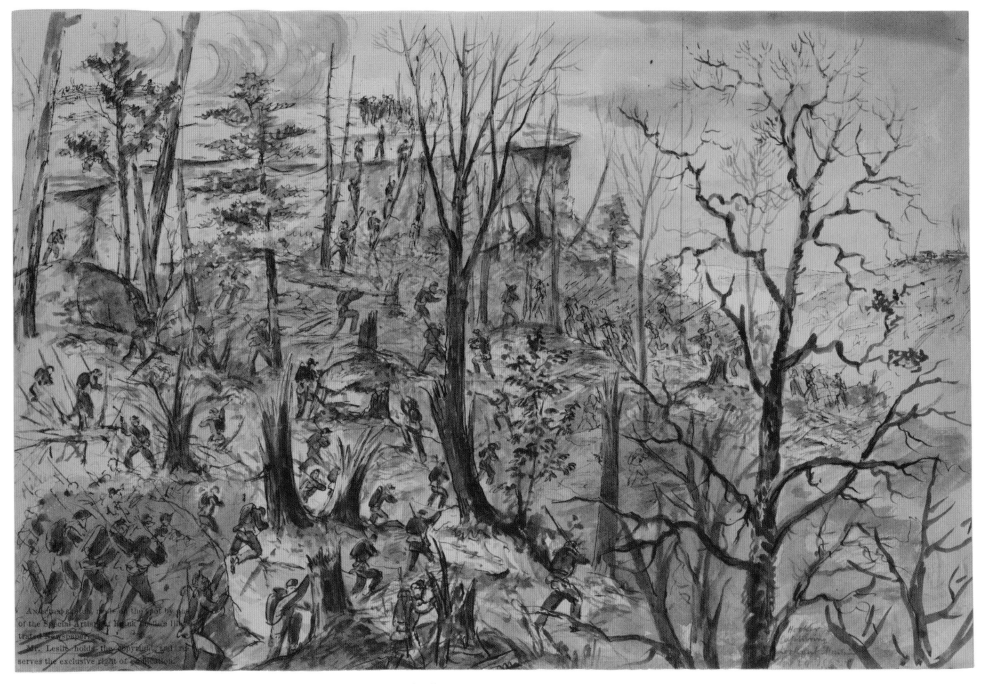

J.F.E. Hillen, *Hooker Capturing Lookout Mountain*, November 24, 1862, New York Public Library.

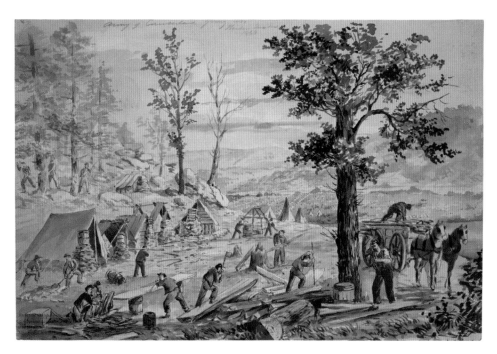

J.F.E. Hillen, *Preparation for Winter. Army of Cumberland Going into Winter Quarters,* December 1863, Print Collection, Miriam and Ira D. Wallach Division of Art, Prints and Photographs, the New York Public Library, Astor, Lenox and Tilden Foundations.

ject of the sketch on page 820, the skirmishers of Geary's division being in the fore-ground. The line of battle, as it swept over the ridge, was composed of the divisions of Generals, Cruft, Geary, and Osterhaus, the other divisions, of Hooker's column being disposed on the flanks and as supports. The picture on page 829 illustrates further the same affair.

The centre picture on page 821 represents the brigades of General Whitaker and Colonel Ireland, of Cruft's and Geary divisions—Whitaker's brigade stretching to the rocks that from the crest of the mountain swept over the ridge on which the rebel rifle-pits were located. At this place the fight was short and severe.

The other drawings on the same page show the rebel work on the crest of the mountain, from which the rebels did not remove the guns (two light pieces) until after night-fall; and the sketch of the crest of the mountain will explain why we did not get up there in time to capture them. On the morning of the 25th Captain Wilson, Sergeants Wagers,

Joseph Becker, *Graves of Union Soldiers, Gettysburg,* September–October 1863, Courtesy of the Becker Collection, Boston, MA.

Davis, and Woods, and Privates Hill and Bradley, of the Eighth Kentucky regiment, Colonel Barnes, volunteered to place the colors of the regiment on the rocks forming the top of the mountain. Up they went, gaining the top by a route such that a single rebel might have disposed of the party. As the sun rose the next morning its first ray brightened the old flag on the very top of Lookout Mountain . . .[18]

J.F.E. Hillen depicted the event for *Frank Leslie's*, portraying the tree-studded mountainside with distinctive flair.

The culminating battles of 1863 in Tennessee, and the lone Union flag of victory atop Lookout Mountain at year's end, symbolized the close of a difficult year for both sides. Such competent and successful military officers as Grant, Hancock and Thomas moved up the military command in the North and contributed to major victories at Gettysburg, Vicksburg and Lookout Mountain. The rebel armies under Lee remained resilient, tenacious, cunning, aggressive and stripped-to-the-bone dangerous. Frank Vizetelly's international audience, wondering at the war's outcome, examined his sketches and read his pro-Southern letters. *Harper's* and *Leslie's* readers, already accustomed to outstanding pictorial reportage from the field, could look forward to expanded coverage in the coming year, while the *New York Illustrated News* struggled. Like the war, American publishing had become a test of attrition and survival.

THE PRESS ON THE FIELD.

TAKING NOTES. ON A STAFF. SKETCHING.

OUR ARTIST.

A CORRESPONDENT.

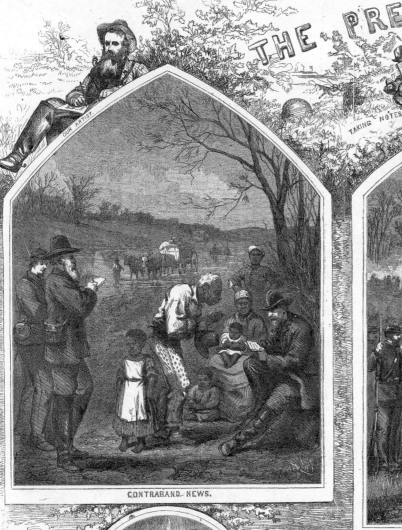

CONTRABAND NEWS.

IN ACTION.

RELIABLE INFORMATION.

Th. Nast.

NEWSPAPERS AT HOME.

THE SKETCH BOOK.

THE NEWSPAPERS IN CAMP.

The End Begins

The mundane duties of life in camp once again occupied both armies through the winter in early 1864. The Specials thus turned to scenes of human interest, noting in particular the growing numbers of black men, women and children coming into the Union lines in search of freedom. *Leslie's* artist C.E.F. Hillen, with the Army of the Cumberland, contributed a page of vignetted scenes portraying black citizens performing numerous duties for the Union Army. As the editors explained, "It is not our part to discuss questions of political bearing, but simply to portray living history . . . Did it enter into the dream of those who voted for the secession of South Carolina, that the slaves around them would, in less than two years, be the paid, uniformed, equipped soldiers of the United States?"[1] Fred Schell in Vicksburg and Frank Schell in New Bern, North Carolina, sent in

Thomas Nast, *The Press on the Field, Harper's Weekly,* April 30, 1864, image provided courtesy of HarpWeek.

THE PICKET

What ruddy stain is this?

Perchance of morning flowers—

Of dew-wet, odorous flowers;

Did ever mother, ever maiden kiss,

On cheek of new-born down,

Or set with bearded brown,

These flowers, and think the inner heaven of heaven

Had no such bliss?

It may be morning blooms are passing fair;

But since to human cheeks their tints were given,

The sweetest blooms are there.

A pale face motionless,

Close by the stain of flowers,

The stain of blood or flowers;

Did ever mother, ever maiden press

White fingers on this stone,

And think to be alone,

And not feel *it* were very far from heaven

And happiness?

It may be. Since white fingers once have pressed

Such sculpture, the quick pulses through them driven

Are very near to rest.

A grave dug in the sand,

Near to the stain of flowers—

The red stain *not* of flowers;

Shall ever mother, ever maiden stand

Within a lonely home,

And say, "When will he come

Out from returning ranks? How long he lingers

With his victorious band!"

It shall be. Tender, loving lips have kissed

Their last: and never more shall thrill white fingers

For that one picket missed.[2]

—Anonymous, *Harper's Weekly*, January 16, 1864

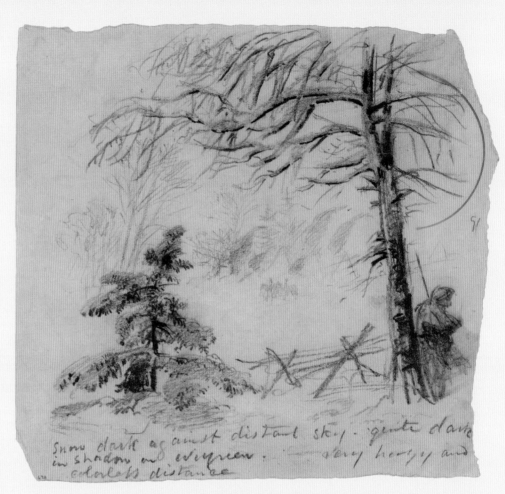

Alfred Waud, *Winter Picket Duty*, ca. winter 1863–1864, Library of Congress.

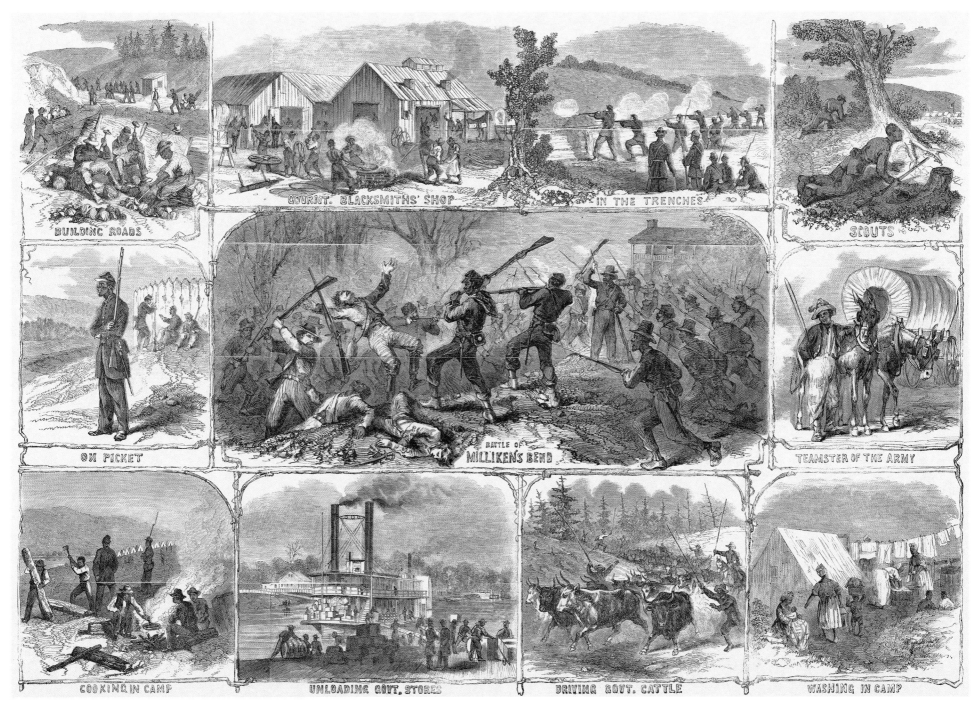

Labels within image: BUILDING ROADS · GOVNT. BLACKSMITHS' SHOP · IN THE TRENCHES · SCOUTS · ON PICKET · BATTLE OF MILLIKEN'S BEND · TEAMSTER OF THE ARMY · COOKING IN CAMP · UNLOADING GOVT. STORES · DRIVING GOVT. CATTLE · WASHING IN CAMP

C.E.F. Hillen, *The Negro in the War—Sketches of the Various Employments of the Colored Men in the United States Armies,* Frank Leslie's Illustrated Newspaper, January 16, 1864, image provided courtesy of HarpWeek.

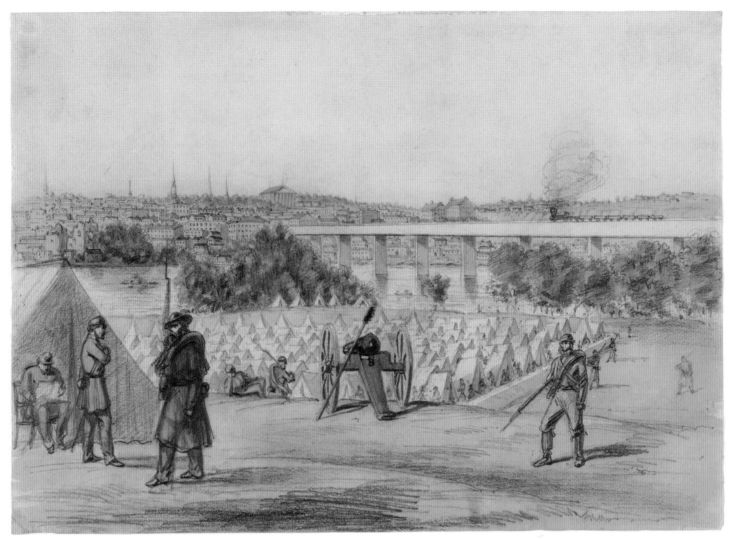

Frank Vizetelly, *Camp of Federal Prisoners on "Belle Isle" Richmond, Virginia,* ca. 1863, *Illustrated London News,* April 9, 1864, MS Am 1585, Houghton Library, Harvard University.

sketches and letters detailing the growing military presence and active social life of newly emancipated blacks in the South. William T. Crane, on the other hand, reported from South Carolina with a sketch depicting a black regiment attacked by rebel officers hunting with bloodhounds, a terrifying holdover from the plantation era:

The use of bloodhounds in hunting down maroon negroes is too well known to need explanation or denunciation. It is one of the features of the system. Our Government once resolved to employ bloodhounds against the Seminoles, in Florida, but the public voice denounced the return to barbarism. Little did the rulers of the land then expect to see bloodhounds used against soldiers fighting under the Stars and Stripes. But the use of colored regiments by the Government has led the insurrectionary leaders to employ hounds as auxiliaries. There have been several collisions between the sable troops and their enemies, but the negro fleeing for life, unarmed and unequipped, is a different being from the drilled soldier.[3]

Lincoln called in Ullyses S. Grant from the west in March 1864 to take over direction of all the Union armies. Grant was appointed lieutenant general, the

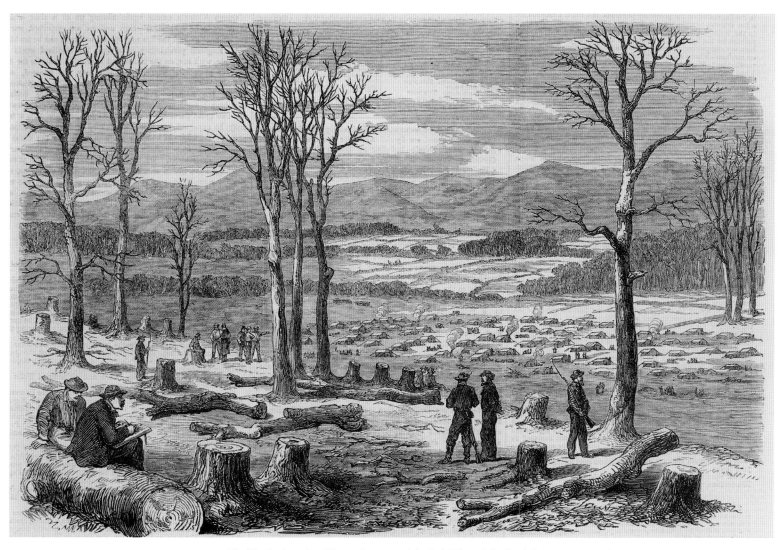

Frank Vizetelly, *The War in America: Winter Quarters of the Left Wing of the Confederate Army on the Rapidan, Illustrated London News,* April 2, 1864, Library of Congress.

post held by George Washington; he promised to confront and destroy General Robert E. Lee's Army of Virginia. In boots-on-the-ground fashion Grant pitched his tent within General George Meade's Army of the Potomac headquarters along the Rapidan River in Virginia across from Lee's winter camp.

Just after the first of May, Grant ordered Meade's army south across the Rapidan into the Wilderness, a region of stunted trees and dry brush, few roads, rough terrain and tenacious overgrowth adjacent to the Chancellorsville battlefield of 1863. Grant sought to confront Lee in the open somewhere south of the

Wilderness on the road to Richmond but the rebels attacked first, using the tangled landscape to mitigate their opponent's overwhelming military superiority.

The Battle of the Wilderness proved a turning point. The Specials illustrated both sides of the watershed moment: Alf Waud sketched the horror of wounded men attempting to escape the flames caused by shells exploding in the dense, dry and stunted woods, while Edwin Forbes drew an exhausted yet exhilarated company of Union troops at a roadside cheering their commander. Grant's signal to follow Lee's battered army southward rather than pull back to recover showed new

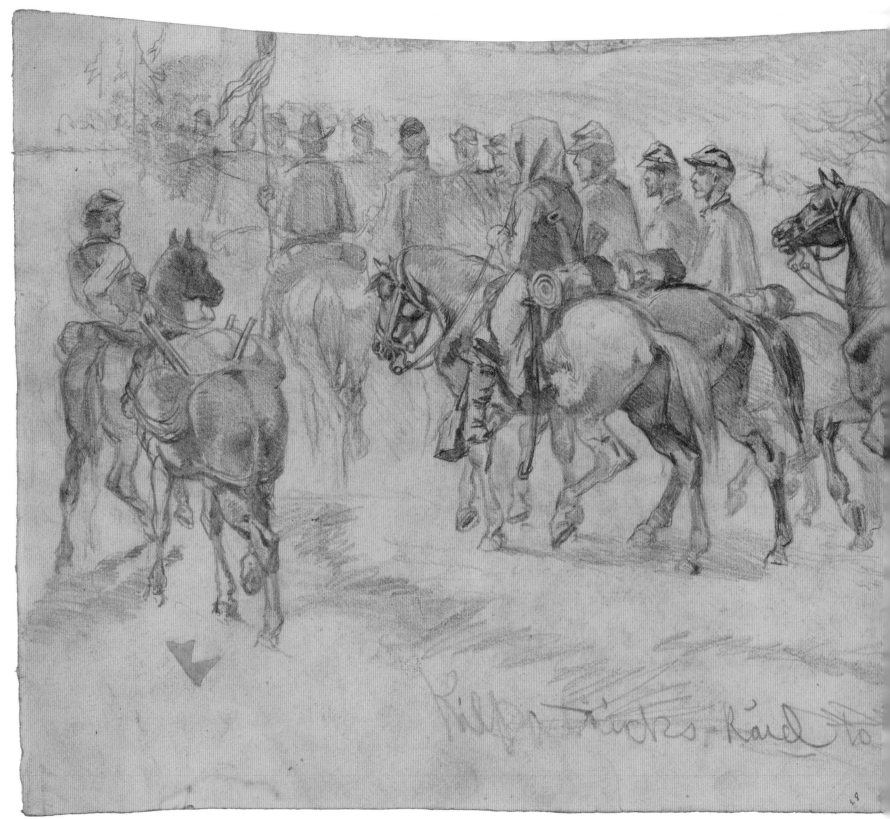

Edwin Forbes, *Kilpatrick's Raid to Richmond,* ca. March 1864, Library of Congress.

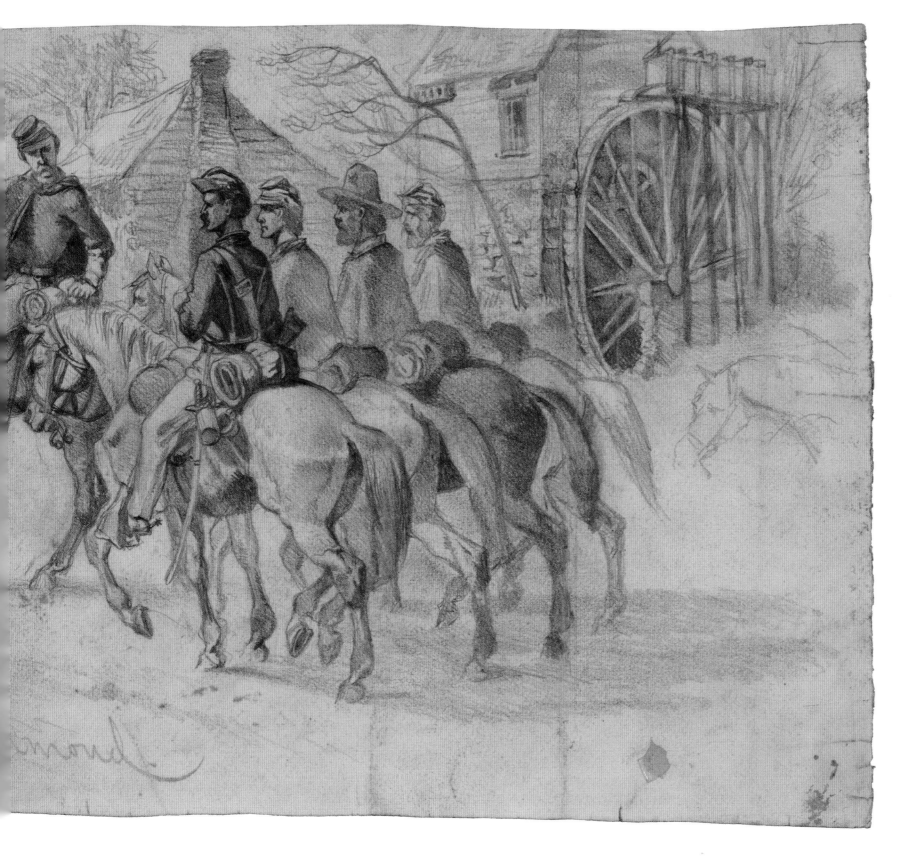

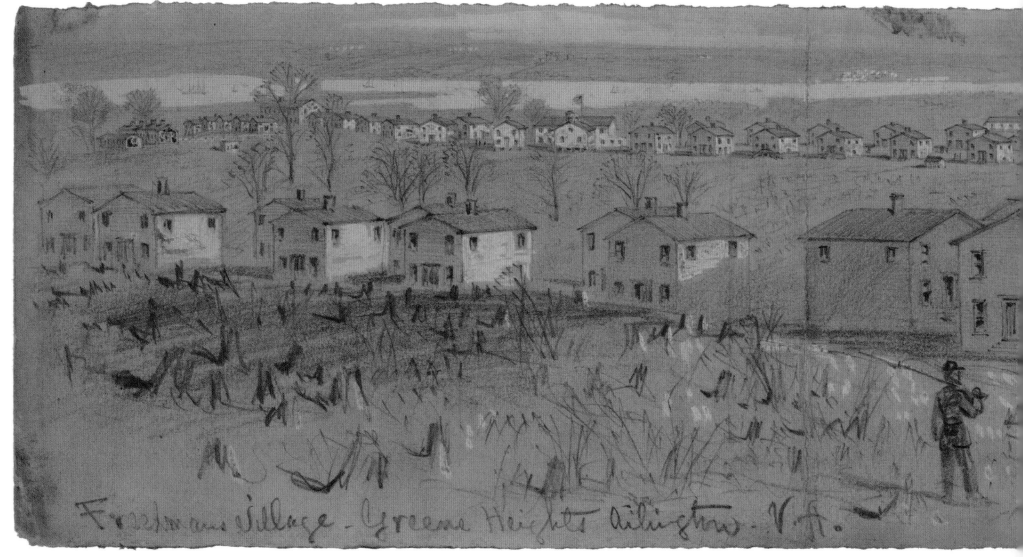

Alfred Waud, *Freedmans Village—Greene Heights Arlington, VA,* April, 1864, *Harper's Weekly,* May 7, 1864, Library of Congress.

mettle among the Union leadership. Subsequently, along the road to Richmond, at Spotsylvania, Cold Harbor and Petersburg the sketch artists depicted Grant's overall strategy of unrelenting force. He sent Sherman south and east through Atlanta to Savannah, and the Union cavalry led by Sheridan and Custer into the Shenandoah Valley to rout rebel troops and destroy their provisions. The strategy worked and by fall 1864, the Confederacy and its army were on their last legs.

Apparently, the *New York Illustrated News* was, too, although saved for six months in the New Year by publisher and political power-broker William Jen-

nings Demorest. Promising the commencement of "a new era" in its history, including family fare and added features for women, along with war coverage, the *News*, strapped for cash and artists, delivered nothing new or original, and Demorest finally gave up the effort and closed its doors in mid-August. The weekly intermittently published pictures of the conflict through the spring but no longer featured salaried Specials.

Harper's and *Leslie's* hardly noticed the loss, having cornered the pictorial weekly market between them. The war theaters expanded in early 1864, when

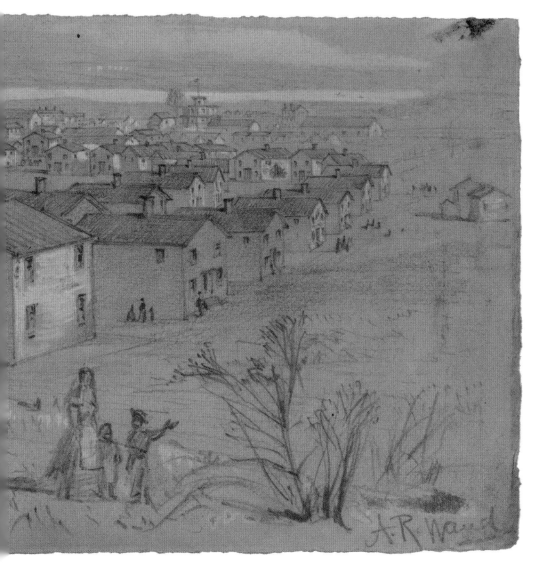

augment its coverage of the Siege of Petersburg, along with additional contributing artists.

With the *New York Illustrated News* missing in action at the Battle of the Wilderness, the Specials from *Harper's* and *Leslie's*, including Alf Waud, Edwin Forbes and newcomer Joseph Becker covered the campaign. *Frank Leslie's* reported:

> The battles have not been in open field, as our readers know. The armies fought in dense woods, and used them for defence. At night trees were felled, and formed with earth into temporary breastworks. If time permitted a double line was made, as shown in the case illustrated in our engraving. Here our men would make a stand against the enemy, whose approach was heralded only by their presence.[4]

Conditions became nightmarish as falling shells ignited the underbrush. The flames quickly spread and threatened soldiers immobilized in the woods by their wounds. Alf Waud described the horrific scene:

> The fires in the woods, caused by the explosion of shells, and the fires made for cooking, spreading around, caused some terrible suffering. It is not supposed that many lives were lost in this horrible manner; but there were some poor fellows, whose wounds had disabled them, who perished in that dreadful flame. Some were carried off by the ambulance corps, others in blankets suspended to four muskets, and more by the aid of sticks, muskets, or even by crawling. The fire advanced on all sides through the tall grass, and, taking the dry pines, raged up to their tops.[5]

When the smoke had cleared almost thirty thousand men lay dead, dying, or wounded on the field. Of that number, Union troops comprised about eighteen thousand, 50 percent more than the Confederate account. Knowing his military machine could absorb such losses Grant vowed to press on and telegraphed to Lincoln the memorable words: "I propose to fight it out on this line if it takes all summer." Turning his horse toward Richmond, Grant was met by wildly cheering troops. Edwin Forbes sketched the scene. The army moved on to Spotsylvania Court House and another bloody engagement with the enemy.

At Spotsylvania, the rebels once again made Grant pay for his aggressive tactics. Casualty figures and percentages rivaled those at the Wilderness. Lee's armies inflicted huge losses on Grant's divisions but in turn lost more men than they could replace. Union Army major Charles F. Morse remarked in a letter at

conflict broke out everywhere in the South. Fighting persisted along the Mississippi, where Union gunboats now ruled the river. C.E.H. Bonwill and Fred Schell maintained their posts in Louisiana while William Crane monitored Union-besieged Charleston for *Leslie's*. Theodore Davis traveled for *Harper's* with the Army of the Cumberland in Tennessee, while Edwin Forbes and Alf Waud kept track of the Army of the Potomac. New Specials soon came on the scene, including Joseph Becker, Andrew McCallum, Edward F. Mullen and James Taylor for *Leslie's*. *Harper's* brought in William Waud and A. W. Warren to

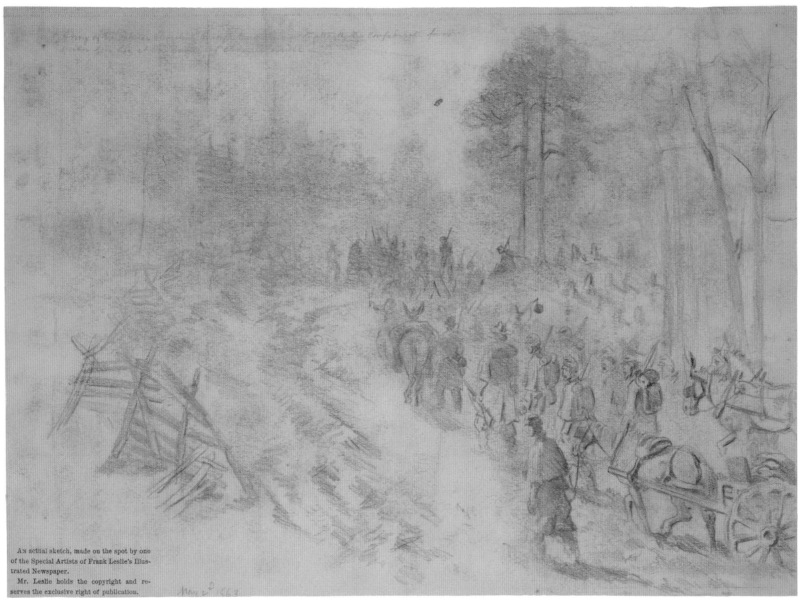

An actual sketch, made on the spot by one of the Special Artists of Frank Leslie's Illustrated Newspaper.

Mr. Leslie holds the copyright and reserves the exclusive right of publication.

Edwin Forbes, *Army of the Potomac Marching through the Wilderness to Attack the Rebel Army under Gen. Lee*, May 2, 1863, Print Collection, Miriam and Ira D. Wallach Division of Art, Prints and Photographs, the New York Public Library, Astor, Lenox and Tilden Foundations.

Alfred Waud, *Genl. Wadsworths Division in Action in the Wilderness, near the Spot Where the General Was Killed*, May 5–7, 1864, *Harper's Weekly*, June 4, 1864, Library of Congress.

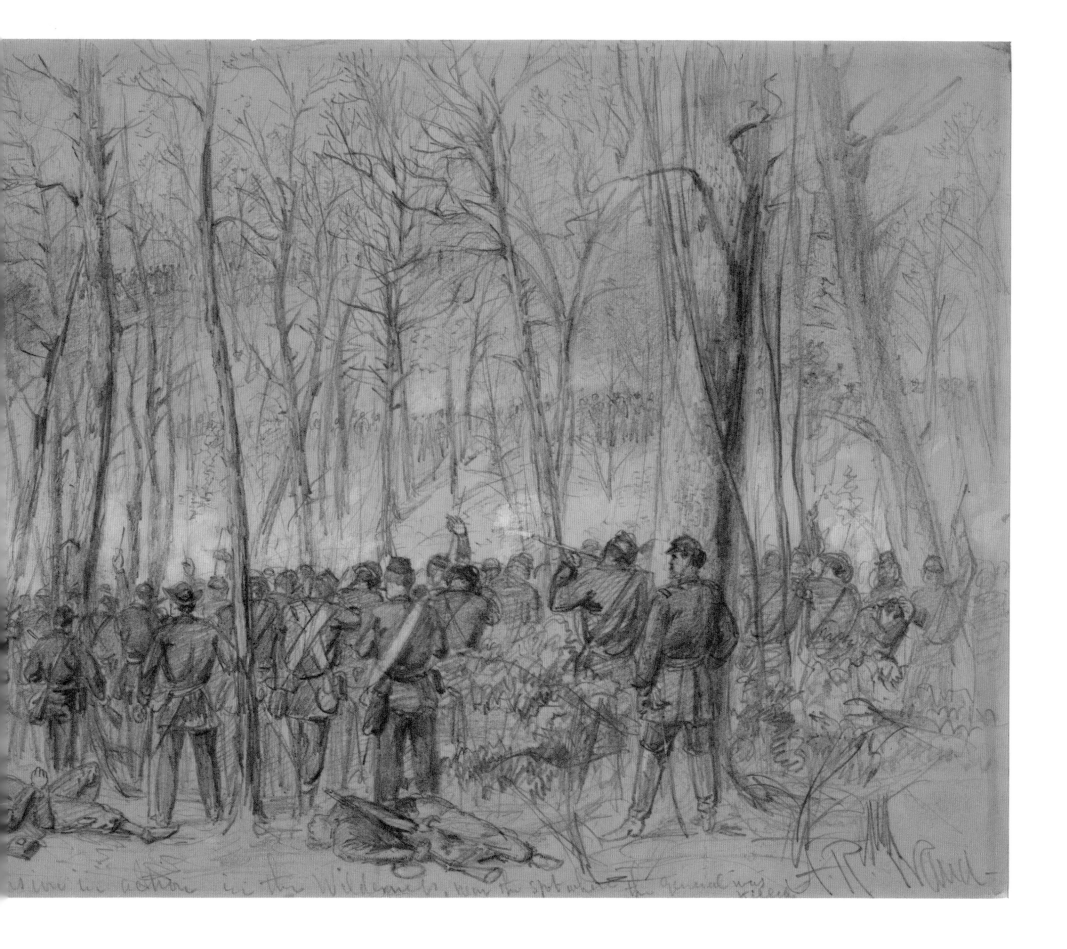

...in action in the Wilderness, near the spot where the general was killed

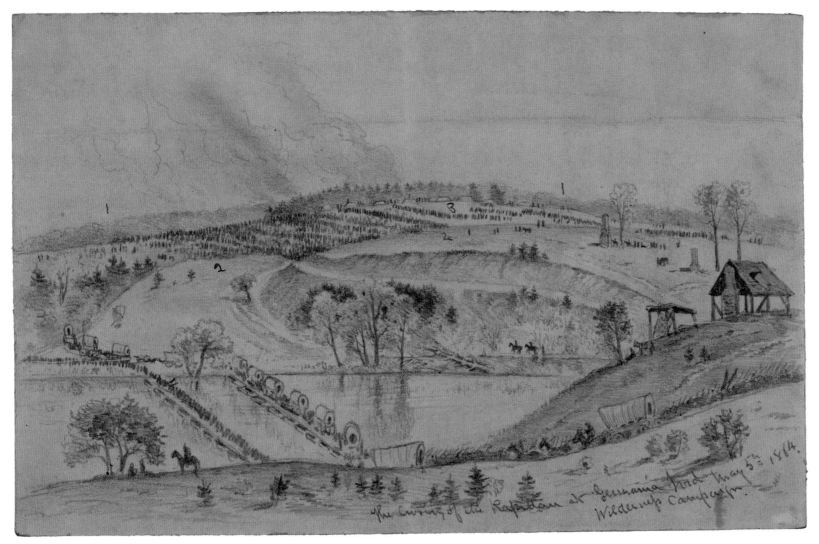

Edwin Forbes, *The Crossing of the Rapidan at Germanna Ford, May 5, 1864—Wilderness Campaign*,
May 5, 1864, Library of Congress.

Alfred Waud, *Wounded Escaping from the Burning Woods of the Wilderness*, May 5–7, 1864,
Harper's Weekly, June 4, 1864, Library of Congress.

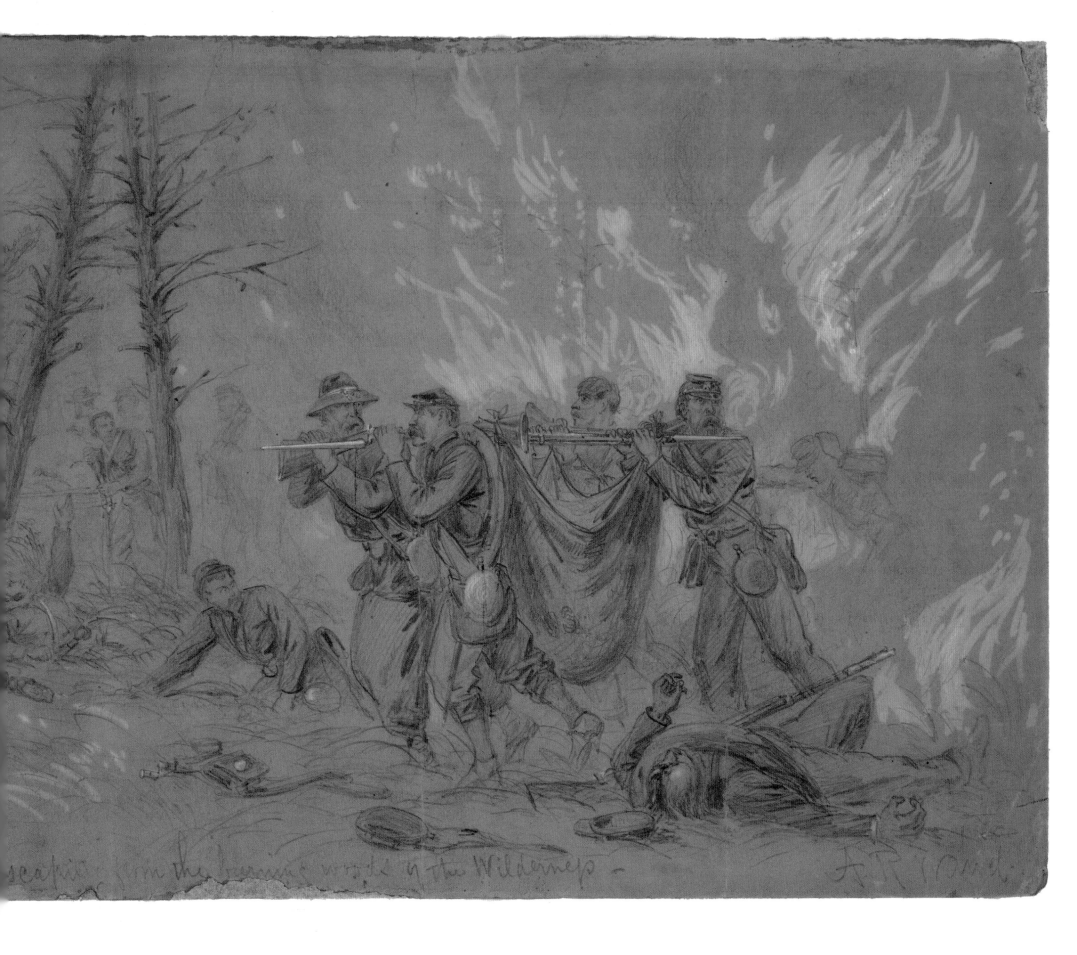

escaping from the burning woods of the Wilderness —

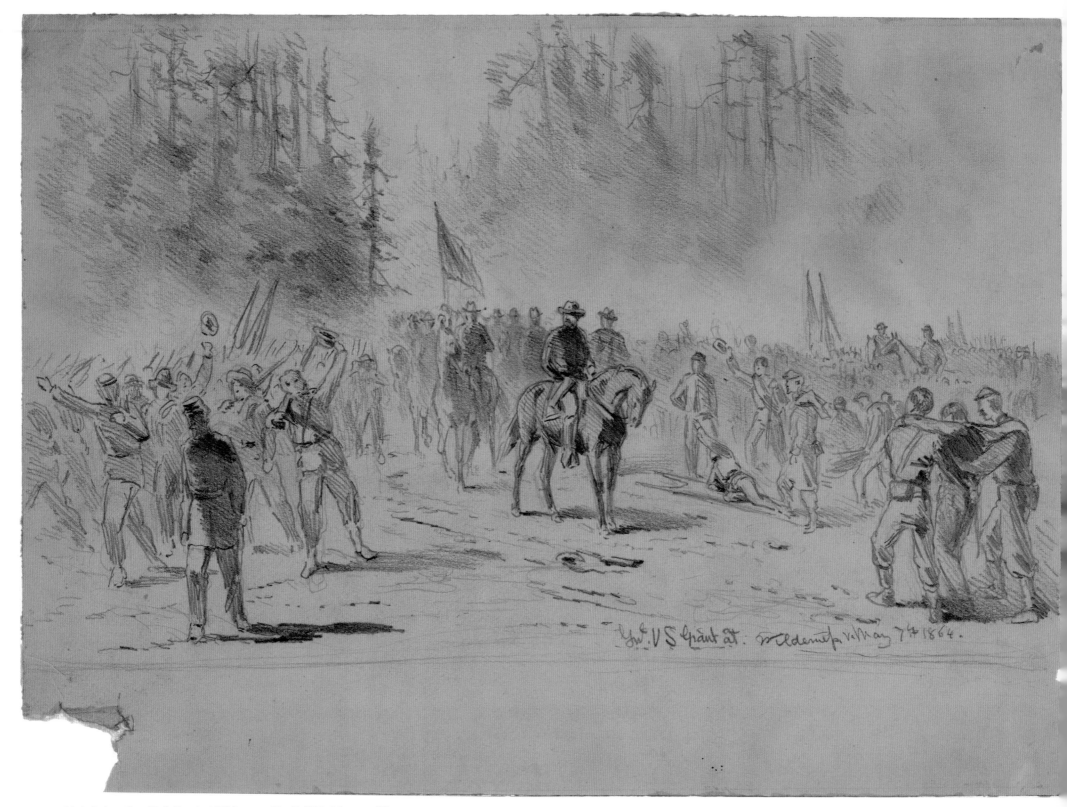

Edwin Forbes, *Gen. U. S. Grant at Wilderness,* May 7, 1864, Library of Congress.

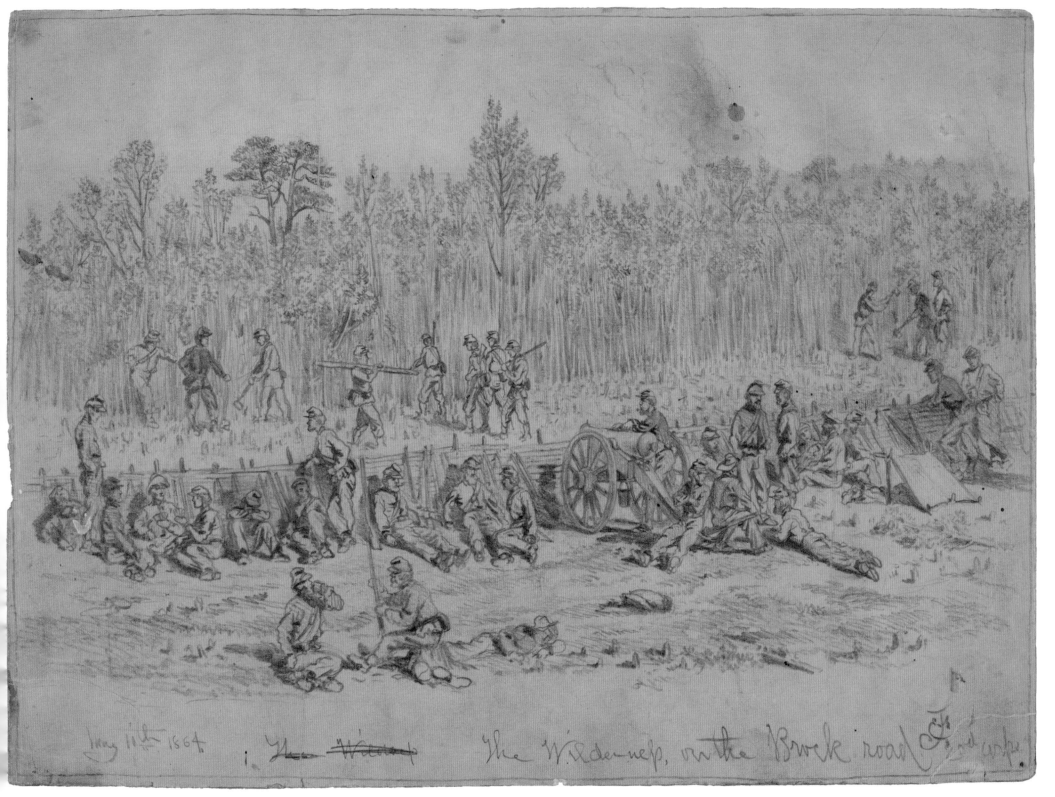

Edwin Forbes, *The Wilderness, on the Brock Road, 2nd Corps—May 11th 1864*, May 11, 1864, Library of Congress.

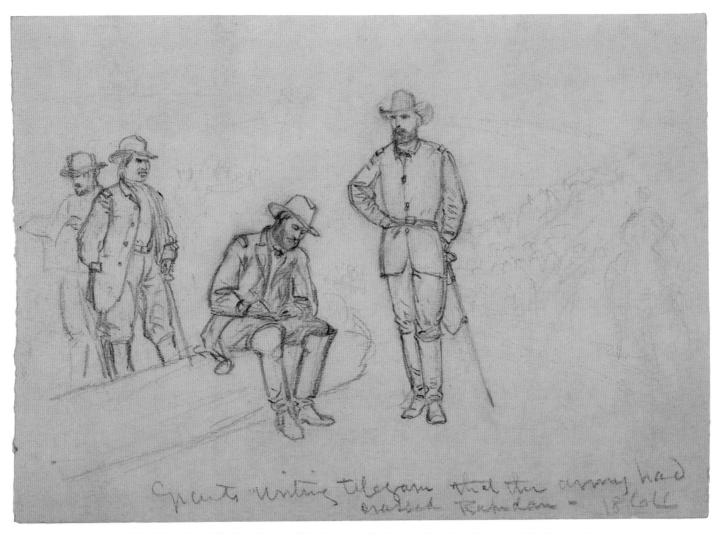

Alfred Waud, *Grant Writing Telegram That the Army Had Crossed Rapidan*, May 3–4, 1864, Library of Congress.

the time, "Life is cheap this year almost everywhere in the army."[6] Particularly in the Army of the Potomac. Waud, Becker and Forbes were with the troops to sketch their exploits. A *New York Times* reporter described the battle:

> The history of the day, after 6 o'clock in the morning, is all summed up in five successive and fierce assaults which *Lee* made to retake the lost position. At first *Ewell's* corps alone confronted *Hancock*, but during the day *Hill* and *Longstreet* were drawn over from the rebel left, and the whole army of Lee flung itself in five desperate efforts to recapture the breastworks. But it was all in vain, as every assault met a bloody repulse.

> So terrific was the death-grapple, however, that at different times of the day the rebel colors were planted on the one side of the works and ours on the other, the men fighting across the parapet. Nothing during the war has equaled the savage desperation of this struggle, which was continued for fourteen hours.[7]

Edwin Forbes contributed a sketch portraying the cavalry charge at the Battle of Yellow Tavern, during which Confederate general Jeb Stuart received a mortal wound at the hands of Union general Philip Sheridan's cavalry. Although the image likely derives from accounts and Forbes's creativity rather than his

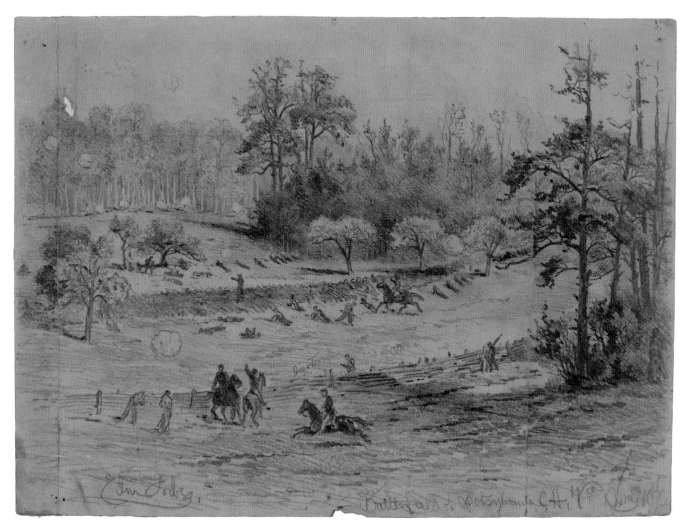

Edwin Forbes, *Battlefield of Spotsylvania C.H. May 10th 64,* May 10, 1864, *Frank Leslie's Illustrated Newspaper,* June 4, 1864, Library of Congress.

firsthand knowledge, readers were given a plausible and realistic version of the scene.

Frank Vizetelly numbered among those who mourned the rebel legend, Stuart. Vizetelly wasn't there at the time, however. In March, he had returned home to London for respite. Not knowing if he would ever return, if his Confederate companions or their cause would survive, he set down his thoughts in an extraordinary letter, published in his London weekly later that spring:

Two months ago I rode through the log and canvas city illustrated in the Engraving on the preceding page, and as I left it I lingered for a few min-

utes to make a farewell sketch. There was much of sorrow in the feelings that governed me at that moment. I was looking, perhaps for the last time, on the camp that sheltered men who had been my companions for nearly two years. What thoughts crowded on me then—what a kaleidoscope of great events whirled through my recollection! Many a gallant deed and many a well-fought field that I had witnessed with my Southern friends were reviewed rapidly as I rose in my saddle and waved a trembling adieu. There curled the Blue smoke from the tent of Robert E. Lee, whose hand I had just shaken, and whose friendship I am proud to own; there were the quarters of the gallant Stuart, whose guest I had been for the

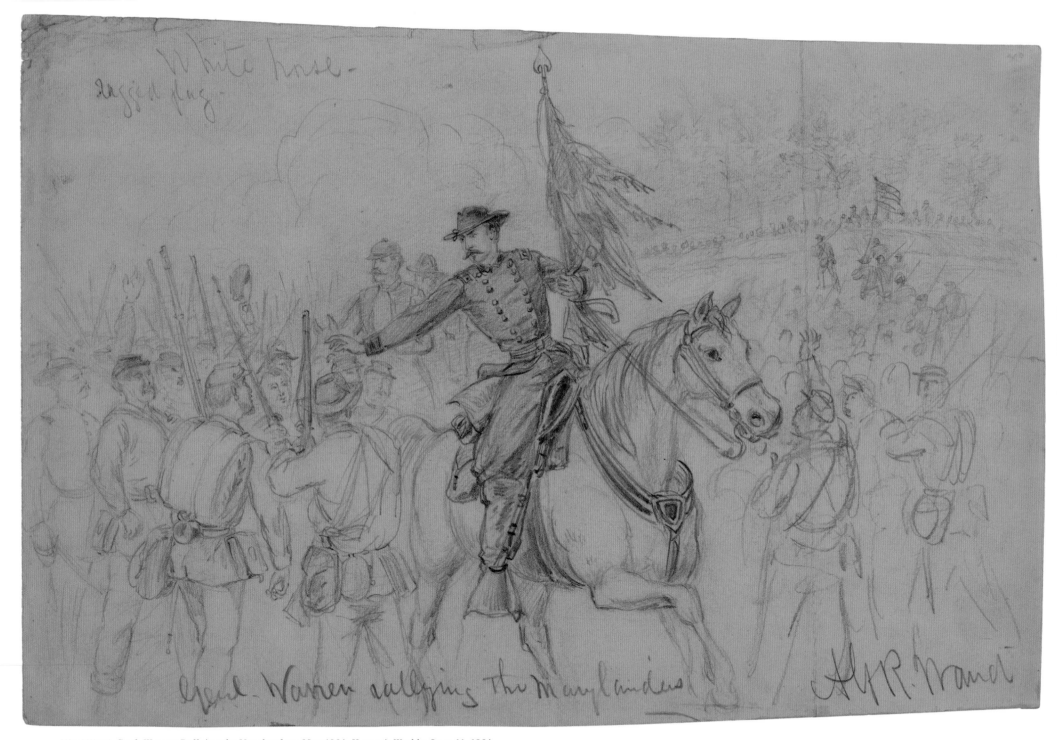

Alfred Waud, *Genl. Warren Rallying the Marylanders,* May 1864, *Harper's Weekly,* June 11, 1864, Library of Congress.

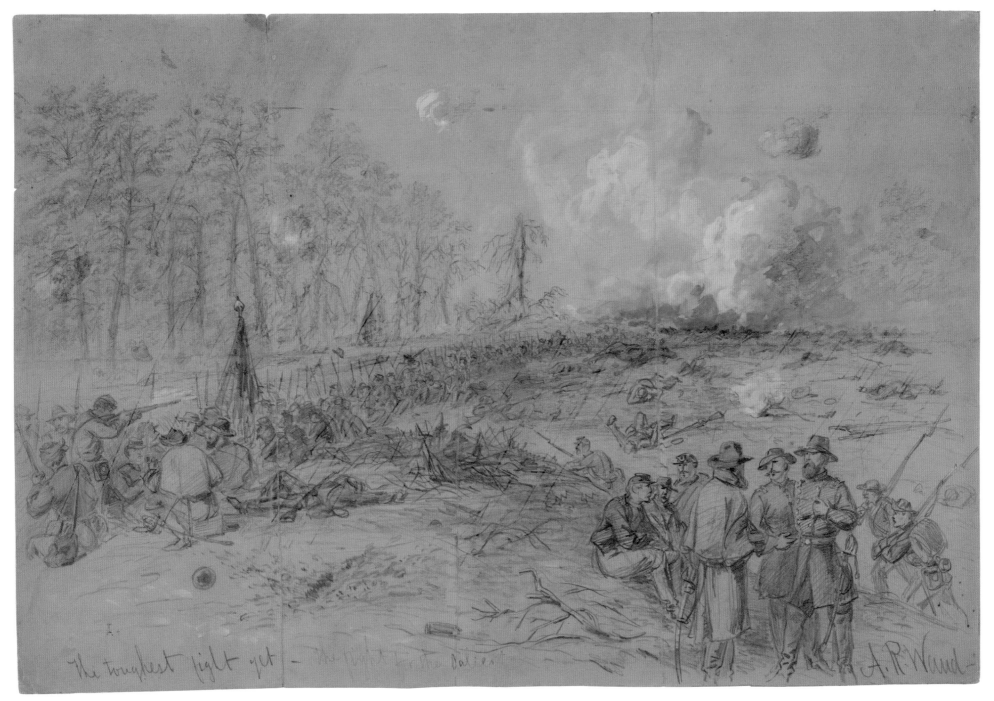

The toughest fight yet — The fight for the Salient

Alfred Waud, *The Toughest Fight Yet. The Fight for the Salient [Spotsylvania],* ca. May 8–13, 1864,
Harper's Weekly, June 11, 1864, Library of Congress.

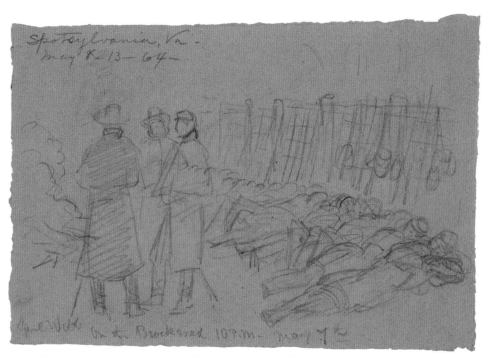

Alfred Waud, *Spotsylvania, Va—May 8-13-64*, May 7, 1864, Library of Congress.

past few days, and whose hospitality in the field I had enjoyed for many months. Yes; every soldier of the army of Northern Virginia was a comrade; we had marched many weary miles together, and I had shared in some of their dangers. This brought me nearer to them than years of ordinary contact could have done; and now, as I looked on their camp for perhaps the last time, I realised painfully and forcibly the many friends who were lying there, some of whom would breathe their last in the first glad sunshine of coming spring. Not only did I survey the camp of the living, but around me, on every side as far as the eye could reach, lay spread the battle-fields of Virginia; and in many a distant clump of pine wood slept their last sleep those whom I had known in life. *Requiescant in pace.* Far away in the background, tipped with snow, towered the mountains of the Blue Ridge, every pass of which bears the imprint of the dead hero, Stonewall Jackson, and of the gallant men who fought with him in the valley of the Shenandoah that lies beyond. Through these passes were made some of those wonderful flank movements which for celerity and success have challenged the admiration of the world.

There, within the eye's glance, lay a classic ground, crimsoned with deeds that will make history for the future. The camp which now looked

so calm and peaceful in the clear winter's sunshine, with naught to disturb the quiet but the stroke of the pioneer's axe cutting fuel for the bivouac fire, would in a few short weeks be broken up. Across the Rapidan, which flows beyond the nearer crest of hills, lay the enemy, only waiting probably the first approach of spring to renew the awful drama that has spread desolation over many a once smiling acre of Virginian soil. As I grasped the hands of my friends at leavetaking, they knew that the present lull was but the forerunner of a coming storm; every man amongst them spoke hopefully and confidently of the future, and here, dispassionately, will I assert that, whatever be the result of the approaching campaign, I am confident that General Lee and his veterans will have done their duty. And now, while bidding farewell to an army with which I have been associated for a lengthened period, let me take an opportunity of thanking all those officers and soldiers whose guest I have been during my sojourn in the Confederacy.

From the Rappahannock to the banks of Yazoo in Mississippi, from the Tennessee to the Atlantic seaboard, every detachment, every Southern command, has received me with unvarying courtesy and whole-souled hospitality; what they have had has been cheerfully shared with your correspondent. To procure me facilities great warriors and "medicine men" have not hesitated to inconvenience themselves where necessary, and if your readers have not benefited as they might have done by my experiences, it is the fault of a rigorous blockade which has intercepted much destined for your pages.[8]

At the front in May, Robert E. Lee missed Jeb Stuart's talents as Ulysses S. Grant's brutal, seemingly inexorable Overland Campaign moved on from Spotsylvania. Edwin Forbes and Alf Waud continued to carry the load in Virginia, with Forbes now joined by Joseph Becker. At the Battle of Jericho Ford on the North Anna River, Forbes produced a picturesque sketch of the conflict from a distant hilltop. At Cold Harbor, Alf Waud made straight for the hottest part of the fight:

The lines these troops hold have been taken from the enemy, and are not more than a hundred yards from the rebel front. The smoke on the extreme left marks the position of a section of *Stevens's* battery, while *Mott's* battery occupies the fore-ground. These and other batteries at this point soon silenced the enemy's artillery, while musket-balls in reckless profusion swept the rifle-pits, among which the dead and wounded lay thickly.[9]

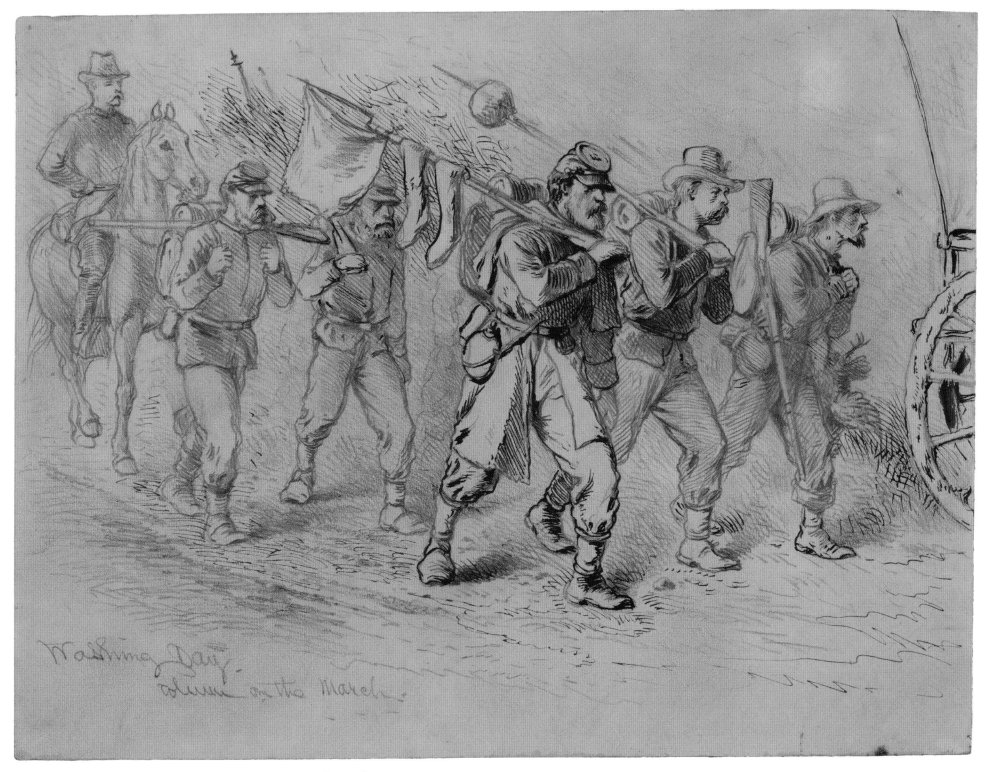

Edwin Forbes, *Washing Day—Column on the March,* May 15, 1864, Library of Congress.

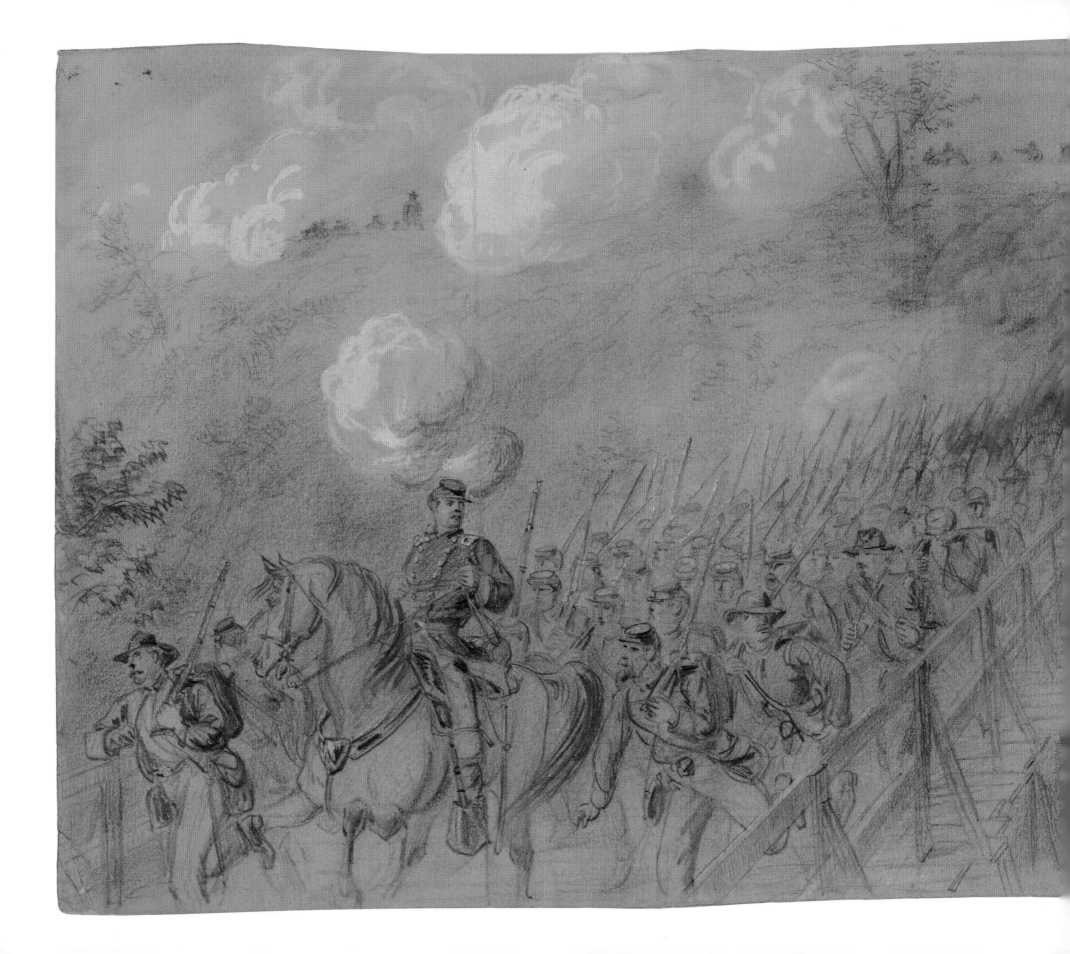

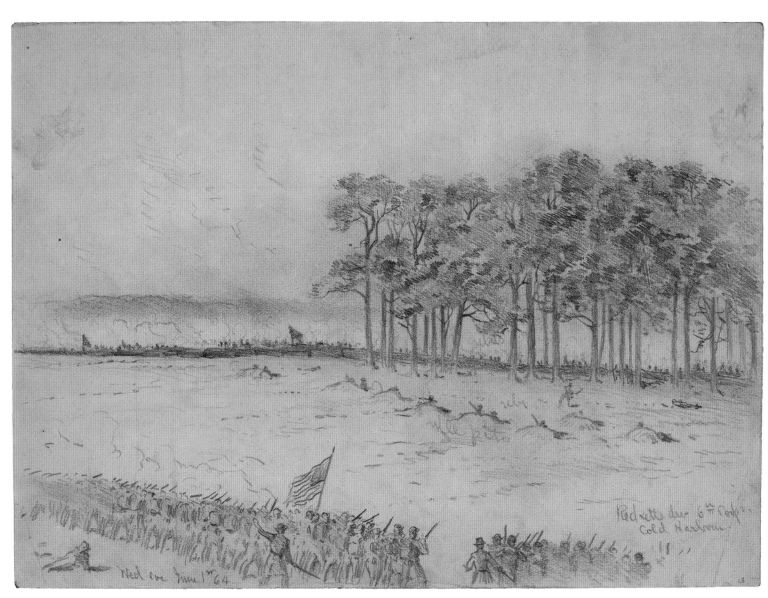

Edwin Forbes, *Ricketts Division, (6th Corps), Cold Harbor,* June 1, 1864, Library of Congress.

Alfred Waud, *N.Y. 14th Heavy Artillery Crossing Chesterfield Bridge on the North Anna under a Heavy Artillery Fire,* ca. May 31, 1864, *Harper's Weekly,* June 25, 1864, Library of Congress.

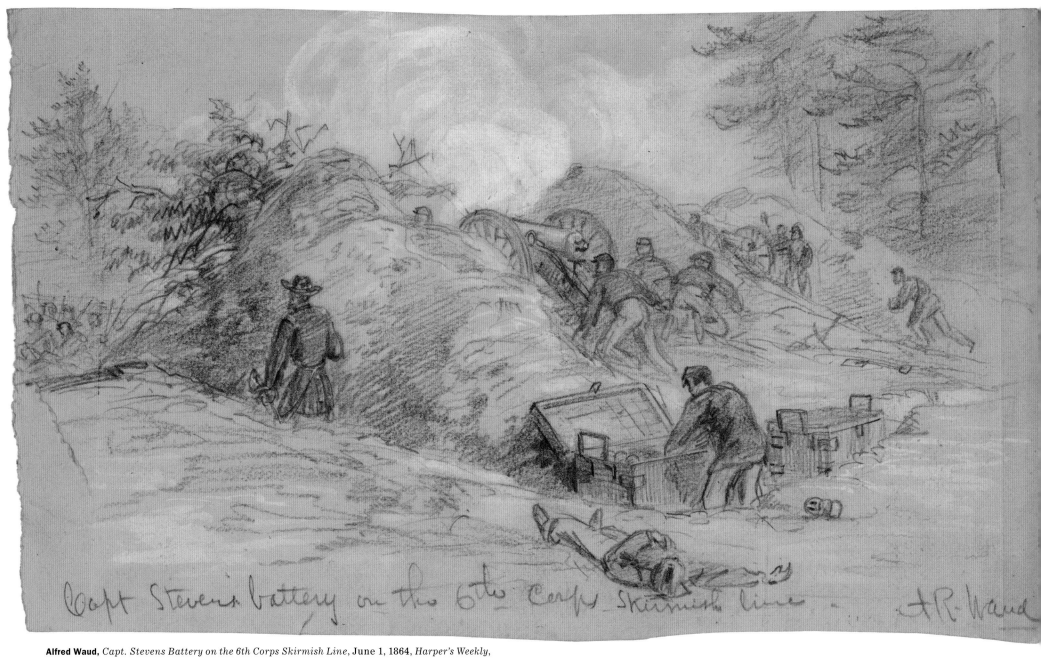

Alfred Waud, *Capt. Stevens Battery on the 6th Corps Skirmish Line,* June 1, 1864, *Harper's Weekly,*
June 25, 1864, Library of Congress.

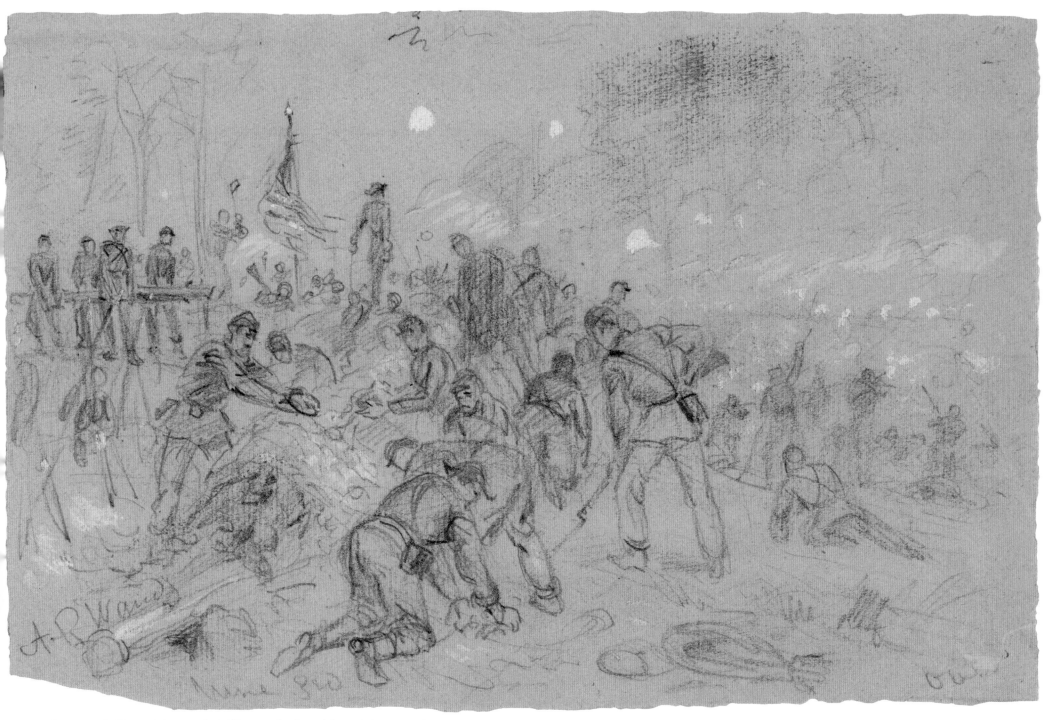

Alfred Waud, *On Hancocks Front—the Soldiers Hav[ing] No Picks and Shovels Used Bayonets, Tin Pans, Old Canteens, and Even Their Hands in Throwing Up Breastworks ARW,* ca. June 3, 1864, Library of Congress.

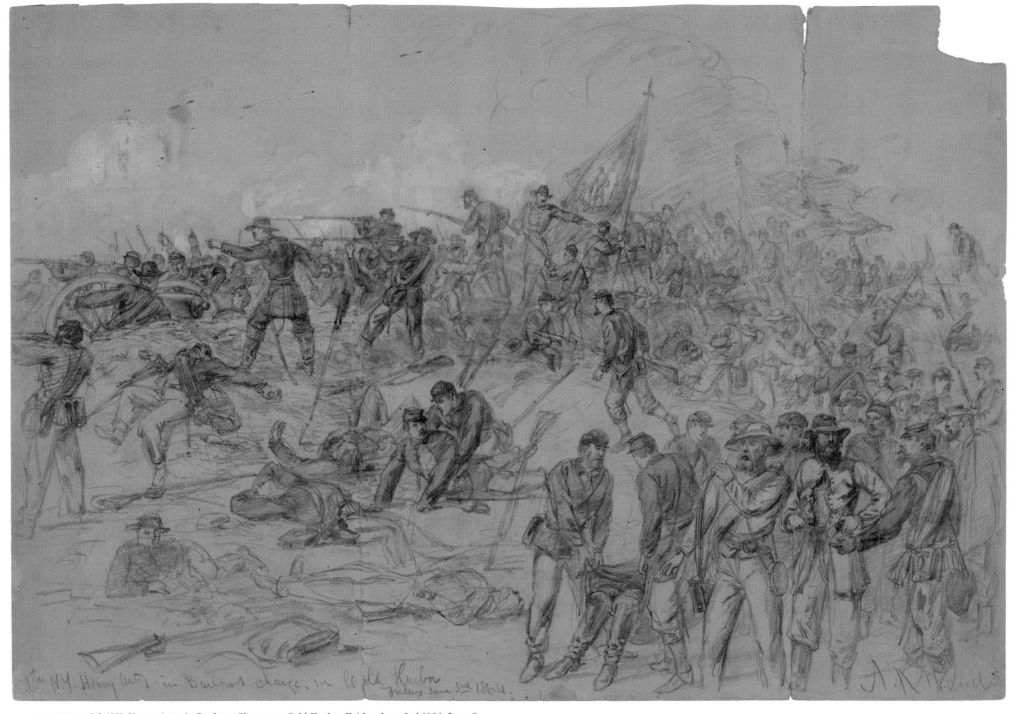

Alfred Waud, *7th N.Y. Heavy Arty. in Barlows Charge nr. Cold Harbor Friday June 3rd 1864,* June 3, 1864, *Harper's Weekly,* June 25, 1864, Library of Congress.

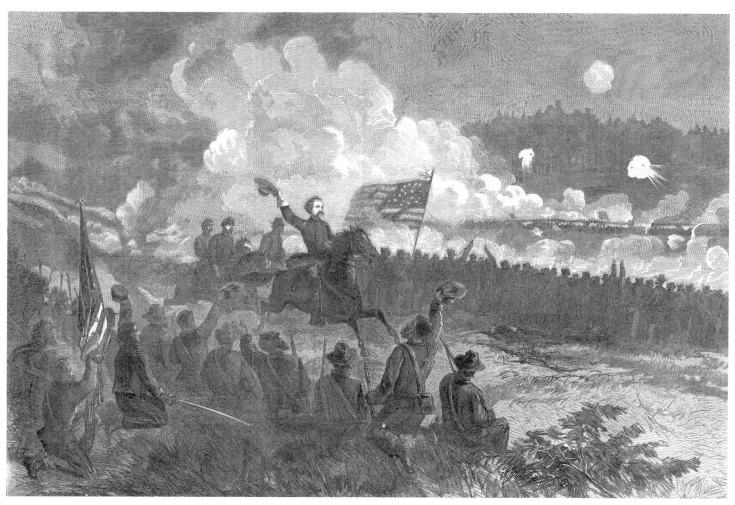

Theodore R. Davis, *General Sherman's Campaign—the Rebel Assault on Logan's Position the Battle at Dallas, Harper's Weekly,* July 2, 1864, image provided courtesy of HarpWeek.

In fact, there were just over six thousand Union casualties on June 3 at Cold Harbor, while the Confederates lost perhaps fifteen hundred men. Another bloody Pyrrhic victory for Lee's armies, who had won battle after battle but now appeared to be losing the war. Grant, who later wrote in his memoirs that he "always regretted that the last assault at Cold Harbor was ever made," pressed on while Lee fell back. Rebel troops never won another major fight.

Theodore Davis, with General Sherman's army marching through Georgia, saw nothing but Union success. He followed Hooker's troops at the Battle of Resaca, and wrote from the scene:

On the evening of the 14th a portion of General Hooker's corps, who had reached a point on the extreme right, were, at a critical moment, turned upon by the enemy, and driven back to the Fifth Indian Battery, Captain Simonson, which held a position of great importance. General Hooker, without a moment's delay, ordered Colonel Robinson's brigade of General Williams's division to charge the rebel line, which was almost upon the battery of the gallant Simonson. The brigade immediately advancing, the rebels were forced back and the battery saved.[10]

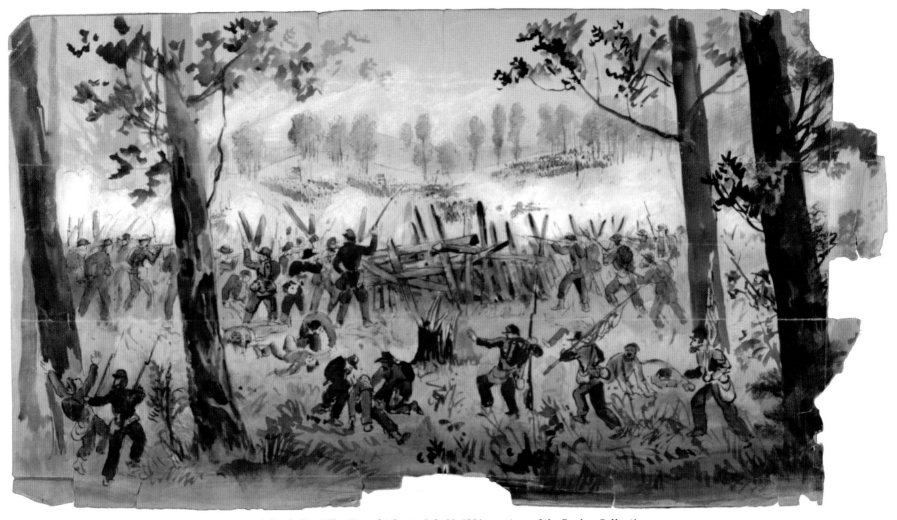

J.F.E. Hillen, *A Battle Two Miles West of Atlanta*, July 30, 1864, courtesy of the Becker Collection, Boston, MA.

On the other hand, C.E.H. Bonwill, with General Banks's Red River Expedition in Louisiana for *Leslie's*, witnessed a disaster unfolding:

> The retreat of Banks from before Shreveport has been attended with difficulties, losses, perils and triumph, which the participants will not soon forget, and which even amid the absorbing interest attendant on the operations of Gens. Grant, Butler and Sherman deserve illustration, and we, therefore, use some of our sketches sent on by our Special Artist.[11]

Most public attention in the North soon focused on Petersburg, Virginia, just twenty-three miles south of Richmond, when Grant's army crossed the James River and after some early tentative attacks, lay siege to the city.

The Siege of Petersburg began with an assault on June 15, 1864, and ended with the city's surrender almost ten months later on April 3, 1865. Both *Harper's* and *Leslie's* augmented their staff with additional Specials to cover the expanded lines and range of activities. E. F. Mullen and Andrew McCallum joined Edwin Forbes and Joseph Becker working for *Leslie's* while *Harper's* brought in Alf Waud's younger brother, Will. The artists at Petersburg, like the soldiers, knew

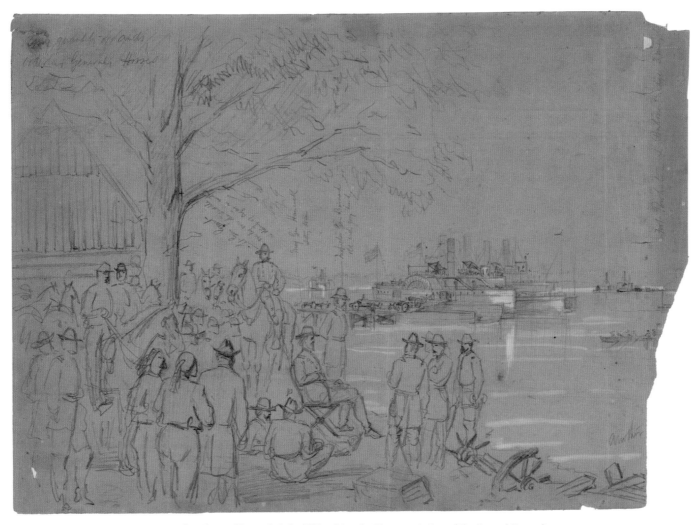

William Waud, *Gen Grant, Hancock & Staff Watching the Transportation of the Second Corps from Wilcox Landing to Windmill Point across the James River,* June 14, 1864, *Harper's Weekly,* July 9, 1864, Library of Congress.

long periods of utter tedium punctuated by sporadic, intermittent skirmishes and assaults. They drew soldiers in the trenches and their lives in camp, skirmishers, stragglers, cooks and teamsters. *Frank Leslie's* reported that snipers remained a constant danger:

> The sharpshooters kept steadily at work, their rifle-pits not being more than 100 yards apart and, in some cases even less. No part of the body could be exposed for a moment. Gradually, however, the fire slackens on both sides, and at last it dies away. After a pause some adventurous

one raises his head, and calls out: "How are you, Johnny?" "How are you, Yank?" comes in reply, with a hearty good will, and the ice being broken a promise follows not to shoot, and out they sally to stretch their limbs and take a moment's freedom. The rifle-pit and the tree-top give up their denizens, who gradually approach the half-way line, and with the characteristic spirit of the universal nation begin to swap.

Richmond papers and tobacco are exchanged for Northern luxuries, and for a time all is gay banter and friendly intercourse. At last the warning is given. "Run back, Johnnys," "Run back, Yanks." Men regain

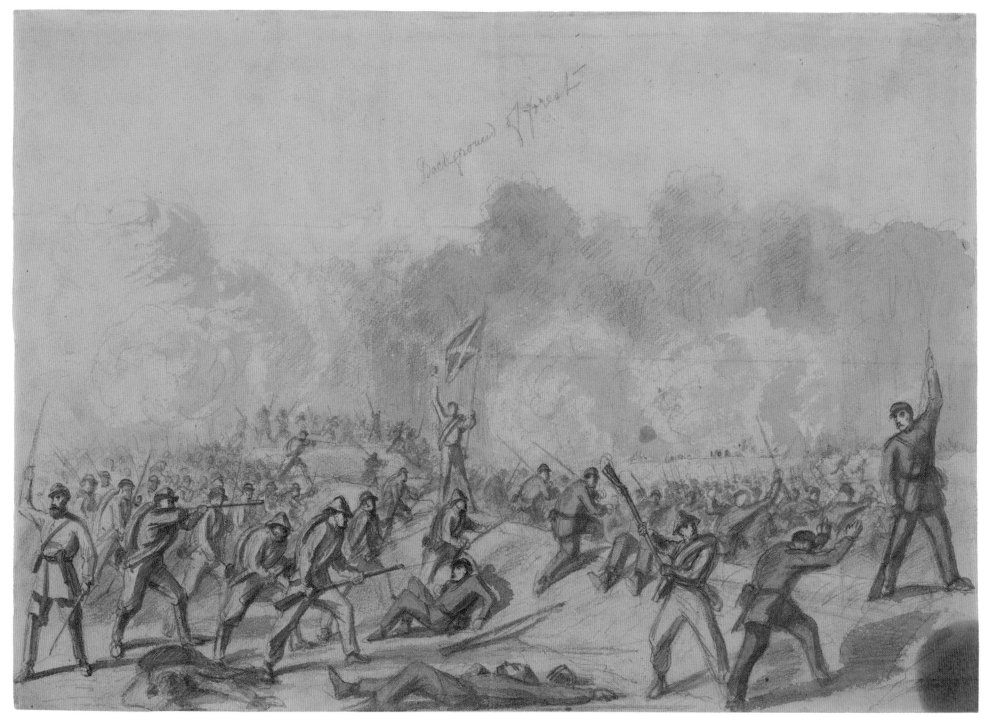

Frank Vizetelly, *The Texans of Field's Division Longstreet's Corps, Retaking from the Federals the Outer Line of Entrenchments on the South Side of the James River Headquarters Longstreet's Corps, James River, Virginia,* June 17, 1864, *Illustrated London News,* July 30, 1864, MS Am 1585, Houghton Library, Harvard University.

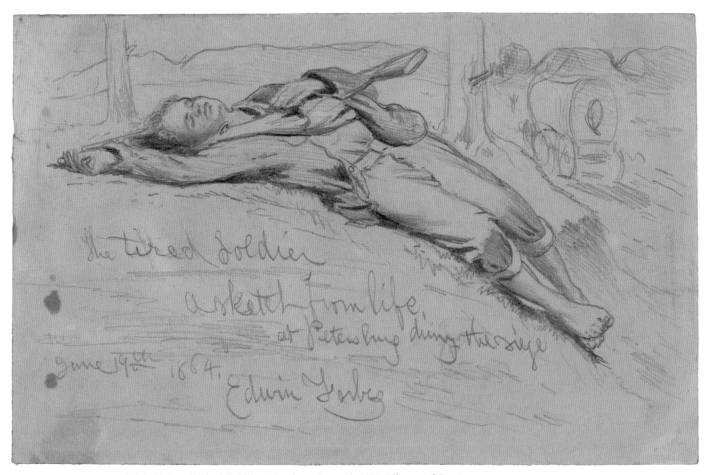

Edwin Forbes, *A Tired Soldier, Petersburg,* June 19, 1864, Library of Congress.

their posts, and the firing begins, high at first, and evidently with no intention except to warn that the stern reality reigns once more.[12]

The Petersburg campaign proved challenging even for such a veteran as Alf Waud. Owning the trust of military superiors was a dubious honor, as General Meade requested a sketch from Waud of the earthworks comprising the Petersburg defenses. On the finished piece the Special wrote, "It took over an hour and a half—rebel sharpshooters kept up a fire at me the whole time."[13] By September Waud suffered from dysentery and lack of sleep from the constant shelling.

Frank Vizetelly arrived at the Petersburg front from England via Richmond with sketches and a tale to tell, having run the blockade into Wilmington, North Carolina, from British-held Nassau Island in the Caribbean:

Upon the evening of Wednesday, the 1st of June, the Lilian and the Florie, two of the fleetest and most beautiful of the blockade-defying vessels, started simultaneously from Bermuda upon the first trip inward which either had ever made. Both belong to the same company, but there is an emulation between the two rival vessels which is not satisfactorily allayed by their experiences hitherto, but which waits the solution of further trial. The weather was lovely, the sea like a milldam, and favourable beyond expression to light draught and gossamer craft, such as are these blockade-runners, which lightly scratch the surface instead of clutching the ribs of old ocean; and which in summer seas have no more to fear from heavy seagoing craft, like the Rhode Island or the Vanderbilt, than has the Irish night-express from the lumber-

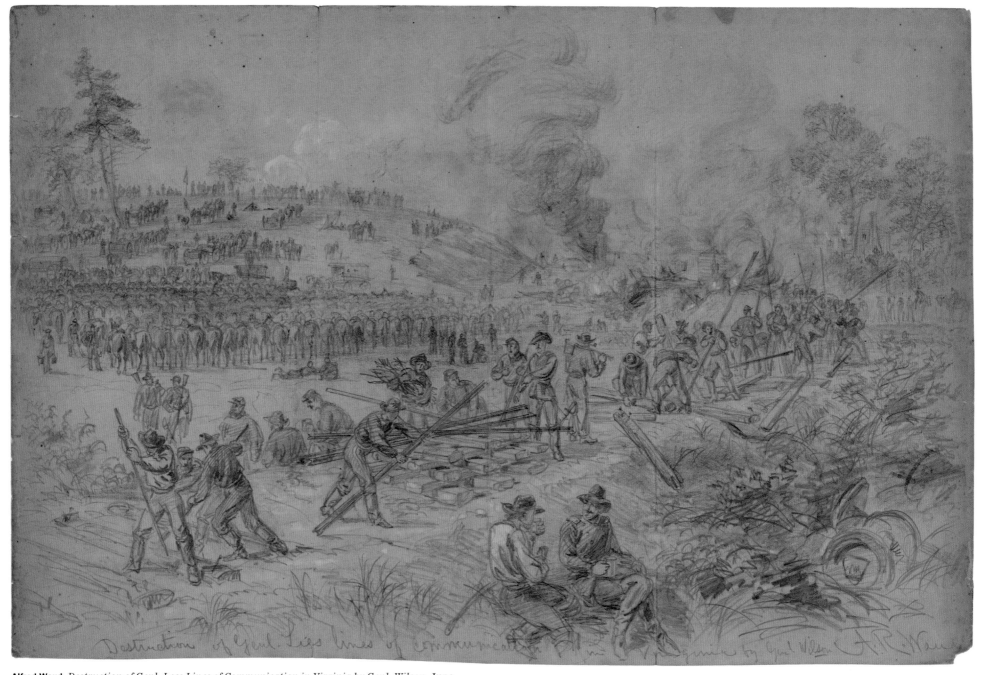

Alfred Waud, *Destruction of Genl. Lees Lines of Communication in Virginia by Genl. Wilson,* June 20–25, 1864, *Harper's Weekly,* July 30, 1864, Library of Congress.

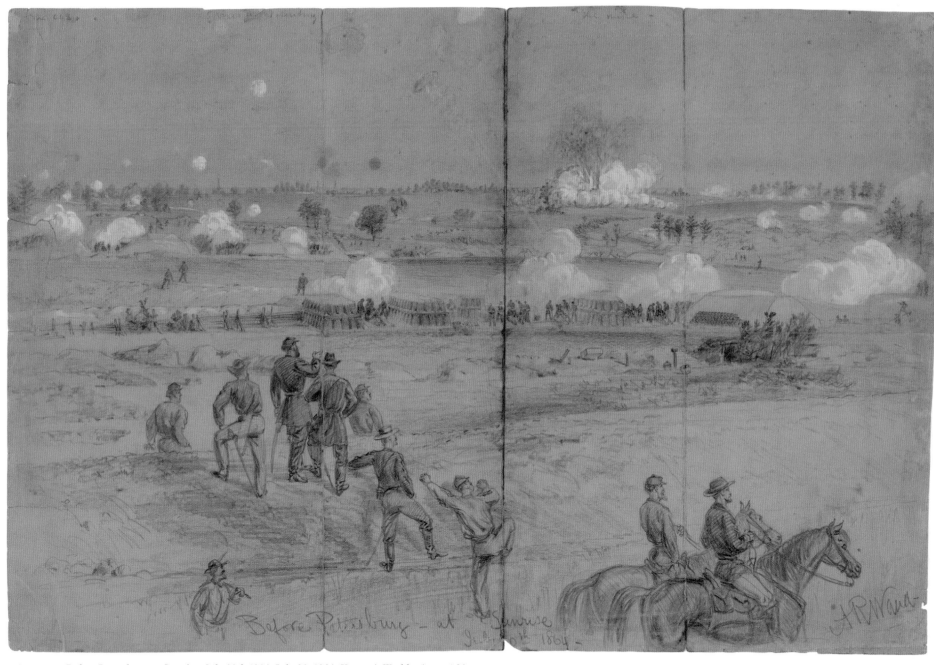

Alfred Waud, *Before Petersburg at Sunrise, July 30th 1864*, July 30, 1864, *Harper's Weekly,* August 20, 1864, Library of Congress.

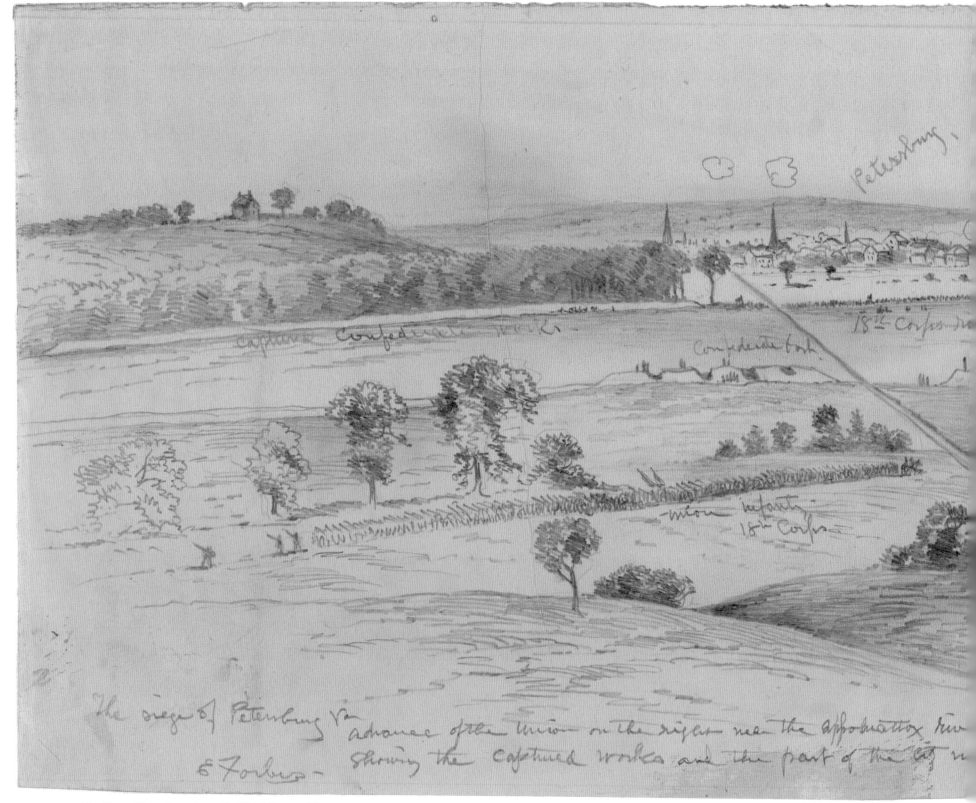

The siege of Petersburg Va
advance of the Union on the right near the Appomattox River
E Forbes — showing the Captured works and the part of the city n...

Edwin Forbes, *The Siege of Petersburg,* June 18, 1864, Library of Congress.

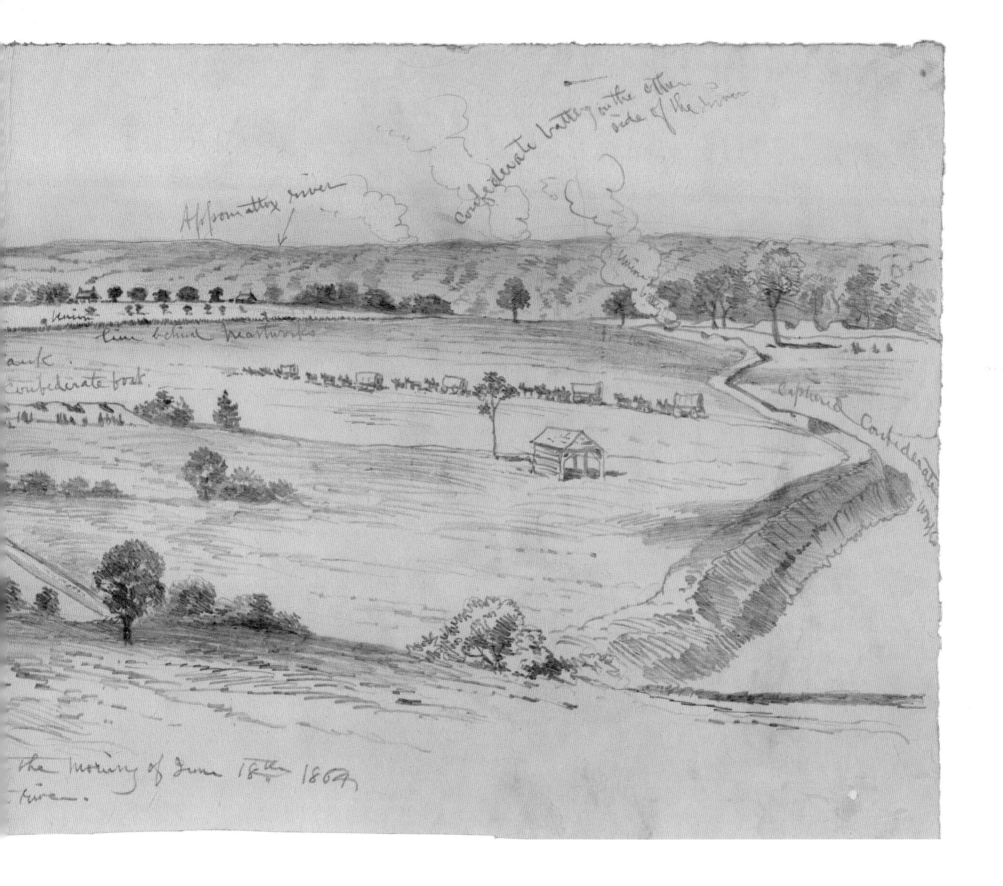

Appomattox river

Confederate battery on the other side of the river

Union line behind heartworks

bank.
Confederate post.

captured Confederate works

the morning of June 18th 1864
river.

ing freight-train which leaves Euston-square five minutes in its rear. Rarely have two more attractive prizes slipped through the meshes of the blockade than the two vessels of which I am writing... The night wore rapidly away; two o'clock, three o'clock, half past three o'clock in the morning came, but by no eye peering through the thick gloom could the looked-for light at Fort Fisher be discerned. Then, as the morning dawned, we prepared to lay-to for the day, between the outer and inner cordon of the blockaders. It was hardly to be expected that we should escape for sixteen hours unobserved; but it was a signal instance of good luck that from four in the morning till half-past one p.m. we were unmolested. Then the tall masts of a large Federal cruiser, and her immense paddle-wheels and lofty black hull were visible, and for the first time, as our antagonist approached us from the direction of Wilmington, the 'airy fairy Lilian' prepared to give us assurance of that speed which we all felt she possessed. Some slight delay there was before steam could be fully got up, and for some twenty minutes our pursuer seemed to gain upon us. But as the pressure of steam ascended from fifteen pounds to twenty, from twenty to twenty-three, from twenty-three to twenty-six, and as the revolutions of the paddle mounted from twenty-six to twenty-eight, from twenty-eight to thirty-three per minute, the Lilian flew out to sea swift as arrow from a bow. In little more than two hours the hull of our pursuer was invisible, and her topgallant sails a speck upon the distant horizon. But as she still lay between us and Wilmington it became necessary to run round her. This also the light-heeled Lilian had little difficulty in accomplishing; but as the sun dropped into the sea, and our pursuer, although distant, still hung upon our rear, we found that, reckoning little the speed of our advance, we had sighted the inside blockade squadron before the close of day. There was nothing for it but to persevere, and fortunately, before we approached close to land, darkness had completely set in. Silently and with bated breath we passed cruiser after cruiser, distinctly visible to every eye, and suggesting the flashing out of a blue or Drummond light, and the rush of grape-shot and shrapnel through our rigging and bulwarks. But it was not destined that upon this occasion the Lilian should receive her baptism of fire. Just as we approach Fort Fisher a dark spot is seen on the bar. It is a Federal launch, seen by

Alfred Waud, *Siege of Petersburg, 18th Corps,* July 1864, *Harper's Weekly,* July 30, 1864, Library of Congress.

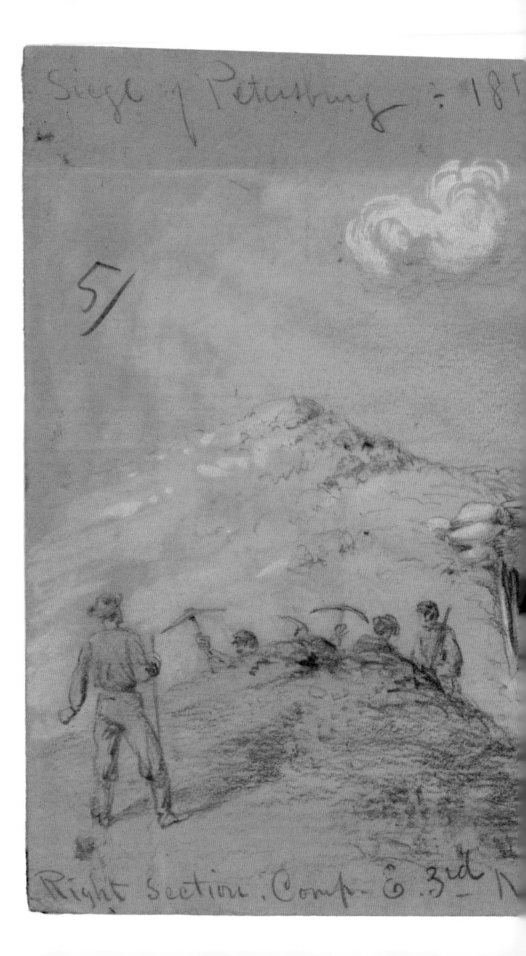

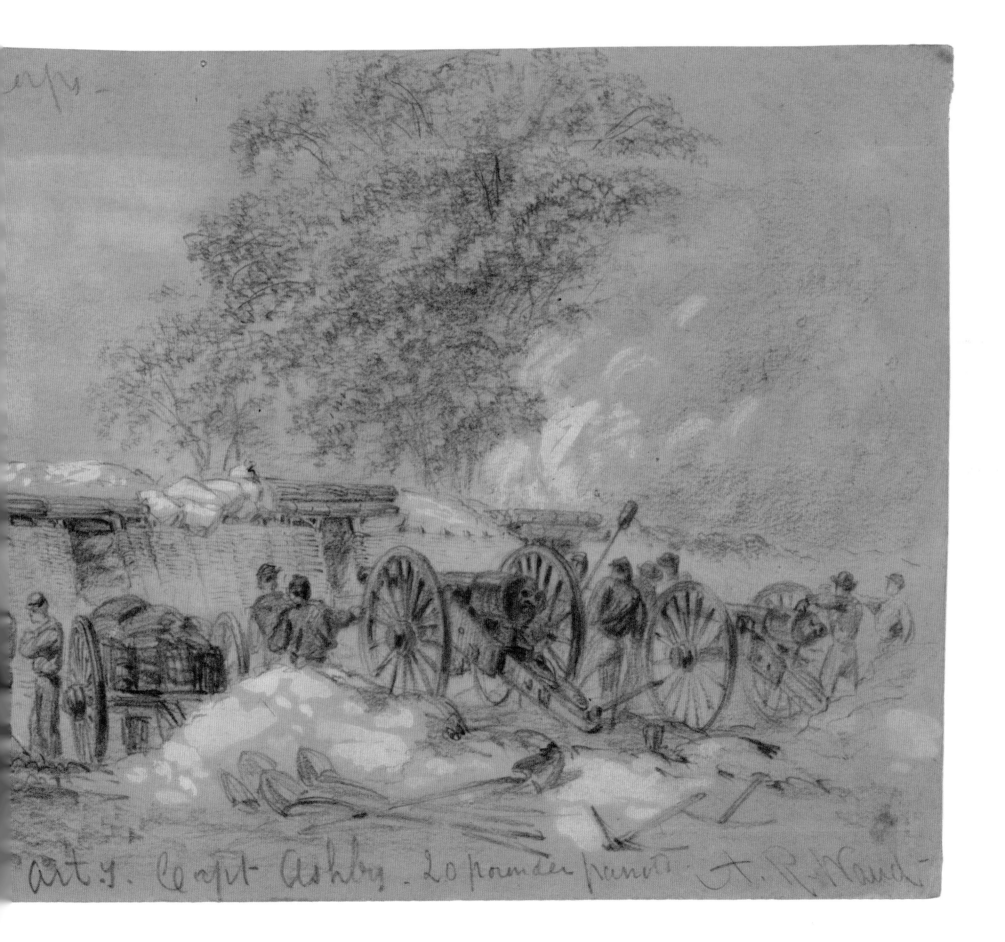

Art. I. Capt. Ashby. 20 pounder parrott. A. R. Waud.

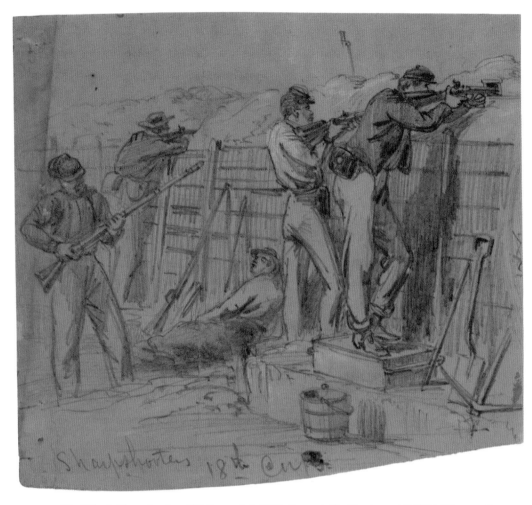

Alfred Waud, *Sharpshooters 18th Corps,* July 1864, *Harper's Weekly,* August 6, 1864, Library of Congress.

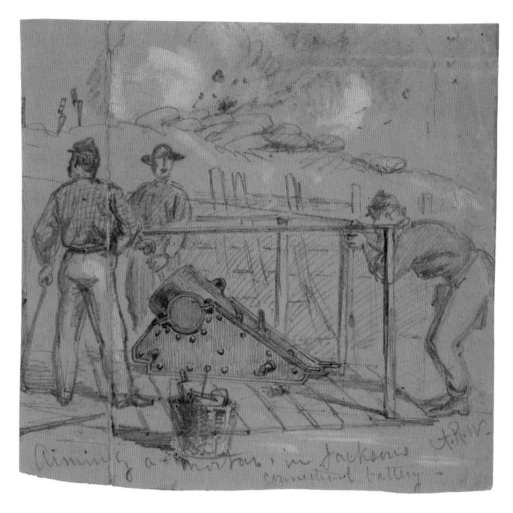

Alfred Waud, *Aiming a Mortar, in Jacksons Connecticut Battery,* ca. June–July 1864, *Harper's Weekly,* August 6, 1864, Library of Congress.

us too late for Captain Maffit to indulge the anxious wish of his heart and to run her down. We pass her within twenty yards, and again the expected volley of musketry is wanting. Another moment and we are under the mound upon which stands the fort, and eagerly questioned for news. 'The news is good all round.' 'Three times three for General Johnston;' 'six times six for General Lee;' and in mirth and laughter and song the night wears away. Three hours after us comes the Florie, and is heavily fired at as she wears inwards. But morning finds both vessels and their cargoes safe at their wharf in Wilmington, nor is it rash to predict for them both the probability of many returns.[14]

He returned to a devastated countryside, a ravaged people and an army fighting for its life. With unbridled passion and sentiment, he wrote:

Stokes's division was one of those which were sent across the James River to meet Grant on his approach to Petersburg. Its march formed the most picturesque scene I have ever witnessed. The woods had caught fire in many places from shells thrown into them, and the bright flames leapt up the tall trees, casting a ruddy glare upon the faces of those careless warriors as they passed under the fir-branches, which were dropping flakes of fire. Now and then an old shell would explode in the undergrowth; but this was looked upon as an enlivening incident,

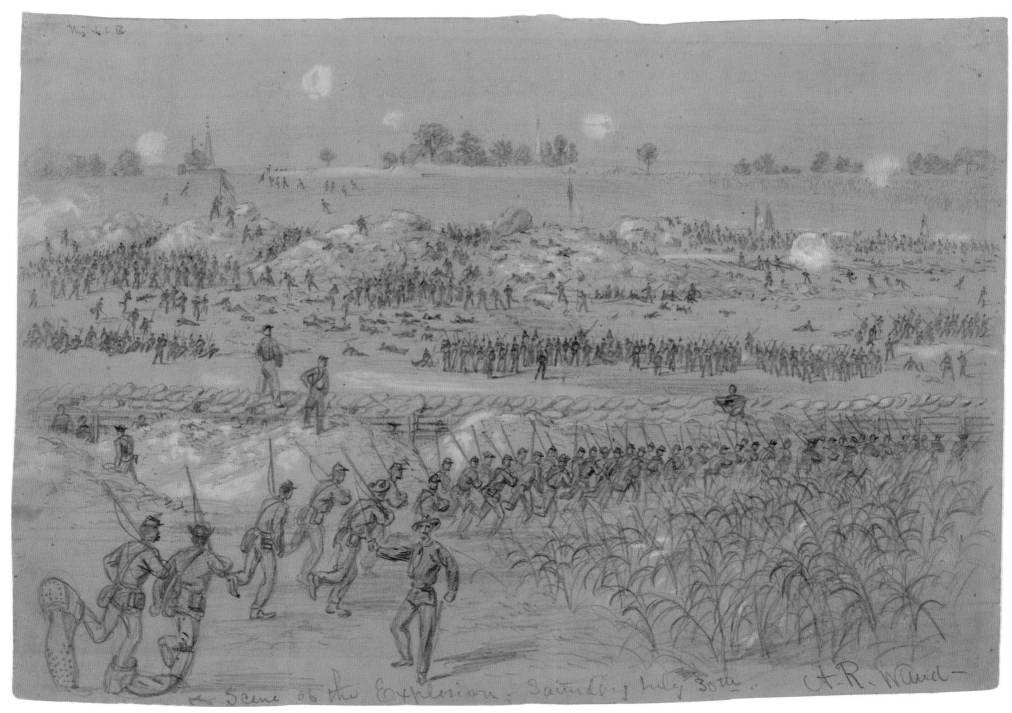

Alfred Waud, *Scene of the Explosion Saturday July 30th*, July 30, 1864, Library of Congress.

Frank Vizetelly, *Back Again to Dixie—the "Lilian" Running through the Blockading Squadron,*
On Board the C.S.S. Lillian, Wilmington, North Carolina, June 5, 1864, MS Am 1585, Houghton
Library, Harvard University.

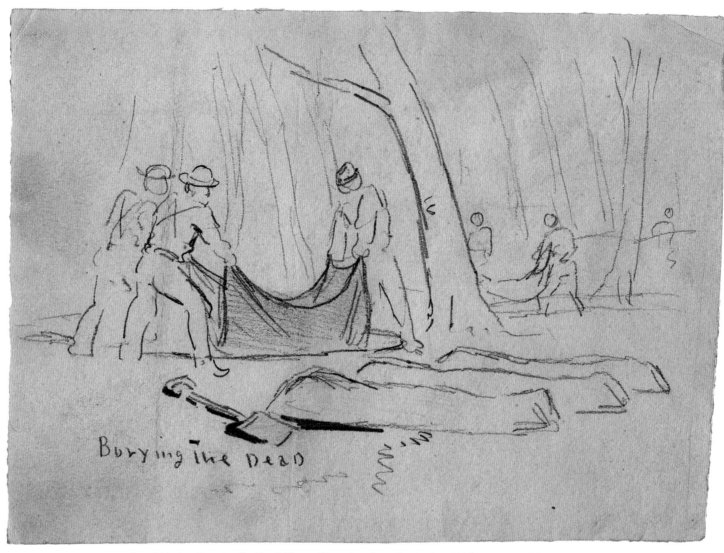

Joseph Becker, *Burying the Dead (Siege of Petersburg)*, ca. September 1864, courtesy of the Becker Collection, Boston, MA.

with which the men were rather pleased. The woods about Bottom's Bridge are filled with dead Federals, whom their humane commander, General Grant, has left unburied. Perhaps the burning of the timber in which these corpses lie will save Richmond from a pestilence they would otherwise create. For miles outside the works of Richmond you meet with such fearful traces of the slaughter which the Federals suffered in their unsuccessful efforts to break through the Confederate lines.[15]

In Washington, D.C., in mid-July, President Lincoln saw Confederate troops firsthand at the Battle of Fort Stevens, a brazen attack on the Capital from the north by a troop of Southern soldiers. E. F. Mullen, who was there as well to sketch the scene, reported:

Brief as was the combat last evening, it was bloody. Of the rebels I counted the burial to-day of about 250 and saw and talked with 59 desperately wounded. The usual proportion between killed and wounded,

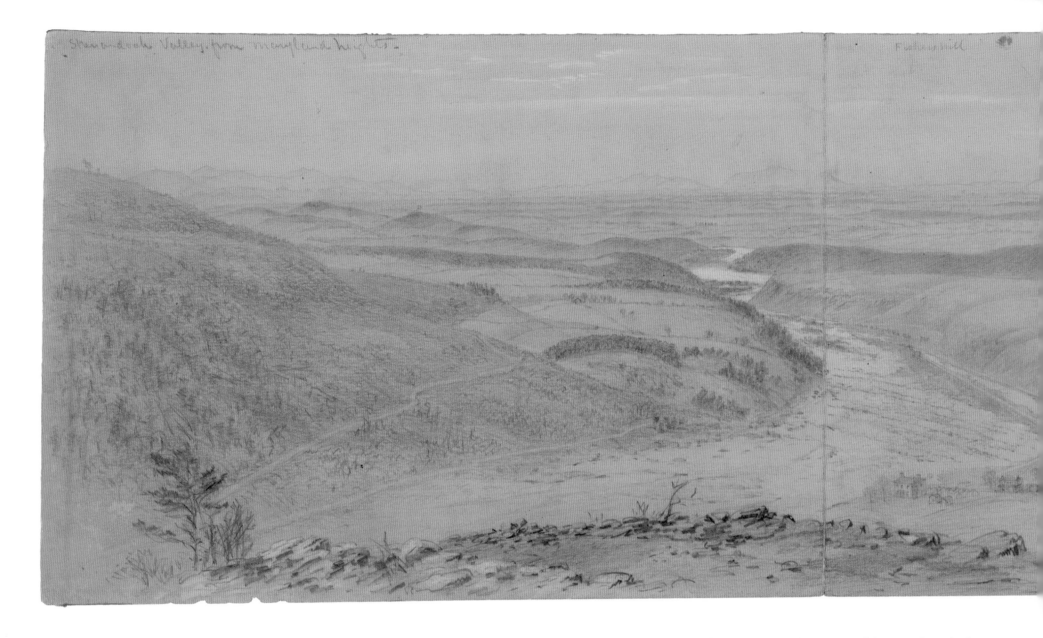

Shenandoah Valley from Maryland Heights.

if maintained in their action, would, with the ascertained killed, make a total of killed and wounded of 1,500.[16]

The Battle of the Crater, a Union debacle within the Petersburg lines that took place on July 30, produced numerous sketches detailing its horrendous execution. Army sappers dug tunnels and laid mines under the Confederate works, then exploded the charges, creating a vast cavity in an attempt to both destroy and distract the rebel defenders. The plan went horribly wrong. Union troops, most of them African American, charged into the crater instead of around it and were easily killed by the Confederates. Northern casualties numbered almost four thousand as opposed to about fifteen hundred from the South. Alf Waud saw the mine go up and described it for *Harper's* readers:

With a muffled roar it came, and as from the eruption of a volcano—which it much resembled—upward shot masses of earth, momently illuminated from beneath by the lurid flare. For a few seconds huge blocks of earth and other débris, mingled with dust, was seen in a column perhaps 150 feet in height, and then the heavy volume of smoke,

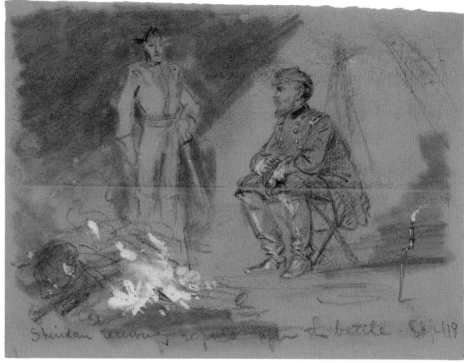

which spread out in billowy waves on every side, enveloped all, like a shadowy pall for the two hundred souls thus rushed into eternity. As if for breath there was a short pause, the rebels regarding the giant apparition as though spell-bound, and then one hundred and fifty guns opened in one grand volley upon the rebel lines. The storming columns could be seen springing forward to the doomed work; but the rapid cannonade soon hid that portion of the line in smoke, though the savage discharges of musketry showed plainly the enemy did not propose giving up without a struggle. Their artillery withered under the terrible

accuracy of the fire directed against them, made but desultory firing, and soon became almost silent before the Fifth Corps. The Petersburg Express made regular trips into the city; the mortar shells, visible to their destination, creaked through the air and formed beautiful rings and spirals; while the sun, struggling through the heavy vapors of battle, recalled Campbell's lines:

> "'Tis morn. But scarce you level sun
> Can pierce the war-clouds rolling dun."[17]

The Siege of Petersburg continued throughout summer and fall 1864 while the public's attention wandered to other theaters. Grant threatened the supply lines feeding Richmond, Sherman attacked Atlanta, and Sheridan moved into the Shenandoah Valley. Theodore Davis, J.F.E. Hillen and C.E.F. Hillen remained with Sherman in Georgia and pitched in with illustrations from the Battle of Atlanta, fought July 28. J. E. Taylor followed Sheridan into the Valley

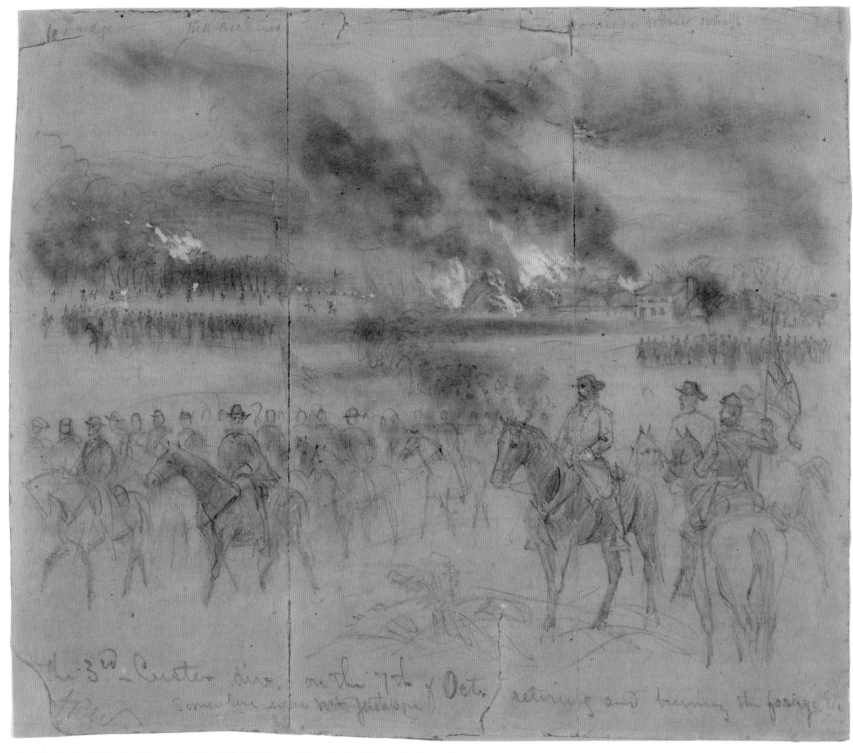

Alfred Waud, *The 3rd Custer Div. on the 7th of Octr. Retiring and Burning the Forage Etc. Somewhere near Mt. Jackson,* October 7, 1864, Library of Congress.

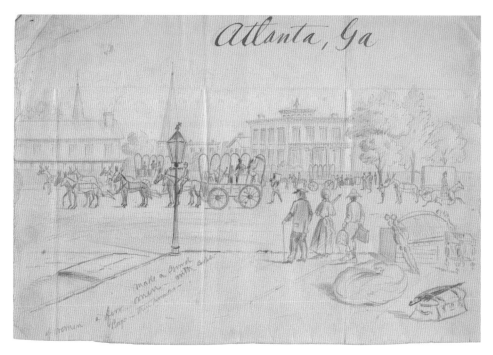

Unattributed, *Citizens Leaving Atlanta as Consequence of the Late Order of Gen. Sherman*, ca. 1864, courtesy of the Becker Collection, Boston, MA.

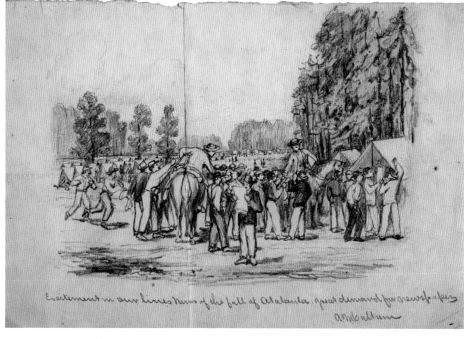

Andrew McCallum, *Citizens Hearing of Fall of Atlanta*, 1864, courtesy of the Becker Collection, Boston, MA.

for *Frank Leslie's*, soon to be joined by Alf Waud for *Harper's*. Taylor sent back a sketch:

> [It] shows why the Shenandoah valley is the bone of contention. The richly stored barns of the farmers are coveted by the starving legions of Lee, and straitened as he is by Grant, he may better meet Grant than famine, and sends Early to gather the harvests. Our armies in their advance also need supplies, and there are plenty who are openly hostile to make the foraging a matter of no reluctance. In the present case, which occurred in Clarke county, Va., on the Selden estate, our men are retaliating for the plunder of Maryland and Virginia.[18]

At Petersburg, with little action to enliven their days, the artists turned to camp life and social and political activities. Black soldiers now fought for the North and former slaves were valued by both sides for their potential contributions to the war effort. Life among the newly arrived Contrabands continued to be of interest:

The negro furnishes, in his various phases of existence, wonderful studies for the artist and philosopher. Never, perhaps, has a race seen such a moment as this, when the chains of bondage are breaking from off the limbs of 4,000,000 of men. The distant roar of battle is to them a sound of deliverance. With all the uncouth, odd and queer manifestations of joy, they prepare to reach the camp of the delivering Yanks. Yoking together most incongruous teams before the farm wagon of their fled master, with ass, and ox, and horse, with household gear queerly assorted, with useless truck and little that can rarely serve them, they start for the Promised Land, and may often be seen coming in as our Artist—a most close student of nature—depicts them with his usual felicity of portraiture.[20]

Joseph Becker produced numerous drawings detailing black life in and around the military—soldiers, teamsters, washer-women, cooks and children. A number of Specials sketched religious services in camp. Becker himself drew and described an evening prayer meeting at a Contraband camp at the Union supply depot at City Point, Virginia. His editors wrote:

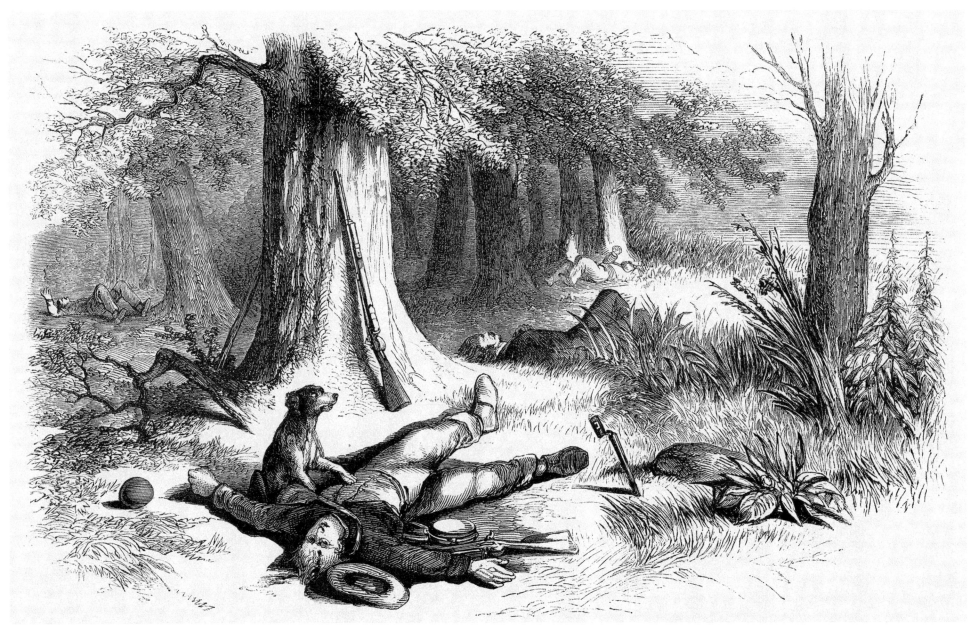

James E. Taylor, *Sheridan's Campaign—an Incident at the Battle of Winchester—a Faithful Dog Watching and Defending the Dead Body of His Rebel Master, Frank Leslie's Illustrated Newspaper,* October 15, 1864, image provided courtesy of HarpWeek.

CANINE FIDELITY: *An Incident in the Battle of Winchester.*

Our Artist, after the battle of Winchester, strolling over the ground marked by the battle and in the woods in front of the 19th corps, where the most stubborn fighting took place, and the dead lay thickly strewn amid the trees, which towered above them, found an incident which he has sketched. Of the fidelity of the dog we have often heard. Here was an instance. A rebel soldier lay dead on his back, killed, apparently, almost instantly by a bullet through his forehead, his gun beneath him as he fell, a round shot but a few feet from him. By his side was his faithful dog. It was in vain to attempt to approach the corpse, the animal, true to his master, allows no one to draw near, but remained there, steadfastly keeping watch by the dead, waiting, doubtless, for some familiar face to approach.[19]

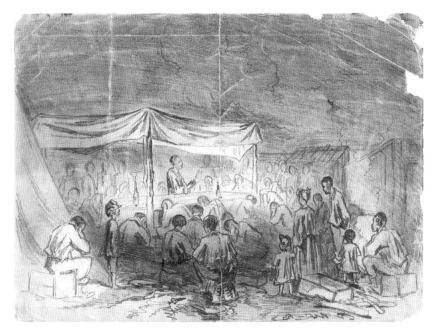

Joseph Becker, *Evening Prayer Meeting at City Point (Siege of Petersburg), September 2, 1864, Frank Leslie's Illustrated Newspaper*, October 1, 1864, courtesy of the Becker Collection, Boston, MA.

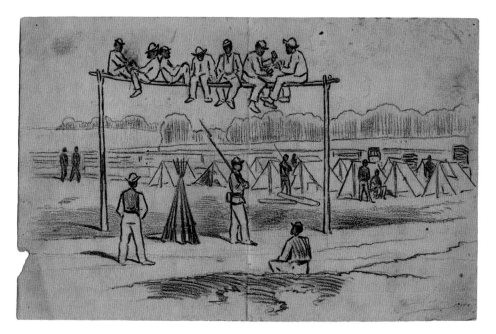

Joseph Becker, *Scene in One of the Camps of the Negro Regiment: Mode of Punishing Negro Soldiers for Various Offences (Siege of Petersburg)*, October 31, 1864, *Frank Leslie's Illustrated Newspaper*, December 10, 1864, courtesy of the Becker Collection, Boston, MA.

Our Artist in Gen. Grant's camp was struck one evening at City Point by the singing of a colored prayer-meeting, and approaching, was so struck by the simple earnestness, real piety and untutored eloquence of Brother John, who led the services, that he could not forbear sketching the scene.[21]

In Charleston, South Carolina, Leslie's resident artist, William T. Crane, found the scene of Union Army officers paying off black soldiers remarkable:

How strange it is now to look back at the commencement of this war! What advance has been made in many ideas. When it was first suggested that the negroes who escaping from slavery were becoming a burthen on the Government should be armed and drilled, a feeling of intense bitterness was aroused. The opponents of the Government and the sympathizers with rebellion were of course loudest and most vehement in their denunciation of the system. The rebel Government threatened and has fulfilled its threat of refusing quarter to Negro soldiers and their officers, but Government persisted, and a considerable part of the army now consists of Negro soldiers. The matter is no longer an experi-

ment. The regiments differ greatly; those with capable, diligent officers surpassing of course those where the men who hold commissions shirk the unwelcome task of drilling and guiding their men. Our Artist before Charleston sketched the paying off of one of the Negro regiments; and if we may judge from the bearing of the men, they have found officers who aim to do their duty to their command and their country.[22]

As fall progressed the nation moved nearer the 1864 presidential election, in which Republican incumbent Abraham Lincoln faced former Union general George B. McClellan, the Democratic candidate. For the first time soldiers could vote in camp and Specials noted the new procedures. William Waud sketched Pennsylvania soldiers voting in the Headquarters of the Army of the James and E. F. Mullen drew Union troops gathered around election posters. On Election Day, November 8, Joseph Becker sketched *View of the Polls near Fort Wadsworth on the Weldon Road.*

Drinking, gambling and other more salubrious activities also occupied the soldier's days and nights. Joseph Becker portrayed black soldiers punished for their transgressions by being compelled to sit atop an elevated log for hours at a time. Other sketches depict white soldiers suffering the same sentence. In

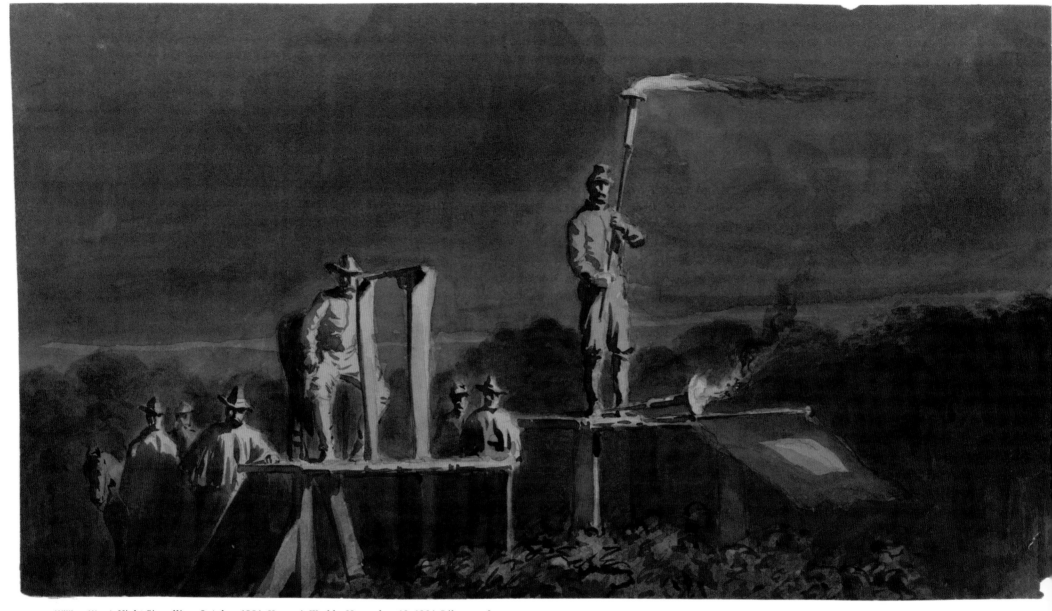

William Waud, *Night Signalling,* October 1864, *Harper's Weekly,* November 12, 1864, Library of Congress.

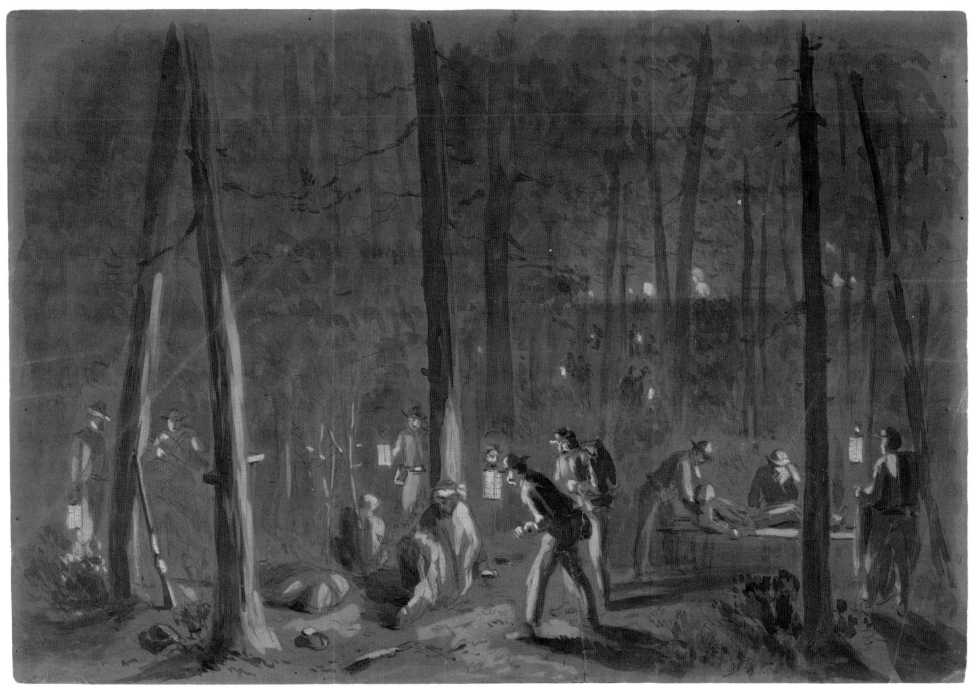

William Waud, *Hospital Attendants—Collecting the Wounded after the Engagement—within Our Lines near Hatchers Run,* September–October 1864, *Harper's Weekly,* October 29, 1864, Library of Congress.

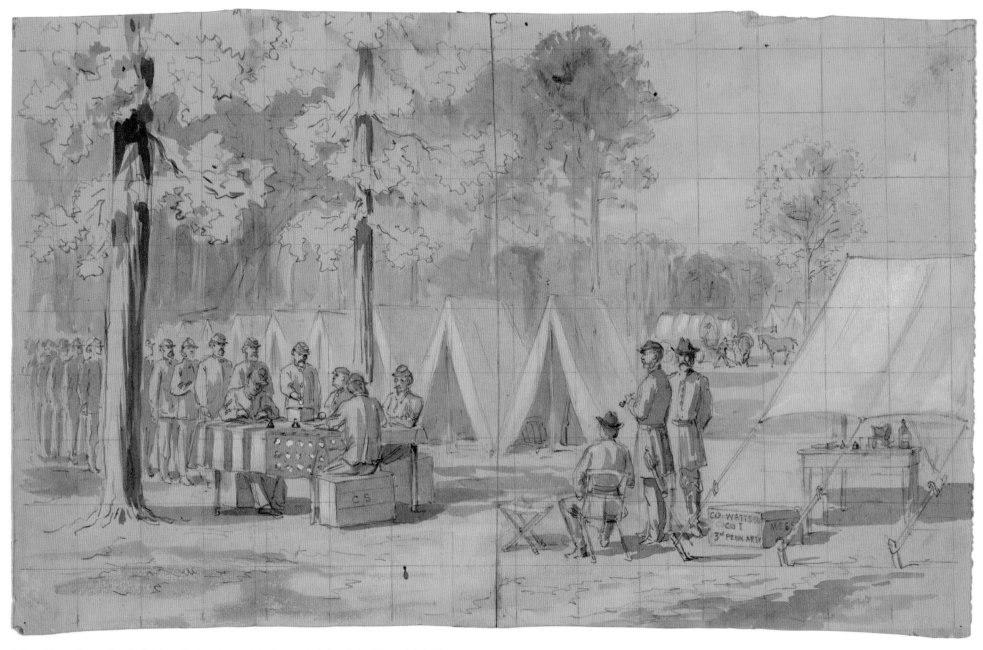

William Waud, *Pennsylvania Soldiers Voting, Army of the James,* October 1864, *Harper's Weekly,*
October 29, 1864, Library of Congress.

Thomas Nast, *Compromise with the South, Harper's Weekly,* September 3, 1864, image provided courtesy of HarpWeek.

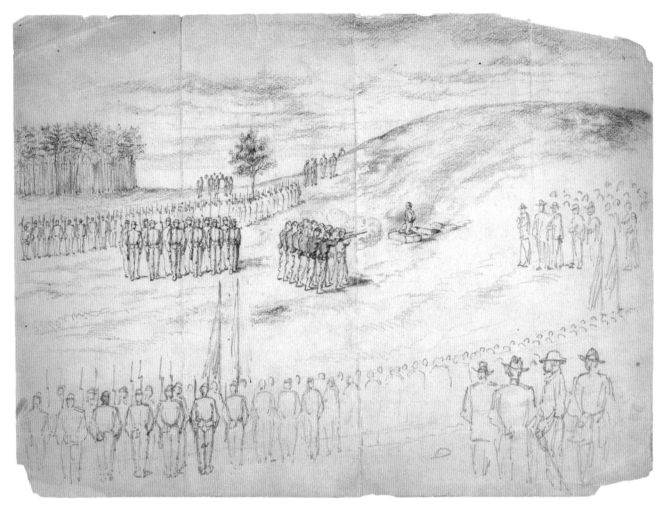

Edward F. Mullen, *Execution of Frank McIlhenney of the 24th Mass Regt on the Afternoon of the 8th August at Deep Bottom, Va.*, August 8, 1864, courtesy of the Becker Collection, Boston, MA.

the Becker sketch the miscreants appear to be playing cards, which would seem to have defeated the purpose of the penalty. E. F. Mullen sketched soldiers at Petersburg receiving a ration of whiskey after a day's work:

> The work in the trenches, which is so constant and unremitting, and on which so much depends, could hardly be carried on without giving the soldiers some stimulant. We give a sketch of the dealing out what is deemed a safe ration to the brave men who so readily do their part in this toilsome and [text is unclear] work. The effort to dispense entirely with liquor, in the damp and unhealthy districts where an army is too frequently obliged to operate, has but increased the amount of sickness, and Government, taught by experience, acts with moderation and wisdom.[23]

While some Union soldiers were voting along the James River, others were fighting in the Shenandoah Valley as Sheridan dogged the heels of Confederate general Early, destroying Southern farms, factories, and railways in the region. In the North, the public welcomed this new aggression, while in the South it caused havoc. Frank Vizetelly rode to the Valley and witnessed its destruction, sending sketches and heated descriptions back to London:

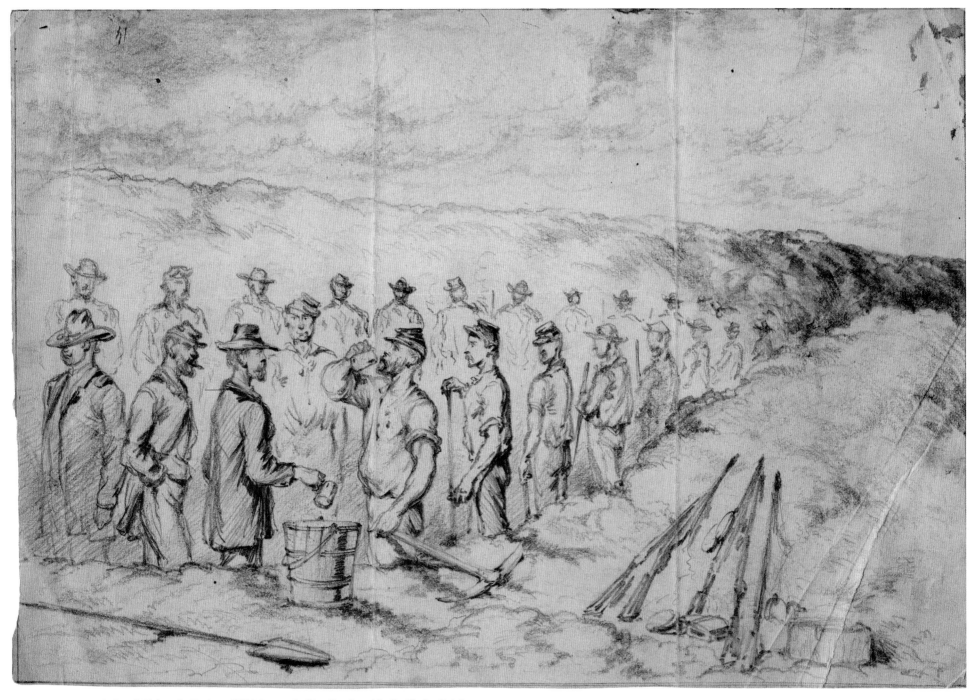

E. F. Mullen, *At Dutch Gap // Giving the Ration of Whiskey to the Men Employed in the Works,* October 22, 1864, courtesy of the Becker Collection, Boston, MA.

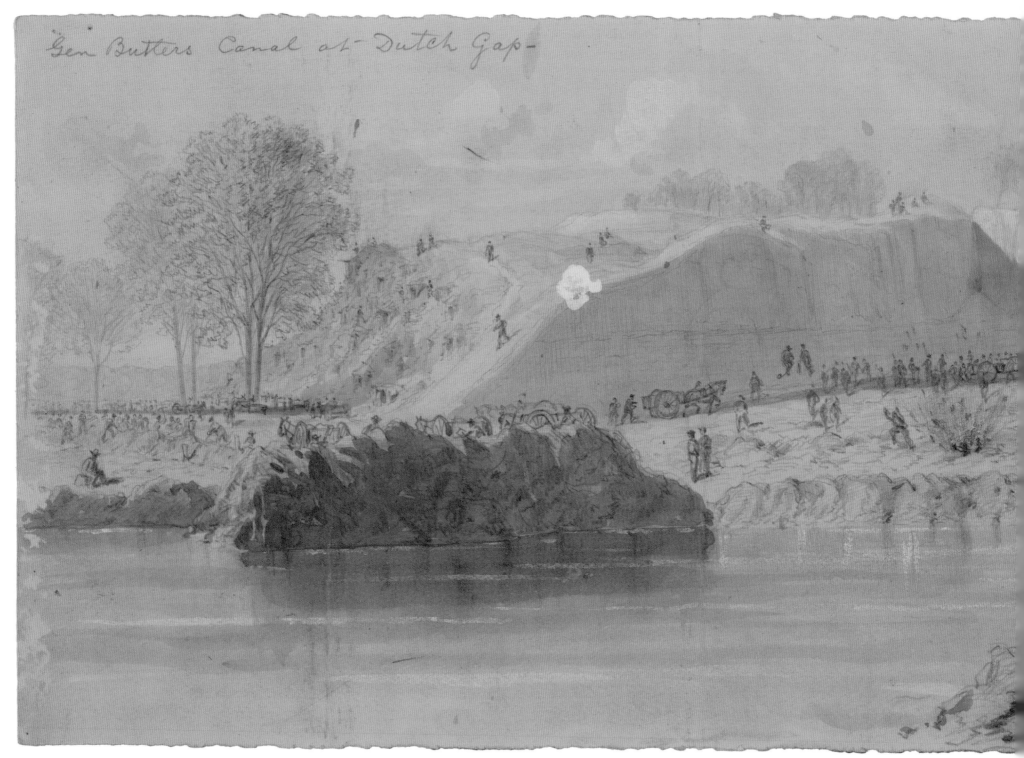

"Gen Butlers Canal at Dutch Gap—

William Waud, *Gen Butlers Canal at Dutch Gap*, October 1864, *Harper's Weekly*, November 5, 1864,
Library of Congress.

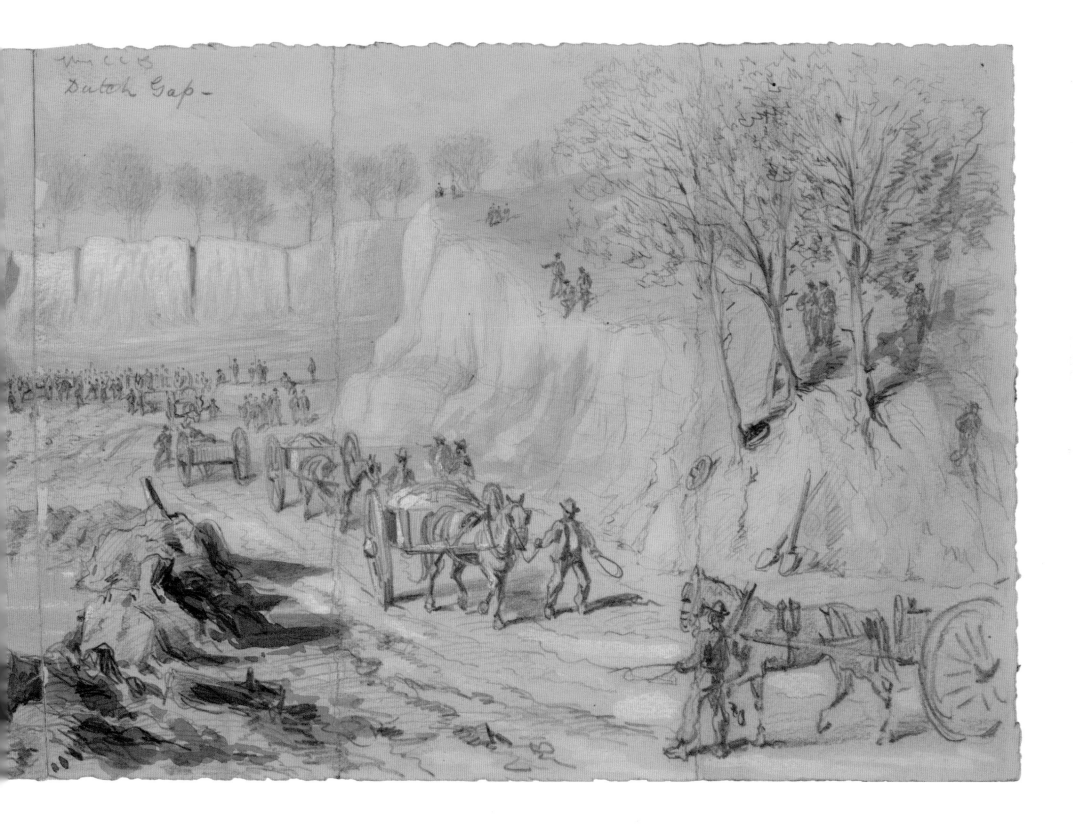

Dutch Gap –

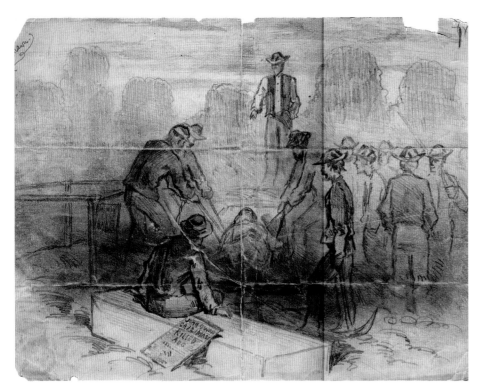

Joseph Becker, *Something to Coax the Appetite: Exhuming the Bodies of Union Soldiers (Siege of Petersburg)*, November 2, 1864, courtesy of the Becker Collection, Boston, MA.

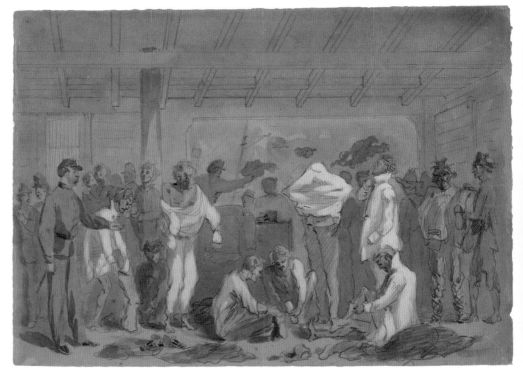

William Waud, *Returned Prisoners of War Exchanging Their Rags for New Clothing On Board Flag of Truce Boat New York*, ca. December 1864, *Harper's Weekly*, January 14, 1865, Library of Congress.

The Blue Ridge is seen in the distance, to our right hand; and to our left is the smoke and flame of burning villages which have just been visited by the Federal army. Our Special Artist, indeed, from his actual observation, testifies that, on this occasion, "the Federals retreated, burning and laying waste every homestead in their track; thereby reducing hundreds of families to absolute poverty and possible starvation"— treating the State of Virginia as a hostile country, but in a spirit of wanton destructiveness unknown to modern European warfare.[24]

Alf Waud sent in a sketch featuring young General George Armstrong Custer, cavalry commander under Sheridan, sitting astride his horse amidst a landscape reduced to fire and ruin. Sheridan had his day at the Battle of Cedar Creek in October, riding to the front in a frenzy to turn a rebel rout into a Union victory. Immortalized in a popular poem and numerous postwar paintings and prints as "Sheridan's Ride," the most plausible version appeared on the cover of *Harper's* in early November, probably produced by a Home Artist from a photograph of the general. All of the other images, far more famous, portray Sheri-

dan as he looked years later after he had shaved off his beard and his belly had filled out.

In Petersburg, Specials continued to gather. J. R. Hamilton and A. W. Warren joined the *Harper's* ranks, along with Charles H. Chapin. Will Waud left to join Sherman's campaign in Georgia and South Carolina. On the Savannah River he sketched an exchange of prisoners arranged by boat:

The convalescents, numbering 2000, were first removed from our transports. Three hundred of the prisoners were very sick, and had suffered greatly on the voyage. Our prisoners subject to exchange under this arrangement were to be delivered on the 15th. The whole number to be exchanged is ten thousand, but there will be considerable delay in effecting the transfer, on account of the deficiency of the rebel means of transportation both by land and water. The rest of the rebel prisoners will be delivered at City Point, on the James River, this measure having been adopted for the comfort of those who are so ill that the voyage by sea might prove fatal.[25]

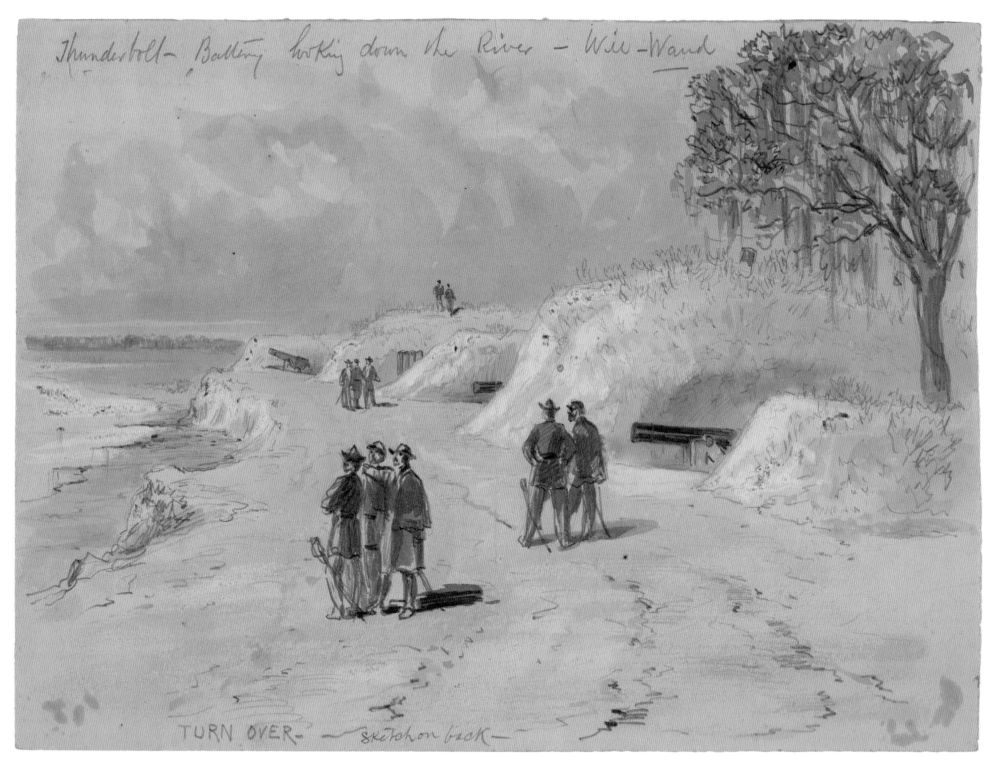

Thunderbolt Battery looking down the River — Will Waud

TURN OVER — *Sketch on back* —

William Waud, *Thunderbolt Battery Looking Down the River*, ca. December 1864, *Harper's Weekly*,
January 14, 1865, Library of Congress.

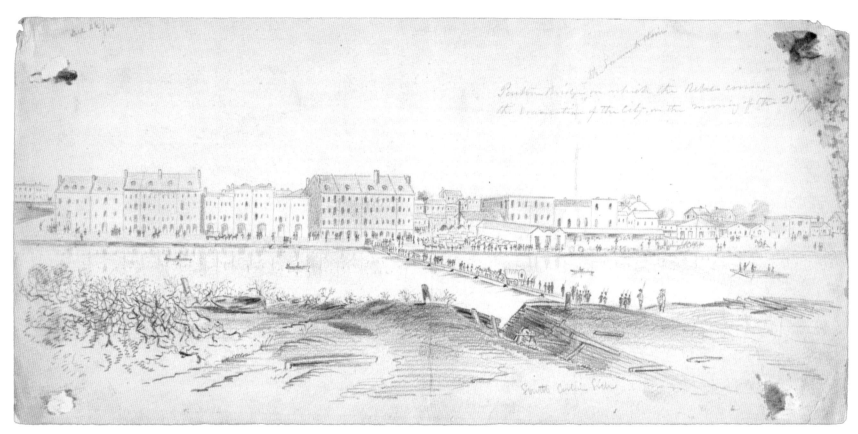

W. T. Crane, *Pontoon Bridge Used for the Rebel Evacuation of Savannah December 26, 1864,* December 26, 1864, courtesy of the Becker Collection, Boston, MA.

J.F.E. Hillen, C.E.F. Hillen and Theodore Davis continued their pictorial reportage from Atlanta and vicinity. When Sherman's army entered and occupied the city on September 2, the Northern general sent Lincoln the famous telegram: "Atlanta is ours, and fairly won." C.E.F. Hillen apparently filed the sketches described in the following account:

We publish two very interesting sketches from our Special Artist with Sherman's Army, which illustrate the harsh side of war. The expulsion of the rebel inhabitants, although loudly denounced by secessionists, and in some instances disapproved by their Northern sympathisers, was absolutely indispensable to the safety of the Union army, as they would have been a nest of spies and active opponents in the event of any crisis. This was rendered the more imperative, since it was necessary to hold Atlanta as a military strong-hold, and not merely as a conquered city. With the usual generosity of the Union Generals to their enemies, Gen. Sherman permitted the inhabitants to carry off all their household goods and other personal effects, lending them Union wagons to transport them 10 miles into the rebel lines, concessions never yet made by the Confederates when they have obtained possession of any Union town. Our Artist has represented the motley group as they appeared on the morning of their exodus, and it strikingly shows how terrible has been the price paid by the Seceded States for their dream of guilty ambition. But a glance at our picture renders description unnecessary.[26]

Union troops remained in Atlanta throughout the fall but John Hillen inscribed a sketch from November 11: "I send you a sketch of the last train that will run North, as I understand the place is to be destroyed to-morrow, on which day we leave Atlanta."[27] It was three days later, on November 15, as he left for Savannah, that Sherman ordered the city burned to the ground.

At year's end, newspaper readers in the North had reason for optimism. Grant and Meade had Petersburg under their thumb and supply lines to Richmond in a tourniquet. Sheridan and Custer had Early on the run in the Shenandoah, and the "breadbasket of the Confederacy" had been reduced to waste and ashes. Sherman's March to the Sea had vanquished southeastern cities, devastated the landscape, impoverished the countryside and its citizens and reduced the regional capital to rubble. President Lincoln won reelection and a mandate to finish the war. That Thanksgiving in camp, with soldiers enjoying their holiday gifts from family and well-wishers, seemed significant and symbolic:

It isn't the turkey, but the idea, that we care for," said one of the soldiers in Gen. Sheridan's army to one of the agents from New York, who accompanied the poultry to its destination. This remark strikes the keynote of the sentiment with which our men have received and appreciated the gift from home, sent to them when we were all rejoicing, in order that they might rejoice with us. Every kind and patriotic heart, to which the cause of our country is dear, will be glad and grateful that such geniality exists between the people and the soldiers. It is by acts such as this that we are knit together in a common cause, superior to selfishness, and looking towards the good of the whole nation.[28]

Soldiers and citizens in the North could finally catch a glimmer of hope in their common struggle as the Confederacy collapsed.

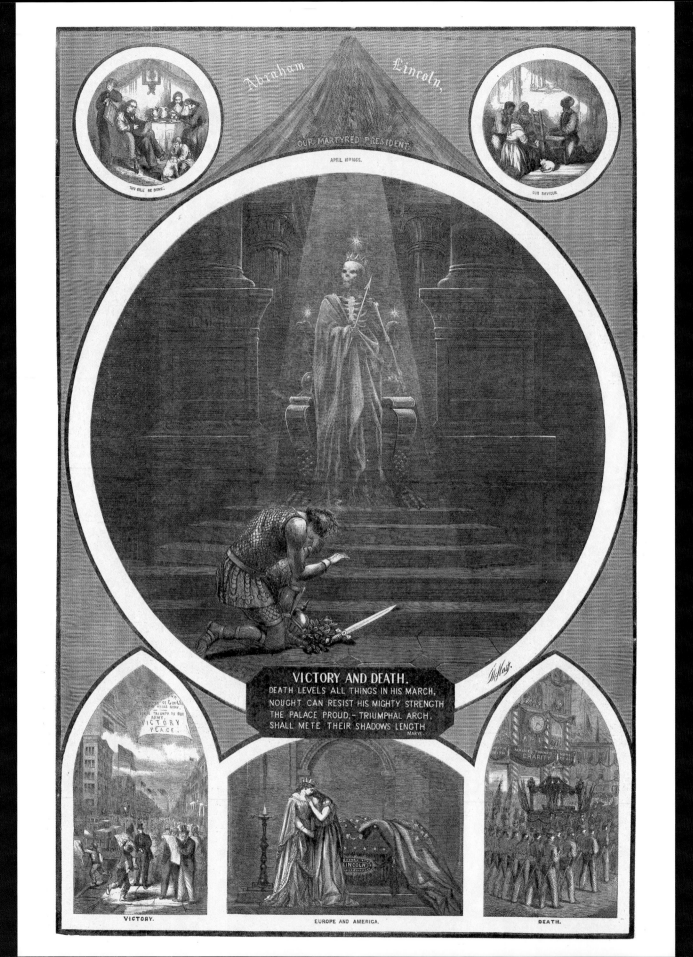

Abraham Lincoln,

OUR MARTYRED PRESIDENT.

APRIL 15ᵀᴴ 1865.

THY WILL BE DONE.

OUR SAVIOUR

VICTORY AND DEATH.

DEATH LEVELS ALL THINGS IN HIS MARCH,
NOUGHT CAN RESIST HIS MIGHTY STRENGTH
THE PALACE PROUD,— TRIUMPHAL ARCH,
SHALL METE THEIR SHADOWS LENGTH

MARVE.

LINCOLN

VICTORY.

EUROPE AND AMERICA.

DEATH.

CHAPTER FIVE

1865

Victory and Death

Illustrations of Sherman's punitive March to the Sea through Georgia and South Carolina dominated the weeklies issued in the New Year. William T. Crane stepped away from his post in Charleston to follow the campaign for *Leslie's*, while William Waud joined Theodore Davis, who had been with the troops for *Harper's* since the campaign commenced. Frank Vizetelly remained within Lee's headquarters in Virginia, but intermittently ranged west to the Shenandoah Valley and the Blue Ridge Mountains, where he befriended rebel guerrilla leader Colonel John Mosby:

During my late visit to the valley of the Shenandoah with Kershaw's division, I was fortunate enough to fall in with Mosby and a party of his famous band. Though I

Thomas Nast, *Victory and Death, Harper's Weekly*, June 10, 1865, image provided courtesy of HarpWeek.

found it extremely difficult to meet with this renowned partisan chieftain, there are those amongst the Federals who find him when they least expect and much less desire it . . . Originally, Mosby's band consisted of but one company, but it has lately been raised to a thousand, and he himself made a colonel in the Confederate army, though none of his men are regularly enlisted soldiers. They are mostly sons of farmers and gentlemen, who prefer the ubiquitous life and its stirring adventures offered by their chieftain to the comparative monotony of the ranks in a Virginia regiment. They receive no pay from the War Office, but, instead of it, they are allowed to dispose of their captures for their own benefit, the Government being the purchaser. As soon as an expedition has been resolved upon, Mosby sends a summons to his men, who are dispersed in every direction, to meet him at some gap in the mountains, generally at night, and few fail to answer the call. If they should do so three times consecutively they are immediately handed over to the authorities and conscribed into the regular army. My sketch shows a rendezvous of the band in a pass of the Blue Ridge; Mosby is seated on his horse in the shadow of a rock, and troopers are galloping up on all sides; others are dismounted, waiting the order to move. Beneath, the Shenandoah river winds its course through the fertile valley of Virginia.[1]

Mid-January found Vizetelly huddled beneath the walls of Fort Fisher, North Carolina, which protected the mouth of the Cape Fear River for Confederate blockade runners and smugglers. For almost three days, from January 13 to 15, more than fifty Union gunships shelled the fort before ground forces under General Alfred Terry breached the rebel defenses and captured the fort. Vizetelly describes his experience in an extensive note inscribed in his own hand on the back of his sketch of the fort: "Your correspondent had one or two very narrow 'shaves' & he considers himself remarkably lucky in not being taken with the garrison, only fifty or so of which succeeded in getting away."[2] Joseph Becker caught the action from the opposite perspective for *Leslie's*, giving an all-encompassing

Alfred Waud, *For Ft. Fisher Direct. The Expedition Leaving the Chesapeake*, December 1864, *Harper's Weekly*, December 31, 1864, Library of Congress.

view from outside the walls with a bird's-eye panoramic vista of the fort showing the Union gunships beyond.

Another diversion for readers from Sherman's bloody path occurred on March 4, with Abraham Lincoln's second inaugural at Washington, D.C. Immortal words concluded his melancholy yet optimistic oration:

With malice toward none; with charity for all; with firmness in the right, as God gives us to see the right, let us strive on to finish the work we are in; to bind up the nation's wounds; to care for him who shall have borne the battle and for his widow and his orphan, to do all which may achieve and cherish a just and lasting peace among ourselves and with all nations.[3]

William Waud, *Entrance Hall of Mr Chas. Green's House, Savannah Ga, Now Occupied as Head Quarters by Gen Sherman,* January 1865, *Harper's Weekly,* January 21, 1865, Library of Congress.

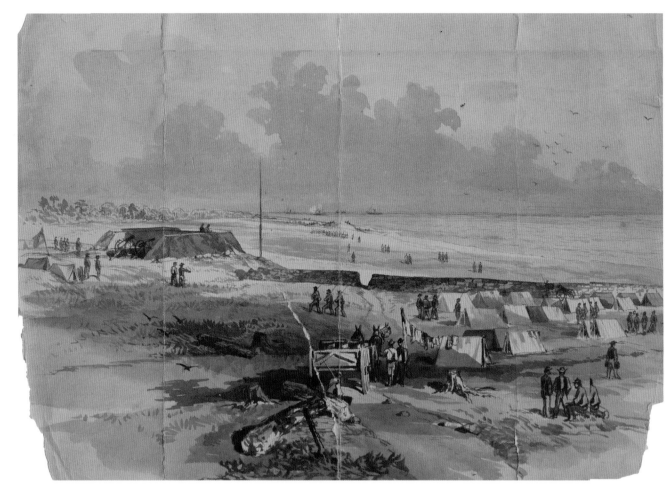

Joseph **Becker,** *View of Our Works Looking towards Wilmington (Capture of Wilmington),* January 28, 1865, courtesy of the Becker Collection, Boston, MA.

Leslie's offered the following word-picture:

Notwithstanding the showers of rain that fell in the attendance was immense, and the procession of great magnitude and state. It formed on 16th street, near Pennsylvania avenue, shortly before eleven, and directly after commenced moving towards the Capitol. The military escort consisted of two regiments of the Invalid Corps, a squadron of cavalry, a battery of artillery, four companies of colored troops, and several bands of music. The line of march was decorated with flags, and the windows along the route were crowded with spectators, who manifested the utmost enthusiasm. The streets, however, were in a miserable condition, consequent on the rain of the morning, which slackened about eight o'clock, and entirely ceased about eleven. The procession was over a mile in length. The President was in the Capitol busily engaged in signing bills. A few minutes before twelve, the official procession began to file into the Senate Chamber. First came the members of the Supreme Court; soon after Mr. Lincoln entered, accompanied by Vice-President Hamlin, the members of the Cabinet, the Diplomatic Corps, officers of the army and navy. After Vice-President Hamlin had bidden farewell to the Senate as its presiding officer, the oath of office as Vice-President was then administered to Mr. Johnson, and the Senators elect of the 39th Congress were then

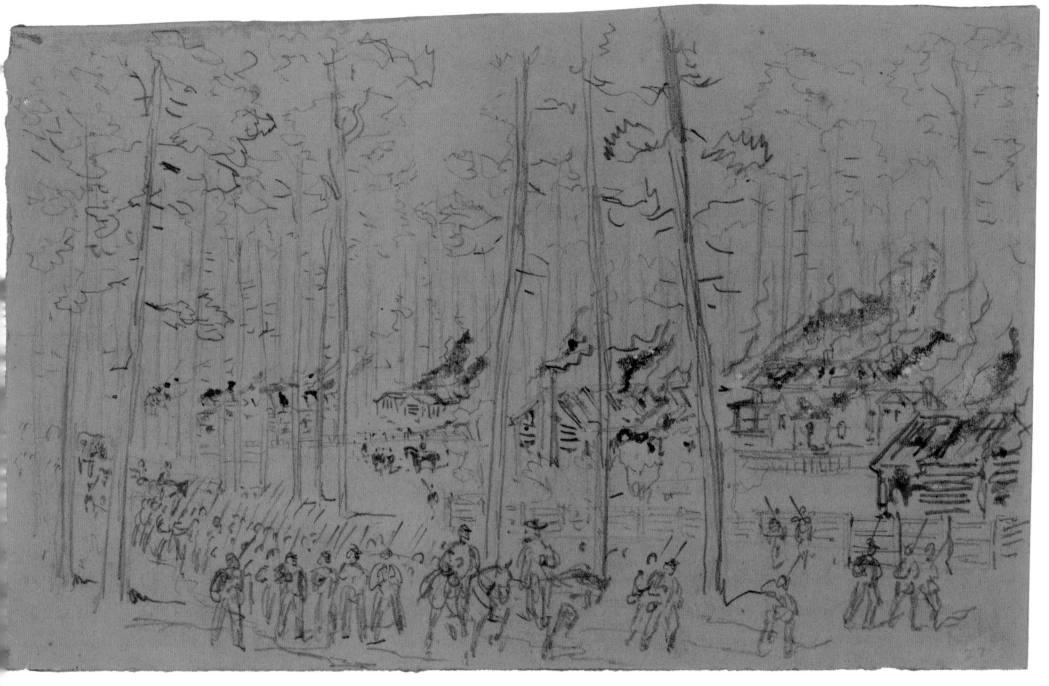

William Waud, *Sherman's March through South Carolina—Burning of McPhersonville,* February 1, 1865, *Harper's Weekly,* March 4, 1865, Library of Congress.

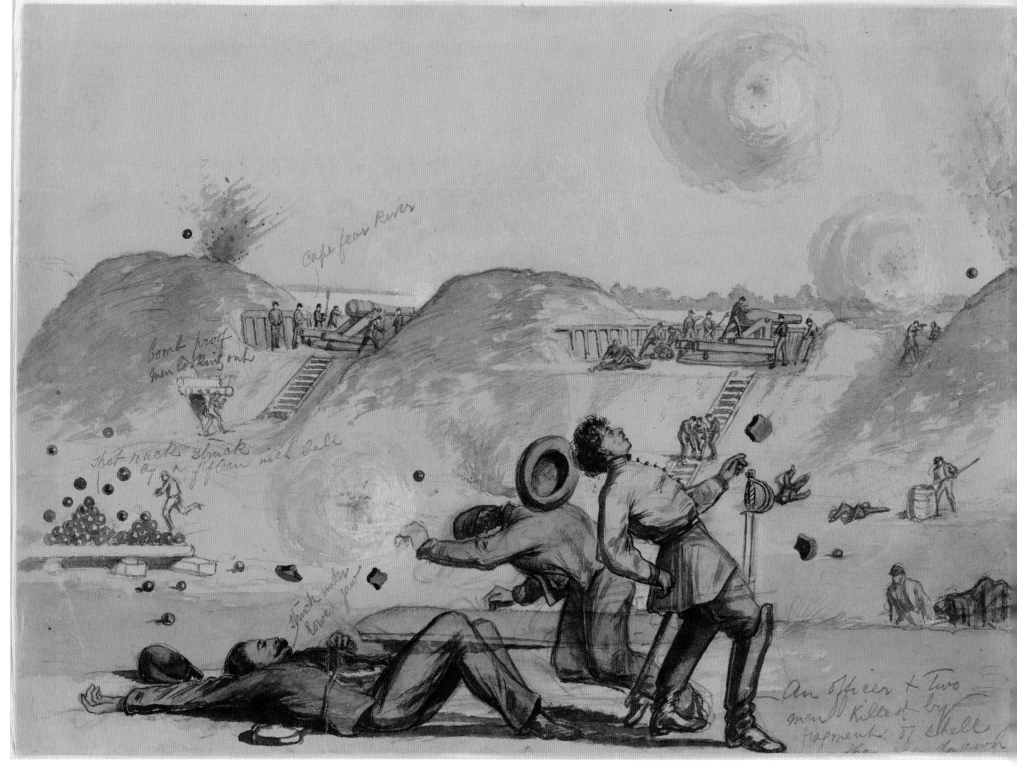

Within the illustration, the following handwritten annotations appear:

Cape fear River

Bomb proof men looking out

shot racks struck by a fifteen inch ball

Truck under lower jaw

An officer & Two men Killed by fragments of shell

Frank Vizetelly, *The Interior of the North Eastern Salient of Fort Fisher during the Attack of the 13th 14th & 15th of Jany [sic],* January 13–15, 1865, *Illustrated London News,* March 18, 1865, MS Am 1585, Houghton Library, Harvard University.

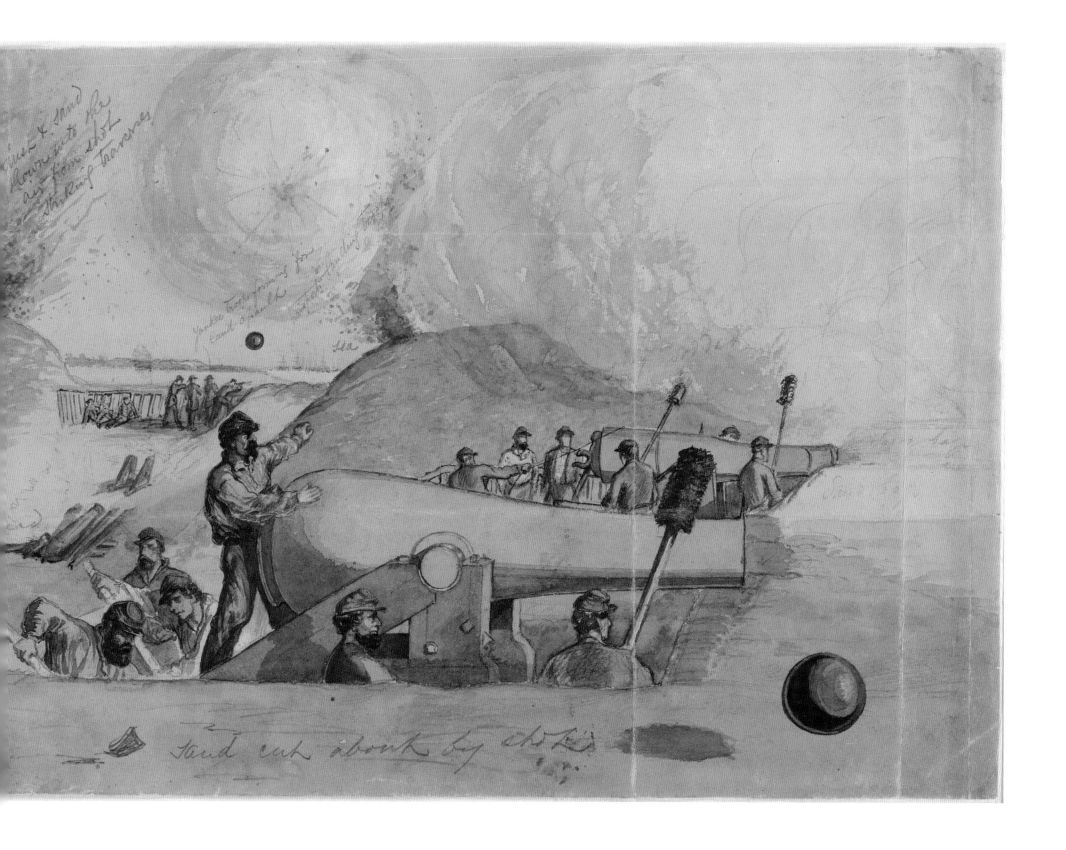

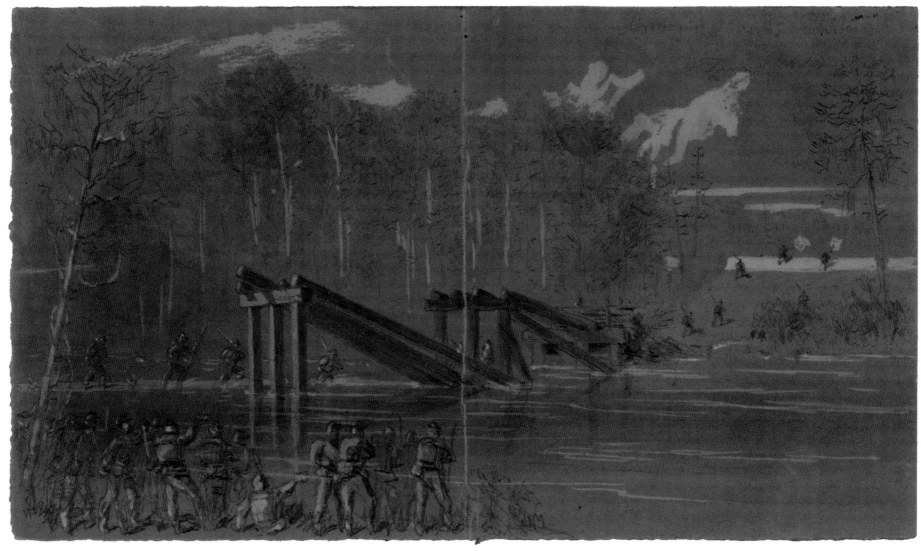

William Waud, *Crossing the North Edisto*, February 12–13, 1865, *Harper's Weekly*, April 15, 1865, Library of Congress.

sworn in, after which the official procession was formed and proceeded to the platform in front of the portico of the eastern face of the Capitol, where the ceremony of the inauguration of the President-Elect was concluded. The appearance of Mr. Lincoln was the signal for a tremendous outburst of enthusiastic cheers. When this tumult subsided, the President stepped forward and delivered his inaugural address. At the conclusion of these proceedings the procession was reformed, and the President was escorted to the White House. It is estimated that over 30,000 persons were present, notwithstanding the depth of mud in which they were obliged to stand.[4]

In his speech Lincoln characterized "the progress of our arms," as "reasonably satisfactory and encouraging to all." He offered no prediction on the outcome but the end was near and the victor apparent. The illustrated weeklies were filled with sketches of Northern military exploits and Southern devastation. William T. Crane submitted a sketch depicting a fire at Savannah, Georgia,

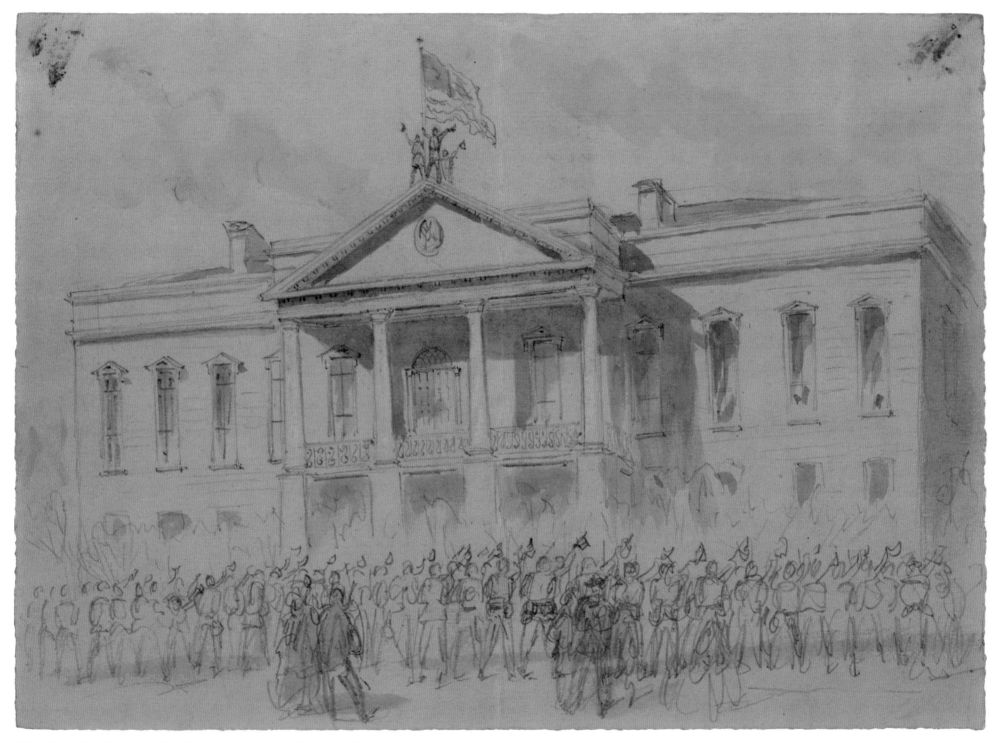

William Waud, *Lt Col Kennedy of the 13th Iowa, 3rd Brigade, 4th Division, 17 A.C. Raising the Stars & Stripes over the State House Columbia,* February 15–17, 1865, *Harper's Weekly,* April 8, 1865, Library of Congress.

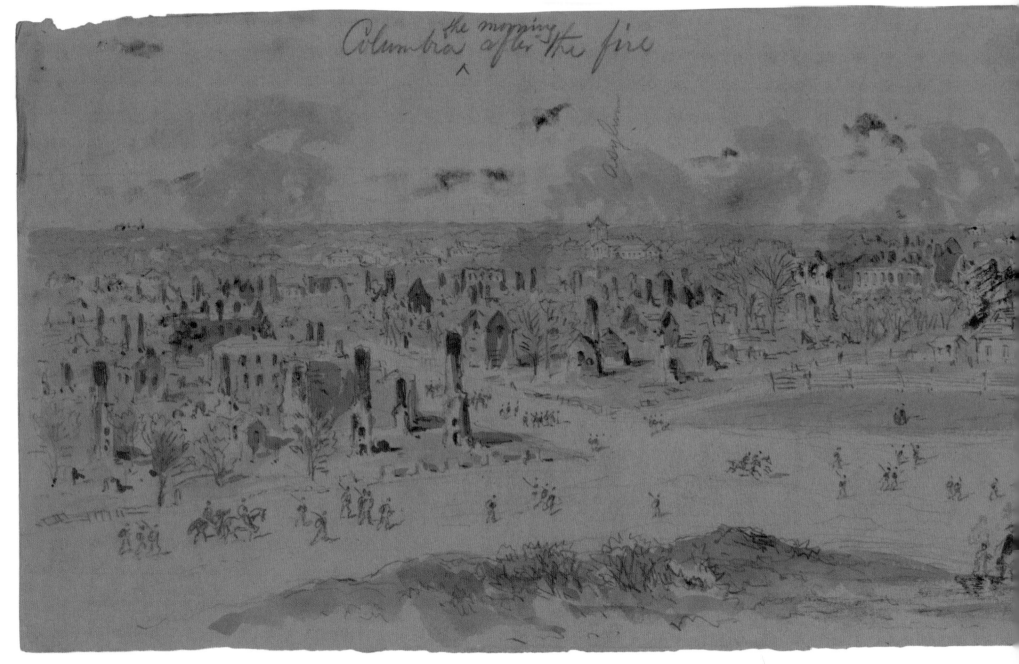

the morning
Columbia after the fire

William Waud, *Columbia the Morning after the Fire,* February 18, 1865, *Harper's Weekly,* April 1, 1865, Library of Congress.

set off by Union shelling. Davis and Waud marched with Sherman's men through swamps, over corduroy roads and log bridges. They sketched the fighting men and observed the changing world around them. Joseph Becker, while sketching in Wilmington, North Carolina, after the Battle of Fort Fisher, noted the desperate conditions of formerly proud people: "It was a painful sight to see how the once haughty citizens of the great blockading emporium came for their family supplies. As usual, in similar cases, they were most courteously treated by the Federal authorities."[5]

General Sherman, who suffered from no such sentiments, explained his attitude in a September 1864 letter to his commander General Halleck: "If the people

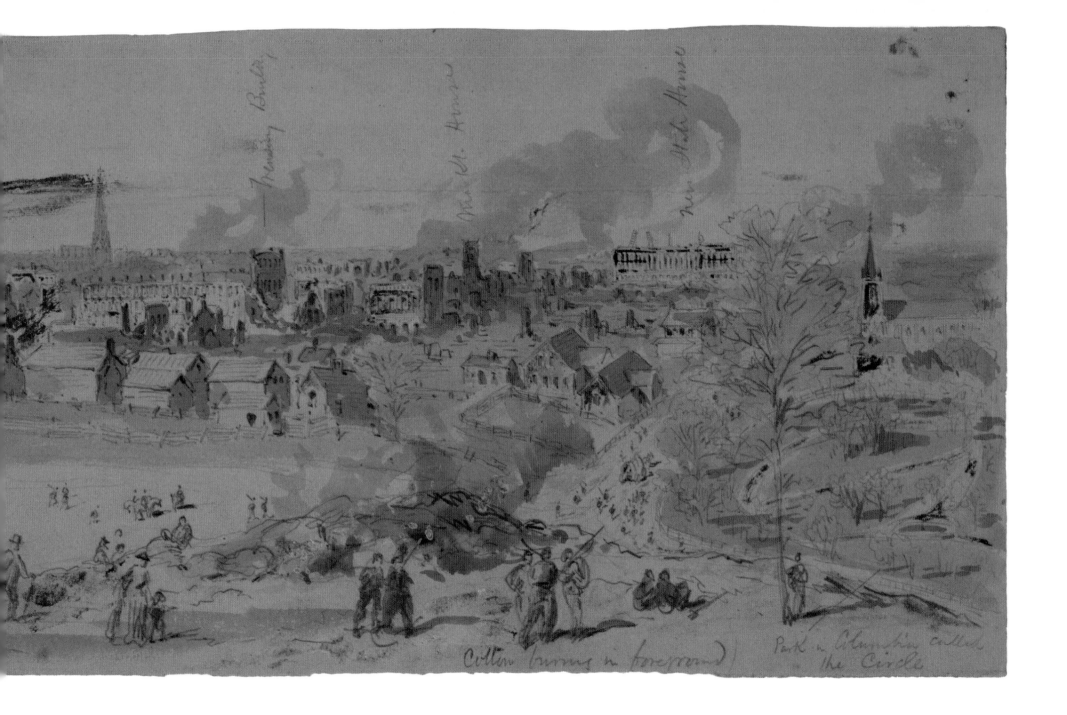

raise a howl against my barbarity and cruelty, I will answer that war is war, and not popularity-seeking. If they want peace, they and their relatives must stop the war."[6] Sherman kept going, with the Specials in tow. The march was terrible and relentless. In April, *Harper's* published a stirring group of sketches from South Carolina, including an illustration of troops victoriously waving the U.S. flag atop the roof of the Columbia, South Carolina, state capitol. Three sketches in the group attributed to Theodore Davis, including the Capitol drawing, were actually done by Will Waud as the editors noted in a future edition. This same early April number, with the soldiers flying the Stars and Stripes over the Capitol, includes another Will Waud drawing that portrays the city of Columbia burning.

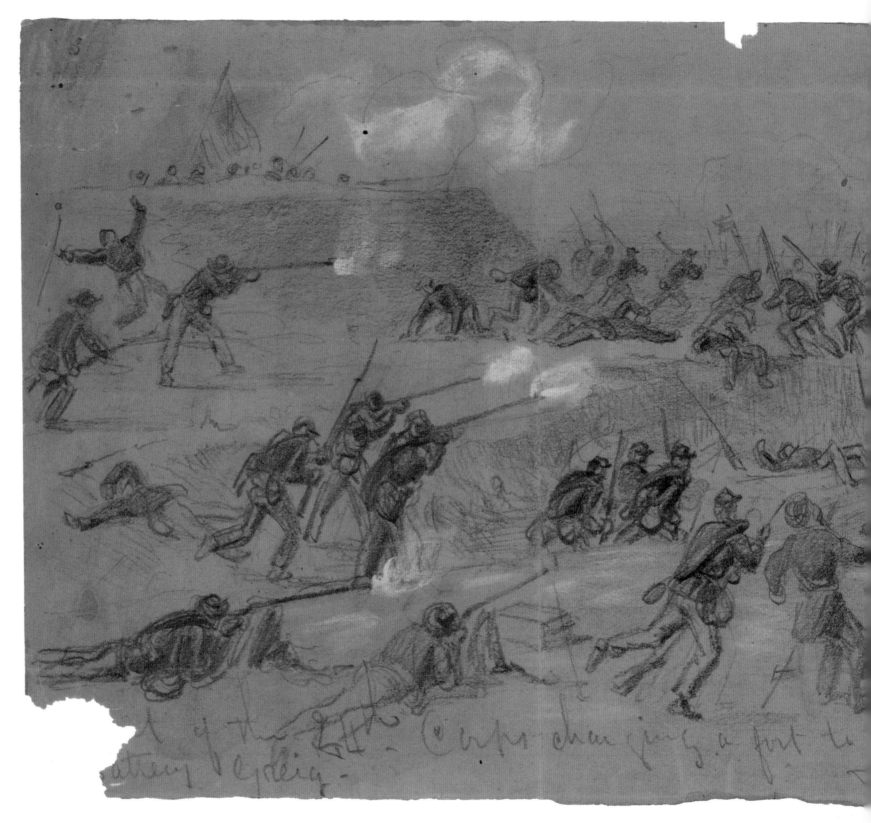

Alfred Waud, *The 24th Corps Charging a Fort to the Left,* April 2, 1865, Library of Congress.

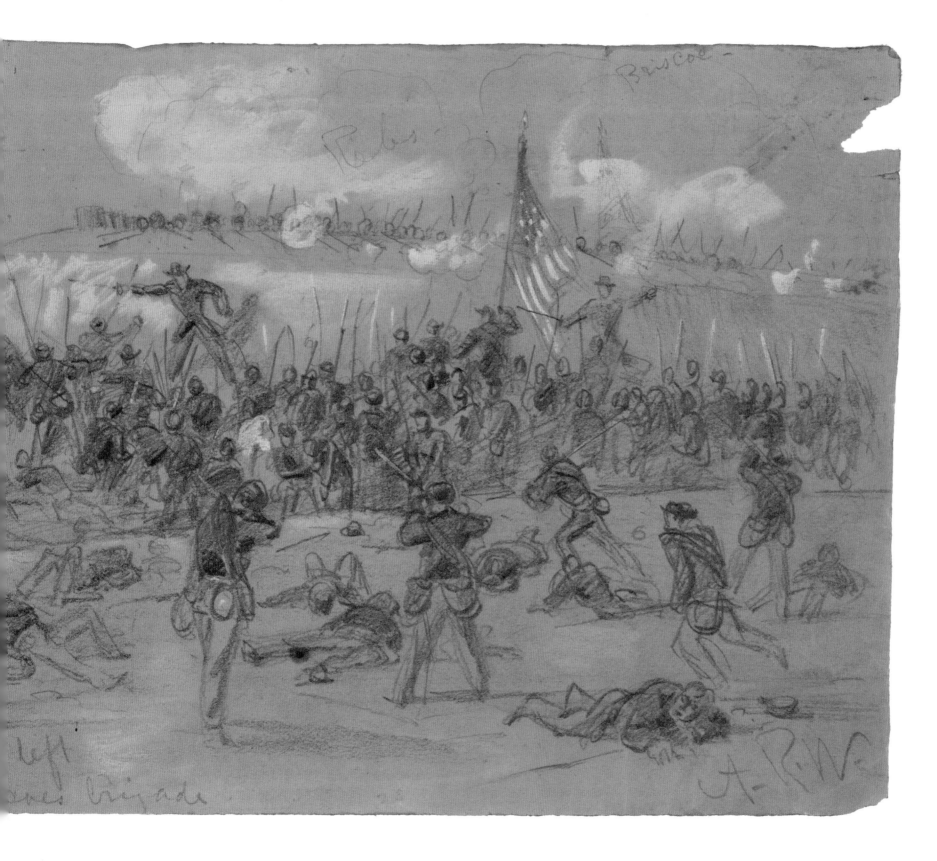

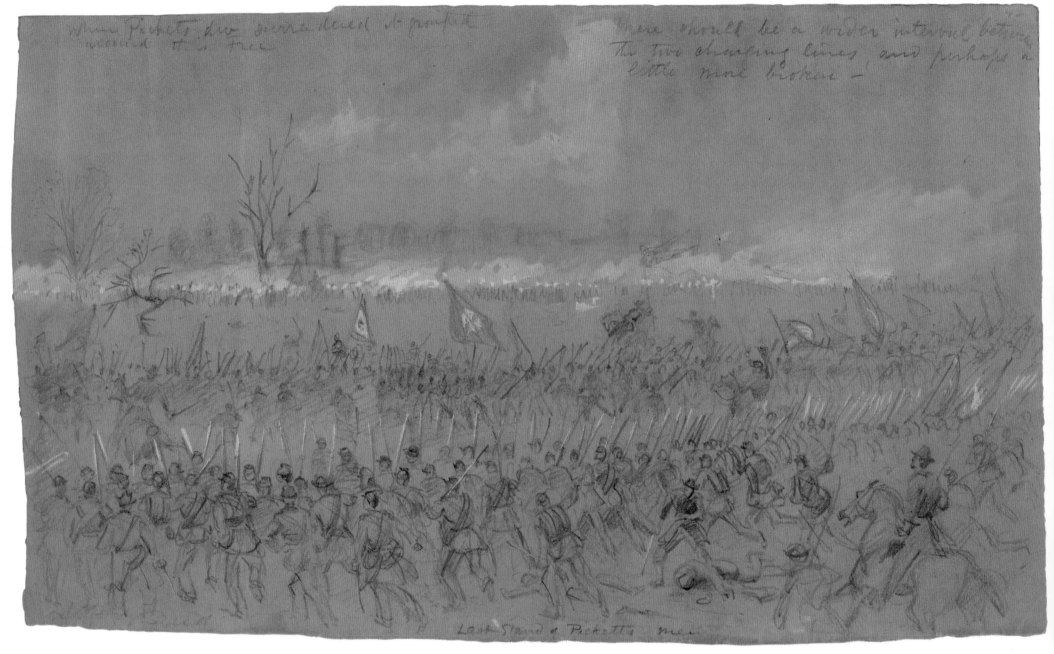

Alfred Waud, *Last Stand of Picketts Men. Battle of Five Forks*, April 1, 1865, Library of Congress.

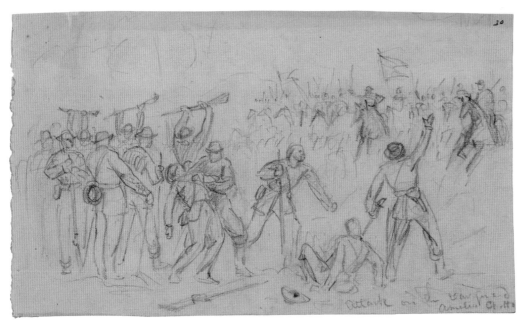

Alfred Waud, *Attack on the Rear Guard. Amelia Ct. Ho.*, April 2–5, 1865, Library of Congress.

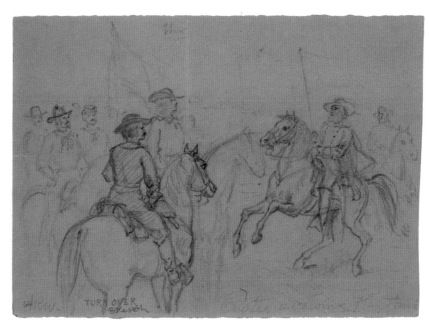

Alfred Waud, *Custer Receiving Flag of Truce*, April 6–9, 1865, Library of Congress.

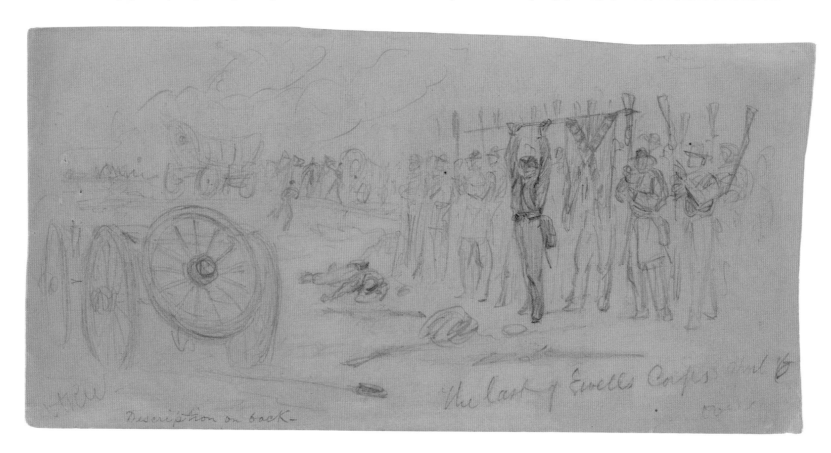

Alfred Waud, *The Last of Ewells Corps, April 6*, April 6, 1865, Library of Congress.

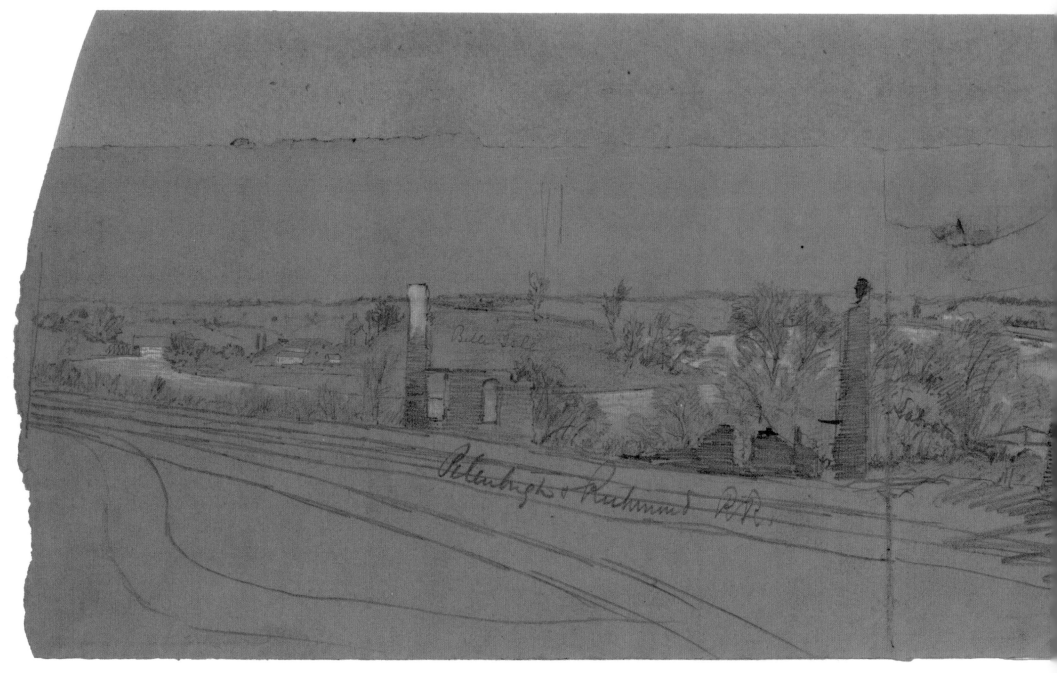

A. W. Warren, *Richmond,* ca. April 3, 1865, *Harper's Weekly,* April 22, 1865, Library of Congress.

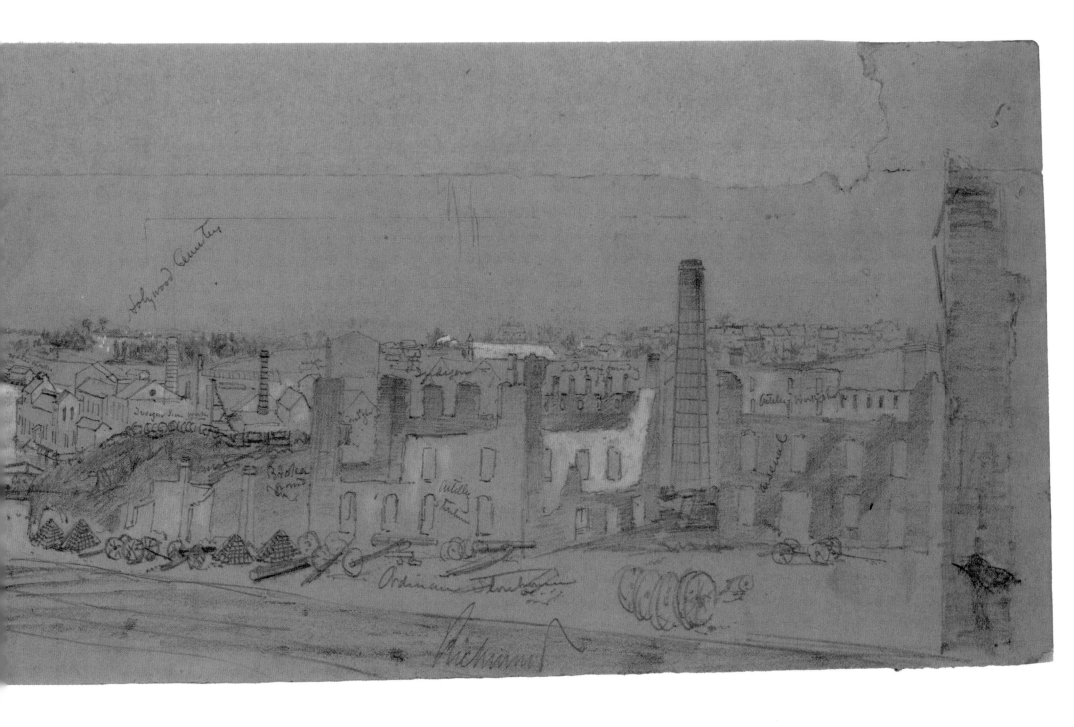

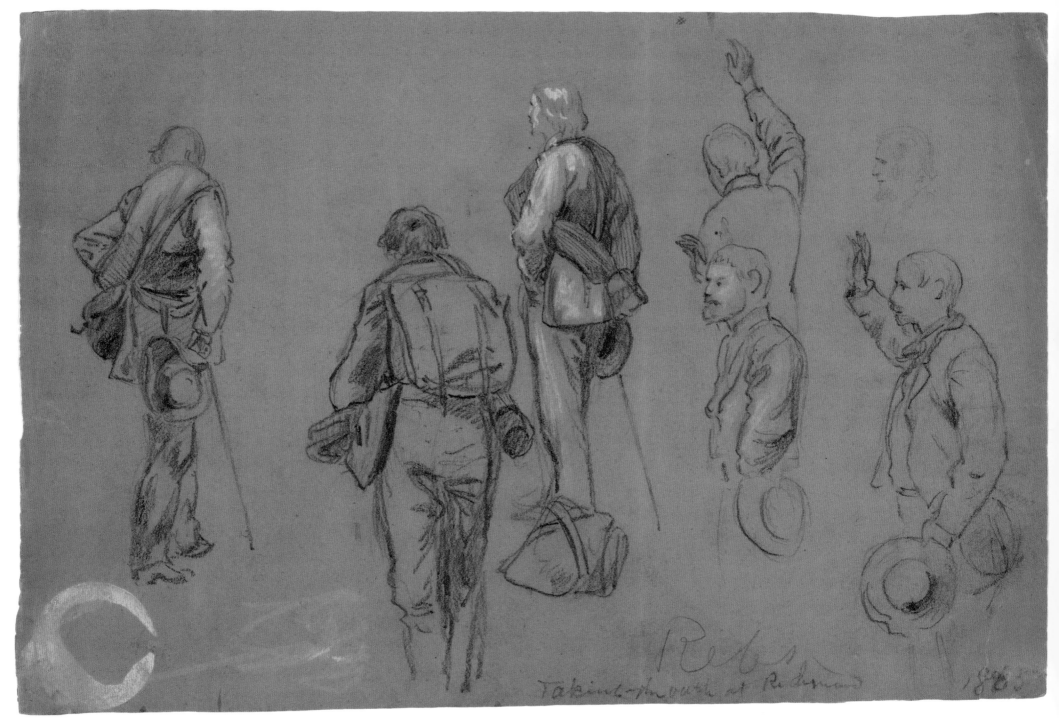

Alfred Waud, *Rebs Taking the Oath at Richmond*, April–May 1865, Library of Congress.

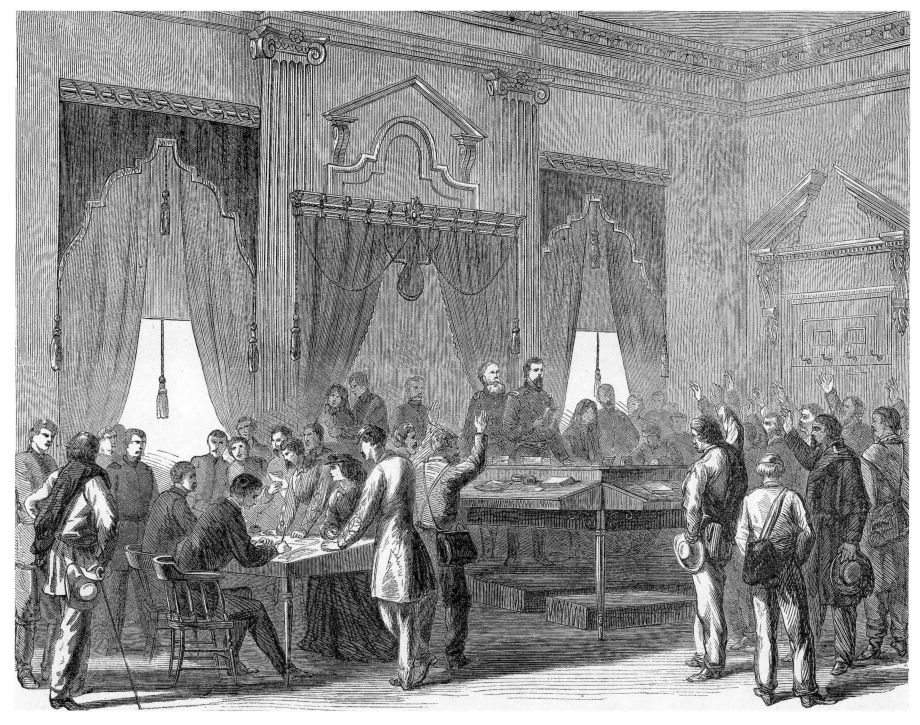

Alfred Waud, *Rebels Soldiers Taking the Oath of Allegiance in the Senate Chamber at Richmond,*
Virginia, Harper's Weekly, June 17, 1865, image provided courtesy of HarpWeek.

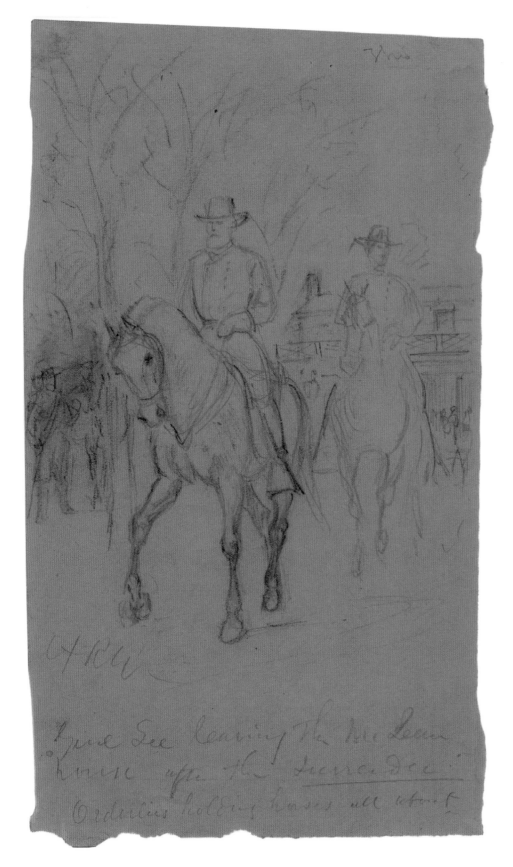

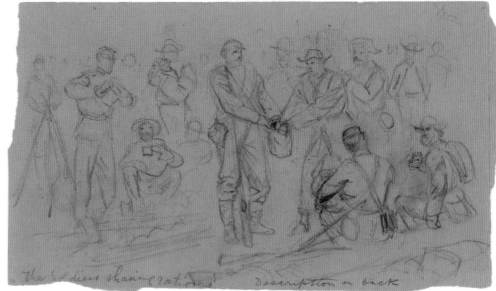

Desultory action around the Petersburg front stirred only intermittently through the first months of 1865. Special Artist A. W. Warren was on hand at the Battle of Hatcher's Run in February when General Gouverneur Warren's Fifth Corps extended Union lines aggressively in support of cavalry raids on Confederate supply routes and railroad lines west of the city. Six weeks later, on March 31, the end came quickly as rebel troops under Major General John B. Gordon attempted to force their way out of the Union siege works in the Battle of Fort Stedman. Within a week, Gordon's initial breakout had been stymied, the rebel line weakened and overcome, the Confederacy shattered. Union general Sheridan's defeat of the rebel leader Major General George E. Pickett at the Battle of Five Forks on April 1 forced Lee to flee the city and save his army. Grant's forces followed up quickly and by the next day Union forces were in the rebel capital. *Frank Leslie's* reported:

PETERSBURG EVACUATED, AND RICHMOND OURS.

This is the graphic and most significant dispatch which we stop the press to insert—news that makes this the brightest Monday that ever dawned, and excites the country as one man with joy and pride.[7]

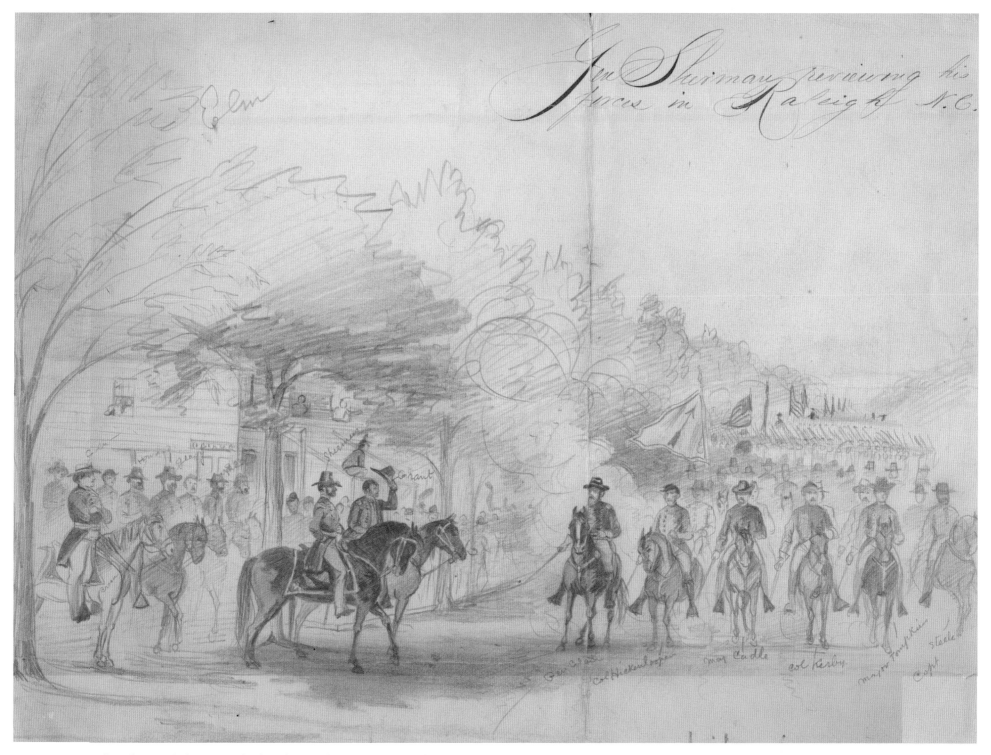

James E. Taylor, attributed, *General Sherman Reviewing His Forces in Raleigh, N.C.,* April 24, 1865, courtesy of the Becker Collection, Boston, MA.

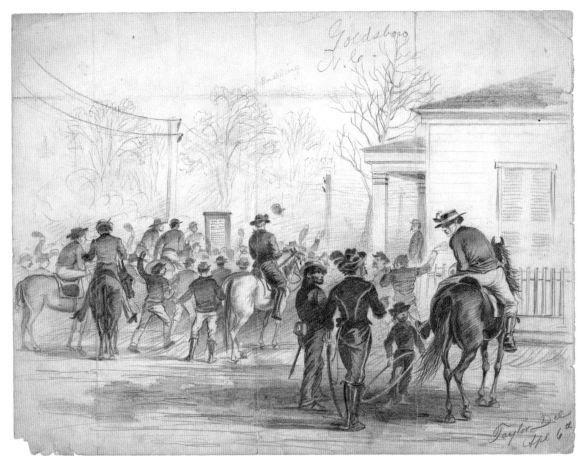

James E. Taylor, *Hearing the News of the Fall of Richmond, Goldsboro, North Carolina,* April 6, 1865, courtesy of the Becker Collection, Boston, MA.

Within the next several days Northern forces continued the work of rounding up Southern troops and forcing their surrender. Alf Waud sketched General George Custer, whose meteoric rise from lieutenant was charted in the pictorial press, receiving flags of surrender from C.S.A. officers. A. W. Warren sent back astonishing images of the ruined cityscape. Waud also documented the disarming and disbanding of the rebel army. His sketch of Robert E. Lee's departure on horseback from the April 9 meeting with Grant at Appomattox Court-House invests the defeated leader with cool dignity and grace.

Events moved swiftly after the fall of Richmond, too swiftly for the weeklies to keep pace. Just a matter of days separated Gordon's Petersburg breakout from Lee's capitulation at Appomattox Court-House. Then, after four years of killing,

news reports from Washington, D.C. of one more death, caused a violent spasm of grief:

THE MURDER OF THE PRESIDENT.

The Fourteenth of April is a dark day in our country's calendar . . . Murder had run out its category of possible degrees against helpless loyalists in the South, against women and children whose houses had been burned down over their heads, and against our unfortunate prisoners, who had been tortured and literally starved to death. But there still remained one victim for its last rude stroke—one victim for whom, it was whispered in rebel journals South and North, there was still

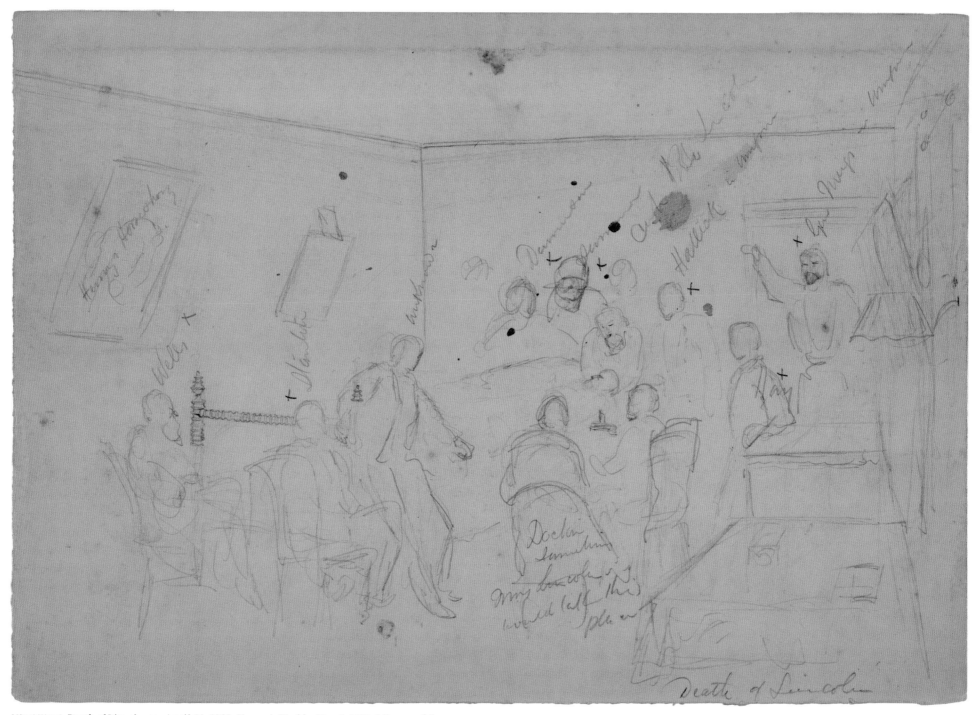

Alfred Waud, *Death of Lincoln*, ca. April 14, 1865, *Harper's Weekly*, May 6, 1865, Library of Congress.

reserved the dagger of a *Brutus*. Beaten on every field of recognized warfare, treason outdid its very self, and killed our President.[8]

Along with illustrations of the event *Harper's* gave its readers heartfelt empathy for their political martyr. Alf Waud produced an urgent sketch of Lincoln's deathbed within the Petersen house, where Lincoln had been carried after being shot at Ford's Theatre by John Wilkes Booth. Frank Leslie deployed old hand Albert Berghaus, a pictorial journalist with investigative skills who had helped *Leslie's* expose the swill milk industry back in the late 1850s, to investigate and follow Booth's trail. Berghaus brought a new level of forensic detail, interviewing principal witnesses and visiting sites to ensure accuracy. Leslie went so far as to publish signed testimony to that effect:[9]

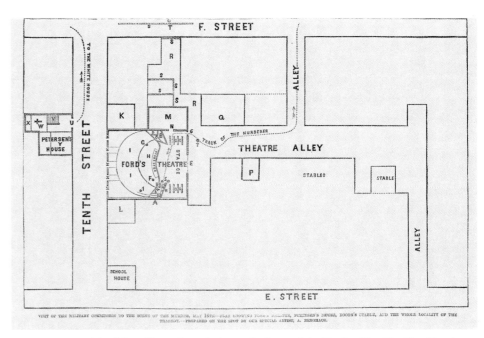

Albert Berghaus, *Visit of the Military Commission to the Scene of the Murder, May 16—Plan Showing Ford's Theatre, Petersen's House, Booth's Stable and the Whole Locality of the Tragedy.—Prepared on the Spot by Our Special Artist, A. Berghaus, Frank Leslie's Illustrated Newspaper,* June 3, 1865, image provided courtesy HarpWeek.

"Artistic Accuracy," *Frank Leslie's Illustrated Newspaper*, April 29, 1865, image provided courtesy of HarpWeek.

Berghaus reconstructed Booth's dramatic leap to the stage from the balcony where he had shot the president. Subsequent editions included additional scrupulously researched illustrations of the events from the night Lincoln died.

Funeral services began in Washington, D.C., at the White House on April 19. C.E.H. Bonwill, back from his wartime assignment in Louisiana, sketched the scene for *Leslie's*, which wrote:

THE FUNERAL HONORS TO PRESIDENT LINCOLN.

The mournful interest which attaches to all the relics of our lost chief will be gratified by the various contributions made by our Artists. Besides the large engraving representing the funeral procession as it divided the sorrowful multitude in the heart of Broadway, we are able to present pictures in detail of the various accessories of the burial. Careful drawings have been prepared of the coffin which held the honored clay; of the car in which it traveled to its final resting-place in Springfield; of its transit by ferry to this city, and of every other particular and incident connected with the sad journey. These will be regularly laid before our readers as space permits, so that they will have the mortal part of their martyred chief constantly before their eyes, up to the moment when it mixes with the friendly dust of Illinois.[10]

Harper's engaged Will Waud to follow Lincoln's corpse on its railway journey home.

The funeral itinerary called for a thirteen-day approximation of the route Lincoln had traveled to his 1860 inauguration. Major metropolitan stops included Baltimore, Harrisburg, Philadelphia, New York City, Albany, Buffalo, Cleveland, Columbus, Indianapolis and Chicago, with sporadic local stops each day. In its final May number, *Harper's* published Will Waud's sketches of the pre-

THE FUNERAL CATAFALQUE AT SPRINGFIELD, ILLINOIS.

REMOVING THE REMAINS FROM THE CAPITOL, SPRINGFIELD, ILLINOIS

MR. LINCOLN'S FORMER RESIDENCE AT SPRINGFIELD, ILLINOIS.

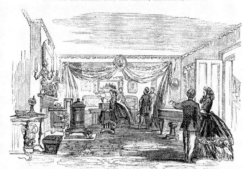

PARLOR OF MR. LINCOLN'S FORMER RESIDENCE AT SPRINGFIELD.

INTENDED TOMB OF PRESIDENT LINCOLN, SPRINGFIELD.

HOUSE WHERE ROBERT LINCOLN WAS BORN, SPRINGFIELD.

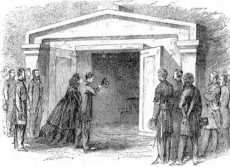

ROBERT LINCOLN AT THE TOMB OF HIS FATHER.

COLLECTION BOX FOR MONUMENT FUND IN THE FORMER RESIDENCE OF MR. LINCOLN, SPRINGFIELD.

SPRINGFIELD, ILLINOIS, THE LATE AND LATEST HOME OF THE MARTYR PRESIDENT.—A SERIES OF SKETCHES BY OUR SPECIAL ARTIST, THOS. HOGAN.

sentation of Lincoln's coffin and burial service at Springfield, Illinois, while *Leslie's* furnished its readers with illustrations by newcomer Thomas Hogan.

PRESIDENT LINCOLN'S BURIAL.

It was on a beautiful May day that President *Lincoln* was buried at Oak Ridge, Springfield. At noon the remains were brought from the State House in the same hearse which had carried *Lyon* and *Thomas H. Benton* to their graves. The hearse was surmounted by a beautiful crown of flowers. From the portico, as the procession advanced, a chorus of hundreds of voices sang the hymn—

"Children of the heavenly King,

Let us journey as we sing."[11]

Accounts of the Booth manhunt, his capture and killing by federal soldiers at a tobacco farm outside Port Royal, Virginia, followed; *Harper's* featured onsite sketches by Special W. N. Walton. *Frank Leslie's* commissioned a dramatic view of the execution of Booth's four co-conspirators in Washington, D.C., on July 7. The illustration derived from sketches by Special Artists D. B. Gulick and William T. Crane.

While Lincoln's killer was being pursued, the business of celebrating the Union victory and convincing all militant Confederates to lay down their arms continued. Joseph Becker, Alf Waud and Theodore Davis remained in the field sketching the war's denouement. Alf Waud caught the fierce action at Fort Mahone outside Petersburg on April 3:

The charge was as impetuous as its conduct was skillful. The chevaux de frise, which was broken through by the furious onset of the national troops, was, after the capture of the fort, carried over to the other side, so as to form a protection against an attempt on the part of the rebels to recapture the work. The troops were thus enabled to hold the fort until the arrival of reinforcements.[12]

Davis was on hand with Sherman at the surrender of General Joseph E. Johnston. He offered sketches of the house where the meeting took place and piles of arms and equipment turned in by rebel soldiers.

Thomas Hogan, *President Lincoln's Funeral—Lying in State in the Capitol, Springfield,* June 10, 1865, Collection of the New-York Historical Society.

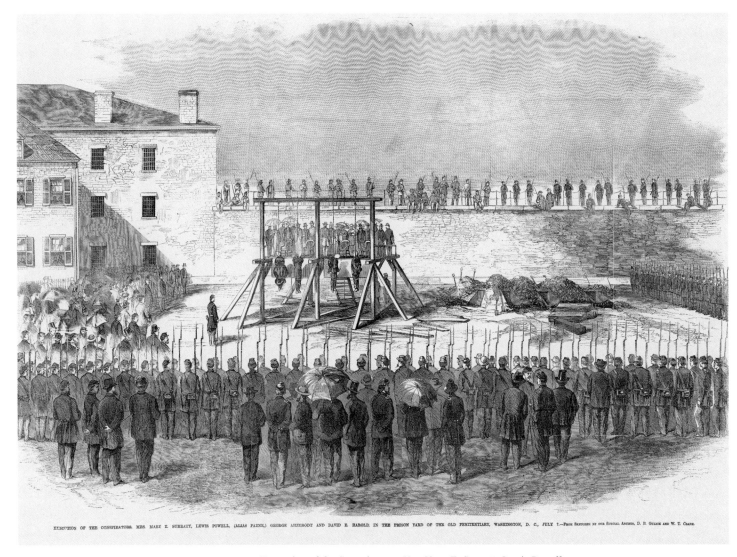

EXECUTION OF THE CONSPIRATORS. MRS. MARY E. SURRATT, LEWIS POWELL, (ALIAS PAYNE,) GEORGE AHZERODT AND DAVID E. HAROLD, IN THE PRISON YARD OF THE OLD PENITENTIARY, WASHINGTON, D. C., JULY 7.—FROM SKETCHES BY OUR SPECIAL ARTISTS, D. B. GULICK AND W. T. CRANE.

D. B. Gulick and W. T. Crane, *Execution of the Conspirators, Mrs. Mary E. Surratt, Lewis Powell,*
(Alias Payne,) George Ahzerodt and David E. Harold, in the Prison Yard of the Old Penitentiary,
Washington D.C., July 7, Frank Leslie's Illustrated Newspaper, July 7, 1865, image provided
courtesy of HarpWeek.

In the nation's capital, the Union Army celebrated at the end of May with a huge two-day military review. The first day featured the Grant's Army of the Potomac, the second Sherman's Army of the Tennessee. Foretelling the future of pictorial journalism, *Harper's* commissioned its illustrations of the procession from famed photographer Alexander Gardner, a Mathew Brady protégé. Gardner's camera could compose and capture the wide-angle posed and formal views of this staged event.

THE GRAND REVIEW AT WASHINGTON.

In the spring of 1861 there was raised a cry of alarm—"The Capital is in danger!" and thousands of young men from the store, from the workshop, and from the farm rushed with muskets in their hands to the rescue. We remember the sense of security which was felt when it was known that the gallant Seventh had bivouacked in the streets of Washington. Others came—a long train of armed men from every hamlet in

the loyal States—and from the streets of that capital these men, and others who have joined their ranks, have for years been marching and fighting until they have reached the victorious end—until they have swept from the field all those who once menaced the safety of the Government, conquering most of them in battle, and dismissing the rest to their homes as paroled prisoners.[13] What a record of heroism is compressed within the limits of those years!

Frank Leslie's countered with coverage by Brady himself along with sketches by former Special J. E. Taylor and Crane. A small article published in the journal on June 10 noted the war's ultimate end:

"IT IS FINISHED!"

The Secretary of War announces the surrender of the last organized force of the rebellion, in the following official dispatch:

"A dispatch from Gen. Canby, dated at New Orleans, May 26th, states that arrangements for the surrender of the Confederate forces in the Trans-Mississippi Department have been concluded. They include the men and matèriel of the army and navy."

The authority of the United States is now completely re-established throughout the entire country. The rebellion is dead; the great Civil War is over. Peace has returned again to bless the land. The rebel ram, Stonewall was given up on the 14th of May to the authorities of Cuba, in Havana, and will probably be surrendered to the United States on demand. The only remaining rebel cruiser on the ocean is the "Shenandoah," last heard of in the East Indies.[14]

One loose rebel thread remained, with Confederate President Jefferson Davis, members of his Cabinet, their families and an extended entourage on the run attempting to escape federal capture. The Northern sketch artists, at a loss to cover this final scene, drew what amounted to speculative caricatures of Davis in various costumes and guises according to rumors circulating regarding his whereabouts. In perhaps the most remarkable scoop of his extraordinary career, however, Frank Vizetelly joined Davis and his party; he left the president only days before his capture when the group finally split to speed movement and

Unattributed, *Capture of Jefferson Davis, at Irwinsville, GA., at Daybreak of May 10th, by Col. Pritchard and Men, of Wilson's Corps, Frank Leslie's Illustrated Newspaper,* June 3, 1865, image provided courtesy of HarpWeek.

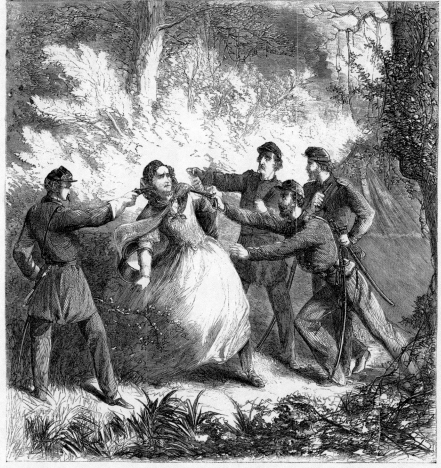

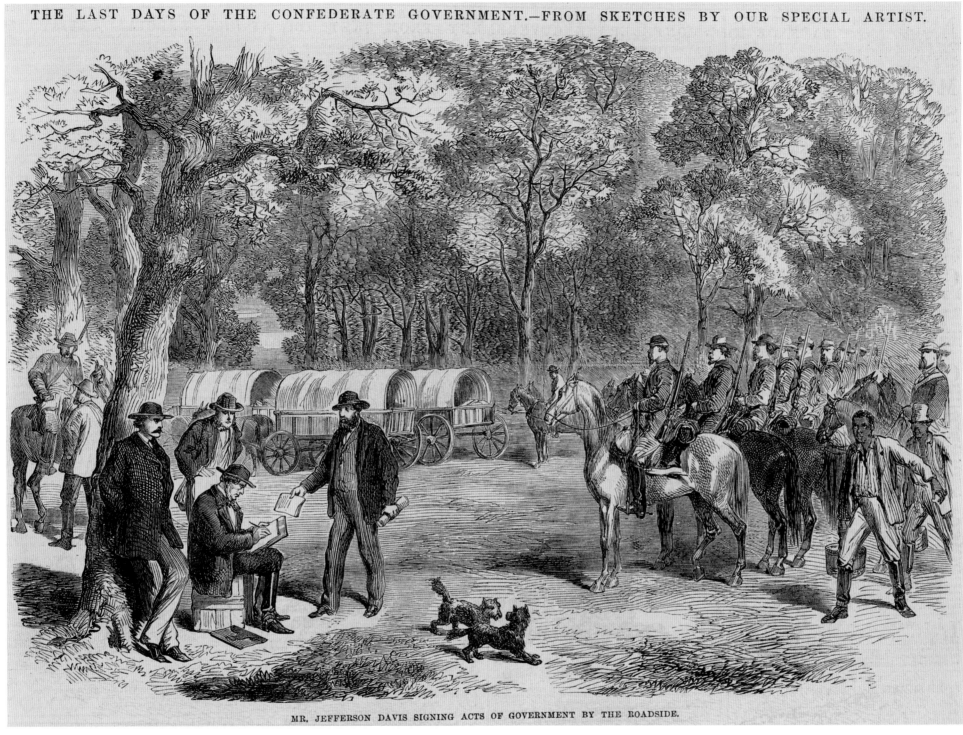

MR. JEFFERSON DAVIS SIGNING ACTS OF GOVERNMENT BY THE ROADSIDE.

Frank Vizetelly, *Mr. Jefferson Davis Signing Acts of Government by the Roadside,* Illustrated London
News, July 22, 1865, Library of Congress.

elude pursuit. Vizetelly's sketches and letters back to London revealed the truth about the Confederate leadership's sad fate, contrary to the fictions printed in northern newspapers. Vizetelly's sympathy for the Confederacy adds a sense of pathos to the scene:

FLIGHT OF PRESIDENT JEFFERSON DAVIS AND HIS MINISTERS OVER THE GEORGIA RIDGE, FIVE DAYS BEFORE HIS CAPTURE. —FROM A SKETCH BY OUR SPECIAL ARTIST

Our Special Artist and Correspondent who was lately employed in the service of this Journal at the head-quarters' camp of the Confederate Army in Virginia has furnished us with an Illustration of almost the final scene in the history of the Southern secession. After the surrender of General Lee's army and the abandonment of Petersburg and Richmond, in the first week of April, our Artist went to join the army of General Joseph Johnston, and saw the last shot of the war fired; he then attended the journey of the fallen President, Mr. Jefferson Davis, a distance of 700 miles, to the neighbourhood of Macon, in Georgia, and did not leave the party until it was disbanded, by Mr. Davis's request, two days before his capture. The sketch from which our present Engraving is made was taken by our Artist five days before the capture of Mr. Davis, when passing over the Georgia Ridge, a range of wooded hills forming the boundary line of the State of South Carolina. Mr. Davis is the central figure of the three horsemen riding in front; General Bragg is on his right hand, and Mr. Benjamin, his Secretary of State, on the *left]*; behind Mr. Davis, and on his right hand, is General Breckenridge; next whom is Mr. Regan, the Postmaster-General; the rest of the party are the staff of Mr. Davis and the Kentucky soldiers of his escort. Two or three loiterers by the roadside, in the right-hand corner of our Engraving, seem to be watching the passage of the fugitives with sentiments of deep compassion and regret.[15]

More sketches with Vizetelly's descriptive notes followed later in July, after the artist himself returned to London, and included an illustration of what he identified as "probably the last official business transacted by the Confederate Cabinet." Instinct, experience, courage and remarkable tenacity led Vizetelly on the journey into exile with Davis and his last days of freedom.

The country moved on after Lee's surrender, Booth's killing and Davis's capture. Sketch artists remained in demand to illustrate a nation rebuilding and reuniting, natural, binding wounds with scenes of shared interest that transcended regional concerns: the construction of the railroads, veterans returning home in the East, civilian life emerging anew in the South, new towns rising in the West.

William T. Crane, whose heroic reporting for *Leslie's* from within the rebel stronghold at Charleston, South Carolina, never lived to see Reconstruction. He survived the Civil War only to die of a throat disease in July while on assignment drawing the Booth co-conspirator trial for *Harper's* in Washington, D.C.

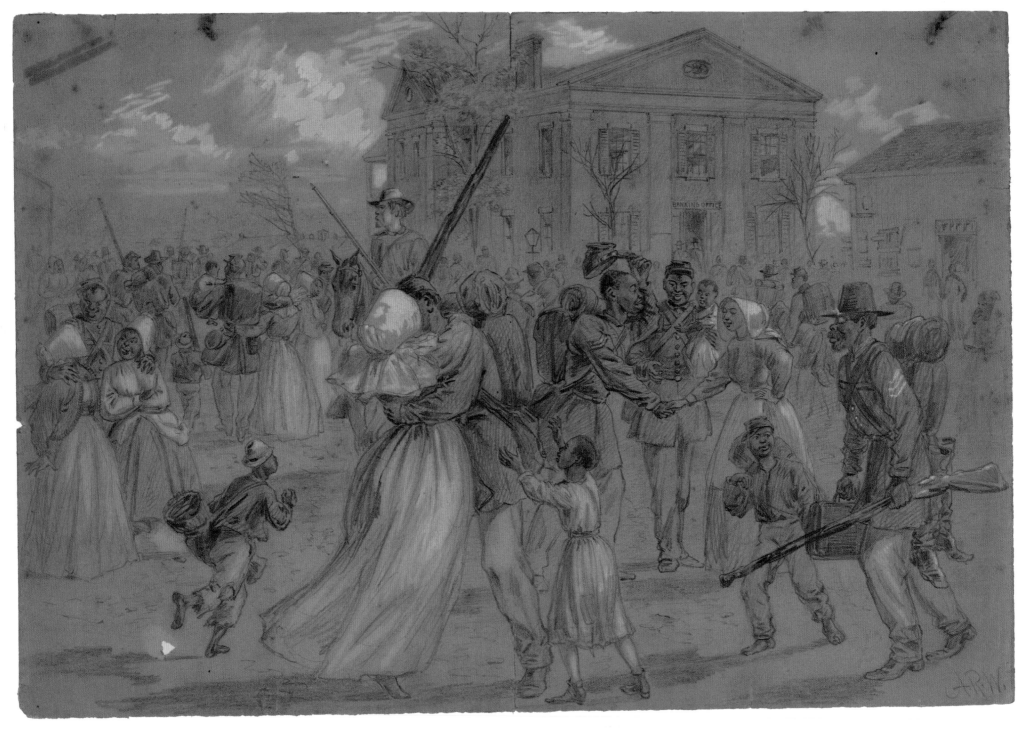

Alfred Waud, *African American Soldiers Mustered Out at Little Rock, Arkansas,* ca. March–April 1866, *Harper's Weekly,* May 19, 1866, Library of Congress.

EPILOGUE

With the end of the war, the Specials dispersed to their families, friends and future. Alf Waud and Theodore Davis, two of the most prolific war artists, both stayed on with *Harper's*, perhaps as much to satisfy their own curiosity as the nation's regarding what lay in store:

> It is like the rising of a new world from chaos. To us the late Slave States seem now almost like a newly-discovered country. For the first time we ask earnestly: What are their resources and opportunities? How has the great earthquake left them—with what marks of ruin upon their cities and fields—with what changes of social and political character? We shall leave to our artists the task of answering these absorbing questions, so far as it is possible to answer them by means of pictorial representations.[1]

Thomas Nast also remained with *Harper's*, becoming the country's foremost editorial cartoonist and a legendary figure in American journalism. His anticorruption crusade against "Boss" Tweed and his ring of cronies in New York would prove a landmark achievement. Winslow Homer's postwar career is chronicled in any number of books and museum exhibitions. His wartime sketches became iconic postwar paintings; their transcendent vision, beauty and humanism stirred a unifying impulse in the nation and helped launch his international reputation. Edwin Forbes also used his war sketches to build a career in fine art. His large-scale paintings of Civil War subjects portrayed major battles on an epic scale; he created an extensive portfolio of limited-edition etchings depicting the life of a soldier in the Union Army and contributed numerous illustrations to publications picturing the conflict. Joseph Becker, still new to the Special's art, kept at it, making sure *Leslie's* readers stayed abreast of developments in towns and cities across America. He took a special interest in the country's diverse populations. Henri Lovie retired rich with cotton investments to his native Cincinnati; Alex Simplot quit due to illness and found a career as a schoolteacher and part-time illustrator in Dubuque, Iowa. Will Waud, talented but apparently dissipated, stayed on the fringes of the pictorial publishing industry for a decade before dying prematurely of unknown causes in 1878. Edward F. Mullen died "of drink" sometime before 1870. Frank Schell and Fred Schell both returned to Philadelphia, where each became part of the city's commercial art community. Arthur Lumley continued with *Harper's* after the war, contributing as well to the *Illustrated London News*, the *London Daily Graphic*, and *Le Monde Illustré*. One of the first members of the American Society of Water Color Painters and an Exhibitor at Britain's Royal Academy, the Irishman Lumley resided in Brooklyn until his death at age seventy-five. Frank Vizetelly, the world's most famous and influential pictorial correspondent, continued his spectacular career after the war. It ended suddenly in winter 1883 when, on assignment in the Sudan for the *London Daily Graphic*, he disappeared during the British Sudan campaign of the Mahdist War.

Within a couple of decades, the profession Vizetelly had pioneered virtually disappeared as well. There were exceptions. During the 1898 Spanish-American War fought in Cuba, Frederic Remington produced illustrations for newspaper publisher William Randolph Hearst, who (according to a famous, apocryphal story) cabled the artist: "You furnish the pictures and I'll furnish the war." Noted painter John Sloan started out as a sketch artist and covered the Cuban campaign for *McClure's Magazine*. Nevertheless, the age of the Special had largely ended by the turn of the century as camera technology improved and wartime photojournalists captured frontline action for the first time. Sketch artists appeared with troops during World Wars I and II and more recent conflicts as well but only as a supplement to the work of photographers, both men and women. Their heyday may have been shortlived but their impact endures. Specials were uniquely suited to portray the vast geographical range, topographical diversity, intense psychological drama and physical trauma that characterized the Civil War. They were trained for mobility and accuracy, and their shared sense of the picturesque and the human condition produced an astounding record of conflict and devastation. Their battlefront sketches document a period of profound violence and terror with courage, compassion and resilience, and reflect the personal qualities that set them apart and set a standard for generations of pictorial journalists to come.

NOTES

Abbreviations Used in Notes and List of Illustrations

BC Becker Collection, On Deposit, Boston College

BMFA Museum of Fine Arts, Boston

CHSI Cooper-Hewitt, Smithsonian Institution

FLIN Frank Leslie's Illustrated Newspaper

HL Houghton Library, Harvard University

HW Harper's Weekly

ILN Illustrated London News

LC Library of Congress

NGA National Gallery

NYHS New York Historical Society

NYIN New York Illustrated News

NYPL New York Public Library

SIL Southern Illustrated News

ULC Union League Club

WHS Wisconsin Historical Society

INTRODUCTION

1. Henri Lovie, "Life of a Special Artist," *FLIN*, December 7, 1861: 35.

2. *HW*, June 3, 1865: 339.

3. *FLIN*, April 12, 1862: 366.

4. "Our Position," *FLIN*, November 24, 1860: 1.

5. Inscription on unattributed sketch entitled *Camp Fires at Night*, NYHS.

6. Alfred Waud, *Fairfax*, Ca. July 1861, LC.

7. Henri Lovie, *Battle for Fort Henry*, 1862, BC.

8. Henri Lovie, *Camp Lily*, 1861, BC.

9. *FLIN*, December 27, 1862: 214.

10. Fletcher W. Thompson, *The Image of War: The Pictorial Reporting of the American Civil War* (New York: Thomas Yoseloff, 1959), 81.

11. Alfred R. Waud correspondence, 1862–1880, Manuscript Division, Library of Congress.

12. In M. Paul Holsinger, ed., *War and American Popular Culture: A Historical Encyclopedia* (Westport, CT.: Greenwood Press, 1999), 96.

13. *ILN*, April 18, 1863: 432–33.

14. HW, May 24, 1862: 327.

15. J.F.E. Hillen sketch inscription described as "Artist's Report," NYHS.

16. *FLIN*, May 21, 1864: 130.

17. *FLIN*, May 21, 1864: 130.

18. Michael L. Carlebach, *The Origins of Photojournalism in America* (Washington, DC: Smithsonian Institution Press, 1992), 82.

19. William A. Frassanito, *Early Photography at Gettysburg* (Gettysburg, PA: Thomas, 1995). On the contrived position of the dead rebel soldier in Alexander Gardner's and Timothy O'Sullivan's view of Devil's Den, see pages 268–73; on Frassanito's respect for Waud, see page 103.

20. Albert Bigelow Paine, *Th. Nast, His Period and His Pictures* (New York: Macmillan, 1904), 69.

CHAPTER ONE
1861: WAR CALL

1. *FLIN*, November 24, 1869: 3.

2. "Our Position," *FLIN*, November 24, 1860: 1.

3. *FLIN*, January 26, 1861: 145.

4. *NYIN*, January 12, 1861: 146.

5. *NYIN*, February 9, 1861: 210.

6. *NYIN*, May 4, 1861: 402.

7. *NYIN*, March 9, 1861: 274.

8. *NYIN*, March 23, 1861: 309.

9. *HW*, April 27, 1861: 257.

10. *NYIN*, May 25, 1861: 34.

11. *NYIN*, June 1, 1861: 58–59.

12. *FLIN*, May 25, 1861: 19.

13. *FLIN*, July 6, 1861: 113.

14. *HW*, May 4, 1861: 274.

15. *HW*, May 11, 1861: 293.

16. *HW*, May 25, 1861: 331–32.

17. *HW*, June 1, 1861: (Fort Pulaski): 343, (Montgomery, Alabama): 344–45; (description): 341.

18. *HW*, June 1, 1861: 338.

19. *HW*, June 22, 1861: 386.

20. *HW*, June 22, 1861: 394.

21. *HW*, July 13, 1861: 447.

22. *HW*, July 13, 1861: 443.

23. *ILN*, February 16, 1861 (sketch): 139; (description): 138–40.

24. *ILN*, March 23, 1861: 266.

25. *ILN*, May 4, 1861: 424.

26. *ILN*, June 15, 1861: 563–64.

27. *ILN*, July 6, 1861: 22.

28. *ILN*, July 6, 1861: 22.

29. *ILN*, July 13, 1861: 28.

30. Alfred Waud, *General Sickles and Staff in a Reconnoitering Expedition along the Banks of the Potomac*, 1861, LC. General Daniel Sickles was a prominent, scandal-prone Democratic politician from New York City.

31. *ILN*, August 3, 1861: 121.

32. *HW*, August 10, 1861: 510.

33. *ILN*, August 10, 1861: 43–45.

34. *ILN*, August 17, 1861: 168.

35. *HW*, July 22, 1861: 187.

36. *Boston Courier*, August 5, 1861: 224.

37. *HW*, August 31, 1861: 555–58.

38. *FLIN*, September 28, 1861: 318.

39. Junius Henri Browne, *Four Years in Secessia: Adventures Within and Beyond the Union Lines* (Detroit: W. H. Davis, 1866), 27–28.

40. *HW*, September 21, 1861: 607.

41. *NYIN*, October 21, 1861: 387.

42. *NYIN*, December 9, 1861: 89–90.

43. Alfred R. Waud correspondence, 1862–1880, Manuscript Division, LC.

44. *NYIN*, December 9, 1861: 90.

45. *NYIN*, January 18, 1862: 169–170.

CHAPTER TWO
1862: GLORY NO MORE

1. *HW*, February 22, 1862: 119–21.

2. *HW*, March 22, 1862: 178.

3. J.F.E. Hillen, *Surprise of Rebels between Hurricane and Logan, Western Virginia, by a Detachment of Colonel Platts Zouaves (Thirty-fourth Ohio Volunteers), under Lieutenant Rowe*, HW, January 18, 1862: 45.

4. *FLIN*, March 1, 1862: 226.

5. *ILN*, February 22, 1862: 200.

6. *ILN*, March 1, 1862: 233.

7. *ILN*, March 22, 1862: 296.

8. *FLIN*, March 15, 1862: 257–58.

9. *HW*, March 22, 1862: 178.

10. Civil War historian William P. Campbell erred when he wrote in the 1961 Corcoran Gallery of Art exhibition catalogue that Henri Lovie "was not present at the Battle of Shiloh." As W. Fletcher Thompson, Jr., noted in his 1959 study, *The Image of War*, Lovie arrived with Grant and began sketching on "the extreme left wing." See Hermann Williams, Jr., ed., *The Civil War: The Artist's Record* (Washington, DC, and Boston: Corcoran Gallery of Art/Museum of Fine Arts, Boston, 1961), 86, and Thompson, *Image of War*, 70.

11. *HW*, May 24, 1862: 327.

12. David Tatham, *Winslow Homer and the Pictorial Press* (Syracuse, NY: Syracuse University Press, 2003).

13. *NYIN*, May 17, 1862: 26.

14. Tatham, *Winslow Homer*, 124.
15. *HW*, May 17, 1862: 306.
16. Tatham, *Winslow Homer*, 117.
17. Tatham, *Winslow Homer*, 116.
18. Alfred R. Waud correspondence, 1862–1880, Manuscript Division, LC.
19. George Sala cited in Frederic E. Ray, *Our Special Artist: Alfred R. Waud's Civil War*, 2nd ed. (New York: Stackpole Books, 1994), 11.
20. *HW*, October 3, 1863: 635–37.
21. *HW*, August 9, 1862: 503.
22. Williams, *The Civil War*, 209.
23. *HW*, August 16, 1862: 523.
24. *FLIN*, September 13, 1862: 387.
25. *ILN*, June 14, 1862: 607–8.
26. *ILN*, July 26, 1862: 111.
27. William Stanley Hoole, *Vizetelly Covers the Confederacy* (Tuscaloosa: University of Alabama Press, 1957), 44–48.
28. *ILN*, November 8, 1862: 487.
29. *FLIN*, August 16, 1862: 325.
30. *FLIN*, September 27, 1862: 3.
31. *HW*, September 27, 1862: 618.
32. *ILN*, October 4, 1862: 369.
33. *HW*, September 27, 1862: 618.
34. *FLIN*, October 11, 1862: 46.
35. *ILN*, November 8, 1862: 487.
36. *FLIN*, October 18, 1862: 56–57, 60.
37. *FLIN*, November 22, 1862: 141.
38. *FLIN*, December 20, 1862: 199–200.

39. *HW*, December 13, 1862: 794.
40. Arthur Lumley, *Night. The Sacking of Fredericksburg—& Biovace* [sic] *of Union Troops*, 1862, LC.
41. *NYIN*, January 3, 1863, 139.

CHAPTER THREE
1863: EMANCIPATION BLUES

1. *FLIN*, January 3, 1863: 225.
2. *HW*, January 10, 1863: 17.
3. *ILN*, January 31, 1863: 126.
4. *HW*, January 17, 1863: 34.
5. *HW*, February 28, 1863: 143.
6. *HW*, March 21, 1863: 187.
7. *ILN*, April 18, 1863: 432–33.
8. *ILN*, April 4, 1863: 372–73.
9. *ILN*, August 8, 1863: 127.
10. *HW*, June 27, 1863: 405.
11. *FLIN*, July 25, 1863: 290.
12. *FLIN*, March 14, 1863: 396.
13. *HW*, July 4, 1863: 427.
14. *HW*, September 9, 1863: 603.
15. *FLIN*, September 26, 1863: 12.
16. *ILN*, December 26, 1863: 661–64.
17. *FLIN*, October 31, 1863: 83.
18. *HW*, December 26, 1862: 821.

CHAPTER FOUR
1864: THE END BEGINS

1. *FLIN*, January 16, 1864: 267.
2. *HW*, January 16, 1864: 38.

3. *FLIN*, March 5, 1864: 369.
4. *FLIN*, May 28, 1864: 151.
5. *HW*, June 4, 1864: 358.
6. Margaret E. Wagner, Gary W. Gallagher, and Paul Finkelman, eds., *The Library of Congress Civil War Desk Reference* (New York: Simon and Schuster, 2002), 294.
7. *HW*, June 11, 1864: 382.
8. *ILN*, April 2, 1864: 314.
9. *HW*, June 25, 1864: 410.
10. *HW*, June 18, 1864, 395.
11. *FLIN*, June 18, 1864: 206.
12. *FLIN*, July 2, 1864: 231.
13. Alfred Waud, *In Front of Petersburg*, 1864, LC.
14. *ILN*, July 16, 1864: 70.
15. *ILN*, August 6, 1864: 137–38.
16. *FLIN*, August 8, 1864: 315.
17. *HW*, August 20, 1864: 542.
18. *FLIN*, October 1, 1864: 20.
19. *FLIN*, October 15, 1864: 49.
20. *FLIN*, August 20, 1864: 339.
21. *FLIN*, October 1, 1864: 20.
22. *FLIN*, August 20, 1864: 349.
23. *FLIN*, October 22, 1864: 76–77.
24. *ILN*, October 22, 1864: 407.
25. *FLIN*, November 12, 1864: 124.
26. *FLIN*, November 2, 1864: 124.
27. *FLIN*, December 17, 1864: 205.
28. *FLIN*, December 24, 1864: 215.

CHAPTER FIVE
1865: VICTORY AND DEATH

1. *ILN*, January 21, 1865: 66.
2. Inscription on verso of sketch, HL.
3. Abraham Lincoln, Second Inaugural Address, March 4, 1865, Abraham Lincoln Papers, Series 3, General Correspondence, 1837–1897, LC.
4. *FLIN*, March 18, 1865: 403.
5. *FLIN*, April 1, 1865: 20.
6. William Tecumseh Sherman, *Memoirs of General W. T. Sherman*, ed. Michael Fellman (New York: Penguin Books, 2000), 479.
7. *FLIN*, April 15, 1865, 51.
8. *HW*, April 29, 1865: 257.
9. *FLIN*, April 29, 1865: 82.
10. *FLIN*, May 13, 1865: 119.
11. *HW*, May 27, 1865: 321–22.
12. *HW*, May 27, 1865: 327.
13. *HW*, June 10, 1865: 358.
14. *FLIN*, June 10, 1865: 178.
15. *ILN*, July 1, 1865: 623.

EPILOGUE

1. *HW*, April 28, 1866: 259.

SELECTED BIBLIOGRAPHY

ON THE PICTORIAL PRESS

Butterfield, Roger. "Pictures in the Papers." In *American Heritage*, vol. xiii, no. 4 (June 1962): 32–55.

The Civil War: A Centennial Exhibition of Eyewitness Drawings. Washington, DC National Gallery of Art, Smithsonian Institution, 1961. An exhibition catalogue.

Starr, Louis Morris. *Bohemian Brigade: Civil War Newsmen In Action*. New York: Knopf, 1954.

Thompson, W. Fletcher, Jr. *The Image of War: The Pictorial Reporting of the American Civil War*. New York: Thomas Yoseloff, 1959.

Williams, Hermann Warner, Jr., ed. *The Civil War: The Artist's Record*. Washington, DC, and Boston: Corcoran Gallery of Art Museum of Fine Arts, Boston, 1961. An exhibition catalogue.

WEB SITES

www.bohemianbrigade.com.
www.harpweek.com.
www.sonofthesouth.net.

SPECIAL ARTISTS' BIOGRAPHIES

Bookbinder, Judith, and Sheila Gallagher, eds. *First Hand: Civil War Era Drawings from the Becker Collection*. Boston: McMullen Museum of Art, Boston College, 2009.

Groce, George C., and David H. Wallace. *The New-York Historical Society's Dictionary of Artists in America 1564–1860*. New Haven and London: Yale University Press, 1957.

M. & M. Karolik Collection of American Water Colors and Drawings, 1800–1875, vol. II, *The Civil War, 1861–1865*. Boston: Museum of Fine Arts, Boston, 1962.

Taft, Robert. *Artists and Illustrators of the Old West, 1850–1900*. Chap. 4 discusses Theodore R. Davis and Alfred R. Waud. New York: Charles Scribner's Sons, 1953.

WORKS BY AND ABOUT INDIVIDUAL SPECIAL ARTISTS

Cochran, Robert T., Jr. "Witness to a War: British Correspondent Frank Vizetelly," *National Geographic*, vol. 119, no. 4 (April 1961): 452–491.

Davis, Theodore R. "How A Battle Is Sketched." In *St. Nicholas*, vol. XVI, no. 9 (July, 1889): 661–668.

Eby, Cecil D., Jr., ed. *A Virginia Yankee in the Civil War: The Diaries of David Hunter Strother*. Chapel Hill: University of North Carolina Press, 1961.

———. *"Porte Crayon": The Life of David Hunter Strother*. Westport, CT: Greenwood Press, 1973.

Forbes, Edwin. *Thirty Years After: An Artist's Memoir of the Civil War*. New York: Fords, Howard and Hulbert, 1890.

Grossman, Julian. *Echo of a Distant Drum: Winslow Homer and the Civil War*. New York: Harry N. Abrams, 1974.

Hoole, William Stanley. *Vizetelly Covers the Confederacy*. Tuscaloosa: University of Alabama Press, 1957.

Hunter, John Patrick. "Alexander Simplot, Forgotten Bohemian." In *Wisconsin Magazine of History*, vol. 41, no. 4 (1957–1958), 256–261.

Ray, Frederic E. *Our Special Artist: Alfred R. Waud's Civil War*, 2d ed. New York: Stackpole Books, 1994.

Tatham, David. *Winslow Homer and the Pictorial Press*. Syracuse, NY: Syracuse University Press, 2003.

LIST OF ILLUSTRATIONS

INDEX

Page numbers in *italics* refer to illustrations.

242

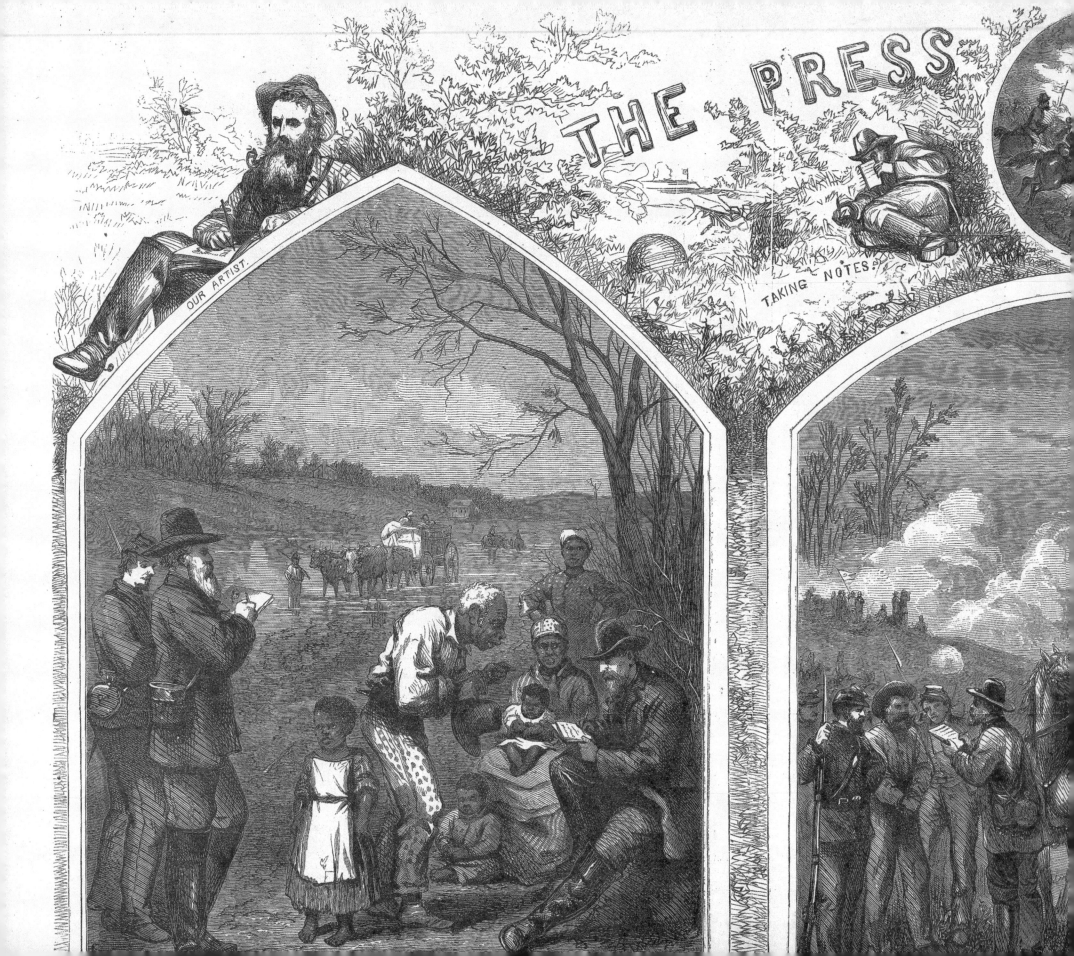

THE PRESS

OUR ARTIST.

TAKING NOTES.